ANIME EXPLOSION !

P9-CSE-437

ANIME EXPLOSION !

The What? Why? & Wow! of Japanese Animation

Patrick Drazen

Stone Bridge Press • Berkeley, California

PUBLISHED BY

Stone Bridge Press, P.O, Box 8208, Berkeley, CA 94707

TEL 510-524-8732 • sbp@stonebridge.com • www.stonebridge.com

Readers: Please send your comments on this book to animeinfo@stonebridge.com.

The publisher extends its thanks to the studios, artists, and companies that cooperated in the publication of this book and the acquisition of images. Your help and generosity are greatly appreciated! We have done our best to contact rightsholders to obtain permissions for and to faithfully and accurately credit all copyrighted materials. Please advise us at editorial@stonebridge.com of any oversights and omissions.

Front cover design and artwork by Elizabeth Kirkindall of Big-Big-Truck.com.

Interior book design by D. S. Noble.

Printed in the United States of America.

10 9 8 7 6 5 4 3 2007 2006 2005 2004

Anime Explosion! The What? Why? and Wow! of Japanese Animation
ISBN 1-880656-72-8

Contents

Preface vii

Acknowledgments xv

PART ONE: INTERPRETING ANIME

1. A Page Right Out of History 3
2. Conventions versus Clichés 16
3. The Social Web and the Lone Wolf 27
4. *Mukashi Mukashi*: From Folktales to Anime 37
5. The Naked Truth 48
6. Rated H: Hardcore Anime 59
7. "A Very Pure Thing": Gay and Pseudo-Gay Themes in Anime 78
8. *Bushido*: The Way of the Warrior 104
9. *Shojodo*: The Way of the Teenage Girl 117
10. Enter the *Mamagon*: The Japanese Mother 130
11. Faith-Based: Christianity, Shinto, and Other Religions in Anime 142
12. Who Ya Gonna Call?: The Spirit World in Anime 155
13. The Starmaker Machinery: Anime and Idol 169
14. It's Not Easy Being Green: Nature in Anime 183
15. War Is Stupid: War and Anti-War Themes in Anime 192
16. Birth and Death and Rebirth: Reincarnation in Anime 208

PART TWO: FILMS AND DIRECTORS

1. *Windaria* 223

2. *Wings of Honneamise*: Tora-san in Space 230

3. *Utena: Giri/Ninjo* and the Triumph of Conservatism in Pop Culture 237

4. *Giant Robo*: Anime as Wagnerian Opera 246

5. Flying with Ghibli: The Animation of Hayao Miyazaki and Company 253

6. The *Sailor Moon* Phenomenon: Love! Valor! Compassion! Middie Blouses! 280

7. *Escaflowne* 288

8. *Evangelion* 298

9. *Please Save My Earth* 310

10. The Big *Pokémon* Scare 317

11. *Plastic Little*: Not What You Think 327

12. The Old and New Testaments of Masamune Shirow 333

13. *Key the Metal Idol* 342

Afterword: The Future of Anime 349
Bibliography 359
Index of Names and Titles 363

Preface

They can be seen on Japanese television morning, noon, or night, as well as on the movie screen and in video stores. Their viewers are male and female, grade schooler and graduate student, housewife and businessman. The content can include raucous humor or theological speculation or horrifying pornography—or all three at once. Their visual quality can be as amateurish as *South Park* or on the cutting edge of computer-generated imagery. Thanks to cable TV and videocassettes and especially the Internet, the number of their fans around the world has grown in recent years, and is still growing. You've probably watched them all your life and may not have realized it.

They are Japanese cartoons (more properly, *anime*, which simply means "animation") and for most *gaijin* (non-Japanese), an introductory volume like this one is an absolute necessity. This is because anime bear almost no resemblance to their Western cousins like *Road Runner* or *Rocky and Bullwinkle*. The lack of resemblance is ironic, since the two media evolved roughly from the same sources. They diverged for several reasons.

For one, the Japanese don't regard animation as a "children only" playground. Certainly there are cartoons aimed at a juvenile audience, and these

are often brought to Western television with only minor adaptations. Japanese animators, however, have also used animation to explore broader themes: love and death, war and peace, the historical past and the far future. Once these animators took the first giant leap away from the age and subject-matter limitations of the West, they kept exploring, kept pushing the envelope to see what would happen next.

Another big difference between Japanese and Western animation is that, like *manga* (Japanese comic books), anime were never intended for the export market. Hollywood often develops its products with an eye toward overseas sales. Cop shows and westerns, for example, are careful never to give their lawmen a six-pointed star for a badge, since even a casual resemblance to the Star of David would affect sales in Arab countries.

Artists in Japanese pop culture, however, usually haven't had to worry about such concerns. Some anime may find their way overseas, but until recently it was safe to assume that most such productions would not—and could not—travel very well. Anime are, after all, Japan talking directly to itself, reinforcing its cultural myths and preferred modes of behavior. Whether there is any dissonance between anime and reality, such as the comparatively limited but still evolving role of women in Japanese society versus their cartoon status, is a question to be dealt with separately. For now, we need only note that most of the anime you are about to meet were not intended to be seen by non-Japanese eyes. Some sort of guide is necessary for the uninitiated, to explain the cultural landmarks and in-jokes.

Why does it matter? Cartoons are kid stuff, right? Actually, no pop culture medium should be taken lightly, since it contains the capacity to guide viewers along the path of socially acceptable thought and action. Film critic Peter Biskind reminds us, for example, that:

movies influence manners, attitudes and behavior. In the fifties, they told us how to dress for a rumble or a board meeting, how far to go on the first date, what to think about . . . Jews, blacks and homosexuals. They taught girls whether they should have husbands or careers, boys whether to pursue work or pleasure. They told us what was right and what was wrong, what was good and what was bad; they defined our problems and suggested solutions. And they still do.[1]

Biskind looked at Hollywood movies and the way that they both reflected and influenced American life. The content of Japanese animation is the topic under consideration here, but the mechanism is the same. Yes, there are cutesy animals, but there are also dating tips for the lovelorn from a girl who lives in a videocassette, and there are history lessons from a former samurai. Students are encouraged to keep up their studies; the young are reminded to respect the elderly. Slapstick and sorcery, humor and horror, sports and sex, machines that rule the sky and gods that rule the forest all coexist in anime. There seems to be a mind-numbing variety of messages in this medium, until one realizes that all these stories tell pretty much the same story, one that has been told and retold in Japan for hundreds of years. The trick is to separate the message from the glitzy, hi-tech messenger.

This isn't a problem specific to the Japanese culture. Anywhere in the world, pop culture is essentially a balancing act. To sociologist Todd Gitlin, popular culture is successful to the extent that it combines the old and the new:

Capitalism as a culture has always insisted on the new, the fashionable, the novel. . . . The genius of consumer society is its ability to convert the desire for change into a desire for novel goods. . . . Popular culture above all is transitory; this guarantees not only turnover for the cultural marketers but currency

[1] Peter Biskind, *Seeing is Believing: How Hollywood Taught Us to Stop Worrying and Love the Fifties* (New York: Pantheon, 1983), 2.

for the customers. But curiously, the inseparable economic and cultural pressures for novelty must coexist with a pressure toward constancy. Nostalgia for "classics"—old movies, "oldie" songs, antiques—is consumer society's tribute to our hunger for a stable world. Consumers want novelty but take only so many chances; manufacturers . . . want to deploy their repertory of the tried-and-true in such a way as to generate novelty without risk.[2]

Gitlin was speaking specifically of American network television. He probably didn't have in mind a culture where the spirits of one's dead ancestors drop by every year for the summer festival, where the latest hit on the pop charts might have an explosion of traditional taiko drums as well as a dozen layers of synthesized techno, and where mythology thousands of years old is still being told and retold in new and striking ways. Unlike the culture of the United States, a mere infant at just over two hundred years old, Japanese culture has for centuries lived out Gitlin's balance of the old and the new. It has mastered ground rules that most outsiders can only guess at—hence, this guide.

This book is divided into two parts. Part I deals with major themes of Japanese culture sounded in anime—themes that don't always appear in the most obvious form. Part II takes a closer look at some of the feature films, television series, and direct-to-videocassette animation known as Original Animation Videos (OAVs—or sometimes as OVAs) that have become "classics" of their genre. Many anime, if not most, are based on manga, so there will also be examples from that medium, as well as looks back to the various heroes and monsters of Japanese folklore and legend, some of whom still live in anime. The choice of anime in Part II is not based on popularity in Japan or the West, but on the extent to which they reflect Japanese life and attitudes.

[2] Todd Gitlin, *Inside Prime Time* (New York: Pantheon, 1983), 77–78.

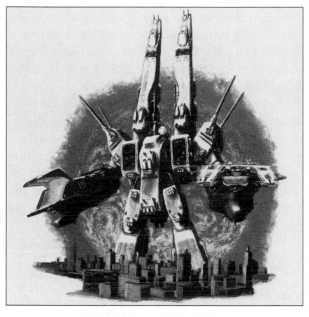

Super-Dimensional Fortress Macross Is it a rocket ship? Is it one big ship, capable of deploying little ships? Is it a self-contained city? The 1982 TV series Super-Dimensional Fortress Macross, *known also in the U.S. as part of the Robotech franchise, was one of the first big anime hits in the West and, like Japanese animation itself, is many things at once, including a few things you never even thought of . . .*

Still, why have such a guide at all? Shouldn't art be allowed to stand or fall on its own ability to speak cross-culturally? The problem with this view is that, while a culture may be a living entity, the manifestations of that culture are not. It is a mistake to confuse Japanese culture with any one of its offshoots. Manga and anime, like sumo wrestling and Kabuki, are not the totality of the culture but point to certain aspects of it. The birth or death of a communications medium or art form does not necessarily forecast a massive change within the larger culture. The pre-television *kami-shibai* storyteller, for example, who illustrated the tales he told on the spot, gave way to manga, but an analysis of the content of the stories in both media may show more continuity than difference.

Then, too, cultural changes do not always occur from within. The United States has been accused of waging cultural war against the rest of the world, and there's some truth to that. American movies account for a major share of the Japanese box office, and styles in clothing and music are carried from California across both oceans. Studying the

Americanized aspect of Japan could lead us to the mistaken assumption that the Japanese culture is exactly like ours. They dress in suits, they listen to rock bands, and they eat Kentucky Fried Chicken—how different can they be?

The pop culture examples in this volume illustrate the ways in which our cultures are different—and yet, in spite of the differences, capable of communicating essential truths from one culture to the next. Just because this material wasn't intended for export doesn't mean that we in the West can't learn from it. And among the things we can learn from it is that we can learn from it.

What else can we learn from it? Let's take a look. But first a word about . . .

Spoilers, Puns, Names—and Sex

This book will give away the endings of classic (or soon-to-be-classic) anime. Since the goal is to examine the society that anime comes from, it would be self-defeating not to discuss all the relevant plot events. Some of the stories are archetypes whose endings can be guessed at anyway. Some of the endings will also become common knowledge in time precisely because the work is a popular example of its genre. To speak of spoilers in the case of classic literature, mythology, or even history, is absurd.

By the way, here are some spoilers: Jane Eyre marries Mr. Rochester, Tom Sawyer and Becky get out of the cave, Dracula gets a stake through his heart, and the *Titanic* sinks.

Oh, you already knew? See what I mean?

Japanese has puns galore. Because the language has so many Chinese characters that can be pronounced in two or more ways, and because there are so many different words that can be pronounced the same way (for instance, the characters for "flower" and "nose" are both pronounced hana, albeit with different stresses), the potential for humor is always there. I first ran into this word-

play at an Asian foods store. A package of pickled garlic cloves had a picture of a popular manga character: a burly, masked, pro wrestler. Why did they use this wrestler to promote garlic? Because the wrestler was the title character of the long-running Japanese comic *Kinnikuman* ("Muscle Man"). And the Japanese word for garlic is *ninniku*. So, if you sold garlic and were looking for a spokescartoon . . . The blessing is that these gags just get funnier and funnier the more of them you encounter (such as Ranma Saotome's Chinese fiancée, whose name is transliterated "Xian Pu" and pronounced "Shampoo"). The curse is having to explain some of the more opaque gags, since a simple translation often isn't enough. I'll try to keep the explanations brief.

Since for some readers this guide may be an introduction to both an art form and the culture that created it, most of the Japanese names have been westernized by putting the family name last. For example, the given name of the great cartoonist and animator Dr. Tezuka—Osamu—is placed first here: Osamu Tezuka. Only in the case of *Sailor Moon* characters will there be an exception, since the order has to begin with the family name to properly convey a point the artist is trying to make. Note, too, that Japanese words in this book do not use the macrons, or long signs, to indicate extended vowel sounds; these are often left off names and titles in English-language releases or are presented in variant forms, such as *Rurouni Kenshin* or *Fushigi Yûgi*. And there is also variation in film titles, depending on the date and origin of the foreign release. We have tried to keep everything consistent and in order, but there are inevitably problem areas. . . .

While aspects of Christianity abound in Japanese pop culture, that's as far as it goes. Christianity has a peripheral influence at best in Japan's daily life and historical culture. One group of Christians that would have totally baffled the Japa-

nese was the Protestant sect that made the word "Puritan" a synonym for "sexually repressed and uptight." The Japanese, in contrast, have a long history of racy, bawdy humor, allowing examples in their pop culture of full-frontal nudity, sex, scatology, and ultraviolence that would have never got past the Comics Code or the Federal Communications Commission of the United States. In Japan it's on full display even in anime not thought of as being *hentai*, or sexually oriented, and it might be a bit more than the average Westerner is used to. One need look no further for a hint of what's to come than a line from the theme song of the 1973 television anime series (and subsequent revivals and reworkings) inspired by the "bad boy" of manga Go Nagai and his "love warrior," Cutey Honey. The line: *Oshiri no chiisana onna no ko*, "She's the girl with the cute little ass."

You have been warned.

Acknowledgments

Writing this book was a bit like being a manga artist: just me, my thoughts, and my pen (my word processor, actually). But, just as it takes lots of people to turn manga into anime, it took a lot of people to bring this book into being.

First credit has to go to my wife, Carlos (yes, that's her name; long story . . .), for her patience, persistence, and encouragement that kept things moving.

Many thanks also to my brother Dan, who mailed me a few random pages of *Weekly Shonen King* manga magazine back in the '80s, giving me a hint of the depth and breadth of Japanese popular culture.

I owe a debt beyond words to the folks at Stone Bridge Press, who decided to take a chance on a novice's manuscript. All credit is due to publisher Peter Goodman, assistant Alden Harbour Keith, publicists Miki Terasawa and Dulcey Antonucci, and especially editor David Noble. It's tough enough to get a manuscript from the inbox to the bookstore; it gets harder when the author lives 2,000 miles away, and business has to be conducted by e-mail, FedEx, fax, and occasional phone calls. My hat is off to the whole crew.

My editor's job was simplified by having a few

friends beta-read the manuscript chapters for mistakes of fact or grammar, or just bad writing that needed to be improved. Thanks go to Daniel Drazen, Donald Dortmund, Anjum Razaq, Jennifer Gedonius, Chris Barr, Lynda Feng, and Claire Peterik.

There are also many, many anime industry reps I have dealt with while getting permission to use images to illustrate this book, on both sides of the Pacific Ocean. Whether these dealings bore fruit or not, it was a valuable lesson, and I got to deal with a lot of very nice people. So, in no particular order, I'd like to thank: Julie Ninomiya of Kodansha Publishing; Kazuko Shiraishi of Gainax; Rena Ikeda and Shigehiko Sato of Fuji Creative Corp.; Ryan Gagerman of D.I.C.; Dallas Middaugh, David Newman, Rika Inouye, and Koichi Sekizaki of Viz Communications; Kenichiro Zaizen of Amuse Pictures; Junko Kusunoki of AIC; John O'Donnell, Luis Perez, and Mike Lackey of Central Park Media; Minoru Kotoku of Tezuka Productions; Chieko Matsumoto of Mushi Production Co.; Stephen M. Alpert of Studio Ghibli; Scott Carlson and Anita Thomas of AnimEigo, Inc.; Kris Kleckner of The Right Stuf, Inc.; Bruce Loeb and David Weinstock of Pokémon USA; Tak Onishi at Japan Video and Media; Fred Patten; Jerry Chu and Jason Alnas from Bandai; Matt Perrier at Manga Entertainment: Anna Bechtol, Corey Henson, and Ken Wiatrek of ADV Films; Meredith Mulroney of Media Blasters; Sara Bush of Nintendo of America; Maki Terashima of Production IG; Danielle Garnier and Matt Perrier of Manga Entertainment; Libby Chase of Harmony Gold USA, Inc.; and Tom Devine of NuTech Digital, Inc. Also thanks to Elizabeth Kirkindall of Big-Big-Truck.com for the great cover.

This book is dedicated to my nieces—Mica J Powers and Nana Asantewaa Armah—and the upcoming generation of anime fans:

"It's gonna be your world!"
(from the theme to *Cardcaptor Sakura*)

Part One:
Interpreting Anime

A Page Right Out of History

American fans of Japanese animation wouldn't have Pokémon, Akira, or Totoro to enjoy if it weren't for Walt Disney, cable television, and the VCR. An informal history of anime in the United States, going back to 1963.

A lot of Japanese anime—not all of it by any means, but certainly more than animation in the West—is aimed at viewers with double-digit ages and triple-digit IQs. As they did with automobiles, the Japanese have taken an American creation and reworked it into something far beyond what its creators considered to be the state of the art. Toontown, like Detroit, has to play some serious catch-up if it wants to stay in the game.

Hooray for Hollywood

Ironically, there would be no animation in Japan or anywhere else had it not been pioneered and developed in the United States shortly after movies themselves were invented. Of the two mainstay studios in American animation between the World Wars, one didn't last very long. Brothers Max and Dave Fleischer had some very popular characters to their credit. These included the animated versions of the *Superman* comic book and of the newspaper comic *Popeye*, and especially the cartoon

vamp Betty Boop. Max Fleischer also invented the rotoscoping technique of filming live actors, then drawing cartoons based on their movements. This accounted for the realistic look of the title character in the 1939 Fleischer feature *Gulliver's Travels*, while the little people of Lilliput and Blefuscu were blatantly cartoony.

The top of the animation mountain, of course, was Walt Disney. He pioneered sound and color, as well as avant-garde techniques that would hardly ever be used again. If people anywhere in the world saw animation at all before 1941, it was probably Disney animation. Disney broke new ground with the 1937 feature-length *Snow White and the Seven Dwarfs*. For the next four decades Hollywood animated features followed the lead of Walt Disney in treating animation as a "family" medium: targeted at children, but with the occasional bit of in-joking dialogue or eye candy for the grownups who brought the children into the theater in the first place. (And singing; don't forget singing. That deserves its own chapter, especially in light of Japan's take on pop music and anime. For now, suffice it to say that, because *Snow White and the Seven Dwarfs* was structured along the lines of European operetta, with songs aplenty, some animated features in the West still feel obliged— sixty years later—to break into song every five minutes, even if there's no particular reason.)

However, cartoons in the West were often just a sideshow. Animation before television, after all, usually meant theatrical short subjects, and the only place to see animation was at the movies.

The Doctor Is In

At first the Japanese took their cues on animation from the same medium that American television animation did: Disney's animated theatrical short subjects and feature films. However, Disney's early animation—both the artistic technique and the humanist philosophy—became the subjects of

Astroboy *One of the most recognizable comic-book characters even a half-century after he was created, Dr. Osamu Tezuka's Astroboy naturally become Japan's first anime superstar. Who could have predicted he'd make such an impact on American television audiences as well?*

study as well as entertainment for a medical student named Osamu Tezuka (1925–89). His nickname—*manga no kamisama* ("God of Comics")—is no exaggeration. His forty years as a cartoonist saw massive changes in the form and content of Japanese comic books, changes that usually traced back to innovations by Dr. Tezuka himself. His manga (an estimated career total of 150,000 pages) used storytelling devices that were influenced not only by Disney but also by French New Wave cinema. In fact, "cinema" is the key word; with their use of panning shots, extreme close-ups, time-lapse, flashbacks, and other cinematic devices, Japanese comics literally exploded off of the paper they were printed on.[1] The transition to television animation was thus a short and simple one.

It was helped along when Dr. Tezuka created Japan's first animated TV superstar. While Mickey Mouse, Tom and Jerry, and Bugs Bunny were created for the movies and then found life on American television, a robot that looked like a young boy moved from the comic-book pages directly to the small screen, and promptly became one of the most memorable characters of all time, on both sides of the Pacific. Published in Japan for years as *Tetsuwan Atomu* (*The Mighty Atom*) and animated by Tezuka's own Mushi Productions studio, he's still remembered outside Japan as *Astroboy*. With spiky hair, eyes as big as fists, rockets in his feet, and

[1] Reiji Matsumoto, another master of manga, was an avid collector in his youth of American comics, which were plentiful in Japan during the Allied Occupation. His verdict: the full-color printing was "wonderfully meticulous and has a polishedness based on proper drawing skills," but Western storytelling was "... too simple. Each story's exposition-development-twist-conclusion were so short and lacked complexity. So I was more drawn toward the Japanese manga methods that were more like American movies and sophisticated French movies." From "Riding the Rails with the Legendary Leiji," an interview with Takayuki Karahashi in *Animerica* 4, no. 7: 9.

machine-guns in his butt, Atomu was a new kind of robot for a post-Occupation Japan. His enemies aren't just bug-eyed monsters from outer space— he has the ability to tell if people are good or evil just by looking at them, so he spends time with law enforcement as well as his family. (He was originally created by a mad scientist to replace the scientist's son, killed in a traffic accident, but by the end of the series Atomu acquired two robot parents and two younger siblings.)

Watching *Astroboy* here and now, and especially *Astroboy's* initial episode, first broadcast in 1963, is something that will stay with you even in the wake of high-tech marvels such as *Akira* and *Ghost in the Shell*.

At times the black-and-white pictures are as primitive as an old *Popeye* short; at times the graphic quality rises to the level of *Dumbo*. But there is also the overall difference from typical Western storytelling, whose joys cannot be over-stated. Watch Atomu rise up from the laboratory table. This isn't a parody of Frankenstein movies; this is the creation of a life—tentative, inquisitive, singular. Something in the way he moves and ges-tures tells us that, at some level, this really is a wide-eyed child taking his first steps. Look at the castoff performers at the Robot Circus, consigned to the junk heap only because cute is boring. Con-sider the ringmaster as a low-rent Stromboli from *Pinocchio*; then watch as the Robot Circus burns down, and as Atomu rescues the ringmaster. From his hospital bed, the ringmaster finds out who saves him—a scene that would lead immediately to repentance in the West—but then the sonova-bitch still claims he owns Atomu, in spite of robots having been granted civil rights. (Unlike Disney features, which didn't try to be topical except for a few pop culture references, *Tetsuwan Atomu* con-sciously and deliberately mirrored the American civil rights struggles of the day. It's hard to think of an American television series—live or animated—

that did the same, and it's equally hard to think of a Disney movie that could be called "topical.")

They're Coming to America

Not long after its premiere on Japanese TV on the first day of 1963, Atomu made the jump to American television. Back in the early 1960s, most TV stations in the United States were not even on the air twenty-four hours a day, and the notion of cable TV with hundreds of channels was the stuff of science fiction. This was a time of growth and expansion, however, with color broadcasting just around the corner. The growing need for programming coincided with the experimental approach in those days of broadcasters who were willing to try just about anything. Anime were especially welcome because of their lack of ethnic specificity. One of the conventions of anime (to be discussed later) was to draw characters as if they were American, or at least white. Even if the characters were supposed to be Japanese, they seldom looked Japanese. Thus, translation was no trouble at all; characters could be renamed, relationships and motivations juggled, and plots rewritten with relative ease. This became a major consideration later, when Japanese plots and pictures went far beyond what was permitted by American broadcast standards.[2]

Astroboy flew across the American tube from 1963 to 1964, and his cartoon countrymen grabbed their passports, changed their names and followed in short order.[3] The giant robot *Tetsujin 28-go*, based on a manga by Mitsuteru Yokoyama, hit the West in 1965 as *Gigantor*. He was not, however, the star of the show—this robot, unlike Atomu, was not a sentient being but a huge (forty-foot-tall) machine controlled by a small boy, the son of the inventor. This created an archetype for several "a boy and his robot" series to follow, from *Johnny Socko* to *Evangelion*.

Dr. Tezuka followed up *Astroboy* with several series based on his manga. The year 1965 alone saw

[2] This also meant that anime could be translated into a variety of languages for broadcast around the world. Among the series available in Spanish, for example, are *Princess Knight, Lost Universe, Tenchi Muyo, Dragonball Z, Saint Seiya,* and *Yokohama Kaidashi Kiko (Yokohama Shopping Journal)*—some of which haven't yet been translated into English.

[3] The first run of *Tetsuwan Atomu* on Japanese TV was from the first day of 1963 to the last day of 1966.

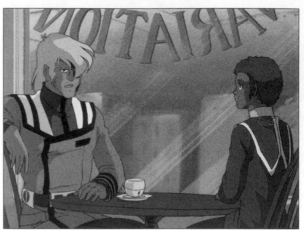

Macross/Robotech The Japanese series Macross, *broadcast in the West as* Robotech, *broke new ground in several ways. The elaborate story-line, for example, was as fully developed as a live-action drama. Here, two lovers meet in a restaurant—a surprise in itself, since showing a mixed-race romance on American television was still rather avant garde in the early '80s.*

Wonder Three and *Kimba the White Lion* (based on his manga series *Jungle Emperor*), as well as an animated special based on *Shin Takarajima* (*New Treasure Island*), the groundbreaking 1947 comic by Dr. Tezuka that literally changed the entire medium. In 1967 both the cross-dressing Princess Sapphire of Dr. Tezuka's *Ribon no Kishi* (*Princess Knight*) and the Mifune family arrived on Japanese and American television. Teenager Go Mifune circled the globe driving the Mach 5, a highly advanced racecar, accompanied by his father, little brother, and girlfriend. If this seems familiar, it's because reruns of *Mach Go Go Go* can still be seen on cable television under its American name, Speed Racer.[4] By the late '60s, though, American interest in Japanese animation had declined to almost zero.

Anime: The Second Wave

It wasn't until 1979, in the wake of the popularity of George Lucas's *Star Wars*, that another anime series hit American television, but its impact was considerable. *Star Blazers*, the animated version of Reiji Matsumoto's *Uchu Senkan Yamato* (*Space Cruiser Yamato*), was a revelation, since it had a twenty-six-week story-arc, dwarfing its predecessors the way its namesake dwarfed other battleships.[5] Whether or not television executives in the West anticipated

[4] Because the number five is pronounced *go* in Japanese, the title can also mean "Mach 5, Go (the verb), Go (the driver's first name)." And the puns are just beginning. . . .

[5] The spaceship in this series was built inside the wrecked hull of the World War II battleship *Yamato*. For more on the *Yamato*, see the sidebar on page 205.

it, some of the older kids in the audience were watching as much for the personal interaction (some characters die, others fall in love) as for the space battles against the Gamilon forces.

The 1980s brought about two revolutions in American broadcasting: the explosive growth of cable, and consumer videotape recorders. The proliferation of cable channels—some of which specialized in showing cartoons—meant that large blocks of airtime were suddenly opening up on America's vast wasteland, and something unique, or at least different, had to be plugged into the space. More than a few Japanese anime series moved in to fill the void.

Among them was *Go Lion* (*Five Lions*, 1981), renamed *Voltron*, which mixed two anime genres to create an intriguing new hybrid. It started with the formula for the "science team" first established in the *Gatchaman* series[6] and revived (with occasional minor variations) in dozens of other Japanese series. (The team almost always consisted of: hero, woman, child, big beefy guy, lone wolf. The latter may seem odd, since loners usually aren't part of a team, but such teams usually include a wild card to spice things up, since he's capable of anything from criminal behavior to borderline psychosis.)[7] Then it put the team inside five lion-shaped robots that combine to form one giant human robot. This notion of recombinant robots traces back to *Getter Robo*, the 1974 brainchild of Go Nagai. By the time the Transformers started gaining popularity in the West, the ground was well prepared.

Robotech went American television one better—or rather three better, since three different Japanese TV series were collected and edited together to produce this 1985 series that is still hailed as a major leap forward in science-fiction broadcasting, live or animated.[8] In this wild and woolly space opera, the Earthlings do not build the giant superdimensional fortress Macross, it crashes into the Earth years before the battle against the Zentraedi

[6] This series, whose full Japanese title is *Kagaku Ninjatai Gatchaman* (*Science Ninja Team Gatchaman*) has also appeared on American TV under titles like *Battle of the Planets* and *G-Force*. It's the one with people whose costumes look like bird suits.

[7] In the 1987 TV series *Zillion*, for example, a story based on a toy laser pistol, whose plot was inspired in equal parts by *Star Wars* and the *Gundam* series, the team (as renamed in the English dub) consists of J. J. (hero), Apple (woman), Addy (child), Dave (big beefy guy), and Champ (lone wolf). So perfect was this formula that it was even used in the parody anime-within-an-anime *Gekiganger Three*. This fictitious series is part of the plot of the 1996 series *Martian Successor Nadesico*. The clips, characters, and plots "quoted" in *Gekiganger Three* all evoke '70s "giant robot" and "science team" series, and in this case the team of heroes is made up of Ken Tenku (hero), Miss Nanako (woman), the adopted Junpei (child), Akira (big beefy guy), and Joe Umitsubame (lone wolf).

[8] The science-fiction saga known in the West as *Robotech* was a collage of *Macross*, *Southern Cross*, and *Mospeada*.

aliens. It then becomes a city-cum–aircraft carrier for launching attacks against the Zentraedi. Unfortunately, the Earth forces are still trying to figure out how the ship works. At one point, a portion of the ship collapses on itself, trapping fighter pilot Hikaru Ichijo (aka Rick Hunter) with . . . a pop singing idol, Lynn Minmay. This sets up a romantic triangle, since First Officer Misa Hayase has also had her eye on Hikaru.

Some watched for the space battles. Some watched for the romance, including love affairs both interracial and interplanetary (although the nude shower scenes were cut for American broadcast). Some watched for the sheer chutzpah of the ultimate weapon against the Zentraedi turning out to be—the pop singing idol, Lynn Minmay. But it was the top of the line in anime to appear in the West, and Western viewers clearly wanted more.

So did the Japanese. Dr. Tezuka's sophisticated stories and complex characters had spawned a wave of groundbreaking manga, and this in turn inspired generations of cartoonists and animators who would never have considered these media otherwise. As he observed in 1987, "many talented people who would normally go into the literary field or the movie industry came into this field one after the other, and they bore much fruit. . . . Now, Japanese cartoons have the expanse and technology unparalleled in the world."[9]

Just Push Play

Part of that '80s technology was the videocassette recorder. It revived some old favorites, and relieved some studios from the burden of having to think in terms of shaping their animation for broadcast. Direct-to-cassette animation (known as "original animation videos" or OAVs) started in Japan in 1983 with a space opera called *Dallos*. The ability to create direct-to-viewer animation not only stretched the content envelope, but stretched the fan base literally around the world. As soon as

[9] *Catalogue of the Osamu Tezuka Exhibition* (Tokyo: Asahi Shimbunsha, 1990), 286.

[10] In a show of devotion almost unique in Western television, the fans of *Sailor Moon* have actually brought enough pressure to bear on producers and distributors to force a continuation of the series. In Japan, *Sailor Moon* ran for five years (200 episodes), plus three hour-long features and a twenty-minute special. The fan group S.O.S. (Save Our Sailors) launched an extended petition drive after English dubs were only produced midway through the second season. As of this writing, the first four seasons have been broadcast in English, and dubs of the three features are commercially available on videocassette.

[11] As for the big screen, the vote is still out, but then that road has always been a bit rocky. These days, Japanese feature animation—absent from American theaters since 1981—is returning. *Ghost in the Shell*, *Jin-Roh*, *X: The Movie* (based on a girls' com

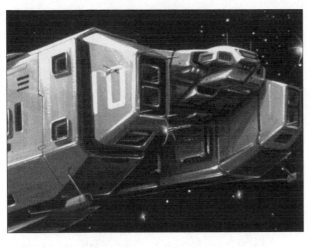

Robotech The Armor class of Earth spaceship seemed like a good idea at the time. It was large, it was heavily armed, and each ship served as a hanger for four hundred manned and unmanned craft. Unfortunately, it wasn't enough. Earth had only built ten Armor class ships, and four of those were lost in the first wave of Zentraedi attacks. The Earth was in serious trouble, until the Macross crashed into the planet. . . .

unedited, unadulterated Japanese animation became just another offering on the American video-store shelf, word began to spread.

Fast-forward to 1995, and the biggest breakthrough up to that time: *Sailor Moon.* The brainchild of *shojo manga* (girls' comics) artist Naoko Takeuchi, this series is part magical fantasy, part romantic comedy, and part science fiction. The show's been a hit in Japan, in the U.S. and Canada, in Poland, in the Philippines, in Brazil, and especially on the Internet. Literally hundreds of Web pages sprang up overnight praising one or all of the Sailor Scouts. Even Tsukino Usagi, Sailor Moon herself, the whiny, klutzy crybaby who manages to get it together each episode just in time to save the world, has legions of devoted fans.[10]

After that, two even bigger blockbusters hit the American small screen.[11] *Dragonball Z* evolved out of a long-running (weekly from 1984 to 1995) manga series by Akira Toriyama. Its animated version has been no less long-lived.[12] Based loosely—very loosely—on a classic Chinese novel involving the exploits of a monkey who accompanies a Buddhist priest on a pilgrimage from China to India, the *Dragonball* epic is about Goku, a naïve child with considerable martial arts prowess and a heart of gold.[13] He also has a golden sphere, one of seven

ic by the CLAMP collective, and not to be confused with Spike Lee's biography of Malcolm X), *Metropolis, Escaflowne: A Girl in Gaea,* and *Perfect Blue* have received art-house showings, as has Hayao Miyazaki's masterpiece, *Princess Mononoke.* The popularity of the first *Pokémon* feature is an inaccurate barometer, as is any faddish juggernaut.

[12] Actually three linked series, *Dragonball, Dragonball Z,* and *Dragonball GT.*

[13] Dr. Tezuka's first animated feature, the 1961 *Saiyuki (Journey to the West),* was based on the same Chinese legend, although it was chopped and rewritten before it appeared in America as *Alakazam the Great.* Ironically, in 1941, a young Tezuka watched a now-rarely-seen Chinese animated film, *Princess Iron Fan,* that was based on part of the same legend. Even more ironically, *Princess Iron Fan* was also cut—by Japan's military government, which didn't approve of the monkey's anarchistic antics in the middle of a war—especially a war with China.

dragonballs used to summon the Dragon God. The series, consisting of over five hundred episodes, follows Goku as he fights, grows up, fights, marries, fights, has children, fights, dies, and passes on the dragonball to his son Gohan (a name that in Japanese literally means "rice," or, generically, "a meal").

Couldn't get any bigger than that? Consider *Pokémon*. This 1997 offshoot of a video game has become wildly successful on both sides of the Pacific. It finds dramatic potential in the clash of oddly shaped and oddly powered fantasy critters, whose victories or defeats are the key to a boy's ambition. Along the way villains (both sinister and humorous) are overcome and lessons are learned about teamwork, persistence against overwhelming odds, and the gentle, compassionate spirit known in Japan as *yasashisa*.

From Manga to Marketing

Not that anime or manga have always had such high-minded and pure motives. They're just as much in it for the money as their Western counterparts. (*Pokémon*, after all, is based on a Nintendo toy.) The major difference is in the structure, the ways that the deals are interrelated.

The genesis of most American cartoons used to be the printed page. From newspaper comic strips such as *Popeye* and comic books like *Superman* to books for young people such as *Winnie-the-Pooh* and the stories of the Brothers Grimm, the emphasis was on finding something tried-and-true, with a guaranteed audience. (Disney moved in two directions at once in this regard, basing some of its feature films on literary sources, while also creating comic-book versions of original characters such as Mickey Mouse and Donald Duck.)

Things started to loosen up in America in the '60s in terms of source material; it's safe to say that *Fat Albert and the Cosby Kids* was the first cartoon whose genesis was a stand-up comic. The

Care Bears were an established line of toys before they were animated; other merchandise was developed in tandem with the animation as a way of financing the project in the first place. In the postmodern era, American cartoons have been based on feature films (e.g., *Beetlejuice, Men in Black, Teen Wolf,* and—in a strange twist of fate—the live *Batman* films, which were themselves based on new versions of the comic book, now grandly referred to as "graphic novels," some of which showed the influence of Japanese manga!). Other cartoons refer back to older animated series. Most modern American animated series, however, are based on original ideas.

Many Japanese anime begin life as comic books (the phrase "based on the manga by" is used a lot in this book). This has several advantages, including the good will and familiarity of an audience that already knows and cares about the characters. It also enables the viewer who is familiar with the manga story to fill in blanks; the animator can glide over some story details, confident that the intended audience will make sense of it. Anime can also be based on literary classics: from historical Japan and China (the courtly romance of *The Tale of Genji,* the Edo-period epic *Hakkenden,* and especially the Ming-dynasty novel *Journey to the West*), modern Japan (the postwar novel *Hotaru no Haka*), and other nations (ranging from India's scriptural *Rig Veda* to the nineteenth-century European tearjerker *A Dog of Flanders*). Of course, original ideas have been animated as well. But market forces also affect the creative process in Japan. Large toy companies like Bandai not only market everything that can be marketed out of a popular weekly series; they sometimes suggest the addition or modification of a character to make it more bottom-line friendly. The artist/director can also expect input from the animation studios, publishing houses, and anyone else with a piece of the action.

There is one significant marketing difference

Metropolis *Japanese animation started, in a sense, with Dr. Osamu Tezuka, whose film* Saiyuki *(Journey to the West), based on a Chinese Buddhist legend, was edited and dubbed into* Alakazam the Great! *He also created several television series based on his manga, some of which were very successful. Even after his death, one of his earliest manga,* Metropolis, *was adapted in 2001 by* Akira *creator Katsuhiro Otomo and directed by anime veteran Rintaro.*

when it comes to anime: Japan has the road show. Whether it is a weekly TV series, a feature film, or a collection of OAVs, the producers will often bring out a sample of the release at an event that is less than a "sneak preview" but far more than an expanded trailer. Fans who come to such a "road show," usually about four months in advance of the premiere, will likely hear an idol singer performing the theme to the new anime, and see and hear the principal voice actors, as well as the manga artist, novelist, or whoever created the work in the first place, as well as a sample of the work.[14]

Anime: The Next Wave

The success of *Pokémon* in the West, scoring the kinds of numbers that the monied interests of television dream about, opened the door for other similar Japanese series. Titles such as *Digimon*, *Monster Rancher* (in Japan, *Monster Farm*), *Yugi-Oh*, and *Cardcaptors* (originally titled *Cardcaptor Sakura*) might never have made it onto the American tube, regardless of their intrinsic merit, without the success of *Pokémon*. And these are just the series in the same "little kids, strange monsters, and collectible trinkets" genre; other broadcasters gambled on other Japanese anime such as *Tenchi Muyo*, *Blue Submarine No. 6*, *Gundam Wing*, and *Escaflowne*.[15]

This book will touch on major anime television series, feature films, and OAVs. Some of these will be long-runners—episodic series with a twenty-six-week story-arc, or even longer. Some anime are

[14] Sometimes the theme song has absolutely nothing to do with the anime to which it is attached. It serves as much as a vehicle for the singer as for the production. Sometimes there is a direct connection, and sometimes the connection is more tenuous. However, unlike the United States, where television theme songs have been pretty much phased out (in order, one suspects, to sell more ad time), the theme song is alive and well on Japanese television—even if it's only a ninety-second edit of a full-length song.

aimed at the kind of person for whom Tolkien's *Lord of the Rings* is a quick read. For others, the long-story form is an extension of the way some kinds of television are broadcast: instead of a series of self-contained scripts that barely relate to each other except through continuing characters, there is one colossal story-arc, from beginning to end. This is hardly a new convention to those who were devoted fans of *Dallas*, *Dynasty*, or any of the "prime-time soaps," wherein the plot of episode B was directly dependent on what happened in episode A. Few other genres of American television, however, have tried to write so expansively. From *McHale's Navy* to *Bonanza*, the discipline of a continuing story is one that Western television has chosen for the most part not to master. This is not to say that there isn't a certain predictability in some anime script conventions, as there is in television programs in the West. Some of these conventions are in fact comforting to their audiences. In any case, we need to think in terms of conventions, and of the cultural shorthand used in the scripts and on the screen, to understand more fully what's being communicated.

[15] While *Tenchi* and *Gundam* were quite successful (and *Blue Submarine No. 6*, a four-part OAV, was a one-time special), such was not the case with *Escaflowne*, perhaps the greatest artistic achievement of the group. One is inclined to blame Fox Network producer Haim Saban for treating it as just another Saturday morning filler and canceling the series after a handful of episodes. However, given the mythos and morality of this series (discussed later in this book), perhaps no amount of preparation could have made *Escaflowne* a mainstream success in American. It was, however, broadcast in full in Canada, where it found an appreciative fan base.

2

Conventions versus Clichés

Anime is supposed to make the audience feel something. This chapter looks at why fans feel what they feel: visual, auditory, and social conventions from Japanese daily life embedded in anime.

Every once in a while anime discussion groups on the Web get choked with run-downs of the "clichés" of anime. It may not be the most overworked word in discussions of the topic, but it is certainly the most misunderstood. Before we proceed any further, we need to understand why.

Art does not exist in a vacuum; its time and place determine the aesthetics the work can get away with. And for art to be considered acceptable by its audience (and this is true whether talking high or pop art), it has to be recognizable as art. How? By embodying the rules pertaining to that work in that time and place.

Let's not kid ourselves: art is defined by its rules. Only in recent decades, with the likes of seemingly random artists like Jackson Pollock, has art without rules even been a concept, much less a possibility. Pop culture, to be popular, avoids the avant garde, which by definition sets out to break the rules, to lead rather than follow, and to upset the bourgeoisie at every turn. Changes in culture

are usually incremental rather than wholesale; rules are amended rather than abandoned.

We tend to forget this, since history changes our perspective. Beethoven was an innovator, writing Romantic music while the Classical school was still in vogue. However, he developed Romanticism by modifying Classicism, not by throwing it out altogether. Only a few avant-gardistes have gone for the sweeping change, and their names are seldom remembered. Few remember Harry Partch, the composer who decided that the "well-tempered" scale of the Western musical tradition was no longer interesting—he redivided the octave and, because most musical instruments couldn't adjust, invented his own.

Similarly, abstract animator Norman McLaren abandoned representational drawing altogether; his techniques involved scratching images onto film emulsion with a pin or stripping the emulsion off altogether and painting directly onto the clear surface. The results were chaotic, confusing and hardly ever used again—although McLaren's techniques were revived in 1995 for some of the more hallucinatory sequences of *Evangelion*.

The point of this digression is to recognize that the word "convention" has positive connotations and the word "cliché" has negative connotations, but not everyone who uses the words understands why. A gesture, a plot-point, a speech, or a bit of business—these are not necessarily clichés simply because they are used a lot. In some circumstances, these often-used devices still have the power to thrill and amuse and move an audience.

Attending the Conventions
Take one of the most popular ballads of nineteenth-century America: "Home Sweet Home." In and of itself, the song is, to a modern audience, corny and saccharine, and playing it while looking at a character's home could be considered trite and unimaginative. Yet that same song, in a

scratchy turn-of-the-century gramophone recording, is played near the end of *Hotaru no Haka* (*Grave of the Fireflies*) as the camera surveys for the last time the swampy home of the two dead children. The moment is definitely not a cliché, crowded as it is with so many messages to the audience, not the least of which is: They would never have been driven to this place were it not for American bombing and adult indifference.

Therefore, and let's keep the distinction clear:

A *convention* is an acceptable device that is intrinsically part of the narrative or character design, and which, although old, can still be used in fresh ways.

A *cliché* takes the place of creativity. Clichés are used by lazy and untalented artists to finish off a work, rather than finding fresh uses for the conventions that inform the work at its best.

An example: in any given swordfight, from *Ruroni Kenshin* and *Utena* all the way back through live-action samurai epics to Dr. Tezuka's gender-bender swashbuckler *Princess Knight*, there is a standardized bit of choreography. The opponents start separated by some distance. They run full-tilt at each other, pass by each other in such a way that you can't tell if anyone was even hit, and then stand dead still in a dramatic pause. It takes another second or two to reveal the damage.

When used creatively, or sincerely (meaning with a complete reliance on the validity of this device as a part of telling the story, without tongue in cheek, and without looking for a quick expedient to meet a deadline), this does not become a cliché. Look at the first duel in the first episode of *Utena* (1997). Saionji tries to slice a flower from Utena's coat with a mystical saber. Utena showed up for the duel armed only with a bamboo practice sword. In spite of the mismatch, you know who will win. However, the action is nonetheless exciting. Another example: this choreography is also used in the 1988 film *Akira*, except that motorcy-

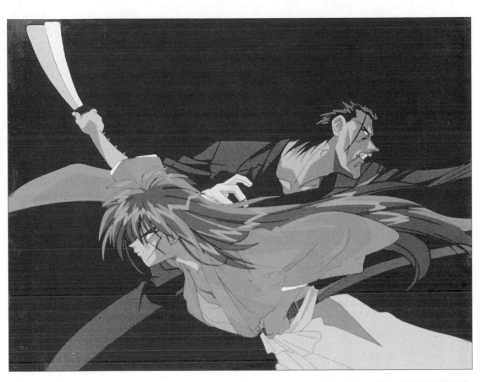

cles replace the swords in a high-speed game of chicken. The convention only becomes a cliché through overuse or when used by the numbers.

At the end of Rumiko Takahashi's *Maison Ikkoku* (1988), Yusaku Godai finally marries his beautiful widowed landlady, Kyoko Otonashi. If that were the sum total of the story, it would be a cliché: a predictable ending that was just sitting in the wings, waiting for its cue to come onstage. However, in the manga form of the story, Takahashi stretched the courtship over seven years, and the reader (and viewer of the anime series) saw it end in an amazing inversion of stereotyped gender roles: Kyoko continues to be the building manager, while her husband works in the otherwise completely feminine world of day-care.

The Sound of Anime
Maison Ikkoku is one of the more interesting anime series in its use of conventional symbols and cues;

Ruroni Kenshin Just about any swordfight in Japanese pop culture, whether live action or animated, includes this bit of choreography: a freeze-frame just after the attack, when we can't tell who struck the winning blow. Seconds later, the truth is revealed (even if it seemed rather obvious from the beginning).

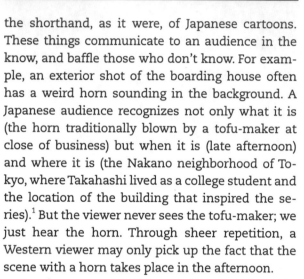

Princess Nine Protagonist Ryo Hayakawa pitches an odd-looking baseball. Baseballs, tennis balls, golfballs—none of these look round when they're in flight. The convention, used in countless sports manga and anime, is to squash the ball to suggest the speed and power of its flight.

the shorthand, as it were, of Japanese cartoons. These things communicate to an audience in the know, and baffle those who don't know. For example, an exterior shot of the boarding house often has a weird horn sounding in the background. A Japanese audience recognizes not only what it is (the horn traditionally blown by a tofu-maker at close of business) but when it is (late afternoon) and where it is (the Nakano neighborhood of Tokyo, where Takahashi lived as a college student and the location of the building that inspired the series).[1] But the viewer never sees the tofu-maker; we just hear the horn. Through sheer repetition, a Western viewer may only pick up the fact that the scene with a horn takes place in the afternoon.

Another example of the creative use of a sonic convention is in the entire *Evangelion* series, begun in 1995. Many of the outdoor scenes, including establishing shots of Misato's apartment building, take place with the droning of insects in the background. In fact, it is the sound of cicadas, noisy little insects that assert themselves in Japan every summer. However, they are exclusively summer insects. Evangelion features their buzzing week after week, month after month. To someone who was only used to hearing them for a short time each year, this is profoundly discomforting. In the plot, this reflects the changed climate of Japan after the Second Impact, when the Earth shifted on

[1] See Toren Smith, "Princess of the Manga," *Amazing Heroes* 165 (May 15, 1989): 23.

its axis and Japan's climate became permanently tropical. The constant hum of cicadas is a reminder to the viewer (at least, the viewer who knows cicadas) that this is a world in which something has gone horribly wrong.

Listing all the elements of anime shorthand and their meanings would take a separate volume, but there are a few broad conventions that absolutely must be understood at the beginning. Many of these conventions began in manga and carry over to anime.

Inside the Lines

Perhaps the most distinctive convention is the tendency, in moments of action or high emotion, for the background to vanish entirely. Instead, we see broad sweeping lines suggesting speed or power. This device focuses our attention on the character, but also cues us that the character is engaged in a major struggle or effort. Examples abound; it is a rare anime that does not have such a scene.

This character focus is linked in part to a storytelling element of both anime and manga: the preference for long story-arcs. This kind of storytelling not only allows for elaborate plot development, but for character development as well. In anime, the latter is usually the more important. People who watch anime expect to see characters grow and change and react to stress. The reactions can be subtle or raving, but in any event the focus is on the character. When the background vanishes, that focus becomes literal.

Loose Lips

The second example of an anime convention is the apparent lack of naturalness in the movement of a speaking character's mouth. For those who were raised solely on Disney theatrical animation (as opposed to their recent made-for-television animated series), the staccato up-and-down mouth movements of anime characters is fake-looking.

You are left feeling even more uneasy when, watching a subtitled anime and hearing the original Japanese dialogue, you realize that the mouth movements still don't precisely match the spoken words. What kind of shoddy workmanship is this?

It's not shoddiness. It's not even universal, since some studios are more conscientious than others about matching lip movements to spoken words. There are, in any case, several reasons why this might be so.

It's just different over there. Hiroki Hayashi has directed one of the most popular of all anime, *Tenchi Muyo*, as well as *Bubblegum Crisis 2040.*[2] He also worked as an artist on the American series *Thundercats.* As he pointed out recently:

> In an American series the dialogue is written and then recorded first and the pictures are done to go along with it. This is different in Japanese [sic], where pictures are done first and then the voices are recorded afterwards. . . . Generally we only use three pictures [of mouth movements] for when the character is talking, as opposed to in the American series, in which we had to do eight.[3]

Earlier media. Before television and mass distribution of magazines, one classic type of Japanese storyteller was the *kami-shibai* man. He would set up an easel with a series of drawings that he used as illustrations for his stories, supplying the various voices and sound effects himself.[4] In that case, in the unmoving mouths of Bunraku puppets, and in Noh theater, in which the protagonists usually wear masks, Japan has a history of giving the audience mouths that move without speaking or speech from a mouth that doesn't move.

Western examples. Most Western television animation actually has the same problem. Yogi Bear's mouth movements are not much more precise than Speed Racer's. Indicting the entire medium because of this convention is petty at best.

[2] This is the 1999 made-for-television series, revisiting the OAV series of the 1980s directed by Katsuhito Akiyama.

[3] From an interview with Geoffrey Tebbetts, *Animerica* 7, no. 8: 15, 33.

[4] Frederik L. Schodt, *Manga! Manga!: The World of Japanese Comics* (Tokyo: Kodansha International, 1983), 62.

Eastern preference. Here again, we find a priority on the emotional life of the character, with less concern as to whether the cartoon is technically perfect. Anime voice actress and pop singer Megumi Hayashibara tells in her autobiography (published in manga format) of classes she took to prepare for voice work. "The most important thing for a voice actor is not to try and match the voice [to the mouth movements], but to get as close as possible to the way the character feels."[5] In any event, the erratic lip-synching is fairly easy to get used to, and does not take away from the enjoyment of watching anime.

Do Blondes Have More Fun?

Another convention to note traces back to the early twentieth century. During the Meiji period (1868–1912), Japan ended two centuries of isolation from the rest of the world by discarding many of its traditional ways. Anything modern was automatically "in," and anything Western was by definition modern. So newspaper comic strips began in Japan by copying Western characters, and animation followed suit decades later. The result was a string of characters that looked "white" or had "blonde" hair, even if they were ethnically Japanese. It has literally taken decades before the recent crop of manga artists, born after World War II, began to draw Asians that look Asian. In the meantime, a character like Sailor Moon can be understood by Japanese viewers to be Japanese, her blonde hair notwithstanding.

Get Real

A fourth convention is connected to the third, and goes back to the 1960s, when artistic styles in manga began expanding beyond the cartoony look of the postwar years. Manga fans who grew up to be the next generation of artists began to choose either to keep to the older style in emulation of Dr. Tezuka, Reiji Matsumoto, Shotaro Ishinomori,

[5] http://www.nnanime.com/megumi-toon/mgbko22.html.

Super-Deformity

Parody drawings have been around as long as drawing itself. There are examples from ancient Greece as well as ancient Japan: people drawn with distorted features, or drawn to look like animals, or animals drawn to look like people. And anime, which evolved out of both manga and Western cartoons, has long made use of rubbery faces and limbs.

But one particular anime convention can be accurately dated. The spring of 1988 saw two production houses working on "super-deformed"

(SD) comedy projects. Sunrise, creators of the *Gundam* series, were working on the movie *Char's Counterattack* when they came up with SD *Gundam*, a series of short episodic OAVs by Gundam director and designer Gen Sato.

Both the people and the mecha have huge heads, short bodies, childlike appearances, and anarchistic attitudes. The purpose is humor and the humor is blunt—Gundams launch for an attack, for example, only to get tangled in a fishing net.

Meanwhile, over at Artmic Studios, the creators of the all-woman *Gall Force* crew were working up their own SD project. *Ten Little Gall Force* brings us child-body versions of the crew, not to patrol the universe but to make a music video.

From then on, everything was open for super-deformity. SD versions of the all-girl baseball team appear as commercial "bumpers" in *Princess Nine*. The television series version of *Record of Lodoss War* ends each episode with "Welcome to Lodoss Island," an *omake* (bonus) in which even the dragons are super deformed. The third *Sailor Moon* movie briefly gives us SD versions of the Sailors, tricked into believing they're children eating a gingerbread house. And Go Nagai has come up with SD versions of his own characters, including the bloodthirsty Devilman.

Ghost in the Shell Panel details of Motoko regular and super-deformed (SD) from Masamune Shirow's classic manga.

Ryoko Ikeda and other major names, or to surpass them and work in a more realistic style. This "realistic" style actually ranged from caricature to hyperrealism and everything in between. The new style even rated its own name—*gekiga* (drama pictures)—to distinguish it from manga. The bottom line is that anime shows the same range, from the highly detailed to the blatantly cartoony. In recent years, a trend has arisen to take realistic, even serious, characters, and submit them to caricature as "little kid" versions of themselves. These are sometimes called SD (for "super-deformed") or CB (which means either "child body" or *chibi*— "shorty," "runt"). These letters in a title usually mean comedy ahead.

Body Talk

Other manga/anime conventions are more culturally specific to Japan. These include:

- Scratching the back of the head when embarrassed
- The appearance of a giant drop of sweat (not to be mistaken for a teardrop) or the apparent outline of a large X on a character's temple in times of stress
- Blood gushing from the nose when sexually aroused
- A large bubble of phlegm coming from a character's nose denoting that the character is asleep.
- Extending a fist with the pinky finger stretched straight out is a gesture (usually by a male) to indicate that the speaker or the subject of the sentence "got lucky."[6]

All of these conventional gestures cue the audience not only as to what is happening (or about to happen), but also how to feel about it, by invoking similar situations in previous anime. Far from being "spoilers" about the plot, they are in their own way reassuring.

[6] An illustration of this gesture is an episode of the manga *Maison Ikkoku*. Due to a misunderstanding, Godai has checked out of the boarding house; by the time that error is cleared up, another one pops up and Kyoko refuses to rent his old room back to him. His search for someplace to stay takes him to the apartment of his college friend Sakamoto. Godai knocks on the door; he hears some running and thumping inside the apartment. The door opens a crack to show Sakamoto's face and his hand with outstretched pinky. The message is clear: "I've got a girl in here and we're a little busy right now . . ." It would be awkward to have to say that in so many words, and an embarrassment to the girl. With a gesture, the meaning is communicated wordlessly.

There is a still shot during the opening credits of *Princess Nine*, a 1999 series about a girls baseball team challenging their male counterparts, that demonstrates this quite nicely. The series is built around Ryo Kawasaki, a fifteen-year-old pitching phenomenon who apparently inherited her fiery left-handed style from her father, who was also a professional-class pitcher (and who was killed in a traffic accident when Ryo was five). The scene shows Ryo's face, caked with dirt and streaked with tears, under the stadium lights—but they are tears of joy, as she looks toward Heaven. Anyone who's seen any sports manga or anime at all knows what's happening: the battle is over, the hard-fought victory is won, and she is communing with her father in Heaven.

If handled casually or cynically, this scene would not carry half the power it does. Instead, it's a cue to the audience that, despite the hurdles Ryo has to face, both athletically and personally, right will prevail.[7] It's a reassurance that the audience needs to hear more and more, ironically enough, as it gets older and has to cope with the complexities of Japanese society.

[7] The personal arena alone can get quite complicated; a mere romantic triangle is rather simple geometry these days. In *Princess Nine*, for example, Ryo soon finds herself having to choose between the Boy Next Door and the Baseball Phenom at the high school that has recruited her; the Baseball Phenom, meanwhile, is being set up in the media to be the beau of the school's Tennis Phenom . . . and so it goes.

The Social Web and the Lone Wolf

Everyday life in Japan is a complex web of family relationships, social roles, and even language. The popular culture, including anime, helps keep society on track, even when it focuses on noble and heroic loners.

Every culture has its dominant myths, core beliefs that are almost a secular religion. American culture, for instance, deviates from its European roots in several respects, notably the American belief—almost an article of faith—that the unsophisticated common people possess an innate wisdom unequaled by the upper-class power elite. This has manifested itself in a variety of ways, from America's first independent act of political dissent (the Whiskey Rebellion, 1794) to books like *The Adventures of Huckleberry Finn*. Several television series have been based on this belief in the triumph of mother wit over sophistication and civilization: *The Beverly Hillbillies*, *The Real McCoys*, *The Waltons*, *The Andy Griffith Show*, *The Simpsons*, and even *Fresh Prince of Bel Air*. But the American mythos is a topic for another book.

Japan's mythos has been polished and refined, since Japanese culture is about ten times as old as America's. Influences on Japan's cultural mythology range from religion to politics, but it could be argued that the dominant force is real estate.

Togetherness

Take half of the population of the United States (or about 135 million people) and confine them to the three states on the western seaboard: Washington, Oregon, and California. This crunch reflects what life is like in Japan. Much of the total area of this island nation is taken up by mountainous land unsuitable for agriculture or commerce, and more green space is lost each year. Consequently, the concept of "privacy" in Japan has always been very different from that in the West. People in Japan have historically lived up close and personal with each other, with a tradition of architecture that commonly used light wood and paper for interior walls, so there has never been a sense of really being alone. In this culture, a person's identity comes from being part of a group, rather than just a freestanding ego.

The Home Front

This starts with the family. The family name comes first in Japan, and this symbolizes the importance of family membership. Marriages in the old days were a negotiation between clans as often as they were a love-match between two individuals. Even in the face of modernization, group membership is a major part of one's life in Japanese society. Every affiliation, from the school one attended to the fan clubs one joins, becomes part of a formula for life summed up in the words *on* (obligation) and *giri* (honor). "Each group," writes T. R. Reid, "is entitled to loyalty from its members, and these various loyalties essentially define a Japanese life. The groups you belong to make up who you are."[1] Good deeds become part of the common currency of social interaction rather than acts done for the sake of some morality or other. If someone does right by you, you have an obligation to return the favor; if you don't, you are dishonored. This has ethical consequences that make daily life in Japan a different matter from life in

[1] T. R. Reid, *Confucius Lives Next Door: What Living in the East Teaches Us About Living in the West* (New York: Vintage Books, 1999), 74.

the West, where group affiliation is supposed to take second place behind the free will of the individual.

Japanese can be generous to a fault, once a connection has been established; on the other hand, some concepts—including coeducation for girls and equal rights for people with disabilities—had to be introduced to Japan from the West.

This is not to say that Japanese are cold; far from it. As most of the examples in this book will illustrate, Japanese have a preference in their pop culture for stories that are driven more by emotion than by action. A distinction is made between "wet" and "dry," the former implying emotional intimacy, the latter, "keeping a discreet distance."[2] When it comes to social interaction, things stay pretty "dry" unless a bond has been established over time, or such intimacy seems natural to the circumstances.

Two examples from Rumiko Takahashi's *Maison Ikkoku* illustrate this perfectly. In one episode, Godai—against house rules—brings a kitten into his room.[3] His friend Sakamoto is going home for the holidays, and Godai agreed to take care of his cat, which Sakamoto named Kyoko, since he's a big fan of the actress Kyoko Mano. Godai worries about what would happen if he calls the cat by name, since his building manager is also named Kyoko. Sakamoto's remedy is simple: don't call the cat by name.

Of course, this is easier said than done, and when one of the residents overhears Godai talking to Sakamoto on the telephone about "Kyoko," without using the polite suffix "-san" (an impolite form of address known as *yobisute*), he sounds like he's on overly familiar terms with his building manager.

When he's overheard telling Sakamoto that "every night Kyoko crawls into my futon and sleeps with me," Godai's worries about the name problem take a disastrously comic turn.

[2] Reid, p. 69.

[3] Takahashi Rumiko, "Kyoko to Soichiro," *Maison Ikkoku* 3 (Tokyo: Shogakukan, 1983), 63. As the title of this episode shows, this is actually a case of "turnabout is fair play." Kyoko's dog, after all, is named Soichiro, after her late husband.

Love Hina Extended or impro-
vised families—members of a
club or dormitory residents, for
example—must learn to get
along. This is especially true if
there's potential for romantic
competition—as in Love Hina
when the landlord of a girls'
dormitory may be renting to
the girl of his dreams.

[4] "P.S. Ikkoku-kan," Takahashi Ru-
miko, *Maison Ikkoku* 15 (Tokyo:
Shogakukan, 1987), 191.

At the other end of the scale is the final episode,
"P.S. Ikkoku-kan," in which Godai marries Kyoko
after a seven-year courtship.[4] At a reception after
the traditional Shinto ceremony, Godai gives the
expected speech thanking everyone for coming
and talking about the couple's hopes for the fu-
ture. As the speech ends, in a gemlike moment
that marks manga at its best in summing up the
workings of Japanese society as well as the human
heart, Godai starts to tell the guests that "I and
Kyoko-sa . . ." when he stops, realizes what he was
saying, and changes it to, "I and Kyoko."

This is no small bridge that has just been
crossed; until this moment, even when addressing
her directly, he has usually called her *kanrinin-san*
("building manager," plus the polite suffix), follow-
ing a common Japanese custom of referring to
people by their job titles. Again, this is a case of de-
finition by group membership, in this case, by
one's trade or career. And even in the passionate
throes of premarital sex, he still calls her "Kyoko-

san." Similarly, in the afterglow, Kyoko kisses Godai and tells him, "*Honto wa ne, zutto mae kara, Godai-san no koto suki datta no*" (The truth is, for a long time now, I've been in love with Godai-san). Not only does she refer to him by his family name (she never in the manga uses his first name, Yusaku), but she addresses him in the third person. This may seem odd to us in the casual, rough-and-tumble informality of the West, but in Japan, it is a very natural way of speaking.

Politeness levels—and how an unaware Westerner would deal with them—are part of the dynamics of the Eva pilots in *Evangelion*. Shinji Ikari is the son of Gendo Ikari, the commander of the Eva project. His two fellow pilots—both girls roughly his own age—address him in different ways, which can be attributed to their nationality. The mysterious Rei Ayanami calls him "Ikari-kun."[5] (By the way, there's no chance of confusing Shinji with his father with such a reference; the father would be referred to by his title, as Commander Ikari.) Asuka Langley, however, of half-German parentage and raised partly in America, doesn't bother with such niceties. She usually goes straight for "Shinji-kun" if she's feeling generous; otherwise it's "*baka* Shinji" ("Shinji, you idiot").

Asuka doesn't need to call Shinji an idiot to be rude; just using his first name is enough. "In Japan," as Reid points out, "you might use the given name for somebody who is about your age and who you have known from preschool days. But, generally, in that decorous society, it is much too intimate . . . to refer to somebody you've known for only a decade or so by his first name."[6] "Shinji-kun" is bad enough for a new acquaintance; dropping the -*kun* is a textbook example of *yobisute*.

In an interview with *Animerica* magazine, *shojo manga* (girls' comic) artist Chiho Saito, part of the Be Papas team that created Utena, offers a philosophy of life that is almost nihilistically individualist—except that at the last minute it veers back to

[5] Rei's use of "Ikari-kun" is an example of a fairly recent move toward a kind of democracy. For many years, -*kun* was the suffix used by males of equivalent standing, like classmates or coworkers. Until recently, boys would address girls with the diminutive suffix -*chan*, while the girls were expected to use -*san* toward their male classmates. Boys and girls referring to each other as -*kun* is a step toward sexual parity, but still preserves the identity of the group.

[6] Reid, p. 69.

Japan's traditional cognizance of the way others affect one's life, and vice versa:

> When I was a child, I thought the world was a solid place—I was living in it, and all I did was experience the existing world. But later on I realized that there were people in authority that were trying to change the world according to their own desires. This is true not only in a small world like a household, but also true in as large an entity as society. Those authorities can alter the world's ethics and morals, and use them as their tools. So, at the point that I realized that morality was altered by those in authority, I felt released. Since the restrictions on me as a woman were imposed by people rather than the universe, I realized I didn't have to be restricted by them. So as a human being, I will do what I need to do to pursue happiness regardless of others' restrictions—it's in the pursuit that I become a contented person. *I can't act however I want, because I have to communicate with other people and interact with society, but if you take other people into account, you can find your own way to happiness.*[7]

Even revolution, it seems, has its limits.

Don't Just Say "No"

The fact that maintaining politeness in all social interaction is supposed to be a given in Japan has led to some misunderstandings. President Clinton met with Russia's President Yeltsin in 1994. In a now-famous gaffe, when the subject of the Japanese Prime Minister came up, Clinton warned Yeltsin that "He says 'yes' when he means 'no.'" Japan is not, needless to say, a nation of hypocrites, as a statement like that would suggest. But it is a place where the word "no" is sometimes regarded as too blunt.

Of course, Japanese has a word for "no," but its use is governed by the web of social obligations. This web points to one of the hardest things for

[7] "Chiho Saito and Kunihiko Ikuhara," interviewed by Julie Davis and Bill Flanagan. *Animerica* 8, no. 12: 9. Italics added for emphasis.

many Westerners to understand when learning Japanese: that vocabulary, and even grammar, can change according to one's age, one's gender, and one's social position relative to the other party in the conversation. These "politeness levels" are not taught as such to the Japanese, either, but then they don't have to be; they are constants in society and are learned, like bowing, by example from the cradle.

The Nissan car company issued a series of books titled *Business Japanese* that sought to explain Japan's corporate culture as well as its language. The Western negotiator is cautioned that, although he/she may think "your counterparts give you so little indication all along about just how the negotiation is progressing," the signals are in fact clear to one who understands them. Phrases such as "Well, I don't know . . ." or "It is not possible for our department alone to decide on these points . . ." or even a dead silence have the same meaning: no. The negotiator shouldn't assume that the decision was vetoed on the spot, either: true to the collective ethic, the veiled no "reflects [the opinion] of superiors consulted at length prior to the meeting."[8]

This consensus approach is exemplified in an episode of the 1995 anime based on Wataru Yoshizumi's teen romance manga *Marmalade Boy*. This story is about the blossoming romance (and the obstacles along the way) between Yu and Miki. The set-up to this whole story, though, is especially unusual, and could have served Cole Porter as the basis for an entire musical.

Even though Yu and Miki knew each other, their parents had never met. At least, not until they all went on vacation to Hawaii. In a twist of fate that had to unsettle all concerned, both Yu's and Miki's parents decide to divorce, in order to remarry the spouse of the other family! Even worse, they decide when they get back to Japan that it would be best for all of them to live in one big house!

[8] International Division of Nissan Motor Co., Ltd., ed., *Business Japanese: A Guide to Improved Communication*, 2nd ed. (Tokyo: Gloview Co., 1987), 276.

This novel arrangement hits Miki the hardest: Yu is now her step-brother as well as her housemate, which complicates any blossoming romance. The grownups note her unhappiness and decide to act. They stage an elaborate fight, which threatens to tear the families apart. Of course, when things look as if they'll fall apart, Miki decides that she really didn't mind the unorthodox living arrangements, and peace is restored.

The goal, after all, is harmony, or *wa*. This is why the grownups didn't simply order Miki to accept the grownups' rules or the will of the majority. *Wa* is not about democracy or majority rule; it is about consensus, about all group members working in concert toward the same goal. There would always be a problem if Miki had a hidden agenda, if her dissatisfaction with the new living arrangements was never confronted. By bringing her back into the fold, harmony is achieved.

Watch Your Language

The emphasis on social propriety has given rise to another Western misperception, as misleading as the "yes means no" stereotype: that Japanese has no swear words. This may seem very strange, especially if one is watching an anime dubbed into English and some macho character is swearing like a drunken sailor. In fact, there are words for certain body parts and functions that are not generally used in Japanese society. On the other hand, there are words that are "swear words" but are not as socially forbidden in Japan as in the West; *kuso*, for example, is both the literal and figurative equivalent of "shit," but doesn't carry the weight of the Western s-word. An actor or an anime character can say *kuso* on Japanese television with almost no repercussions. However, given the Japanese emphasis on politeness, the culture has developed other ways of insulting people that don't depend on four-letter words (or their equivalents).

Hayao Miyazaki's *Princess Mononoke* (1997) con-

tains an excellent case in point. The monk Jiko is
first seen having soup at a roadside restaurant,
and he complains in the original script that "this
tastes like hot water." Both the grammar and the
vocabulary are bluntly insulting to Japanese ears,
yet author Neil Gaiman, who adapted the film into
English, felt that the line by itself wasn't blunt or
insulting enough for American ears. His version of
the line has Jiko comparing the soup to "donkey
piss." That change probably says more about
Gaiman's culture than it does about Miyazaki's.

Out On the Edge

Many examples of Japanese pop culture reflect the
social web as it is woven and broken and rewoven
in daily life. (These anime and manga titles sel-
dom cross over to the West, since such "real life"
dramas are considered too alien for Americans, as
compared to the more accessible genres of slap-
stick and science fiction.)[9] However, Japanese pop
culture reinforces cultural beliefs by both positive

Black Jack The ultimate out-
sider: a doctor who refuses to
be licensed by the Establish-
ment, whose surgical skills are
nothing short of miraculous,
who charges outlandish fees
for the few cases he chooses to
take on. But fans of manga
and anime have flocked to Dr.
Osamu Tezuka's renegade
doctor, Black Jack, embracing
his singular sense of justice.

[9] One rarity is Rumiko Taka-
hashi's *Maison Ikkoku*, a straight-
forward romantic comedy;
Marmalade Boy is another. I don't
count the popular romantic
comedy *Kimagure Orange Road*
because of its use of ESP as a
plot device.

and negative example. Comics and cartoons usually show ordinary Japanese in extraordinary situations, succeeding by doing the right thing. Other stories, however, show what happens to someone who has few or no social ties, romanticizing the benefits of the solitary life but also reminding the average Japanese how lucky they are that they're not living out on the edge. Ian Buruma has speculated that "the tragic fate of the outsider confirms how lucky (the average Japanese) are to lead such restricted, respectable, and in most cases, perfectly harmless lives."[10]

Yet the "lone wolf" often provides the ideal hook on which to hang a dramatic story. Examples range from the romance of the *ronin* (a samurai without a master) in works like Kazuo Koike and Goseki Kojima's manga *Lone Wolf and Cub* and Nobuhiro Watsuki's *Ruroni Kenshin* to Dr. Tezuka's unlicensed surgeon *Black Jack*. The isolation can be comic, as in the shape-shifting of Ranma Saotome in *Ranma 1/2*, or pathetic, in the case of pilot Shiro Lhadatt in the *Wings of Honneamise*, or political, as in the robots' struggle for civil rights in *Tetsuwan Atomu*. One can be isolated by one's talent, as in Hayao Miyazaki's *Kiki's Delivery Service* (1989), in which a thirteen-year-old witch must, as a rite of passage, travel to a witchless town, set herself up in business, and survive by her magic for one year. In any event, the Japanese myth of the lone wolf can be found, wearing one mask or another, in virtually all of the anime and manga this book will examine. It's a story-telling device that marks the beginning of the journey whose end is either a return to the broader society or continued isolation, perhaps even death. But this is not a modern pop culture development. The lone wolf has haunted Japan's legends for centuries, and many old characters have simply put on new costumes for their appearances in anime and manga.

[10] Ian Buruma, *Behind the Mask: On Sexual Demons, Sacred Mothers, Transvestites, Gangsters, and Other Japanese Cultural Heroes* (New York: Meridian, 1984), 218.

4

Mukashi Mukashi: From Folktales to Anime

Although some lament that Japan is losing touch with its history, its centuries-old folktales are an important source subject matter for contemporary anime.

I n 1997 two movies broke box office records in Japan. One was an international blockbuster from Hollywood, James Cameron's *Titanic*.[1] This romanticized retelling of a historical tragedy swept everything in its path in Japan as well as in the United States. But then there was the other record-breaker, the highest-grossing Japanese film of all time: *Mononoke-hime*, an animated feature written and directed by Hayao Miyazaki, (released overseas as *Princess Mononoke*).[2]

The two films are so radically different that a side-by-side comparison at first seems less than helpful. Both are set in the past, but *Titanic* takes place in the early twentieth century against the background of a historical event. There is no clear era that the fantastic events of *Princess Mononoke* take place in, but it looks rather like the sixteenth century. The former movie gives us young adults of two different social classes—one a poor boy on a quest to make his fortune in America, the other a high-born young woman who has a fortune but is emotionally unsatisfied—who meet and fall in

[1] An example of *Titanic*'s impact on Japan: in May 2001 a feature-length anime was released to Japanese theaters involving three of the biggest names in anime. The film is based on Dr. Osamu Tezuka's early manga *Metropolis* and was adapted for the screen by Kazuhiro Otomo (creator/director of *Akira*) and directed by Rintaro (of *Galaxy Express 999* and many others). Yet the film's promotional website included a prominently displayed congratulatory note from *Titanic* director James Cameron.

[2] This title is a bit difficult. The suffix *-hime* means "princess," but the title character, San, rules over nothing; she lives alone in the forest with the spirit-wolves who raised her. *Mononoke* means "evil spirits." The film is half over before we see that *mononoke-hime* is a derogatory nickname given to San by the people of Tataraba—people she was constantly trying to harass and kill. "San" also means the number three, and the feral child was taken in as the third cub of the wolf-spirit Moro.

love just in time for one of them to drown when their ship sinks. The latter movie gives us two teenagers: one a prince on a quest to heal himself and the natural order, the other a feral child, literally raised by wolves. What brings them together is Tataraba, the fortress-city where iron is being forged into guns.

There is no real villain in *Titanic* except possibly for Rose's fiancée Cal, whose behavior throughout is less than honorable. The driving force is a force of nature: an iceberg. In the ancient Japan of *Princess Mononoke*, there are human villains, although one of them—Tataraba's founder, Lady Eboshi—pays a terrible price to be redeemed at the end. The forces of nature, however, are many and varied, from small forest sprites to the supreme god of nature, and they cannot conveniently be called heroes or villains. Human meddling with these forces almost destroys San the feral child, Tataraba, various animal spirits, and the forest itself. And while the lovers in *Titanic* are separated when one of them dies, the young heroes in *Princess Mononoke* realize in the end that, even though they are in love, they come from such vastly different worlds that they can only see each other from time to time.

Here are two movies about as different as any pair of films can be; yet both were vastly popular in Japan. This seems to bear out the observation of Hayao Kawai, a scholar of Japanese folklore, that, while some folktales and legends may resonate worldwide with the kind of shared experience Carl Jung called the "collective unconscious," these tales also "manifest culture-bound characteristics"—variations on a theme that make that particular version uniquely satisfying to that particular place on earth.[3] Thus, the success of *Titanic* in Japan was part of a worldwide phenomenon, while showings of *Princess Mononoke* in the United States were successful only by art-house standards—it certainly didn't set any records. This begs

[3] Hayao Kawai, *The Japanese Psyche: Major Motifs in the Fairy Tales of Japan,* trans. Hayao Kawai and Sachiko Reece (Dallas: Spring Publications, 1988), 3.

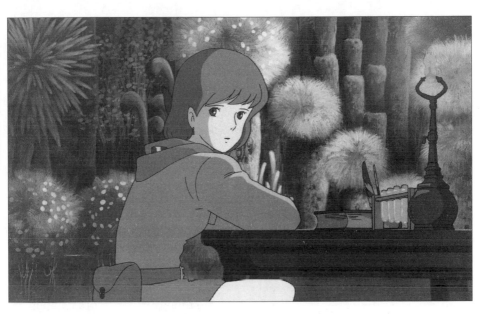

the question: why did the Japanese embrace this movie so avidly? Perhaps it would take a separate book to answer that question. As we probe for an answer, we will also look at other anime, big and small, to see what they can tell us about the culture that created them.

One place to start is "Once upon a time," a rough translation of the phrase *Mukashi mukashi . . .* that begins many Japanese folktales. The compilation of written collections of folktales in Japan was a courtly pastime going as far back as the early twelfth century, and most of the major anthologies still reprinted and read in Japan today date to between the twelfth and fourteenth centuries.[4] Other collections, including the myths and legends of the *Kojiki*, first written down in the eighth century, are much older.[5] There is thus an ample record of the tales (including regional variants) that were the pop culture of their day, entertainments that reflected the dominant attitudes of the culture and in turn helped shape and perpetuate that culture.

Any serious look at Japanese folk tales and their connection to the present would take more than a single chapter. As this book progresses, we will run

Nausicaä of the Valley of the Wind In her laboratory, Princess Nausicaä labors to understand the nature of the giant insects that have overrun Earth. At first glance this epic tale doesn't seem to be based on an old Japanese folk-tale, but it is: Hayao Miyazaki based the title character of Nausicaä of the Valley of the Wind on a thousand-year-old legend, "The Princess Who Loved Insects."

[4] Royall Tyler, *Japanese Tales* (New York: Pantheon, 1987), xix.

[5] Foreword by Richard M. Dorson in Keigo Seki, *Folktales of Japan*, trans. Robert J. Adams (Chicago: University of Chicago Press, 1963), v.

into Japanese folktales in other chapters. For now, though, let's focus on three examples that demonstrate different ways of working with traditional materials. One is a major reworking of a classic story; one features variations on a story and a character; and the last keeps only the slimmest connection to an old tale.

Hagoromo, *Past and Present*

The *hagoromo* legend is given a fascinating twist in *Ayashi no Ceres* (*Ceres: Celestial Legend*, 2000), Yu Watase's *shojo manga* that became a twenty-four-episode TV series. Her treatment of the legend shows what is uniquely Japanese about it, while at the same time highlighting the universality of the original story.

There are more than thirty variants in Japan on the story of the *hagoromo*, a feathered cloak worn by a supernatural being called a *tennyo* (heavenly maiden). In the basic myth, one or more *tennyo* have come to Earth to bathe in the ocean. A poor fisherman named Hakuryo finds a *hagoromo* left draped by one of them over a tree branch. Since he has never seen anything so wonderful, he decides to take it home. The *tennyo* appears in the form of a beautiful maiden, who begs him to return the *hagoromo*, since she is unable to return to Heaven without it. Moved by her tears, Hakuryo agrees to return it, but only if she dances for him.

Watase based her story on a variant in which Hakuryo hid the *hagoromo*, using it as leverage to force the *tennyo* to marry him and bear his children. Years pass; and in an episode reminiscent of the European story of Rumplestiltskin, the *tennyo* overhears her child singing a song that reveals the hiding-place of the *hagoromo*. As soon as she hears this, she grabs the *hagoromo* (and in some variants her child as well) and ascends back to Heaven.[6]

In Watase's *manga* version, Hakuryo is threatened by bandits. Clearly overwhelmed, he begs the *tennyo* for some of her divine power. No sooner

[6] Seki., 63.

does she grant his wish than the power goes to his head: he becomes abusive of his spouse and everyone else. Watase reasoned that the *tennyo* grew resentful at being so ill-used by a mortal. She thus not only made the *tennyo* myth dovetail neatly with other vengeful female spirits in Japanese legend, but turns the *tennyo* into an Asian version of Medea, the priestess who helped Jason steal the Golden Fleece only to be cast aside when a better marriage prospect came along.

Ayashi no Ceres presents us in modern times with the wealthy and successful Mikage family.[7] Their wealth and success is based on their family having acquired a *hagoromo* centuries earlier from Ceres, the *tennyo* who bore the first Mikage's children. But she resented her forced life on Earth and her husband's abusive behavior, and has sought revenge even after death. She has been reborn into one Mikage female after another, fully manifesting herself when the girl turns sixteen. The Mikage males know about this, however, and have been quite careful to kill off any young women with godlike powers.

In the manga, the central characters are Aya Mikage and her twin brother, Aki. She starts exhibiting signs of Ceres possession even before her sixteenth birthday, which means she's doomed unless she flees her family. She finds refuge from hired assassins with a variety of people, including a couple of guys that turn into romantic interests. On that subject, Aya's twin brother, Aki, also turns out to be possessed—by the spirit of the original Mikage who took the *hagoromo* in the first place. He seeks to capture Aya/Ceres, seeing her only as his "woman," thus adding implications of incest to a plot already full of magic, suspense, and not a little humor.

Yet there is another level to the whole story. Bruno Bettelheim's book *The Uses of Enchantment* pointed out that traditional fairy and folk tales are often metaphors for life lessons that would be too

[7] No surprise that the title is a complex pun. The adjective *ayashii* means "unearthly," "wondrous" but also carries the literal meaning of "incredible," "not to be believed." The word is written in the title with a variant Chinese character that also means "bewitching." In addition, the central character's name is Aya. Much of this information is from Andy Nakatani, "Ceres: Celestial Legend," in *Animerica* 9:4 (April 2001), 6.

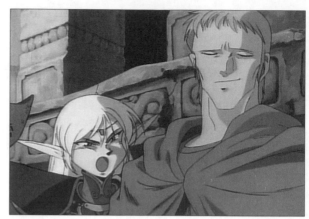

Record of Lodoss War It
doesn't pay to get some beings
angry at you. A party of ad-
venturers squabbles among
themselves. The party includes
the elf Deedlit, a powerful spir-
it who can control the elements
and who can more than take
care of herself, thank you very
much.

intimidating if they were communicated directly.
In Bettelheim, these lessons were presented in
terms of classical Freudian psychology. *Ceres* is far
less psychologically orthodox, but is still a life les-
son couched in Japanese pop-culture terms. Andy
Nakatani describes the story as "a girl put into a
severely traumatic situation." He's right, but on a
level he may not realize. Aya is confronted not only
by assassination, but also by adolescence. Watase
has given her audience an elaborate allegory about
a teenaged girl's entry into womanhood (symbol-
ized by Aya's possession by Ceres the *tennyo*) and
the realization of the powers that accompany this
new status. In order to do this, she must look out-
side of the family that has until now been her
shelter and support, for their priorities are no
longer her priorities. They may not like the
changes she's going through, but these changes
were destined to happen from a time before mem-
ory. And, in order for all to end happily ever after,
the goddess must confront her abusive spouse—
not in battle, but in compassionate understanding.

This last point would seem to be inconsistent
with what has gone before. The supernatural Ceres
has waged a grudge match against Mikage and his
clan for generations, and the expectation (if this
were a classic demon-wife story) would be that
Ceres would not stop until she received satisfac-

tion, which would probably mean the death of Aki. However, Japanese culture does not encourage vendettas for their own sake. There is always a context in stories such as that of the forty-seven *ronin* who waited literally years to avenge the death of their master, or in the case of *Hakkenden*, the "eight dog soldiers" born in scattered parts of Japan who had to grow up and find each other before they could protect their clan. Vendettas are motivated by personal feelings rather than clan loyalty or even the karma of the universe, and thus tend to disrupt social harmony. And popular culture tends to uphold the social order rather than disrupt it. In the end, Mikage and Ceres are reconciled, even as Mikage is dying (and Ceres will soon follow him in death). Even heavenly beings, after all, have to learn to preserve harmony by being *yasashii* (the adjectival form of *yasashisa*).[8]

The Peach Boy

One of anime's first magical girls, still fondly remembered and imitated today, was 1982's *Magical Princess Minky Momo*.[9] She is actually the child of extraterrestrial parents, who sent the girl to Earth to live with a childless couple (she hypnotized them into thinking that she was always their daughter). Her powers include a magic pen that allows her to transform into an adolescent version of herself—an older Minky Momo who can do anything perfectly, which is surely the wish of any child who has been told, "you're too young." After two seasons on television, Minky Momo decided that she wanted to remain an Earth girl.

Her name, however, should have been a giveaway. She's called Minky Momo not just because of her violently pink hair (in Japanese, *momo* means peach, and the word for pink is *momo-iro*, or "peach-colored") but also because of her antecedents. "Minky Momo" is nothing less than an updated gender-bender version of the story of Momotaro the Peach Boy.[10]

[8] Seki includes a much longer version that essentially continues the *hagoromo* legend by connecting it to the Tanabata legend. This story, also a popular tale in China, shows the fisherman climbing up to Heaven to be with his wife, who was still pining for him. But he is given a set of Herculean labors to perform by his father-in-law, as a result of which he and his wife become stars separated by the Milky Way; they come together only one day every year. That day, the seventh day of the seventh month of the lunar calendar, is still celebrated as a Japanese holiday. Seki, 63.

[9] Perhaps better known overseas as *Magical Princess Gigi*.

[10] I owe this connection to the excellent Minky Momo website by Armando Romero at www.minkymomo.f2s.com.

A long time ago, an old childless couple lived in the woods. One day, while washing clothes at the riverbank, the old woman found a giant peach floating in the river. She took it home, and, when the couple cut the peach to eat it, a boy sprang out. They named him Momotaro, and, as time went by, Momotaro grew healthy, smart, brave, strong, and kind to other creatures.

However, there were demons tormenting the village. Momotaro vowed to stop the demons and went to their island, taking only three millet cakes for food. On the way, Momotaro ran into a hungry dog. The dog asked for food in exchange for help, and Momotaro gave him some. The dog joined Momotaro and they continued on their way. A while later, Momotaro found a monkey, who also asked for food, was given it, and decided to join Momotaro. A pheasant joined Momotaro the same way.

Days later, they arrived at the island. The bird flew over the island to check things out and report the location of the demons' castle back to Momotaro. When they arrived at the castle, the gate was closed. The monkey jumped over the wall and opened the door from the inside. The demons saw Momotaro and the fight began. However, the millet-cakes had given Momotaro and his companions superhuman strength. Momotaro and his animal friends defeated the demons and returned to the village with a wagon full of treasure the demons had given him.

Magical Princess Minky Momo repeats the story by giving Minky Momo as pets the three animals that aided Momotaro: a dog, a monkey, and a bird. It also shows her helping her parents out of more than one scrape (they're not too bright). This also mirrors the story of Momotaro, who started out being raised by the old couple and returned with treasure from the demon island to care for them in turn. This pattern of reciprocal care-giving is still held to be an example of great virtue stemming from the teachings of Confucius.

The Peach Boy reappears in other anime as well. In the second feature based on Rumiko Takahashi's *Ranma,* known in English as *Nihao My Concubine,* the cast of *Ranma* is washed up on a tropical island. The island is owned by Toma, whose coat of arms includes a giant peach, and whose attendants are three men with definite dog-, monkey- and bird-like characteristics. However, this story isn't about him fighting demons; Toma has kidnapped Akane and the other girls, looking for a bride. Because he is the kidnapper as well as owner of the island, Momotaro becomes a demon in this version of his story.

The Peacock King

Sometimes, all that has survived from an earlier folktale to a modern anime is a name. This is the case with *Kujaku-o (Peacock King).* Actually, this name is attached to two sets of OAVs, from 1988 and 1994. The modern story is one of those mysticism-and-martial-arts free-for-alls celebrating rapid moves and ultraviolence. The title refers to one of the quartet of heroes, a young man named Kujaku (Peacock). He and his friends have to prevent a demon, buried in the old capital city of Nara, from being released.

This is our connection to the real Peacock King, a mystical Buddhist deity. A story written down in the sixteenth century tells of a monk named En, so dedicated to the simple life that he wore clothes made of tree bark and ate pine needles. In a vision he was told to chant the Mantra of the Peacock King. When he did so, he developed supernatural powers, which included the ability to ride clouds through the sky.

Much of the story, though, is of his struggles with the spirit Hitokotonushi, master of the Katsuragi Mountains. He was not, however, master of En, who tried to force Hitokotonushi to build a stone bridge to a mountain peak made entirely of gold. The spirit refused; En cast a spell on him and im-

prisoned the spirit at the bottom of a ravine, beneath a vine-covered boulder.[11]

The second set of OAVs takes the battle to two other dimensions in the opening minutes.[12] First, instead of a duel between one monk and one spirit, the prologue speaks of a battle between forces of light and darkness. From here, we jump to San Francisco's Chinatown. In a back-alley antique store, a priceless artifact is stolen by gun-toting Nazis, led by a short bespectacled man in a black trenchcoat.

If this sounds like an imitation of Steven Spielberg's *Raiders of the Lost Ark* with the opening of Joe Dante's *Gremlins* (for the locale) thrown in, it isn't either. It's too confused to be a proper imitation of any one Hollywood blockbuster. The Nazis are referred to as "neo-Nazis," suggesting that the war is long over. However, we also see the zeppelin *Hindenburg* floating over Chinatown.

Quick-cut to a young man in monk's robes on a Tokyo bus. His name is Kujaku, a descendant of the original En, and he's passed his exorcist exams. Lucky for him that he did, because the other people on the bus suddenly turn into zombies. Kujaku dispatches a few, but gets a little unexpected help with the rest . . .

You get the idea. There is a heavy Hollywood influence in anime, which makes sense since animation started in Hollywood. But what's interesting about the *Peacock King* OAVs is not the Hollywood connection, but the ties to Japanese tales and legends. Anime doesn't have to invoke old legends at all, and many don't. However, a great many look back to the old stories for a character, a plot, or sometimes only a name or a place. They didn't have to do this; stories could be made up out of whole cloth, with no reference at all to legend or history.

But there are good reasons not to abandon the past. For one, it is a vast repository of plots, characters, and settings. The classics contain a wealth of

[11] Tyler, *Japanese Tales*, 127.

[12] The first set is grounded in Japanese myth and history, including an attempt to resurrect the bloody sixteenth-century warlord Oda Nobunaga. The second set relies more on the trappings of Hollywood blockbusters.

material an animator or cartoonist could always use to advantage. A second reason is that this is a *shared* history. Animators who went to school ten or twenty years ago learned the same legends about the same gods and goddesses that are still taught to the young moviegoers of present-day Japan. A symbolic shorthand is already in place because of the common understanding of the legends. If your movie or television series invokes the name of the sea goddess Benten (as have the creators of *Urusei Yatsura, Cyber City Oedo 808, Ghost Sweeper Mikami,* and many others), the audience only needs to hear the name and it calls up an image.[13] You don't even have to believe in Benten to draw something from the name.

The word "nostalgia" has been used to describe this particular aspect of the Japanese character,[14] but I don't think that's an appropriate word. A better term might be "continuity." After all, Japanese family structure extends the *ie* (house, family) to include ancestors long dead and those not yet born. The emperor, similarly, traces what is believed to be an unbroken lineage back thousands of years. The American Occupation specifically forbade both of these extended belief structures after the surrender, and yet Japan has not discarded them. This belief in extension, in continuity, is still useful in Japanese life.

From our Western vantage point we look at anime like *Peacock King* and see elements of an old legend used to dress up a modern story. But what if we have it backward? What if we're really watching modern window-dressing used to keep an old story alive into the present, and the future?

[13] Benten, one of the Seven Good Luck Gods who sail the sky on New Year's Eve in their Treasure Ship, is a musician and goddess of the arts, who can if need be change into a serpent.

[14] Joy Hendry, *Understanding Japanese Society* (London: Routledge, 1989), 156.

The Naked Truth

Japanese pop culture takes a much more casual and indulgent attitude toward nudity than pop culture in the West. It's visible even on broadcast television. Even to the youngest viewers. And it's no big deal.

In the beginning—as far as Western civilization is concerned—were Adam and Eve. According to Genesis, they were naked and not ashamed. They got ashamed really quick, though, when they ate forbidden fruit and, like God, learned the difference between good and evil. Let the record show that, though they may have invented farming, herding, and other human legacies, the first invention of Adam and Eve was clothing. They needed the clothing because they knew, after eating the fruit, that naked is bad.

Thousands of years and miles away, in the beginning—as far as Japan was concerned—were Izanagi and Izanami. These two sibling/parents in Japan's creation legend (related in the *Kojiki*) eventually begat Amaterasu the Sun Goddess and her brother Susanoo. At one point, because of Susanoo's rude behavior, Amaterasu shut herself and the sun into a cave, refusing to come out. This put humankind at risk, since the sun was needed for light and warmth. The goddess Uzume finally saved the day by staging a striptease outside the

cave, with all the other gods hooting and hollering as she bared her breasts and flashed her pubic mound. Curious as to what was causing the noise, Amaterasu peeked out of the cave, which was just enough to let the sun back out to the world.

It's hard to think of a more clear-cut pair of opposites. One culture starts civilization rolling by covering the genitalia; the other culture restores light and life to the Earth by displaying them.

Japan has had a long time in which to decide the uses and contexts of nudity. One Japanese traveler, Etsu Sugimoto, sailing to America in the late 1800s on a boat full of Western women, commented on their dress as more immodest than her kimono, giving some interesting reasons:

> I found that most of the ladies' dresses were neither high in the neck nor full in the skirt, and I saw many other things which mystified and shocked me. The thin waists made of lawn and dainty lace were to me most indelicate, more so, I think, unreasonable though it seemed, than even the bare neck. I have seen a Japanese servant in the midst of heavy work in a hot kitchen, with her kimono down, displaying one entire shoulder; and I have seen a woman nursing her baby in the street, or a naked woman in a hotel bath, but until that evening on the steamer I had never seen a woman publicly displaying bare skin just for the purpose of having it seen.[1]

All cultures have their concept of propriety, and what it would take to violate that propriety. In some places, a woman publicly breastfeeding her infant would be scandalous, and in other places it would not raise an eyebrow.

The *Kojiki* creation myth is very familiar to the Japanese, explaining the origins of both the nation and the national religion, Shinto. Every Japanese reader therefore would also have noticed a similarity of the myth to the first installment of Rumiko Takahashi's *Maison Ikkoku*.[2] The denizens of a

[1] Etsu Inagaki Sugimoto, *A Daughter of the Samurai* (Garden City, New York: Doubleday, Doran, and Company, 1934), 154.

[2] The title, like most Takahashi titles, is multitextured. Ostensibly a simple address—the rooming-house (named with the stylishly French *maison*, like many other pieces of downmarket real estate in Japan) at #1 Koku Street—the word *ikkoku* can also mean an instant in time or, as an adjective, stubborn or hot-tempered.

Magic Users Club Of course, bathing isn't just for contemplation or cameraderie; it's also a time of extreme vulnerability, and some folks will take advantage of it. Here, a member of the Magic Users Club watches in dismay as an intruder leaves her even more defenseless than before. Underwear theft is a notorious problem in Japan, but it is also the subject of a lot of humor, since (as perversions go) it's relatively benign.

[3] These denizens are Mrs. Ichinose (housewife) and her son Kentaro, Akemi Roppongi (bar hostess), Yusaku Godai (would-be college student). and the mysterious Mr. Yotsuya (God only knows).

[4] Classically, a *ronin* is a samurai without a master. In the modern sense of the word, a *ronin* is a student of college age who hasn't yet been accepted by a university (usually because he has failed the entrance exams at least once).

funky little Tokyo boarding house open the episode with a considerable surprise: their old building manager has retired, and in his place is a beautiful young widow, Kyoko Otonashi.[3] She's only two years older than the hero, Yusaku Godai, and most of the rest of the series is about his wooing and winning the new manager. As the story begins, however, Godai is a *ronin* studying for the entrance exams.[4] He can't study, though, when the others hold a party in his room (the biggest in the house) to welcome the new manager. Frustrated, he moves into the closet to study. The others take this as a challenge: when Akemi Roppongi declares the closet to be "*ama no iwato!*" (the heavenly cave), the Kojiki-wise reader knows what to expect.

Akemi and Yotsuya start telling Kyoko to stop drinking so much, then to stop taking her clothes off; then they begin praising her body. Kyoko of course hasn't dropped a stitch and is thoroughly embarrassed. Godai, however, can't resist peeking out to look at Kyoko—and gets dragged back into the party.

Anything Goes

Takahashi's next hit after *Maison Ikkoku* contains a great deal of actual nudity, but *Ranma 1/2* is also innocent enough to show to Western grade-school children. The 1986 series focuses on a teenage student of the martial arts, Ranma Saotome, and his father/teacher Genma. Dad has promised Ranma as a fiancée to one of the daughters of his friend Soun Tendo, who runs the Tendo School of Anything-Goes Martial Arts. When Ranma shows up for the first time at the Tendo residence, however, there are a few problems to overcome. For one thing, Ranma has acquired at least two other fiancées (under circumstances too bizarre to go into here). The main problem: Ranma is a girl. Rather, sometimes he's a girl, sometimes he's a boy. During a training exercise on the Chinese mainland, Ranma fell into the Accursed Spring of the Drowned

Maiden. The curse of this body of water is that, having fallen into the spring, Ranma now turns into a girl whenever he's splashed with cold water. Hot water restores his masculine identity.

This kind of setup could easily be fodder for any number of erotic (or downright sleazy) variations. Takahashi, however, has chosen to play it strictly for laughs, thus blunting anything even remotely threatening. One way of taking the edge off of the situation is to reduce the whole curse aspect to absurdity, by having Ranma's father fall into the Accursed Spring of the Drowned Panda. . . .

Ranma is an example of caricatured nudity. There is no attempt at all to convince the viewers they're watching real people. While watching live (or lifelike) nude high-school students may be offensive, if not illegal, Takahashi's humorous manga-style artwork reminds the viewers that this is "just a cartoon." In addition, when we see Ranma undressed, it's usually in context, such as a bath.

Just Another Day in Paradise

One story-specific excuse for nudity—and an example of more realistic artwork—is in Saki Hiwatari's 1993 anime *Boku no Chikyu o Mamotte (Please Save My Earth)*. It's only hinted at in the six-part OAV anime and in a series of music videos that supplemented the OAVs; but then, its audience was already expected to know why Mokuren, the devotee of the goddess Sarjalin, sometimes seemed to be wrapped in a blanket.

Mokuren was (as were both her parents) gifted from birth with the power to commune with plants and animals. As such, when Mokuren's mother died (Mokuren was a very young child at the time), she was spirited away from her father to Paradise, a school run by the Sisterhood of Sarjalin, where she learned to develop her powers. One odd requirement at this sexually segregated school: no clothes. If anyone wanted to visit Paradise (or if Mokuren wanted to sneak off of the grounds to

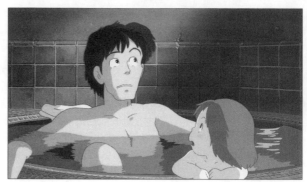

My Neighbor Totoro Two children in a tub is one thing; two girls joined by their father makes some Westerners nervous. Mei and her father wait for Satsuki to join them in My Neighbor Totoro. There's a storm brewing outside, so they're distracted from the question of propriety—which in Japan is pretty much a non-question.

meet a boy, as she did in her early teen years), the students had to wrap themselves in ceremonial blankets.

This causes a problem when the adult Mokuren is first assigned to the lunar observation base. At first she walks around covered only in lush blonde hair that reaches almost to her feet. Once the rules are explained to her, she wears the same jumpsuit as everyone else. She is shown wearing only the blanket in one other circumstance: when she is with her beloved Shion. In Hiwatari's universe, Mokuren's nudity is more than just natural or naïve; it implies a state of grace, of Eden before the fall. Even more, it reminds those familiar with the *Kojiki* that the goddess Uzume used her nudity to preserve life on Earth, and parallels Uzume's divinity with Mokuren's goddess-derived powers to cause plants to grow and flowers to bloom, and her almost fanatical interest in Earth's plant and animal life.

Skinny Dipping

Having a good rationale for displaying nudity can serve to neutralize what might be, in Western animation, a controversial scene. Among the non-erotic contexts for nudity in Japanese pop culture are breastfeeding, pearl diving (admittedly not as common now as it was a half-century ago), and, especially, bath scenes, whether in a private tub, a public hot springs, or even a shower.

Grave of the Fireflies Family bathing is a given in Japan and there is much less embarrassment over nudity, even though contact with the West has brought about a few changes. There is more sexual segregation now than in the past, although if you go out to the less-traveled countryside, public baths may still be mixed.

One nice (in every sense of the word) example of non-erotic bath-related nudity is a scene in Hayao Miyazaki's *Tonari no Totoro (My Neighbor Totoro*, 1988). A man (we find out later that he's a college professor) and his two daughters, ages ten and four, are taking a bath together. They talk about the country house they've just moved into, whether or not it's haunted, and how best to dispel any lingering ghosts. "Scrubbing and soaking together is a time-honored custom for all friends and family, especially children and their fathers. Many Japanese girls bathe with their dads until puberty, while boys and fathers may continue sharing the tub for a lifetime."[5] The scene is just as asexual as the rest of the movie.

There's a similar scene in Isao Takahata's *Grave of the Fireflies* (1988), showing a ten-year-old boy and his four-year-old sister bathing. They seem more interested in trapping air bubbles in the washcloth than in each other's anatomy. A story-arc in Shinji Imaizumi's 1990 boxing manga *God Is a Southpaw* focuses on sports photographer Yukari Kudo, whose photojournalist father was killed in an avalanche when Yukari was about five years old. Her last memory of him was when they were bathing together.[6] And in an episode of the anime television series based on Momoko Sakura's *Chibi Maruko-chan*, the six-year-old title character takes

[5] Kittredge Cherry, Womansword: What Japanese Words Say About Women (Tokyo: Kodansha International, 1987), 90. Mixed bathing would seem to be an erotically charged atmosphere, but in Japan, where the practice is long established, eroticism simply isn't a factor—unless, of course, participants choose to make it so, in, for example, a "soapland," Japan's answer to the massage parlor. Similarly, Tetsuko Kuroyanagi's memoir of her early schooldays recounts how the school's headmaster allowed "clothing optional" swimming among the first-graders because "he thought it wasn't right for boys and girls to be morbidly curious about the differences in their bodies, and he thought it was unnatural for people to take such pains to hide their bodies from each other" (Tetsuko Kuroyanagi, Totto-chan: The Little Girl at the Window, translated by Dorothy Britton [Tokyo: Kodansha International, 1982], 68).

[6] Shinji, Imaizumi, "Speed Zero," Kamisama wa Southpaw 6 (Tokyo: Shueisha, 1990), 94–95.

a bath with her grandfather, and it's really no big deal.

In fact, it's part of a broader phenomenon for which the Japanese have coined the sort-of-English word "skinship": physical contact with a loved one, ranging from a mother carrying a baby on her back and students holding hands on a date to breastfeeding and family bathing.[7] Even cleaning the wax out of one's ears has evolved into a platonic form of skinship—if your steady boyfriend/girlfriend does it while you rest your head on his/her lap. It's a blatant look back to childhood and the source of all such skinship: mother.[8]

Gotta Strip 'em All

Perhaps the most (literally) outlandish excuse for nudity (for the time being, anyway) was the 1996 TV series *Elf o Karu Monotachi (Those Who Hunt Elves)*.[9] The set-up is similar to a host of other anime series in which people from one culture (usually present-day Japan) find themselves stranded in a strange land (usually not of this earth). In this case, the fairy realm is invaded by three humans: muscular lunkhead Junpei Ryuzoji, high-school student and weapons fanatic Ritsuko Inoue, and Oscar-winning actress Airi Komiyama. The elf-priestess Celcia begins the ceremony to send them back, which involves painting the spell onto her own body. Junpei's asides about Celcia's looks, however, make her lose her temper in mid-ceremony, and the spell fragments, flying onto the bodies of five other elves. Not knowing exactly which five, the Earth-trio decide they're going to have to strip any elf they find.

The offensiveness of walking up to someone and demanding that they disrobe is neutralized by sheer absurdity, as in *Ranma 1/2*. The three earthlings are accompanied in their quest for the fragments by Celcia, whose impatience causes yet another calamity early in the series: she is turned

[7] Cherry, *Womansword*, 89–90.

[8] In a *Tetsuwan Atomu* story from 1957 titled "Black Looks," Atomu hunts down the title character, who has been assassinating prominent robots as revenge against the robot he believes killed his mother. When Black Looks is at last reunited with the robot who raised from a foundling (she hadn't died, she was just broken), he puts his head on her lap, in a deliberate mirror of Atomu and his robot-mother at the beginning of the story. The narrator's line from the beginning is repeated at the end, citing perhaps the prime example of skinship: "If there is one resting place in the world it is surely on your mother's lap" (Osamu Tezuka, *Tetsuwan Atomu* 4 [Tokyo: Kodansha, 1980], 151).

[9] Some of the following information is from "Those Who Hunt Elves" by Aaron K. Dawe in *Animerica* 8, no. 8 (September 2000): 16.

Roujin Z Not all examples of nudity in Japanese pop culture are of pin-up girls, nor is nudity necessarily sexual. A nursing-home-resident-turned-hacker in Roujin Z demonstrates how his illegal computer work is bringing him back to life. It also demonstrates Japanese culture's tolerance for humor of questionable taste (even if it is funny).

into a dog. They also acquire Mike (pronounced mee-kay), a tank that behaves like an oversized cat.

There is also some drama and even pathos in the mix. In one installment, a young elf-woman actually begs the invaders to strip her naked. It seems that, to protect her village from a rampaging monster, she put on a suit of magical armor. The magic was that she could not remove the armor. She tells the humans that she hasn't had a bath in three years (and the animators oblige by "showing" the wave of three-year-old funk caused by her bathless state). After several failed attempts to remove the armor, the elf not only manages to remove it, but (after discreetly bathing in a waterfall) puts the armor back on. It seems that she can't just walk away from something she's been so literally close to for three years.

Add to all of the above a range of other gags, from occasional asides to the audience to parodies of other anime, and you have another series like *Ranma*, in which nudity is a necessity, but is not necessarily titillating—by Japanese standards, at least.

Yet these entertaining, relatively innocent uses of nudity reveal some of the problems anime creators face in bringing their art to the West. Showing nudity in prepubescent children,[10] or sexual activity among young teenagers, may keep an episode of a TV series off the air, or stop a movie from being translated for sale in the West. Some

[10] Especially common here are the nude transformation scenes for the "magical girls" such as Pretty Sammy of *Tenchi Muyo* and the *Bishojo Senshi* (Pretty Young Girl Warriors) of *Sailor Moon*.

Tenchi Muyo in Love Apart from the bath, the bed, and the toilet, a common excuse for nudity is the magical transformation scene. Here, Achika prepares to assume her status as a noblewoman in the House of Jurai. Her nakedness, like that of Sailor Moon, Pretty Sammy, and other magical characters, is not intended to be sexual. Rather, it's symbolic of her entering a purified state and becoming worthy of her powers.

distributors have also cut whole scenes to try to avoid any hassles, even if the scenes in question have no overtly sexual content.

The flip side of this cultural divide on the uses of nudity is based on the fact that many anime started out in print, as manga, which literally has its own rules. The legal definition of pornography in Japanese pop culture is governed for the most part by Article 175 of the Japanese Criminal Code. This article bans depictions of genitals, unless they are caricatures or absurd, cartoonish versions.[11] To avoid lawsuits and legal harassment, depictions of genitals are often abstract, or less than detailed. There may be, even in the most blatantly sex-oriented manga or anime, a blank space or a stylized blur in a character's groin. Phalluses may be replaced by tentacles or creeping vines; shellfish have substituted for women's genitals, as they have for centuries in Japanese fertility festivals. As in Hollywood, a close-up on the face can speak volumes. Sometimes, a piece of paper is pasted over the potentially offending artwork— even if it's more like a strip of confetti that hides almost nothing. A common device in the digital age is to mask the offending body part with a "mosaic," a very-low-definition grid of giant squares that still manages to suggest without revealing.

Regardless, sometimes a scene or an entire story that is not pornographic can be put at risk because of Western perceptions that it is pornographic. Yasunori Umezu's 1998 anime *Kite*, a story

[11] Frederik L. Schodt, *Manga! Manga!: The World of Japanese Comics* (Tokyo: Kodansha International, 1983), 133.

of teenage assassins, had to be trimmed of a half-dozen sequences to keep it from being barred from America as pornography. (These cuts, including some edited stills, are detailed on the website http://www.animeprime.com/reports/kite _lesscut_ss.shtml). The extreme violence, however, was left in.

Bathroom Humor

As with the body, so with bodily functions. Japanese society works much of the time by people erecting one façade or another. People say that things are all right even if they're not, they smile in the face of adversity, they promise to "give due consideration" to an idea that nobody would agree to, they compliment cooking that is barely edible. This is not hypocrisy, but based on the belief that living a life of brutal honesty would do more harm than good to the orderly functioning of society. The goal, as we've seen, is *wa*—"the mellow feeling that comes when people are getting along."[12] Given how tightly the façade is embraced, much humor in Japan was, and is, derived from the body involuntarily betraying the truth behind the façade. The stomach that growls even though its owner has just said that he wasn't hungry, the boy hastily breaking off his first kiss so that his girlfriend won't discover his erection—these and many other examples of body humor can be found in Japanese culture, going back hundreds of years.

At the opposite end of the spectrum is the common Western tendency either to evade or only hint at bodily functions, as in this lyric from the Disney film *The Lion King*:

PUMBAA
And I got downhearted . . . Just because I . . .
TIMON
HOLD IT! Not in front of the kids.

Compare the above with a Japanese folk song from World War II, sung by Gen and his adopted lit-

[12] T. R. Reid, *Confucius Lives Next Door: What Living in the East Teaches Us About Living in the West* (New York: Vintage Books, 1999), 78.

tle brother in Masaki Mori's 1983 anime version of Keiji Nakazawa's *Hadashi no Gen (Barefoot Gen):*[13]

> Oh, sweet potatoes for breakfast
> Sweet potatoes for lunch
> We eat them, yes we do,
> AND THEN WE FART LIKE A COUPLE OF PIGS!

Not the sort of thing you blurt out in polite American society. But that's the whole point; why bother looking at another culture at all if it's identical to ours?

Yet there are the beginnings of some cultural crossover. A Japanese *Pokémon* offshoot, *Digimon,* is currently being shown on American television, including one scene that surely would not have gotten past most censors even a few years ago—one wonders how they managed it now. Our heroes (seven kids) and their Digimon ("digital monsters" pretending to be stuffed toys) are being driven around Tokyo by a cousin of one of the kids (in the original Japanese version, not a cousin, but a stranger; Japan, with its historically lower crime rate, hasn't been as obsessed as the West about teaching children not to hitch rides with strangers).[14] We see one of the Digimon moaning and straining and blushing profoundly. At the end of the trip, we see why; the Digimon has left behind on the carseat a Dayglo-pink turd. As far as I know, there were no calls to boycott the network.

But it's one thing to use nudity or scatology to amuse a grade-schooler. What happens when sex rears its variety of heads?

[13] *Hadashi no Gen* is one of the most musical of all manga. Running throughout the story, not just for nostalgia's sake but also to comment on the action, are bits of folk songs, military songs, comic performance pieces—the audio texture of Japanese life before television.

[14] A similar rewrite of a hitchhiking scene occurred in the Disney release of Hayao Miyazaki's *Kiki's Delivery Service.*

6

Rated H: Hardcore Anime

Sex is a part of life and, in Japan, a part of pop culture. But manga and anime know how to add variety and keep things fresh: by lacing sex with humor, with horror, and with old-fashioned sentimentality.

I'm thinking of two artworks, neither of which I could show here for fear of running afoul of "community standards." The first is a 1990 Japanese manga by Mitsuhiko Yoshida, an eight-page story titled *Hajimete no Homonsha* (*The First-time Visitor*). We see a girl going to the door of her home; the doorbell has rung, and she assumes that it's her father. Instead, it's a rhinoceros, and he begins chasing her through a surreal landscape to a garden at the top of a giant screw. We next see the girl apologize to the rhino for running away. She sheds her clothes and begins, let's say, sexually servicing herself with the rhino's horn. This scene is, of course, a dream, and at this point we cut away to the girl's parents. They look at the girl's drawing of a rhino, and quickly pick up on the phallic message hidden within. The father asks if the girl has had her first menstrual period yet, and, sure enough, the last panel shows a dark spot on the sleeping girl's underpants.

Shocking? Bear in mind that Japan is a country where everyone for centuries has been literally

(and unavoidably) in everyone else's business, and that when a girl started menstruating, the tradition once was for family and friends to celebrate with a dinner featuring red beans and rice.[1] Not exactly subtle, but a perfectly logical legacy of an agricultural people who needed to track both human and natural fertility.[2]

Classic works from Japan's graphic arts heritage can be equally graphic. The second work of art I am thinking of is by the nineteenth-century master printmaker Hokusai, whose most famous work is the cycle of prints called *Thirty-Six Views of Mount Fuji*. Yet he too has a sexy side.

Hokusai, who popularized the term *manga*, created one print in 1814 of a mature woman pearl diver, although she's taken time out from her work to be sexually serviced by two octopuses. And every available bit of blank space on the page is filled with either the drawing or line after line of writing, much of it the woman's orgasmic "AAAAAAA."

Is this some kind of joke, or some sick aberration? Actually it's neither. Erotic art has a lengthy history in Japan, and was known classically as *shunga* (literally, "spring pictures"). In modern Japanese pop culture, erotica is known as *hentai* (literally, abnormal or perverted), by the letter *H*, or an attempt to pronounce the letter, *etchi*. Some of these works were part of "pillow books" (manuals illustrating a variety of sexual positions). Some were social satires, in which a third party—sometimes a miniature person—commented on the amorous follies that they were witnessing. Others were illustrations (probably glamorized) of life in the brothels that were legal at the time. Occasionally such a picture would show a threesome, and pictures of men seducing young boys, while less common, did exist.

This is not to say that Japanese culture is wide open and uncensored; at least, not here at the turn of the millennium. It's just that given the legacy of

[1] Kittredge Cherry, *Womansword: What Japanese Words Say About Women* (Tokyo: Kodansha International, 1987), 109.

[2] Here's another case in which the East and the West don't quite meet. In the first scene of Mamoru Oshii's stunning feature *Ghost in the Shell*, based on the manga by Masamune Shirow, we overhear audio traffic being monitored in the electronically enhanced brain of Major Motoko Kusanagi, a secret government agent. At one point an assistant comments on the amount of static in the signal. In the English dub she blames "a loose wire." In the original manga and anime, however, the Major says that she's having her period. The change in the English version is completely pointless. The distributors who dubbed the sword-and-sorcery comedy *Slayers* into English didn't feel that they had to change references to "that time of the month" when teenage terror Lina Inverse suddenly loses her magical powers.

La Blue Girl Returns As has happened with other anime series of the '90s, La Blue Girl has had a computerized facelift. Miko Mido and her older sister look quite different in their second incarnation, having been computer-generated this time around. The series also gave birth to a live-action version and another sequel, Lady Blue, which goes to great lengths to make sure we know that Miko is nineteen years old, and that the series is no longer flirting with child pornography.

shunga, legends of human sexual dalliances with demons and others not of this earth (from the *Kojiki* on up to the infamous anime series *Urotsukidoji*), and a body of erotic literature going back a thousand years to *The Tale of Genji*, Japanese culture has certainly made room for the sexual side of life. It's embraced that side more openly at some times than at others, but the Japanese know it would be foolish to deny sexuality altogether.

The basic attitude toward sex was—and to an extent still is—that the act itself is not as important as the consequences. Two folktales illustrate this. Both center on Buddhist monks having sex—something forbidden by the Buddha, who enjoined his followers not to live an unchaste life. In these stories, the monks break that particular vow, but are not directly punished for breaking it. After all, according to the Buddhist doctrine of karma, each event has its own causes and its consequences, none of which can be avoided. Also, both stories are part of a larger body of tales in which monks have sex with women (when available), but usually with the only available outlet: boy acolytes.

The first story is from the *Konjaku Monogatari (Tales of Times Now Past)*, a collection dating to about 1100. It's the story of a monk who was a wise man and a brilliant scholar. However, he had no

family and no noble patron, and lived a very poor life in a temple in northern Kyoto. Every month he traveled to the mountain sanctuary at Kurama to pray for help in making ends meet. He went to Kurama month after month for years.

Once, during the ninth month of the year,[3] he had left Kurama and was at the outskirts of Kyoto when a good-looking boy of about sixteen started walking with him. The monk asked the boy what he was doing. "My master and I quarreled ten days ago and I left him," the boy replied. "My parents are dead. Please take me with you."

The monk agreed, saying, "Don't blame me for whatever happens. I live a rather dull life."

All that day and the next, the monk found himself increasingly attracted to the youth, who refused to speak any further about himself or his family. He was so pretty, however, that, on their second evening together, the monk began to fondle the youth, as he had done to other temple acolytes. However, he quickly realized that this youth was not like the other young boys, and was in fact a girl.

"So what if I am a girl?" the youth asked. "Will you send me away?"

"I can't keep you here if you're a girl. What would people say? What would the Buddha say?"

"Just treat me the same as you would a boy. I promise that nobody will ever see me as anything but a boy."

The monk's desire for the beautiful youth had been growing and growing. At the same time, he knew that keeping a girl in the temple was a bad idea. Still, in spite of his misgivings and precautions, he could not help being human, and eventually he and the girl became lovers. The monk had never been happier in his life.

Several months later, however, the youth stopped eating. She told the monk that she was pregnant. This distressed the monk; he knew the neighbors were bound to find out. But the youth

[3] According to the Chinese calendar, the lunar new year begins sometime between January 21 and February 21, with the first new moon after the sun enters Aquarius. The ninth month would be roughly the month of October.

simply smiled and said, "Don't say anything to anyone. Act as if nothing has happened. And when the time comes, keep quiet."

Finally came the day when the youth complained of pain "down there." It was time for the baby to be born. The youth told the monk to spread a mat in a shed. The youth cried in pain, and the monk cried in sympathy, but finally the youth gave birth. Her cloak covered every part of her, so the monk could not see a thing. After the birth, the youth lay down to nurse the baby, pulling the cloak over herself. As she did so, the size of the bundle under the cloak shrank. The monk pulled back the cloak. There was no youth, and there was no baby. What there was, however, was a large rock made of solid gold. In this way had the monk's prayers at Kurama been answered. And, although he missed his lover with all of his heart, he chipped pieces of gold off of the rock a little at a time and sold them, and thus was he able to live in comfort for the rest of his days.[4]

This story presents a pattern that recurs in anime and manga, as well as in Japanese legends: having sex with a supernatural being is very different from having sex with a human. The monk, who "could not help being a man" (Royall Tyler's phrase), had sex with boys and thought nothing of it; apparently, neither did other monks, who presumably were also having sex with their acolytes. Having sex with a girl was more problematic, and the monk knew it, since it violated one of the Five Precepts of his faith.[5] However, once again, he could not help himself, which was exactly what the "youth" counted on. The monk's devotion was repaid, first by physical and emotional gifts, then by gold.

Supernatural bedfellows continue to be seen in anime, and are quite a diverse lot. They include Lum, the alien girl of Rumiko Takahashi's *Urusei Yatsura* (1981), who's so full of electricity that her boyfriend Ataru has to wear an insulated rubber

[4] Royall Tyler, *Japanese Tales* (New York: Pantheon, 1987), 221–23.

[5] Do not steal, do not kill, do not lie, do not drink to excess, do not live an unchaste life.

suit to go to bed with her. Another is Chihaya, the effeminate "angel" sent to Earth to observe human behavior in *Earthian* (1989). In the series Chihaya sleeps with his partner-angel, but also lusts after an angel turned human rock singer, and a cybernetic "angel" developed by a mad scientist. All three of the objects of his affection are male, but he is never censured for this. Miko Mido, the sexual ninja in the *La Blue Girl* (1992) series of H-anime, falls into this category as well, by virtue of her father having been a demon. And the anime *Doomed Megalopolis* (1991) has several non-human close encounters, including Yukari (raped by a demon) and Keiko (a *miko*, or Shinto priestess, who defeats the demon by becoming Kannon, the Buddhist goddess of compassion, and offering herself to the demon).

Enough of the non-human (for now). Human sexual relations are complicated enough as they are, as shown in this story from the *Uji Shui Monogatari (A Later Collection of Uji Tales)*, dating from the early thirteenth century.[6] This is the story of a monk named Zoyo, who didn't even try to live an ascetic life. There always seemed to be a party in his quarters. Salesmen of anything and everything sought him out, since he paid the asking price without question. Zoyo was very much involved with earthly pleasures.

This included pleasures of the flesh. One time he saw a young boy dancing at a festival, and quickly fell in love with him. He repeatedly asked the dancer to become a monk. At first the boy refused, saying "I'd rather stay as I am for awhile." Ultimately, however, he agreed, becoming Zoyo's acolyte and bed partner.

One day in the following spring, Zoyo asked the boy to try on his old dancing costume. The clothes still fit him perfectly, and Zoyo asked the boy to perform the *hashirite* dance. But the boy had forgotten all the steps to that dance. He tried a few steps of the *katasawara* dance instead. As he awk-

[6] Uji is an old resort city between the two ancient capitals of Kyoto and Nara.

DNA Hunter *Some women want children, women like Mai, whose fiancé was killed in a mountain climbing accident. But if all they want is the baby, that means someone else has to collect the necessary sperm. The DNA Hunters are the middlemen (or -women). At first Mai is a bit of a washout as a DNA Hunter, but then come kidnappings, torture, and the possibility that Mai's fiancé is still alive. . . . This box art is from the English release, which features the voice work of stars familiar to fans of adult entertainment.*

wardly did so, Zoyo let out a howl of anguish. He realized that, by hounding the boy into becoming an acolyte instead of a dancer, he had lost that which attracted him in the first place. "Why did I ever make a monk of you?" he lamented.

By now the boy was crying too. "I told you to wait!"[7]

The story of Zoyo is another case in which a monk has sex with a young boy, but that in itself isn't the problem. Zoyo forced the boy to change from one kind of life to another, and in doing so lost the very love he was trying to save. He may even have kept the boy on as a sex partner after that realization, but surely any joy in the encounter was now tinged with sadness.

In the 1590s the warlord Toyotomi Hideyoshi

[7] Tyler, *Japanese Tales*, 220–21.

Words Worth *An X-rated anime isn't always based on an X-rated manga. Words Worth is based on an X-rated computer game (and there are lots of those, but that's another story . . .) and set in a sword-and-sorcery realm. The plot, such as it is: During a war between Light and Shadow, Prince Astral of the Shadow realm is engaged to Sharon, but she's interested in a swordsman named Caesar (while she is the object of interest of Sir Fabris of the Light forces). Meanwhile, the neglected Prince Astral rapes the Light witch Marie. . . .*

granted an audience to a Portuguese Jesuit monk named Coelho, and asked several revealing questions about Christian behavior.[8] Sex, or specifically monogamy, was a contentious issue; it was not unusual for upper-class Japanese men to turn to concubines, or even to young boys, as sex partners over and above their wives. The Jesuits could not condone these practices, while the Japanese elite found monogamy an alien concept. (The lower classes, as was the case elsewhere around the world, were seldom polygamous, simply because they couldn't afford it.)

Of course, Buddhist monks traditionally practiced celibacy, and some still do, though in modern times most sects have interpreted the precept not to live an unchaste life to allow for monogamous marriage. Other monks were less scrupulous: the case of Ikkyu Sojun (1394–1481) comes to mind. Ikkyu was of the extreme position of some old Zen masters that, having experienced enlightenment, they became laws unto themselves. At least Ikkyu wasn't entirely self-indulgent; he left behind some wonderfully autobiographical verse, especially poems celebrating his love affair (begun when he was in his seventies) with Mori, a blind prostitute more than fifty years his junior. In any event, celibacy has seldom been a realistic option in Japan, for the clergy or anyone else.

We could discuss the issue of sex in the pop cultures of Japan and the United States for days, and still never reach a conclusion, but one point I want to make is that the quantity of sexual content (or absence thereof) is not a reasonable yardstick for

[8] Mikiso Hane, *Japan: A Historical Survey* (New York: Charles Scribner's Sons, 1972), 145.

rating a culture. Some conservative American politicians think that there is a virtue in eliminating sex from pop culture altogether. They blame a host of social ills on too much frankness. Actually, if anything, we're far less frank than Japan, in whose pop culture nudity and sex are much more common, yet whose crime rate is microscopic compared to that of the United States. Pop culture in the United States is coy about sex, alluding more often than showing, and some of this coyness crosses the line into sleazy suggestion. It could be argued that the smutty jokes of a *Married . . . With Children* or a radio drive-time shock-jock like Howard Stern would do our children more harm than the flat-out and funny frontal nudity of a *Ranma 1/2*.

Having said that, there is an entire sexual subgenre of anime in which you get the old in-out, but usually quite a bit more besides. Japanese pornographer Oniroku Dan, who specialized in sado-masochistic bondage stories, said that a storyteller can't just keep repeating the same story over and over again: "Ordinary sex episodes would be too repetitive. Like (pornographic) photographers, manga artists must pander to the market by coming up with sensational subject matter."[9] The very fact that the public wants to see something a bit different the next time has pushed almost all Japanese pornographers, including producers of H-anime, to be more creative, keep up the interest level, and produce porno that isn't just porno.

Variation One: Humor

How does an author or artist or animator provide variety? With humor, for one thing, as *shunga* prints have done for centuries. There are a couple of delightful *hentai* OAVs that are parodies of the 1990 sword-and-sorcery OAV series *Record of Lodoss War*.[10] At the end of that series, we see the human knight Parn and the elf Deedlit ride off together, presumably to begin the ultimate mixed marriage.

[9] Quoted in Nicholas Bornoff, *Pink Samurai: Love, Marriage, and Sex in Contemporary Japan* (New York: Pocket Books, 1991), 365.

[10] First came the thirteen OAV episodes in 1990 that inspired these parodies; then, in 1998, came the twenty-six-week series called *Record of Lodoss War: Legend of the Heroic Knight.*

But what if it really happened? The 1995 *Elven Bride* series of OAVs tries to answer that question.

The first tape starts at the wedding; an odd wedding, since no guests have shown up. There are prejudicial feelings about this marriage from both the human and the non-human families. The newlyweds, however, believe that acceptance will come in time; they're more focused on the honeymoon. But when it comes down to it, they can't do it. Human and elfin physiology doesn't quite match up, but is Kenji, the newlywed hubby, discouraged? No; he undertakes a heroic quest for the ultimate lubricant. His bride, Milfa, stays home and does housewifely things, even though the village children taunt her, she is charged triple price for food—when she's allowed to buy food at all—and suffers other discriminatory indignities.

Kenji succeeds at his quest, even though he has to journey to Ygdrassil, the world-tree of Norse mythology, and has a brief romantic encounter with a harpy. However, he does it to obtain the sought-after lubricant, so in a sense he wasn't being unfaithful.[11] Meanwhile, Milfa has been enduring the taunts of the townspeople when one of them, whose cart is pulled by a two-headed hydra, loses control. The hydra rampages through town and is about to trample some children when Milfa magically saves them. At this moment, Kenji returns and subdues the hydra. That evening, with the hydra parked in the garage (!), the couple finds that the children have secretly but contritely left gifts of food on their doorstep. They recognized Milfa's selfless spirit in protecting them at the risk of her own life. So, between acceptance into the community and the arrival of the lubricant (supplemented by a couple of alternate positions), this story definitely has a happy ending.

The second episode in the set shows that there are still some problems in the bedroom, and Milfa is recommended to a gynecologist. This doctor happens to be a bit of a pervert, but before he can

[11] This tolerance is the sort of concept that doesn't travel well across the Pacific and may be one of the hardest challenges to the moral order of a *gaijin*. I once asked a Japanese college student about the *ronin* hero of Joji Akiyama's long-running manga, *Haguregumo (Floating Clouds)*. This man, living near the end of the Tokugawa period, was married, with children, but persisted in chasing almost any female he saw. The student told me that he was still a good husband because afterward, he always came home to the family. Bornoff notes that "a comparatively marked degree of indifference to flings with prostitutes remains (to this day); they are too fleeting to endanger a relationship" (Bornoff, *Pink Samurai*, 461).

work his will on Milfa, she's rescued not only by Kenji and a helpful female member of his family, but also by the other patients in the doctor's waiting room. And, given that the other women range from hobbits to werewolves and all are magical to some extent, this is one group of patients you don't want to upset. Sisterhood is indeed powerful.

Milfa, however, apparently is not. Milfa is an elf, a magical being, but chooses not to act like one. Yes, Deedlit, her model, is victimized and almost sacrificed during the OAV series, but why wouldn't Milfa magically strike back at the townspeople who discriminated against her or the doctor who tried to molest her? Two reasons come to mind. One is the desire to paint Milfa as the stereotypical submissive virginal Japanese female. But this works only up to a point; she does use her magic in order to rescue the children from the hydra. This points to the second reason: *wa*. Keiji and Milfa have settled down to live in this village, and the village serves as a second family. Preserving harmony is more important than magically zapping someone to punish a real or perceived slight. Milfa suffers in silence, believing that the villagers' attitudes can—and ultimately will—change.

The 1994 anime *Venus Five* is nothing less than a pornographic parody of *Sailor Moon*. Earth is falling prey to the Inma, a race of demonic beings led by a very impressive hermaphrodite. Once again, as in *Sailor Moon* (or a dozen other crime/alien-fighting science-team shows), five schoolgirls are needed to save the day. They're superpowered, but don't know it yet. The one who has to round them up and instruct them is a cat. Unlike *Sailor Moon's* Luna, the cat in question here is a filthy (in every sense of that word) old tomcat. The girls are revealed by glowing astrological signs. Similar signs appeared in *Sailor Moon* on the foreheads of the Sailors in the "third eye" location, but in *Venus Five* they appear on rather more intimate parts of the

anatomy: a good excuse for a shower scene. In any event, just as having seen *Record of Lodoss War* made the *Elven Bride* tapes funnier, *Venus Five* is funny to the extent that the viewer notes the *Sailor Moon* jokes.

The *Frantic, Frustrated, and Female* (1994) tapes don't have to resort to parody for humor; just to absurdity. The stories all revolve around the plight of one girl who, regardless of sexual stimulation, is unable to reach orgasm. Another girl takes this as a personal challenge: she, the motorcycle-riding lesbian she loves, the lesbian's two sidekicks, and even the original girl's landlady launch into extended—but ultimately futile—sex sessions. The whole thing is built on twin foundations of sex and humor, since not only the story but the subtitles and the non-realistic character design are part of the humorous intent of the series.

The humor continues in the third F3 installment, when a wandering perverted ghost discovers the group. It possesses first the girls (causing them to grow penises), then their sex toys, before it is exorcised. But this installment brings us to the next variation.

Variation Two: Horror

Another popular context for *hentai* is horror. Series such as *Angel of Darkness*, *La Blue Girl*, and *Urotsukidoji (Legend of the Overfiend)* invert the long-standing Western formula of using horror to express sexual anxiety. Gothic literature, notably Bram Stoker's *Dracula*, often carries a sexual subtext to its horrors. Cinema as far back as the silent era (especially *The Phantom of the Opera*) has employed the sexual device of having the monster attack the heroine when she is either asleep or preparing for bed. In the modern era, Hollywood became more explicit, so that mad slasher films such as the *Friday the Thirteenth* series seem to require that the teenaged victims have sex before they can be graphically slaughtered.

The Third Eye

Here again we owe a tip of the hat to Dr. Osamu Tezuka, and in this case, his 1974 manga series *Mitsume ga Toru (The Three-eyed One Has Come)*, about a student from an alien race who has a third eye in his forehead, in the spot defined in esoteric yoga as the sixth chakra, the seat of enlightenment. If the third eye is covered, he's a drooling idiot; when the eye is exposed, he's an evil genius.

Since then, there have been countless manga and anime examples of third eyes, both literal (*3x3 Eyes*) and symbolic (such as the crescent on Luna's forehead and the

tiaras of the Sailor Senshi in *Sailor Moon*). Belldandy and her sisters from Kosuke Fujishima's *Oh My Goddess!* have markings resembling third eyes, denoting their status as systems operators for the heavenly computer Ygdrassil. In the *Tenchi Muyo* universe, Jurai Princess Sasami has such a mark on her forehead, denoting her connection to the guiding spirit Tsunami, who revived Sasami after a fatal accident. And in *Please Save My Earth*, Mokuren has four dots on her forehead in the shape of a diamond; this symbolizes her powers as a Kiches of the goddess Sarjalin and her ability to commune with plants and animals. Mokuren is reborn as Alice Sakaguchi, but Alice is reluctant to face this until a school field trip to Kyoto. When she faints, the dots appear on her forehead, and all the plants in the park burst into unseasonable bloom.

The Three-Eyed One Has Come A scene from Dr. Osamu Tezuka's 1974 manga.

H-anime movies based on horror invert the Hollywood formula by making horror the subtext of a sexually explicit story. Anime such as the *Angel of Darkness* (1995) series are heavy with the old conventions of the Gothic style: isolated houses—old or new—with subterranean lairs, nocturnal thunderstorms, and grotesque otherworldly beings. Of course, they're also heavy with sex of various kinds.[12] However, unlike Hollywood teens, anime characters are not always automatically doomed to be sliced-and-diced just because they have sex.

[12] The subgenre of sex in pop culture has its own sub-sub-genre: sadomasochism and bondage. I consider bondage anime to be an offshoot of the Gothic Horror genre, since many of the trappings overlap (dungeon settings, torture devices, imprisonment, and the infliction of pain). Even the burning of a woman with hot wax from a melting candle—a technique seen a lot in such works in Japan—has a certain Gothic flavor to it.

The *La Blue Girl* (1992) series is perhaps the best example of this more charitable attitude toward sexuality and horror. The series revolves around two sisters, Miko and Miyu. Not only are they inheritors of the traditions of a clan of sexual ninja, their father was a demon. This relationship slightly complicates their sexuality; Miyu, for example, avoids becoming sexually aroused during a full moon (as revealed in the fourth OAV) because if she gets aroused but does not reach orgasm, she turns into a werewolf. Demonic or not, the viewer is meant to cheer the sisters on as they battle rival ninja clans, demons, extraterrestrials, and whatever hazards the scriptwriters put in their way. Sex for them is (usually) joyful, and does not bring down cosmic retribution from Freddy Kruger or Jason.

Urotsukidoji is undoubtedly the most extreme example of the sex/horror approach, to say nothing of the extent to which a story will give rise to sequel after sequel. Between 1989 and 1995 no fewer than thirteen OAVs were made in this series, originally based on a manga by Toshio Maeda, leading Helen McCarthy to complain about "filmmakers [who] milk a cash cow long after it's dead on its feet."[13]

What's noteworthy about the *Urotsukidoji* films is not their capitalism but their conservatism. This may seem an odd word to use about a film that shows women (and men) being raped and then torn to bloody bits by phallic tentacles, but the choice is deliberate. We need to remember that popular culture, to be popular, must necessarily be based on the beliefs of the majority. No story was ever popular and avant garde at the same time. The *Urotsukidoji* series navigates this dilemma by showing all kinds of sexual activity, but punishing only those whose activities are too far out of the mainstream. If a high-school athlete cavorts with three girls at once, they are all doomed. The illicit affair of a servant and master actually triggers the great

[13] Helen McCarthy, *The Anime Movie Guide* (Woodstock, New York: The Overlook Press, 1996), 264.

La Blue Girl *Miko Mido is part demon, part human—and the human side includes a long line of sexual ninja. She and her sister battle monsters. They have sex. Sometimes they use sex to battle monsters. And they have a lot of fun at it.*

1923 Tokyo earthquake in this anime. However, the naïve adolescent fumbling of two teenagers trying to understand sex is tolerated. This is understood as a necessary part of life, even a rite of passage, that does not deserve the death penalty.

Variation Three: Sentimentality

The early anime *Etude* isn't humorous, isn't horrific, isn't even a fantasy; but neither can you call it pornographic in the traditional sense. There are two sex scenes that take up a small part of this forty-five-minute OAV about a brief love affair between a musician and a motorcyclist. And, more importantly, *Etude* represents a third style of H-storytelling: the sentimental. While Western pornography is usually "down and dirty," some *hentai* are highly sentimental, even romantic. Some manga rapes have stopped dead in their tracks because the rapist has been moved by the victim's tears. The most famous *hentai* anime OAV series of them all gained a significant fan following precisely because of its sentimental storytelling.

Cream Lemon—The Ami Nonomura Story

In 1984 the Fairy Dust and Soeishinsha companies began a series of sexually oriented OAVs that still resonate in the Japanese video market. The name *Cream Lemon* became synonymous with sexual

1995 TOSHIO MAEDA/WEST CAPE CORPORATION

Urotsukidoji One of the few publishable scenes from "Infernal Road, " a small part of the vast and sprawling story-arc of Urotsukidoji (Legend of the Overfiend), based on a manga by Toshio Maeda. This may be the best-known series of erotic Japanese animation, or at least the most notorious. At its most basic level, the plot depicts a supernatural battle between the Overfiend and the Lord of Chaos, with only a handful of (relatively) naïve young people trying to keep love and compassion alive. But they have to do so in the middle of extremes of erotic horror, including violent orgies presided over by warped psychic children and the ever-present phallic tentacles. . . .

[14] In fact, some of the major names in anime—both artists and voice actors—have dabbled in *hentai* at one time or another in their careers (naturally it seldom if ever shows up on their resumes). One artist who has crossed over is Hiroyuki Utatane. The creator of the *Count Down* manga and anime, featuring the ravenous transsexual Jun Nakamura, recently found mainstream success with the manga *Seraphic Feather*.

[15] The following synopsis is a condensed version of the Ami Nonomura Shrine webpage by Dave Endresak, currently off the web.

matters handled with taste and talent.[14] The identification was so complete that, just as Jell-O and Xerox became generic nouns for an entire class of products, sexually oriented fan-fiction is now called "lemon." The first *Cream Lemon* releases told the tale of Ami Nonomura, and are regarded as classics of their kind. The following may read more like a Barbara Taylor Bradford novel than a letter to *Penthouse Forum*, but it demonstrates how sexual storytelling can avoid redundancy and provide the character development valued by the anime audience.[15]

In the first installment of the series, "Be My Baby," Ami Nonomura lives with her mother and older brother, Hiroshi. When Hiroshi and Ami were younger, they played "doctor." Hiroshi is still attracted to his sister, and Ami also finds herself drawn to her brother, now that she too is older. In fact, she begins to have sexual fantasies about him, though she could never let anyone know this, incest being taboo. Nevertheless, her attraction for him grows so strong that, while their mother is gone one day, they wind up making love. Unfortunately, mother comes home early and knocks on Ami's bedroom door at the worst possible moment.

In "Ami Again!" Hiroshi has been forbidden by

74 | ANIME EXPLOSION !

their mother from ever seeing Ami again. Ami's friends Satomi and Kyoko take her to a disco to cheer her up. She has too much to drink and winds up dancing with the local "wolf," the rich and good-looking Kono. He takes Ami home and makes love to her. However, she cries out "Brother! I love you!" during the act, mistaking him for Hiroshi in her drunken state.

Ami doesn't remember any of this the next day. Kono picks her up as she's walking home from school and essentially blackmails her into going to a "love hotel" with him. (Kono's ego can't let him believe that Ami would prefer her brother, at least not when she is sober.) After they finish their tryst, Kono compares himself to her brother. She gets upset, slaps him and walks out. She tries to get home through the falling snow, but collapses in a phone booth in despair. Satomi and Kyoko comfort her, and tell her at least her first time was with her brother, whom she loves. The second episode ends with Ami walking alone to school. She meets a puppy on the way; the puppy licks Ami's hand, making her feel less alone.

In the third installment Ami has tried to forget her brother, but she just can't. Everything changes when the phone rings. Hiroshi asks to meet her at a coffee shop. Ami is nearly breathless with excitement, but Hiroshi tells her that they cannot see each other, ever again, then runs away without an explanation.

Ami goes to see Kono. She doesn't like him, but it doesn't matter anymore. He welcomes her, of course, and makes love to her in the bath. But Ami still can't forget how she feels about Hiroshi.

A sleazy manager/photographer starts taking pictures of Ami waiting for her train, then takes her to a bar and explains how big a star she could become. (Kono happens to be at the bar and witnesses what's happening.) Ami becomes quite good at modeling and works very hard to learn how to dance and sing. The recording session goes

well, and Ami is thrilled when her manager hands her a cassette of the session while driving her home in his car. Unfortunately, the manager takes her to a love hotel, rather than taking her home. When he tries to kiss her, she runs down the hall to the exit, out the doorway into the rain. There, in his sports car waiting at the curb, is Kono. He takes her back to his place, and tries to kiss her. Ami tries to slap him, just as she had done before, but this time he catches her hand . . . The next morning, he lets her out on the roadside, and drives off into the rising sun.[16]

The final Ami OAV, *Tabidachi—Ami Shusho (Departure—Ami Final Chapter)* begins with Ami as a singer and model. Kyoko and Satomi want to take Ami to Hokkaido for her seventeenth birthday.

Kono finds himself increasingly drawn to Ami, despite the seemingly endless stream of girls who clamor for his attention. Ami is the only girl he knows who doesn't want to be with him. He actually starts to care for her.

Ami is back home watching her video on TV. The girl on stage performing seems like someone else. Ami decides to quit. Her new manager encourages her to take some time off to think it over more carefully. Ami has also decided to quit seeing Kono. She knows that he only wants her for her body. She goes to him to tell him her decision, and he almost convinces her that he really does love her. However, another girl shows up, and Kono tells her that Ami's just a flower delivery girl. Ami runs out of the room, crying.

The next day, Ami finds a letter in the mailbox from her father in London, addressed only to her mother. Her mother isn't home and, after staring at the letter, Ami opens it. Her father is suggesting that he and her mother get divorced. He's suggesting that he take Ami, and that her mother take Hiroshi, *just like before they were married!* In a very convenient twist of fate, her "parents" were both single parents when they married; she and Hiroshi

[16] The "music video special" titled *Ami Image: White Shadow* shows what happens after Ami is discovered and made into an idol. The special is actually a combination of clips from the first three parts of the story plus original animation, set to music from the series, as well as new vocals for the image video.

do not share a blood relationship at all, so it's no longer a question of incest.

The next morning Ami asks her mother (to whom she is also no longer related by blood, thus putting the animosity between them into a new context) if she could talk to her. Her mother refuses. Ami takes a cab to the station so that she won't be late meeting Kyoko and Satomi. Halfway there, though, she suddenly comes to a decision: she tells the driver that she's changed her mind, and would like to go to the airport. She buys a ticket to London with her mother's credit card, and she flies off to meet Hiroshi. . . .

The very first sex act in this series—Ami and her brother playing "doctor"—is discomfiting to watch, coming dangerously close to child pornography. Yet it sets up the rest of the series, establishing the relationship between Ami and Hiroshi. They apparently remain devoted to each other as they get older. We don't know if Hiroshi behaved himself when he was away, but Ami fights off the advances of her manager and tries to fight off Kono when her mind isn't clouded by either alcohol or despair.

More important than what happens to Ami sexually is the fact that nothing happens to change our opinion of her. Even when she does things that would be considered dubious at best, such as going out drinking at age sixteen or sleeping with Kono to bolster her self-worth, she's never shown as anything but a nice girl caught in a rotten situation. We want her life to get better, even if it means getting together with her stepbrother in a sort-of incestuous relationship.

There are many sort-of relationships in anime that pose problems for some Western readers. The next chapter looks at one of the more problematic: the sort-of gay relationship.

"A Very Pure Thing":
Gay and Pseudo-Gay Themes in Anime

Homosexuality is shown more prominently in Japanese pop culture than in the West. Yet sometimes a relationship that seems gay really isn't, and what may be accepted in some stories is subtly discouraged in others.

In an early episode of the manga *Ghost Sweeper Mikami* by Takashi Shiina, Mikami's lecherous assistant Yokoshima is sent back in time, encountering his voluptuous exorcist boss-lady when she was still a high-school student. When he sees another student, Chiho, fawning and falling all over Mikami, he accuses Chiho of being a lesbian. Chiho's response is blunt: "Lesbian? How rude! The love that Mikami and I have is a very pure thing."

That is the point of departure—and point of confusion—for Western fans of Japanese pop culture. There is conduct and language in anime and manga that would seem homoerotic, even though its practitioners maintain that it is not.

Western pop culture recognizes homosexuality through a set of stereotypes, most of them negative. Homosexual chracters are often portrayed as either "butch" or "flaming queens," displaying exaggerated, parodied traits of the opposite sex. Another stereotype—that of the homosexual afraid to admit to his or her preference—is often characterized by an extreme timidity and indecisiveness

in other aspects of daily life. Then there is the myth of the gay predator, based on the assumption that a "normal" person would have to be seduced or forced into homosexuality. Randy Shilts gives this particular stereotype the B-movie title it deserves: "Lesbian Vampires of Bavaria."[1] Even in more sympathetic portrayals, though, gay characters are often presented as just that: gay first, then characters.

Japanese pop culture takes a very different approach. Often a character will be introduced, placed into the context of the story; and only later (if ever) will the sexuality of the character become an issue (for example, the character of Chihaya the observing angel in *Earthian*). Sometimes the character is played for laughs and sometimes for tragedy, but seldom are characters condemned for their sexuality. In fact, sometimes characters are presented with only a vague suggestion of homosexuality, never made explicit. This is where Westerners tend to lose track.

Sometimes characters act gay but aren't. In many old legends, for example, Buddhist monks were described as using boy acolytes for sex, but that did not necessarily make the monks homosexuals; they simply slept with whatever partners were available. (In one folk tale we've already encountered, the monk finds his acolyte is actually a girl dressed as a boy. He had approached the acolyte assuming he would be having sex with a boy, discovered the truth, and proceeded to get the acolyte pregnant.)[2]

Of course, if characters are unabashedly gay, the reader or viewer knows it, whether the comics and videos have hard or soft cores. Yukio Mishima, Yasunari Kawabata, and other well-known writers have contributed to the use of gay themes in higher-brow Japanese literature, but it's the ambiguous relationships in Japan's pop culture that bear observation here.

[1] Randy Shilts, *Conduct Unbecoming: Gays and Lesbians in the U. S. Military* (New York: St. Martin's Press, 1993), 411.

[2] See "The Boy Who Laid the Golden Stone" in Royall Tyler, *Japanese Tales* (New York: Pantheon, 1987), 221.

Magic User's Club Meet Ayanojo Aburatsubo. He's one of the few gay members of the Magic Users Club. When he's not practicing magic, he's hitting on the only other male in the club, its president. In a story-line that ranges from alien invaders to enchanted teddy bears, a gay, teenage wizard is just one more bit of weirdness making up this OAV series.

[3] In the third season, Chibi-Usa, on a visit from the twenty-fifth century, meets a precocious young teamaster, a boy who is drawn so prettily that the Western dubbers decided to make him a girl. Presumably they did this because the young teamaster, to honor the heroics of the Sailor Senshi, trades in his kimono at the end for a short skirt and middie blouse. Not that they didn't get the joke, but the Western crew seemed to forget that the word "travesty" (a parody or comic version) has the same roots as the word "transvestite."

[4] In a Q&A session at the 1998 International Comics Convention in San Diego, *Sailor Moon* cartoonist Naoko Takeuchi insisted that the Three Lites were always female, which doesn't explain their masculine attire when not fighting the bad guys. At the same conference, she confirmed that Sailors Uranus and Neptune were "a couple," but joked that they only got together because "they had lots of time on their hands." See http://www.black-kat.com/blackmoon/take2.html

Gay or Not? Not (Probably)

There are three such relationships in *Sailor Moon* alone. Two of Queen Beryl's minions, Zoicite and Kunzite, are males whom Western cartoon dubbers at the DIC Studio felt obliged to turn into a male and a female. Zoicite is, admittedly, a very effeminate-looking male, of the type known as *bishonen* (beautiful boy).[3] Two of the Outer Senshi, Sailor Uranus and Sailor Neptune, have an odd relationship: Uranus is decidedly "butch," affecting short hair and slacks (when not fighting evil in a short skirt and middy blouse) and mistaken for a male on several occasions, while Neptune is undeniably feminine. They are, if not a couple, certainly partners. And then there is the appearance late in the story of the pop group the Three Lites, a male trio who transform into a trio of female superheroes (of course their male selves were already fairly androgynous).[4]

In *Sirius no Densetsu* (*The Legend of Sirius*, a 1981 feature film released in English as *Sea Prince and the Fire Child*), the princess of the Fire Kingdom, Malta, has a friend named Piyale who seems unusually friendly, spending practically all her time rubbing against Malta like a cat starved for affection. At first angered and upset by Malta's falling in love with Prince Sirius of the Water Kingdom (after try-

ing to kill him, we see Piyale go off alone to cry her eyes out), Piyale later tries to protect Malta at the cost of her own life.

A close cousin to Piyale is Wakaba in *Utena*. She constantly declares her undying love for Utena, another girl. True, Utena's a girl who constantly dresses like a boy, but still a girl. And yet there is no hint that Utena reciprocates Wakaba's feelings, or that they are anything more than feelings. Neither is shown to be a practicing lesbian.[5] The first episode, in fact, also has Wakaba sending a love letter to Saionji, one of several campus cads at Otori Academy, who promptly puts the letter up on a bulletin board to humiliate Wakaba. Utena's first duel in the arena is against Saionji, to defend Wakaba's honor. And that is literally as far as it goes. From beginning to end, they're just friends and classmates. Wakaba's love for Utena is a very pure thing.

Here Is Greenwood (1991) brings us an oddball character as part of a group of oddballs in the boarding-school dormitory of the title. You can't exactly call Shun Kisaragi a transvestite—he's just a guy who likes to wear long hair and talks in a very high voice. The confusion is played strictly for laughs, and is even doubled later in the series by his "kid brother."[6]

Unlike *Here Is Greenwood*, in which comic characters appear in a nominally serious situation, the entire OAV series known as *Maho Tsukai Tai* (1996) is comedic, and so is everyone in it.[7] This includes high school senior and Magic Club member Ayanjo Aburatsubo. His willowy figure and flowing maroon hair make him appear at first glance to be a girl . . . as do his constant amorous advances on club president Takeo Takakura.

Rumiko Takahashi has given us two crossdressers in two highly successful series. In *Urusei Yatsura* we meet Ryunosuke Fujinami. It's a very masculine name, attached to a very masculine-looking (and acting) girl. Her widowed father, own-

[5] Utena dresses like a boy in order to be heroic; she knows that princes are heroic, but princesses are not. As will be seen later, this belief costs her dearly.

[6] This is a case in which the manga and anime versions diverge. In the anime, the dorm's *senpai* (upperclassmen) room together and sometimes act gay to play mind-games with the hapless hero of the series. In the manga by Yukie Nasu, however, two freshmen roommates actually begin a homosexual love affair; this isn't mentioned in the anime.

[7] This is another title whose meaning is layered. It could be taken as either *Magic Users Club* or the exclamation "We wanna do magic!"

PLASTIC LITTLE © 1994 KINJI YOSHIMOTO • SATOSHI URUSHIHARA / MOVIC CO., LTD. / SONY MUSIC ENTERTAINMENT (JAPAN) INC.

Plastic Little Two girls, one bed. This seems to echo a similar scene in Dr. Tezuka's MW. But this scene from Plastic Little is of a different order, and belongs in the "pseudo-gay" category of anime that teases the viewer. Captain Tita (right) has rescued Elysse from the evil forces of the planet Yietta, and they are asleep in Tita's cabin. There's no indication that they have done anything but sleep. Elysse, whose father was murdered in the first scene, is curled into a fetal ball, while Tita's arm encircles her protectively, not erotically. Their body language suggests a chaste relationship.

er of a seaside refreshment stand, wanted a son, and was determined to have one regardless of his child's gender. The whole thing is played for laughs, with a frustrated Ryunosuke wanting to be feminine but not knowing how to act. She's repulsed by boys who fawn over her and spends a lot of time in hand-to-hand combat with her father (not unlike Ranma Saotome and his father, for different reasons).

Speaking of *Ranma 1/2*, that Rumiko Takahashi story inverts Ryunosuke into Tsubasa Kurenai, a guy who happens to look like a girl but is not effeminate. Years earlier, Tsubasa fell in love at first sight with Ukyo—the same Ukyo who was betrothed to Ranma as a child. Ukyo was attending a girls' school, so he did the inevitable and dressed as a girl to be near Ukyo. Things just sort of kept on from there. . . .

The cross-dressing heroine of Osamu Tezuka's nineteenth-century political/romance manga *Niji no Prelude* (*Rainbow Prelude*) has a deadly serious reason: her brother had been accepted to study music at the Warsaw Conservatory, but he died before he could attend, so she assumed his identity and went in his place. While at the Conservatory, she meets the young Frederic Chopin, gets involved with a piano-maker who is working against the Russian occupation of Poland, and ultimately

A detail of Captain Tita and Elysse from the scene opposite. Note the tender expression of the faces here. Plastic Little is the work of one of the finest artists where the female form is concerned, Satoshi Urushihara. If he wanted you to think there was anything going on between these two, you'd know it.

dies. Like the title characters of the movies *Tootsie* and *Victor Victoria*, she finds that being disguised as a member of the opposite sex creates a hurdle for one's love life.

Not of This Earth

The relationship between Jinpachi Ogura and Issei Nishikiori in *Please Save My Earth* is not ambiguous at all: they're both male high school freshmen. And that's the problem. This non-linear *shojo manga* by Saki Hiwatari and its anime version take place in several realities, only one of which is our present-day Earth. The seven residents of Tokyo featured in the story are all reincarnations of beings from another planet. Thousands of years ago, they set up a research station on the moon to observe the evolution of life on Earth. Jinpachi and Issei were both there, as Gyokuran and Enju. Enju was a woman in love with Gyokuran. Issei remembers this all too well and, at one point, forgets himself/herself and kisses Jinpachi on the mouth. Of course, if you've been keeping score, you know that Issei is not gay. He had momentarily become Enju in love with Gyokuran, and knows that he stepped over the line in that moment. He cannot do it again because of social constraints, yet he also cannot alter Enju's feelings. This makes him, in *shojo manga* terms at least, caught between pub-

lic propriety and personal passion, and therefore a classically tragic figure.

Science fiction is a fairly natural home for anime and manga stories that want to get sexually creative. Characters of unconventional sexuality can be depicted as alien, both literally and figuratively. There's the sexual ambiguity in Moto Hagio's manga *They Were Eleven,* animated in 1986, wherein one character, Frol, is of such unstable genetic makeup that it is neither male nor female. However, cadet Tada is attracted to the androgynous Frol. He knows that if Frol fails this Academy final test, an elderly suitor is waiting to demand that Frol permanently become a woman and marry him. This may mean more than the success or failure of the mission.

As part of her concert in *Macross Plus* (1994), idol singer Sharon Apple moves through the audience, suggestively stroking the faces of men and women alike. Does caressing both genders make her bisexual? The question is absurd. She's a virtual idol, after all, an actualized computer program. It's equally absurd to speak of the sexuality of the audience members—male and female—who thrill to her touch. Sharon Apple is, after all, a celebrity, and as such excites a level of emotion a mere mortal can barely contemplate.

And then there's Benten, the androgynous criminal in *Cyber City Oedo 808.* And there's Mosh, the Zentraedi hairdresser in *Macross II* who claims to have a special "understanding" of both males and females. And there's Berg Katse, henchperson of the villain Sosai X in the *Gatchaman* TV series. Created out of the DNA of a pair of male and female twins, Katse is able to change gender at will. And so on.

Princess Knight

This all started, in a sense, with Dr. Tezuka's 1953 manga *Ribon no Kishi (Princess Knight).* It was the first action/adventure story written exclusively for

王子さまの〜〜
おでまし〜〜り！

Princess Sapphire The gender-bending starts here with another much-loved Tezuka creation. *Princess Sapphire* has been raised to live her life as a prince. The story was a first: a swashbuckling action story for the girls' comic market. It not only redefined storytelling for Japanese girls, but added sexual ambiguity as a permanent part of the mix.

the girls' comic market, and, as both a popular manga and a Japanese television animation, it sent out shock waves that are still being felt.

While the influence of Walt Disney is very clear in Dr. Tezuka's work, a more important influence, in many respects, was his love of the all-girl Takarazuka theater troupe, whose aesthetic is on full display in *Princess Knight*:

> I was often taken by mother to the [Takarazuka] Operas, and though what they presented [was] not authentic, I got acquainted with the music and costume of the world through them. They were in turn a copy of a Broadway musical and that of a show at the

Folies Bergère or the Moulin Rouge, but as I could not know the facts, I was impressed and believed they were the finest art in the world.[8]

A girl, Sapphire, is born to the king and queen of Silverland; this is unfortunate, since by law a woman cannot succeed to the throne. Consequently, the girl is raised to be a prince. When she meets a handsome prince from a neighboring kingdom, her secret identity becomes a problem. Courtiers who want to "out" the princess so that a different family can control the throne compound the problem.

But this story really started in Heaven. Babies waiting to be born on Earth are lined up for the shuttle. As they board, they are given hearts to swallow: pink for girls, blue for boys. Note, however, that this does not assign gender to the babies; they're already male or female. Rather, the heart carries gender-specific behaviors.

A less-than-competent cherub named Chink (or Tink, depending on which romanization system you favor) asks one babe whether it's a boy or a girl; the child says it doesn't know. Wanting to speed up the line, Chink feeds it a boy's heart because "you look like a boy." However, this baby is a girl, and will be born the princess of Silverland. A princess who's a remarkable fencer, among other talents. Yet these talents are directly attributable to the blue heart, not to anything she's done with her life as she grew up. We see this because, on occasion, the blue heart flies out of her body, and her fencing abilities immediately vanish.

The androgyny in *Princess Knight* is deceptive, especially since it has less to do with sex than with gender, or specifically, gender-role expectations. This story is set in a medieval realm not unlike present-day Japan in its expectations: boys are supposed to be brave, girls are supposed to be graceful. Dr. Tezuka's story violates those expectations, but not by promoting an abandonment of

[8] *Catalogue of the Osamu Tezuka Exhibition* (Tokyo: Asahi Shimbun, 1990), 142.

those gender role expectations. After all, Princess Sapphire marries her Prince Charming and lives happily ever after. Dr. Tezuka acknowledged what one writer has called "the inner conflict that derives from the clashing coexistence of two poles" of behavior, and created dramatic friction by rubbing the two gender poles together.[9] The conflict becomes more than just an internal one when the lives of the royal family and even the fate of nations is involved.

Princess Knight also addresses another classically Japanese pair of opposites: duty and desire. Sapphire has been raised to understand that she must dress as a boy in order to keep the throne of Silverland from falling into the wrong hands. She doesn't resent her duty; at times, she revels in the horsemanship and swordplay, as Ranma would later have fun by playing his female incarnation to the hilt. Sapphire's duty becomes more serious when, with her father dead and her mother imprisoned, she disguises herself as a masked swordsman to reclaim the throne. Only in private does she live out her feminine desires, especially after meeting her Prince Charming (whose name is Franz Charming!).

It hadn't happened before, but it definitely happened after: males and females in Japanese pop culture have had a much broader palette to choose from since *Princess Knight*. From scientist to chef, from athlete to actor, modern Japanese pop culture finds heroes and heroines in all walks of life. And some of these heroes/heroines are undeniably gay, such as the police detectives in *Fake* or Daily Wong, a police detective (a coincidence, this isn't a pattern) in *Bubblegum Crisis,* or Iwao Garai, the homosexual Catholic priest who saves the world from a nerve-gas attack in Dr. Tezuka's manga *MW*. Others are transvestites for non-sexual reasons, such as Oscar de Jarjayes, the French noblewoman posing as a swordsman to defend the French monarchy in Ryoko Ikeda's *Rose of Versailles,*

[9] Atsushi Tanaka, trans. Keiko Katsuya, *Catalogue of the Osamu Tezuka Exhibition.*

MW *Pop quiz: Which one is the Catholic priest? Which one is the* onnagata—*a Kabuki actor who specializes in playing women's roles? Which is the hero and which is the villain? In the West, gays are usually found on one side or the other of the Good Guy/Bad Guy divide. Not so in Dr. Tezuka's* MW.

or Boss, bar owner and Yakumo's next-door neighbor/surrogate parent in Yuzo Takada's *Sazan Eyes* (*3x3 Eyes*).

Some homosexuals aren't even gay, as it turns out. Wataru Yoshizumi's teen romance *Marmalade Boy* includes a pseudo-gay character: Bill Matheson. Yu, the hero and "marmalade boy"[10] of the title, spends part of his high school days in New York, where Bill is his roommate. Bill is rumored to be gay, which Bill doesn't mind: in fact, he started the rumor himself. He decided that so many boys were already pursuing the girl he really loved—the attractive blonde Jinny Golding—that he had to take a different approach. So he became Jinny's gay friend. As such, he also had to watch in silence as Jinny was briefly attracted to Yu. Still, Yu has his own girlfriend/stepsister Miki waiting for him back

[10] This name was hung on him by his girlfriend/stepsister Miki, who said that, like marmalade, he may seem sweet but there's something bitter deep inside. Yu's comeback was to call Miki "mustard girl," suggesting that she was nothing but bitterness.

in Japan, and ultimately Bill confronts Jinny and brings his heterosexuality out of the closet.

Shonen Ai

An entire subgenre of manga and anime is devoted to romanticized gay male relationships. It goes by several names; the polite one is *shonen ai* (boy love). The genre is also known by the borrowed English words "boy love" or as "June," the name of a magazine that specializes in gay romance tales.

A lot of Western fans have adopted another name: *yaoi*. This is sort of a shame, since *yaoi* is an acronym, and a rather insulting one at that. The word is derived from the phrase *yama nashi, ochi nashi, imi nashi*. Literally it means "Without climax, without resolution, without meaning," or, to put it another way, "no highs, no lows, no point." This is not homophobic moralizing and is only partly an academic critique of a typical static plotline—in this case, the underlying attitude is probably practical rather than moral or literary. In an earlier example we saw how a romanticized view of a girl's first menstrual period is rooted in an agrarian society's need to track cycles of fertility, and many other Japanese attitudes are still based on centuries spent close to the soil. Such a society would be impatient with a love that did not result in anything productive, much less reproductive. Odd as it may seem in the West, stories of gay love are often directed at an audience of pubescent Japanese girls.

Which raises the question: why? Of the hundreds of books on dozens of topics that would interest a teenage girl, why would teenage (and older) girls in Japan be drawn to stories of men with men?

There are theories. Antonia Levi suggests that Japanese girls "are fascinated by the idea of equality and communication in romance. . . . Japan is a highly gendered society. Men and women lead very different lives. . . . These stories about gay love

are simply a means by which the gender barrier can be temporarily removed to allow for a more general discussion about the meaning and nature of romantic love."[11]

It's true that Japanese adolescence can be highly structured along gender lines. However, the structures themselves—e.g., the Valentine's Day tradition of the girl giving homemade chocolate to a boy—are still serviceable forms of communication. In any event, "a more general discussion" based around *shonen ai* would be a rather limited one because, as we shall see, much gay love in Japanese pop culture is doomed.

To Ian Buruma, this is precisely the point. He quotes *Hagakure*, an eighteenth-century text on samurai ethics, saying that "love attains its highest and noblest form when one carries its secret into the grave." Failing that, the idealized relationship presents two males finding happiness together; then, rather than growing old or confronting social disapproval, they look to death for a final fulfillment.[12]

This makes the fans of *shonen ai* sound at best like a bunch of morbid Gothics. However, the point is not to dwell on the relationship as doomed, but to celebrate it for what it is. Of the few commentators who have examined *shonen ai*, Sandra Buckley may have come closest to the mark. Buckley says that the focus of these manga and anime is "not the transformation or naturalization of difference but the valorization of the imagined potentialities of alternative differentiations."[13] The key words here are "imagined potentialities." *Shonen ai* comics and animation build very elaborate structures of romance between their male protagonists that have hardly any resemblance to real life. These potential structures may exist only in the universe of the characters, but they serve the need of illustrating an ideal of emotion.

Physically, *bishonen*—the "beautiful boys" of Japanese pop culture—may seem even more identical

[11] Antonia Levi, *Samurai from Outer Space: Understanding Japanese Animation* (Chicago: Open Court, 1996), 135.

[12] Ian Buruma, *Behind the Mask: On Sexual Demons, Sacred Mothers, Transvestites, Gangsters, and Other Japanese Cultural Heroes* (New York: Meridian, 1984), 128–29.

[13] Sandra Buckley, "Penguin in Bondage: A Graphic Tale of Japanese Comic Books," cited in Susan Napier, *Anime: From Akira to Princess Mononoke* (New York: Palgrave, 2000), 266, note 28.

and interchangeable than their *bishojo* (beautiful girl) counterparts. For years, the pattern was set by Keiko Takemiya's *Kaze to Ki no Uta (Song of Wind and Trees)*, in which the nineteenth-century French boarding-school boys were sometimes more effeminate-looking than the girls. Since then, however, the *bishonen* has taken on a more masculine look. The sleepy eyes, the tousled hair, the angular cut to the face: the image is as consistent and stylized as Kabuki makeup.[14] Though there is theatrical convention in *shonen ai* comics and animation, there's also history. Regardless of their personalities, nationalities, or the era in which their stories are set, these *bishonen* characters often embody some of the qualities of two historical figures. Understanding the place of these figures in Japanese history will take us a long way toward understanding why Japanese pop culture makes room for homoeroticism, especially as a diversion for teenaged girls.

Two Legendary Beautiful Boys

First is Yoshitsune, boy wonder of the twelfth-century Minamoto clan. He was younger brother to Yoritomo; they and a third brother (Yoritomo was the oldest, age twelve at the time, while Yoshitsune was a newborn) were almost executed in 1159 when their father Yoshitomo was involved in an abortive coup attempt against the retired emperor Go-Shirakawa (who was, despite his nominal retirement, de facto ruler of Japan). The three boys—Yoshitomo's sons by a concubine—were spared on the recommendation of a powerful courtier of the Taira clan named Kiyomori. There was a condition, of course; the boys' mother had to become Kiyomori's mistress. The boys were exiled rather than killed.

Time passed; Kiyomori's influence grew until he was the major power behind Go-Shirakawa. But he hadn't reckoned on the three exiled brothers. By 1180, Yoritomo had married Masako of the Hojo

[14] The look of *shonen ai* characters can also be based on celebrities, including Western pop singers Boy George and Terrence Trent D'Arby.

clan; this gave him access to the manpower he needed to rebel against Kiyomori. Some of the Minamoto's greatest successes in battle, however, were credited to Yoshitsune, who was already commanding an army at the age of twenty-four. Kiyomori died in 1181, but it took about five years for Yoritomo to seize and consolidate power. One way he consolidated that power was to have his brother Yoshitsune executed in 1189. Even though he was only thirty, and Yoritomo's own brother, his military genius was already legendary, and Yoritomo perceived that as a potential threat.[15]

So much for the historical Yoshitsune. Rather like Robin Hood, legend quickly grew around the facts, and the distinction between the two started to blur. In spite of being, according to one account, a "small, pale youth with crooked teeth and bulging eyes," the Yoshitsune of legend became a delicate youth whose effeminate exterior hid a prodigious swordfighter. Kabuki plays about Yoshitsune specified that he be played by an *onnagata*—a specialist in playing females in the all-male Kabuki world.[16] The result is a real-life inversion of the gender confusion of the movie *Victor Victoria*: a man playing a woman playing a man. It's also a complement to the girls-playing-boys of the Takarazuka operas.

Another *bishonen* warrior—this time a Christian—showed up in the early Tokugawa period. The Shimabara Rebellion of 1637–38 started as a tax revolt against Matsukura, the *daimyo* (feudal lord) of Shimabara, who was installed in 1633 and proceeded to levy extreme taxes—as high as eighty percent of the harvest—and torturing those who could not pay by wrapping them in straw and setting the straw on fire. Shimabara, on the western coast of Kyushu, was one of the few Japanese regions where Christianity gained a strong foothold in the sixteenth century, and even though by the time of the uprising Christianity was officially banned by the Tokugawa shogunate, some adher-

[15] Mikiso Hane, *Japan: A Historical Survey* (New York: Charles Scribner's Sons, 1972), 73–76.

[16] Buruma, *Behind the Mask*, 132–35.

Rose of Versailles

It is impossible to overestimate the impact of the manga *Rose of Versailles* by Ryoko Ikeda. Since its publication in 1972 as a serialized story in *Margaret* magazine it has enjoyed subsequent life as an animated series, in live film versions, and—of course—Takarazuka Opera productions. This descendant of Dr. Tezuka's *Princess Knight* has deeply influenced the current generation of anime and manga artists, most obviously in stories of female swashbucklers, including *The Sword of Paros* and *Utena* (both discussed in detail elsewhere in this book).

Unlike its successors, though, *Rose of Versailles* is based on (mostly) real people, although Ikeda does some creative things with them. The series is mostly about Marie Antoinette (1755–93), starting back in her girlhood days, when she was sister of Austrian Archduke Joseph. (If you've seen the movie *Amadeus*, you may recall Joseph—played by Jeffrey Jones as a savvy twit—saying that his sister was worried about her own people. With good reason.) She may end up married to France's Louis XVI, but in the manga she's also close to Swedish diplomat Axel von Fersen (1755–1810) and to the dashing swords(wo)man Oscar de Jarjayes. (There really was a General de Jarjayes, whose wife was a lady-in-waiting to Marie Antoinette, but he did not have a cross-dressing daughter.)

In any case, Oscar's swordsmanship places her in the category of beautiful-but-doomed warriors exemplified by Yoshitsune.

Beyond that, Oscar is another protagonist who constantly has to choose between duty and desire (*giri/ninjo*), in her case times two. Her mother was a courtier, her father an aristocrat, and thus her loyalties clearly lie with the monarchy. Yet, in the manga, Oscar cannot ignore the misery of the common people. Nor can she ignore her own gender. Like any proper *yasashii* heroine, she longs for the love that her masquerade prevents (mostly). This combination of exotic history, complex characters, and thwarted passions helped make the manga a major success.

Rose of Versailles keeps reappearing in some surprising disguises in contemporary anime. The cast of Rumiko Takahashi's *Ranma 1/2* includes Azusa, an obnoxious little rich girl who thinks that all she has to do is name something—anything—and it's hers. When she takes a liking to Ranma's father, Genma (in panda mode), she takes him home, calls him Oscar, and dresses him up as Oscar de Jarjayes. And there's a hilarious sequence in the first season of *Pokémon* in which Team Rocket transform into Oscar and Marie Antoinette. (Of course, since Oscar is a girl who is pretending to be a boy, Musashi/Jessie puts on Oscar's uniform, while her male companion has to wear the gown. . . .)

ents decided to keep the faith while also keeping a low profile.

The initial target of the revolt was the *daimyo* of Shimabara, but raiding parties soon started moving from village to village in western Kyushu, shouting the names of Jesus, Mary, and Santiago during their raids. When the movement spread to the nearby island of Amakusa, the Christian rebels chose as their leader a sixteen-year-old boy named Shiro Amakusa.[17] He could offer the rebels little practical military advice, but this was supplied by a number of *ronin* who joined the rebellion. His role was that of the charismatic leader. Eventually, the rebels were driven off the island of Amakusa by the Tokugawa forces and retreated to Shimabara. The rebel force, numbering about thirty-seven thousand, including women and children, were besieged in a castle for three months. Before the rebels surrendered and were massacred, thirteen thousand of the hundred thousand warriors of the shogunate had died.[18]

Here again we have a good-looking young boy as a military leader: if you believe the legends, a gender-bender Joan of Arc, recognized for his piety. Unlike Yoshitsune, Shiro Amakusa was purely a figurehead, relying on sympathetic *ronin* for the real brains and muscle. However, in the end he had as much chance resisting the Tokugawa as Yoshitsune had of resisting his brother. Just as Yoshitsune killed his wife and child before killing himself, Shiro Amakusa did not survive the siege.

I suggest that this history and its subsequent romanticization, rather than the historicity of medieval samurai having male lovers, underlies *shonen ai* stories in which the lovers are doomed. If gay love were plausible to its audience, it would lose much of its appeal. Remember that we're dealing with "imagined potentialities." The tendency of these loves to be doomed to failure, despite their potential for flowering beauty, is precisely what

[17] Note that this figure was evoked in the television series *Ruroni Kenshin* in the character of Shogo Amakusa, also from the island of Kyushu and also a Christian.

[18] Hane, *Japan,* 148–49.

takes them out of the realm of reality and into that of romance and aesthetics. As the kamikaze pilot was glorified for knowingly flying to his death, the doomed boys of *shonen ai* become beautiful because of their doom.

Unfortunately, most Japanese pop culture in this area is still commercially unavailable in the West. Whether it's because of moral objection to the contents or uncertainty as to how to go about marketing this stuff, true Japanese boy-love material—original stories told with original characters—is hard to come by.[19]

The Internet, however, is another story. Because websites are often produced by fans sharing a favorite work rather than commercial interests trying to sell a product, sites featuring true *shonen ai* can be found, although they're in the minority. What we tend to find instead is a subset of the genre: fan art and fan fiction putting anime and manga characters in gay relationships (some hardcore, some more romantic) whether the original work warranted it or not. The five pilots of the TV series called *Gundam Wing* (1995) have female counterparts, yet a lot of fan sites are produced as if these girls never existed. In the case of Shinji's encounter with Kaoru in *Evangelion,* there has been a lot of controversy as to whether homosexuality was involved or not, and the *yaoi* sites explore this one facet of the story in depth. (As will be seen in the chapter discussing that series, I believe that this was another pseudo-gay relationship.)

The student of such pop culture would have to search diligently to find genuine *shonen ai* manga such as *Ludwig II* by Yo Higuri, *Boys Next Door* by Yuki Kaori, and *Kori no Mamono no Monogatari (Legend of the Ice Demon)* by Shiho Sugiura, or anime such as *Zetsuai (Desperate Love)* or its sequel, *Bronze,* both by Minami Ozaki. If this genre has a magnum opus, in a story with homosexuality as a major force, the winner would be *Ai no Kusabi (Ties of Love),* which was turned into a two-part OAV.[20]

[19] For that matter, the romance expressed in *shonen ai* manga covers a wide range, from the platonic to the sexually explicit. This adds another layer of complexity to a genre that's already difficult enough to study.

[20] Here again we have a title that's a pun. The title is written with the *kanji* that could also be read *The Wedge in the Gap.* However, as both "gap" and "love" are pronounced *ai* the title could also mean "the Wedge of Love," the symbolic meaning of which I'll leave to the reader to imagine.

Ai no Kusabi

Ai no Kusabi (1992) based on a novel by Reiko Yoshi-hara serialized in the magazine *June*, is set in a dystopian future that resembles not only the strat-ified society of Fritz Lang's classic film *Metropolis* but also its many anime counterparts, including the feature films *Grey* and *Appleseed*. The future city of Tanagara, capital of the planet Amoi, is run by a giant computer named Jupiter. Jupiter con-trols all aspects of life, but one wonders about its blueprint for an orderly society. For one thing, fe-males make up only about fifteen percent of the population, mostly in the lower class. Sex has be-come procreation for the poor and recreation for the rich males, who don't do anything themselves but watch handsome young males have sex with other males. Since the elite are sterile, heterosexu-ality for them would be pointless.

One more interesting detail: one's social status is determined not by skin color, but by hair color. Black hair is at the bottom of the ladder, and at the top are (no surprise, really) the Blondies. *Ai no Ku-sabi* is the story of Jason Mink, a Blondie who goes slumming for a sexual "pet" and sets the wheels of tragedy in motion.

The anime version begins with Riki, whose black hair marks him as a member of the lowest class, looking to steal a car. He's set upon by vigi-lantes, but rescued by Jason, who tells him that he is to be Jason's "pet." The relationship is sealed when Jason puts a "collar" around the base of Riki's penis.

The scene jumps three years ahead. Riki is still with Jason, although pets are usually discarded af-ter one year. But Riki's old life intrudes when Riki meets with Guy, his former lover and the leader of the Bisons motorcycle gang. The Bisons sneak into a pet auction but Riki tells them to leave when Ja-son appears. Killie, a young member of the Bisons, approaches Jason with a business proposition. Kil-lie turns into a major drug runner, but sets up the

other Bisons to be arrested or shot. Riki is arrested as well, but is released because he's listed as a pet.

Jason has fallen in love with Riki. Guy, however, isn't about to leave things as they are. He kidnaps Riki and removes the pet collar the only possible way: by castrating Riki. He then summons Jason to a deserted building. They fight, but Guy had wired the building with explosives and sets them off. Riki tries to rescue Jason and Guy from the fire caused by the explosion, but Jason's legs get caught in an automatic door and are cut in half (a symbolic parallel to Riki's castration). Jason is now doomed to die in the fire, so Riki goes back to him. They light up two "black moons" (poisoned cigarettes) and wait for the end. At the moment of Jason's death, Jupiter the computer makes a sound: a moan that is almost human.

Shojo Ai

Anime and manga showing lesbian activity (referred to as *yuri*)[21] are much more common than those showing *shonen ai*, if only because they are often done to pander to male tastes.

One example is the 1990 historical anime released in English as *Sword for Truth*. In the middle of a story about a *ronin* rescuing a kidnapped princess, we see a totally unrelated lesbian sex scene. At least there's a hint of context: the seduction is an attempt to recruit an assassin for an attack that comes later in this installment (apparently the first in an unfinished series). The lesbian sex also takes place under the influence of opium, which adds another layer of meaning to the act in a culture where recreational drug use is much more harshly denounced and penalized than in the U.S.

Of course, nobody expects a context or a plot in H-anime, but sometimes one appears anyway. The *Angel of Darkness* series presents lesbians as both heroes and villains, and the larger story, and not just the fact of their sexuality, determines where the audience's sympathies lie. In the first install-

[21] As explained at the website www.yuricon.org/whatisyuri .htm, there's no clear single source for this name. The first theory is that characters in early girl/girl romances were often named Yuri or Yuriko; the name became a cliché and then a label. Others say that Japanese lesbians were known in the '70s as "the lily tribe" (the Japanese word for the lily is *yuri*). One theory even suggests that the name comes from one of the Dirty Pair, two comically destructive intergalactic policewomen. However, both Dirty Pair members Kei and Yuri are straight, and show an interest in each other only in H-manga.

ment, the dark secret under the chapel is discovered by a pair of lesbian students, one of whom is possessed by the spirits of the forest to combat what they find. The third installment is a cautionary tale against violating traditional gender roles than a *Frankenstein*-style warning "not to tamper in God's domain" (a message that to an extent underlies the entire series). A coed at another academy, scorned and slighted by her classmates, abandons any attempts to befriend them and joins forces with the underground evil to torture and torment them; because this is an H-movie, the torture is usually sexual in nature. She even tries to control the evil herself, treating the monster as a servant carrying out her personal vendetta, but ultimately she runs up against the limit of her power and suffers the consequences. She isn't punished for being a lesbian, but for being brutal.

A true lesbian romance—with love underlying the activity—is much harder to come by, because it threatens both female and male traditional gender roles. The threat to the female role is in the socially transgressive nature of the relationship; the threat to the male is that the male gets marginalized for a change. No matter how many dragons he slays, he cannot claim the princess.

The Sword of Paros

One interesting *yuri* treatment is the 1986 manga *Paros no Ken (The Sword of Paros)*. This manga, with artwork by Yumiko Igarashi and a story by Kaoru Kurimoto, is one of the few to take the precedent of Dr. Tezuka's *Princess Knight* to its logical conclusion, and yet is structured so as to preserve the status quo while still presenting a "happily ever after" ending.

Paros, a vaguely European principality much like Silverland, is ruled by the blond and beautiful princess Erminia, who dresses in male attire and can handle a sword as well, if not better than, any knight in the kingdom.

One day while riding, accompanied by Yurius, a skilled swordsman and Erminia's faithful friend and bodyguard, Erminia saves a peasant girl named Fiona from a wild horse. It is love at first sight for Erminia.

It could be the beginning of a romance for the two girls, yet Erminia is the king's only child and thus heir to the throne of Paros, and as such her duty is to provide the kingdom with an heir to follow her. Her father has arranged a marriage but Erminia refuses to bow to his demands. As an alternative, Erminia is allowed to participate in a tournament; she will marry any swordsman who defeats her. Her heart, however, belongs to the peasant girl Fiona. In the tournament that is to decide her future, Erminia has to face a mysterious masked knight. The duel is fierce and at one point the masked knight manages to disarm the princess. A minister named Alfonso throws another sword to Erminia. It happens to be the mythical Sword of Paros. Just as Erminia is about to rally against her opponent, the King clutches his chest and dies. Alfonso stops the duel and announces that this is an omen that Erminia isn't fit to inherit the throne since her father died the very moment she raised the Sword of Paros. However, the truth is that Alfonso poisoned the king's wine. Alfonso announces that the duel is over and the mysterious knight has won by default: Erminia is to marry him. At that moment soldiers from the neighboring kingdom of Kauros invade the castle and take over control under orders of the mysterious knight (who is actually the prince of Kauros).

Erminia, meanwhile, is a prisoner in her own castle. One night the prince of Kauros attempts to rape her but she manages to hold him at bay. The prince reminds her that soon they will be married and she will have no choice.

Fiona cuts her hair and gets work as the princess's personal page. The two are happy to see each other once more but time is running out.

Fiona explains that the people are planning an uprising against the invaders, and in order to give Erminia the chance to lead it she trades place with her (using a blond wig). Erminia leaves, promising to come back for her the day of the scheduled wedding.

On the day of the wedding, Erminia, Yurius, and their followers ambush the carriage carrying Fiona (disguised as Erminia) on her way to the chapel. Yurius bids Erminia goodbye and Erminia heads off with Fiona on horseback. The last scene shows the two riding off into the sunset. . . .

I sometimes wonder if, after traveling the world, Erminia and Fiona settled down in a chateau in the south of France next to the Duke and Duchess of Windsor. This is not to say that this manga set out to be a gender-bender allegory on the star-crossed romance of England's Edward VIII, but the results were the same. Under the circumstances, Erminia could never have continued to hold power in Paros. Even if the people were open-minded enough to overlook the class difference in their queen having a commoner consort (of whatever gender), there remained one minor problem: neither Erminia nor her consort could ever produce a legal successor to the throne.

Shojo Love: Doomed to Conformity

This message that *Sword of Paros* communicates to an audience of Japanese adolescent girls is far from revolutionary. It is a traditional reminder that their destiny is tied to their biology. Romance may be all well and good, but you have to pay the price. That price is usually power, and for centuries the power of Japanese women resided in their wombs.

Director Mamoru Oshii has stated what he considers to be this crucial gender difference this way:

> [W]omen aren't indecisive about themselves. Becoming a different type of person, or diving off a cliff. Not knowing what's on the other side, but just doing it. I

think men wouldn't be able to do it. And I think that a woman would. Women would take such actions first. I think men would follow after. That's because women give birth. A complete person comes out of their own bodies. That's something that men cannot even imagine."[22]

It isn't just a matter of the individual. In Japanese culture, the self has been less important than the *ie*, or clan, and as sociologist Joy Hendry reminds us, ". . . continuity is an essential feature of the *ie*. The individual members of a particular house, who need not necessarily always be resident, occupy the roles of the living members of that particular *ie*. The total membership includes all those who went before: the ancestors, now forgotten as individuals, the recently dead who are remembered; *and the descendants as yet unborn*."[23]

This is exactly the pattern that appears, explicitly or implicitly, in the *shonen ai* ("boy love") and *shojo ai* ("girl love") genres, and romances of any kind: romance for its own sake is self-indulgent and necessarily doomed. It's a theme that is sounded in soap operas and Kabuki as well as age-old folktales: satisfaction of personal desire without considering the consequences leads to trouble. There may be happiness in the short term, but at the very least one will come to the end of life without descendants. With no one to perform memorial rites, no one to inherit the *ie*, one risks not becoming an ancestor. Which also means that one's own ancestors will have lived in vain. The message is clear: rather than upset a process that has lasted for dozens of generations over hundreds of years, personal gratification is best delayed, if not abandoned altogether, and replaced by a relationship consistent with one's duties to the *ie* and to society.

So Japan, in pop culture as in real life, is hardly a kingdom of cross-dressers or a haven for homosexuals. Far from it; many Japanese gays still stay very deep in the closet. The appeal of homosexual

[22] "*Animerica* Interview: Mamoru Oshii," trans. Andy Nakatani, *Animerica* 9 (5): 13.

[23] Joy Hendry, *Understanding Japanese Society* (London: Routledge, 1989), 23; emphasis added.

relationships in pop culture, especially as heavily romanticized in girls' comics, is precisely because it is so exotic to its readers. But there's also another reason.

This chapter's title speaks of pseudo-gay themes, and that's exactly what appeals to so many female fans of these genres. There is a tolerance in the Japanese culture for intense same-sex attachments that do not threaten social roles, as long as *they stop short of the romantic*. Popular culture, which serves in part as a corrective measure, a guide to steer social conduct and attitude, takes depiction of same-sex romances in Japanese media (a) in the context of the overall story, which sometimes provides a rationale, and (b) with a grain of salt, knowing that a comic book or an animated film is artistic, idealized, and not reflective for the most part of reality. These portrayals are also permitted (c) because the truly gay couple in question usually does not live happily ever after, while the pseudo-gay couple does. Pop culture, you'll recall, doesn't get out ahead of the audience at large.

This last point hardly needs to be stressed. Of course there is no accursed Chinese spring that will bring about gender (or species) changes. One junior high school student will never have to be responsible for saving the planet from invaders from another galaxy. The fantasy nature of the media themselves allows a certain distance to be kept. The Japanese would be the first to say that they can tell the difference between fantasy and reality. But this raises the question: why don't we see more same-sex friendships in American pop culture? If we, like the Japanese, approach comic books and cartoons assuming the fantasy component, why don't we see Betty and Veronica holding hands over a malted in the *Archie* comics?

Because our culture feels more threatened by depiction of intense same-sex friendships than does Japanese culture. We seem too easily to jump

to the conclusion that there can be no such thing as "just friends." In art or in life, we expect—and sometimes seem to demand—that the involved parties "go all the way." Ironically, given our Puritan ancestry, we seem to be more obsessed with sex than the Japanese; at least, if one were to go by the popular culture. The reason is that American pop culture often limits its options to "sex" and "not-sex."[24]

Japanese culture makes room for a much wider range of relationships, recognizing that one can incur duty (*on*) under a variety of circumstances, and the responsibility for honoring that obligation depends on one's social standing relative to the other party. Even in this very personal realm—perhaps especially in this realm—one's personal desires (*ninjo*) count for less in the long run than does group consensus. In spite of its higher visibility (if one counts phenomena such as nudity on late-night television and pornography sold in vending machines) in Japan, "sex is granted a much lower priority in the order of social activity than in the West. . . . Sex, belonging to the soft world of *ninjo* and part of the sphere of mere human feelings as it is, is not very important."[25]

In short, dividing up the world into "sex partners" and "not-sex partners" may work for some Americans, but most Japanese (and I daresay most Americans) would find it to be extremely unrealistic. In any event, one can never act solely on the basis of one's feelings in Japan; the tightly woven social web traps one in a host of expectations and obligations. Japan may have entered the twenty-first century with America, but Japan still has the custom of *omiai*—engagement meetings in which marital prospects are interviewed and surveyed as if they were being recruited for a corporation—and for some Japanese, Western-style romance is still a luxury.

[24] One example among many is the NBC television series *Friends*. As the series has progressed, it has belied its name, being less about the friendship of the six protagonists and more about their sexual or marital lives.

[25] Nicholas Bornoff, *Pink Samurai: Love, Marriage, and Sex in Contemporary Japan* (New York: Pocket Books, 1991), 299.

8

Bushido: The Way of the Warrior

Samurai stories are about medieval swordsmen—but they're also about the ethical code the audience should live by. That's why some modern samurai swing a baseball bat or line up a perfect putt.

America has Wyatt Earp, Britain has Robin Hood, and Japan has Yagyu Jubei.[1] Okay, maybe it's not that simple, but it's a place to start. When dealing with an icon as vital to Japanese culture and masculinity as the historic samurai, you should start by looking for whatever parallels your own culture has to offer.

Jubei the Prototype

The specific details of the life and times of Yagyu Jubei Mitsuyoshi (or, in some sources, Mitsutoshi) are a bit hazy, given that he lived in the early 1600s.[2] His father, Yagyu Tajima no Kami Munenori, was no less than sword instructor to shogun Tokugawa Ieyasu, and he landed that position the old-fashioned way: he earned it, at the battle of Sekigahara (September 15, 1600) that established the control of the Tokugawa shogunate over the entire country. Along the way, he was elevated to the rank of *daimyo* (a provincial feudal lord recognized by the shogun) with a fief centered on what is now called Yagyu no Sato, near the ancient capital of Nara. The

[1] I know I said back at the beginning of the book that Japanese names would be given Western-style, with the family name last. However, when dealing with historical figures, long-standing tradition puts the family name first.

[2] For the biographical information here, I thank the online martial arts magazine *Furyu* at http://www.furyu.com/archives/issue9/jubei.html.

elder Yagyu also developed his own school of swordfighting, although the main move in this school is more strategy than skill: find the enemy's weak point and go for it as soon as possible.

Jubei is heard from at court in 1616 as an attendant to Hidetada, the second Tokugawa shogun, but then vanishes from the record for a decade. He returns to history at age thirty-six, and dies at forty-four on a hunting expedition. In between, he loses an eye, gains two daughters, and writes an oblique book about his swordmanship called *Tsukimi no Sho (The Book of Gazing at the Moon)*, giving future storytellers all the ammunition they needed for their imaginations to fill in the gaps.

Just as the real Robin of Locksley soon vanished under the weighty legends of Robin Hood, stories of Jubei began adding to the original reality. His appearance in legend now pretty much determines the "look" of the samurai in Japanese pop culture. With a hat pulled down over his face to cover his features, including the simple leather strap he wrapped around his head as an eyepatch, the legendary Jubei roamed the country incognito, revealing his identity only when he drew his sword to punish evil.

According to some, he roamed the land to sharpen his skills; other say he was actually spying for the Tokugawa shogun. Some say that he loitered about the Yoshiwara, the prostitution district of Edo, reasoning that he could get in some practice by slashing the throats of lower-level samurai who wasted their time with whores and would never be missed. Other stories relate that Jubei did not adopt the diplomatic speech of the shogunal court, which might explain why he wasn't heard from for a decade.

He was, in legend, a blunt, no-nonsense type who let his sword do the talking, and it spoke volumes. In one story, Jubei reportedly fought seven men at once, slicing the limbs off of three of them and scaring off the others. In another tale, a gang

of bandits tried to rob him in Kyoto; he killed twelve of them, frightening away the rest.

Probably Jubei's best-known legend is alluded to in Akira Kurosawa's classic film *Seven Samurai*. In this case, a *ronin* challenges Jubei to a practice duel with wooden swords. The *daimyo* who referees the match calls it a draw, but Jubei declares himself the winner. The *ronin* demands a rematch to settle the point, this time with real swords. Jubei dispatches his opponent with a single blow.

Jubei lives on in pop culture in a variety of forms. A lurid novel, Futaro Yamada's *Yagyu Ichizoku no Inbo (The Intrigues of the Yagyu Family)*, became the basis of first a film and then a television series starring Japanese action hero Shinichi "Sonny" Chiba. The name Jubei is invoked in anime as well, usually in stories unrelated to the real figure. The 1993 film known as *Ninja Scroll* in the West is actually titled *Jubei the Wind Ninja*, although there's no historical evidence that Yagyu Jubei ever studied the combined magical/martial/assassin art called *ninjutsu*. A 1997 OAV series called *Ninja Resurrection* sets a samurai named Jubei down in the middle of the Shimabara Rebellion of 1637. Even if the timeline was historically possible, it's highly unlikely that Jubei, whose family owed a great deal to the Tokugawa shogunate, would ever turn against the shogunal government, the Bakufu, and side with the Christian rebels. At the far edge of fantasy, there's *Jubei-chan the Ninja Girl* (1999), a twenty-six-week anime series by Akitaro Daichi. This comedy gives us Jiyu Nanohana, a contemporary adolescent schoolgirl who "becomes" Jubei by putting on his eyepatch—improbably shaped in this series like a big red heart. We'll consider how girls can become samurai in the next chapter.

How to Be a Samurai

The basic function of a samurai—a warrior retained in the service of a feudal lord—didn't change much over the years, but attitudes toward

Jubei-Chan The Ninja Girl
Yagyu Jubei may be Japan's greatest samurai, but even he comes in for humorous treatment. Most recently, his fighting spirit becomes vested in his eyepatch; when the eyepatch is worn by a schoolgirl, she becomes Jubei-chan the Ninja Girl, central figure of a recent TV series. Just the name Jubei-chan (Little Miss Jubei) is bad enough. . . .

samurai did. By the mid-seventeenth century, the Tokugawa shogunate had a firm hold on both the imperial court and the *daimyo* who held the key to local power in Japan. Consequently, there was less and less for samurai to do. Samurai was a social status, not just a job description, yet some samurai, with families to provide for but no battles to fight, had to abandon the warrior's life and take up a trade. Others arranged for their daughters to marry into merchant families, while still others became bandits.[3] And in the seventeenth-century equivalent of corporate downsizing, many were dismissed from service to become *ronin*, or masterless samurai.

One such *ronin*, Yamamoto Tsunetomo (1659–1719), lived in the Saga domain on the southern island of Kyushu and served Saga's lord, Nabeshima Mitsushige. When Mitsushige died in 1700, Tsunetomo tried to commit *tsuifuku* (suicide of a retainer after his master's death), but by then this form of extreme loyalty had been outlawed. So Tsunetomo retired to a monastery where he held forth on what he thought was the ideal samurai philosophy. A young samurai took down many of his statements and reprinted them verbatim in *Hagakure* (*In the Shadow of Leaves*), the bible of *bushido*—the "martial way" or the "way of the warrior"—first published in 1716 and never out of print.

[3] Mikiso Hane, *Japan: A Historical Survey* (New York: Charles Scribner's Sons, 1972), 226–27.

Even a casual glance at *Hagakure*, though, reveals that the words of Tsunetomo could have benefited from an editor. His advice runs literally from the sublime ("The end is important in all things; if things end badly, all good that may have come before it will be erased") to the ridiculous ("Walk with a real man one hundred yards and he'll tell you at least seven lies"), but he does lay out the five core values a samurai is supposed to live by: loyalty, bravery, politeness, simplicity, and truthfulness.

The main thing to note about *Hagakure*, though, is that it is all theory and no practice: Tsunetomo—like Jubei before him—never fought in a single recorded battle. His musings were motivated by nostalgia, for an ethos and a way of life he considered dead if not dying. His book is thus an idealization of the reality of the sword that was surely much grittier a century earlier. And this also means that any modern pop culture portrayal of the samurai, whether true to *Hagakure* or wildly deviating from it, is in a sense an ideal of an ideal. Modern samurai sagas tell us more about the time of their creator than the time their adventures supposedly took place.

Postwar Swordsmen

The manga revolution of Dr. Tezuka began during the Occupation of Japan, at a time when all facets of Japanese life were under the eye of America. Samurai stories were a staple of prewar Japan, when Japan's military government approved of *bushido*'s emphasis on stoic self-sacrifice and obedience to one's lord. When the militarists were discredited by defeat, their favored literature also declined for a few years.[4]

It wasn't until 1954—with the Occupation over, the Korean War over, Astroboy dominating the comics, and Godzilla the latest movie star—that a samurai story became a popular hit: *Akado Suzunosuke (Suzunosuke with the Red Breastplate)* by

[4] Frederik L. Schodt, *Manga! Manga!: The World of Japanese Comics* (Tokyo: Kodansha International, 1983), 68–69.

Tsunayoshi Takeuchi. Apart from the vibrant art-work, Takeuchi's stories may have found popularity because the militarism of prewar manga was gone. After a decade spent rebuilding postwar destruction, the old attitudes would not have been welcomed, either by official monitors of pop culture or the mass audience, who simply wouldn't have stood still for the same old propaganda. Instead, the emphasis is on skillful swordsmanship.

This continued the pattern of reshaping samurai to conform, not to history, but to the needs of the moment. The militarists, after all, had encouraged pop culture that praised the military—now it was the opposition's turn. And one thing defeated Japan needed to prove to itself and to the rest of the world was that it had not lost its talents and abilities. As the years went on, each generation recast the samurai according to its own attitudes and agenda.

The '60s, for example, a time of social experimentation and political ferment, gave rise to Sanpei Shirato's *Ninja Bugeicho (Chronicle of a Ninja's Military Accomplishments)*. This samurai series could never have been done in another decade, since it examined the battles of Oda Nobunaga and the other sixteenth-century warlords from a leftist perspective, clearly siding with the oppressed masses and reform-minded ninja—whether they were historical or not.[5]

The year 1974 saw publication of a lengthy samurai manga of a different kind: Joji Akiyama's *Haguregumo*. The word means "wandering cloud" and is the name of the *ronin* who is the leading figure in the story. No longer in service to a noble, he's a husband, a father, and leader of a group of palanquin-bearers. The time is late in the Tokugawa period; European education, known as "Dutch studies" at the time, has been making a comeback, and Haguregumo's son Shinnosuke has been picking up the new knowledge in school (including one phrase in English: My father very nice").

[5] Schodt, *Manga! Manga!*, 70–71.

All in all, *Haguregumo* breaks the mold of the classic samurai tale by showing a samurai who's changing to accommodate the changing times. He's more interested in chasing girls, drinking saké, and raising his son than in swinging a sword. It's a lifestyle that would have found sympathy in 1970s Japan, which like the United States had just gone through a period of social unrest on college campuses and saw the questioning of many traditions and values. Still, this domesticated samurai finds a number of opportunities to draw blood in the name of justice. Akiyama's idea of a swordsman was thus less consistent with the classical ideal, but well-suited to his audience at the time.

A no less interesting *ronin* is the title character of Nobuhiro Watsuki's *Ruroni Kenshin* (1996). The time of the story is the 1880s, during the Meiji Restoration. The emperor is back in power, westernization is taking hold in Japan, and the authorities have traded in their kimono for European uniforms. They've also waged a ruthless campaign against a group of renegade samurai who want to resist westernization and return to the old ways.

Into the middle of this society in upheaval wanders a swordsman who looks all of fourteen years old (his good looks and cute behavior when not battling evil have made this manga and its anime a crossover success with both boys and girls). A cross-shaped scar on his cheek is the only sign that he has had a rough life, but he has left a long and bloody trail of victims. Now, however, he has abandoned the road of blood. He has even reversed his sword (which is sharp only on one edge) and uses the blunt edge to fight people, if he has to fight them at all. The anime and manga both create situations in which bloodshed would seem to be unavoidable for Kenshin, and then watch as he manages to avoid it after all. Add to this a succession of enemies of an almost science-fiction level of unreality, and the result is a samurai story that bears little resemblance to *Hagakure*. This is clearly

samurai life as it was never lived, but as pacifists at the end of the twentieth century would have liked it to be lived.

The Sandlot Samurai

Ruroni Kenshin points to an interesting paradox in Japanese pop culture, one that leads directly to the modern male role models of anime and manga. On the one hand, heroic deeds are supposed to be commonplace to special people like Kenshin. On the other hand, ordinary people like those who read about Kenshin are supposed to be able to perform ordinary deeds heroically. The ordinary deeds are as diverse as life itself, and as plentiful as the fans of anime and manga. Pop culture heroes range from chefs to surgeons, from investment bankers to hotel managers, from policemen to bicycle messengers. The common thread in all these roles is to strive for perfection, to do one's

Ruroni Kenshin The once-bloodthirsty samurai Kenshin also has his sweet and silly side, which is on display in virtually every episode of the series based on the manga by Nobuhiro Watsuki. After all, audiences no longer want a stoic, honor-driven, killing machine for a samurai hero; he has to be able to function in these times, as well.

best, to—as the Japanese say—*ganbaru*. And the present-day arena most like medieval Japan is the world of sports.

Science fiction anime and its manga source material are well represented in the West, but sports anime are hardly ever seen here. However, sports is one of the biggest genres, encompassing both traditional Japanese activities such as archery, kendo, karate, and other martial arts, and Western imports, including golf, soccer, tennis, and the ever-present baseball. Sports even crosses gender lines, in a segregated way, with boxing and basketball for the boys and volleyball and tennis for the girls.[6] The genre even goes over the top into the flaky fantasy realm of pro wrestling.

Western sports entered Japan during the Meiji period, and later governments encouraged sports for developing patriotic spirit. During the Occupation, all sports were suspended for a time, for fear they were echoing the *bushido* spirit that led to World War II. The suspension was lifted in 1950, and Japan eagerly got back on the sports track, the high point being the 1964 Tokyo Olympics. Japanese schools started having Sports Day (Taiiku no Hi) in October 1966, consciously evoking the Olympic Games of 1964.[7]

One thing about manga sports: they—seem—to—take—a—*very*—*long*—*time*. Every pitch, every lob, every golf stroke is played for the maximum dramatic value. Consequently, a boxing match in a weekly magazine like *Shonen Jump* can take weeks, and a round of golf can be drawn out for months. In anime, on the other hand, time and not space is the medium, and the story may only feature the highlights of a match.

Often, however, the story will feature a bit of business that is virtually a ritual: the training regimen. It usually starts when the athlete in question is just a child. At some point he (and sometimes she) becomes consumed with a desire to become the best (fill in the blank) in the world. Often, he

[6] Examples of clubs and sports for girls will come up in this chapter ostensibly about male role models simply because Japanese society is still reinventing itself regarding the role of women, especially in coeducational schools. In any event, girls copy the lead determined by boys, rather than vice versa.

[7] http://ourworld.compuserve. com/homepages/HFeid/home_2e .htm

Princess Nine *Discipline and the will to win are still prized virtues and are attributes that can carry over from swordplay to sports. Here, a member of the* Princess Nine *baseball team develops her hitting power by swinging at waves with a fishing rod. Unorthodox, to be sure, but if it works. . . .*

does this to emulate his father, or to fulfill a dream his father was unable to accomplish. Next, he develops his own homemade, crude, but effective training schedule, and pushes himself into it with single-minded determination. Stories as different as the boxing title *God Is a Southpaw* and the girls' wrestling manga *Super Angels* use this device. The girls-competing-against-boys baseball story *Princess Nine* has one of its players develop a powerful batting style in a very singular manner: the batter, a fisherman's daughter on the island of Shikoku, hits incoming waves with a fishing rod.

Even the supernatural take part in training regimens, as shown in an episode of the "after-hours" anime *Haunted Junction* (1997). Red Mantle, a drop-dead gorgeous masked ghost who haunts toilets and hands out tissue to those who are caught short, is approached by his sister (also a ghost), who wants to take up toilet-haunting. They prepare her by having her stand under waterfalls (a traditional Japanese spiritual purification technique), hike through mountain blizzards (since public toilets are never heated in the winter) and spend time in garbage dumps (to get used to bad smells). But the girl has a problem: she's too shy to speak to strangers. So the training regimen is expanded to include handing out samples on street corners, dancing in discos, and wearing funny cos-

Baseball in Japan

At the turn of the millennium, one of the biggest names in American baseball is Ichiro Suzuki. This heavy hitter may not have all of the baggage Jackie Robinson brought in desegregating the game, but he certainly opened a few eyes and raised a few questions.

Baseball has long been known as America's "national pastime," which had a lot to do with why Horace Wilson brought the game to Japan in 1873. He had come to teach English and American history, but the pastime caught on in a big way. In 1891, a Japanese team challenged the Americans in Yokohama to a game. The American Athletic Club initially did not take the challenge seriously. Convinced of their own superiority as the masters of an American game and sure of a win over the smaller Japanese, it took five years before they finally agreed to a game. The game took place at the AAC, where Japanese had previously not been allowed to enter, and the Japanese team showed no reaction to the boos and catcalls of the *gaijin* (foreigner) crowd. What happened next shocked the complacent Americans. The Japanese won 29–4.

The game went professional in 1935. World War II interrupted things, but the game came back after the Occupation. Now there are two pro leagues in Japan, with a total of twelve teams. The teams have rather unusual names, though; sometimes the name will be American style, with the city and the team (Hiroshima Carp, for example), and sometimes the name will include the team's corporate sponsor (the Nippon Ham Fighters).

Another unusual aspect: sometimes a Japanese game, which is even slower and more deliberate than the American variety, will end play abruptly—because the commuter trains are about to stop running. It's not often that baseball is played for the convenience of the fan. Then again, we don't see baseball as developing "loyalty, self-control, moral discipline, and selflessness."[1] At least, not in America, and not these days.

[1] Quote from "Take Me Out to the Beseboru Game" by David Parker, reprinted at http://isaac.exploratorium.edu/dbarker/beseboru.html

Princess Nine Ryo Hayakawa is the exuberant heroine of this 1999 baseball anime from Tomomi Mochizuki.

tumes in public. None of this is meant to mock the idea of a training regimen—it just extends the training into humorous territory.

The regimen is rough, but exhaustion, bruises, and bloody knuckles are just minor annoyances. After all, the point of the training regimen is not merely training, but about the will to win and the commitment to do whatever it takes to be the best. Almost every sports story in the Japanese pop culture has this underlying idea as the lesson to be learned. Victories are not accepted if they come too easily.

This also reflects Japan's self-image in the world as a cluster of islands with neither the size nor the mineral riches to compete with the superpowers. Victory comes from perseverance—or, as in jujitsu, by strategically exploiting the opponent's strengths and weaknesses.

Perseverance is an important lesson for other facets of life as well as sports. Schoolwork requires it, certainly, but so does the job or a hobby. This makes "Ganbatte!" one of the most common exhortations in Japanese pop culture. As a command carrying the meanings "Go for it!," "Do your best!," and "Hang in there!" it's a word Japanese boys and girls start hearing at an early age.

This is due in part to the influence of Confucius. The teachings of the ancient Chinese educator have had a deep influence on Japanese life in general and the educational system in particular. One teaching is that (all other things being equal) just about anyone can learn to do just about anything, to some degree, if they persevere. Accordingly, the Japanese school system is designed to offer a wide range of choices and opportunities for its students.

This is reflected in anime in the penchant for school clubs. Virtually every school story shows some of these activities. *Maho Tsukai Tai* is named after one such group, the five-member "Magic Users Club," which has to compete for meeting

space with the much larger Manga Club. One episode of *Here Is Greenwood* has the entire dormitory out trying to make its own sword-and-sorcery movie for a school festival, complete with animated clay demons. The 1995 series *El Hazard: The Wanderers* opens during another such school festival, and hints at the wide variety of available clubs, from cooking to broadcasting; a similar fair takes place during episodes of *Sailor Moon* and in the 1993 made-for-TV Studio Ghibli film *Umi ga Kikoeru (I Can Hear the Ocean)*. The trend even continues into college: in *Maison Ikkoku*, Godai joins a university puppetry club, which serves him later in the series, as he finds a career in child care.

If this concern with striving for superiority makes Japanese men and boys seem like joyless workaholics, that's because they are—part of the time. Whether in its agrarian past or its industrialized present, the need to succeed and the recognition that success won't come easily have long been a part of life in Japan. Hence the cram schools and the late nights at the office. Among the compensations is the belief that in their own way they are carrying on the heroic tradition of the past. Bravery on an exam and loyalty to the company aren't exactly the life of a samurai, but they are as close as this century will get to the glorious past. Meanwhile, on the schoolbus or commuter train, men and boys can open up a manga magazine and sense the connection between their seemingly unheroic lives and the lives of the heroes of old.

As for being a girl in Japan; that's a different story. . . .

9

Shojodo: The Way of the Teenage Girl

If "it's a man's world," then why do so many teenage girls in Japanese pop culture acquire magical powers? Because they're nice. With a kind spirit, sometimes it's even okay to slay a dragon.

A sword is meant to kill. Fighting techniques are ultimately used to kill. This will never change.

But dreamers like Kaoru-dono use fighting techniques for something besides killing. And I prefer what Kaoru-dono believes to the way things are. Maybe someday everyone will see why her way is better.

—From the first episode of the anime version
of Nobuhiro Watsuki's *Ruroni Kenshin*

In Douglas Adams's science-fiction spoof *The Hitchhiker's Guide to the Galaxy*, the problems of the world are solved by a teenage girl, sitting alone in a coffeeshop. At least, the problems of the world would have been solved: just as she realized how workable her solution was, but before she could tell anyone, the Earth was bulldozed by extraterrestrials building an expressway.

In Japanese pop culture, solutions to incredibly complex plots are usually pretty simple, and often come down to a single word. Ian Buruma writes that "(t)he key word here is *yasashii* (gentle, meek,

kindly), that term so often used by Japanese to describe their mothers, as well as themselves as a nation." *Yasashii* people are "warm, without a hint of evil and malice, pure in their hearts, and blessed with those unique Japanese antennae, always sensitive to each other's feelings which never need to be spoken."[1] This character trait is supposed to apply to both men and women in Japan up to a point, but—let's face it—there are other qualities a hero needs to be heroic. Traditionally, if a heroine is *yasashii*, then that's enough.

Can it really be that simple, even in anime? Is the answer to the world's problems simply a matter of living as if love was better than hate, life was better than death? Of being kind and having faith? The final episode of *Evangelion* has a line from Misato's lover Kaji that puts the whole paradox of human expectation into perspective: "The truth within oneself is such a simple thing that people are always seeking after Profound Truths." There *has* to be a Big Cosmic Mystery somewhere out there, since nothing less, and certainly nothing as simple or as compassionate or as naïve as the mind of a teenage girl, can account for the answer. It can't be that easy, can it?

The Japanese seem to think so, if their pop culture is any indication. Whether the young girl in question is a princess or a witch, a student or an idol singer, she's rarely along just for the ride. She's usually the spokesperson for the *yasashii* point of view, which means she has at least some of the answers.

Lovely Warriors

As it turns out, the way of the sword and the way of the high school girl are not mutually exclusive. They meet in the *bishojo senshi*, the pretty young girl warriors who star in anime's most popular export, *Sailor Moon*.[2] They meet in other magical girls, most recently in *Magical Girl Pretty Sammy*, a spin-off of the *Tenchi Muyo* series. They meet in *yasashii*

[1] Ian Buruma, *Behind the Mask: On Sexual Demons, Sacred Mothers, Transvestites, Gangsters, and Other Japanese Cultural Heroes* (New York: Meridian, 1984), 211.

[2] In fact, *seiyu* (anime voice actress) Megumi Ogata, who played Sailor Uranus, has begun to advocate what she calls Female Chivalry, urging girls to model themselves on proper male behavior. See the website http://www.geocities.com/Tokyo/4081/file416.html#20.

girls, from Hitomi Kanzaki of *Escaflowne* to Kiki in
Kiki's Delivery Service to Kaoru the martial arts in-
structor in *Ruroni Kenshin*. As long as they honor (in
their own way) the five precepts of a samurai (loy-
alty, bravery, politeness, simplicity, and truthful-
ness) and keep their *yasashii* credentials, these
schoolgirls can be just as heroic as their sword-
wielding male ancestors.

We've already seen one of the first anime hero-
ines to live by *bushido* ("the way of the warrior")
and be *yasashii* at the same time: Princess Sap-
phire of *Princess Knight*. Her descendants include
the swashbuckling *shojo* Utena Tenju in *Utena*. Get-
ting away from European swordplay and cross-
dressers, traditional Japanese martial arts have
produced the same combination, including Akane
Tendo of *Ranma 1/2* (even if Ranma doesn't consid-
er her *yasashii*, there's ample evidence to the con-
trary) and Kaoru, who inherited her father's *dojo* in
Ruroni Kenshin.

San, the title character of Hayao Miyazaki's
masterpiece *Princess Mononoke*, is about as un-
yasashii as it's possible to be. Our first sight of her
face is gruesome: her mouth is smeared with
blood, which she was sucking from a wound in a
gigantic wolf. She lives only to harass and kill hu-
mans, who pollute the forest and threaten the very
gods of nature. Yet even this feral child is capable
of "redemption," once she gets to know a boy her
own age. In the final scene of the movie, she
proves her conversion to the ranks of the *yasashii*
by saying the magic words to Prince Ashitaka: *suki
desu*—I love you. But then, she wasn't far from the
ranks of the *yasashii* to begin with; for all the may-
hem she causes, the movie never shows her actu-
ally kill anyone—though it's not for lack of trying.

Some teenage girls either are warriors or are
connected to boys who are warriors. The five pilots
in the *Gundam Wing* series each seem to have a
shojo counterpart. The principal among these girls,
Relena Peacecraft, has to confront a variety of vil-

Bubblegum Crisis: Tokyo 2040
*It's not easy for a girl to main-
tain the gentle yasashii nature
expected of her when she also
has to kick robot or alien butt.
The "hardsuits" neatly solve
the problem. The suit design
plays up both the need for
strength and protection (the
helmet, shoulderpads, and
limbs that resemble medieval
armor) and the femininity of
the user (the navel-revealing
cutout and the high heels).*

Gundam Wing Sometimes it isn't enough to have a yasashii spirit—a heart full of compassion and caring. Sometimes you have to fight to be gentle. Relena Peacecraft finds herself in this paradoxical position in the TV series Gundam Wing. *Against all odds and in the face of various conspiracies, she works to bring her vision of pacifism to the cosmos.*

lains who want her to abandon her dream of total pacifism. Among these is another teenage girl, Dorothy Catalonia, who is very much Relena's opposite number. She relishes war as a glorious spectacle, with no regard for the loss of life and disruption of cultures caused by war. She's virtually Lady Macbeth, and an example of what an un-*yasashii* girl can be like.

Then there are those who are themselves in the military, or at least the para-military. This is where the juggling act gets especially tricky. How can a character be *yasashii* and be in the business of shooting at people? The problem is partly mitigated because these servicewomen are usually in some hi-tech far future where the actual damage is either minimal or impersonal. *Mobile Suit Gundam 0080* (1989), for example, presents Christina Mackenzie, a Gundam test pilot and systems programmer. However, the audience also knows her to be the former babysitter of fifth-grader Alfred Izuruha, a central figure in the series. The women who crew the *Nadesico* in the 1996 TV series *Martian Successor Nadesico* spend the first half of the story shooting down unmanned spacecraft: not

Martian Successor Nadesico
Yurika Misamaru, captain of
the Nadesico, *is not exactly*
the brightest star in the
galaxy; she gained the captain-
cy with a high score on a Space
Academy exam. Plus, her fa-
ther is a high-ranking officer in
the space force. But she's com-
mitted to her crew.

much risk of being un-*yasashii* there. Two of the pilots on the space battleship *Soyokaze*, in the 1992 series *Irresponsible Captain Tylor*, aren not there because of an eagerness for combat. They're Eimie and Yumie, the cute twin daughters of retired Admiral Hanner, who sends the girls to keep an eye on the unorthodox Captain Tylor.

The presence of *yasashii* girls in potential battle situations reaches its illogical conclusion in *Starship Girl Yamamoto Yoko* (1995). Interplanetary wars in the future are regularly scheduled, and are fought by ships which, if destroyed, automatically teleport the pilot (a cute girl, of course) out of harm's way. It may as well be a video game, which explains why Earth reaches back to a twentieth-century video-game-obsessed teenager (the title character) to be its new champion.

Out of This World

The juggling act is easier when the girl in question is not necessarily from planet Earth. Sahari is a salvage prospector in the science-fiction OAV series *Sose Kishi Gaiarth* (*Genesis Survivor Gaiarth*, 1992). Having to live by herself, she's developed a hard edge and a tough bargaining ability. Her personality causes some problems at first when she meets up with Ital, the good-looking young rebel against

the empire. The longer they stay together, though, the more her *yasashii* side is allowed to come out.

There's a thrilling conjunction of the two approaches to life at the end of the first *Tenchi Muyo* feature film (1992). Long ago, Tenchi's grandfather Yosho, of the alien noble house of Jurai, arrived on Earth, married into the Masaki family, and had a daughter, Tenchi's mother. (Tenchi doesn't find out any of this until he's a teenager himself and female alien visitors start coming out of the woodwork.) Tenchi's mother, Achika, was retroactively attacked as a high school student by Kain, a time-traveling intergalactic criminal, to take revenge on the house of Jurai for helping the police imprison him. Tenchi and friends have to travel back in time to rescue her—otherwise, Tenchi would never have been born.

In the final confrontation in *Tenchi Muyo in Love* (1996), Achika assumes the full powers of a noble of the house of Jurai, wielding a weapon that had been for other Jurai nobles (including Tenchi) a light-sword (clearly borrowed from the *Star Wars* movies). In Achika's hands, though, the weapon is a colossal glaive of energy (although—tradition strikes again—the design is classically Japanese, based on a woman's weapon called a *naginata*). Since Kain had been tormenting Tenchi much as the Emperor tormented Luke Skywalker in front of Darth Vader in *Return of the Jedi*, Achika pays Kain back by splitting him up like kindling. There are anime with fancier swordfights, but few that touch such a primal need. The child in us watches and rejoices that, on some barren moon somewhere in the universe, a mother fought like a tiger to protect her child, even if the child would not be born for another ten years. (But more about mothers in the next chapter.)

It's Magic

The story of *Tenchi Muyo in Love* may be pure science fiction, and the plot device may be called the

Power of Jurai, but we should realize that Lady Achika is really another in a long line of "magical girls." (In fact, the *Tenchi Muyo* universe has its very own magical girl: Princess Sasami, who—perhaps only in her own fantasies—transforms into Pretty Sammy.) Most of these girls are pre-teen, but a few are either adolescent or (like Minky Momo; see the section in chapter 4 entitled "The Peach Boy") become adolescent when they activate their magic.

The magical girl genre goes back to 1966 and the TV series *Mahotsukai Sally (Sally the Witch)*. The series ran for over a hundred episodes, two of which included principal animation by a young animator who was already a five-year veteran in the industry, Hayao Miyazaki. In 1989 Miyazaki would create a feature film based on *Majo no Takkyubin (Witch's Delivery Service)*, a novel by Eiko Kadono about a thirteen-year-old witch (a literally magical girl) trying to find a place in the world.

It may seem horribly obvious, but membership in the Magical Girls is limited to those who are (a) girls and (b) magical, although the definition of "magic" can be a bit loose. Flying is usually considered magical, but this definition would mean that the central girls of Miyazaki masterpieces *Nausicaä of the Valley of the Wind* and *Laputa: Castle in the Sky* are magical. The problem with this definition is that they can't work any other kind of magic. Also, magical girls tend to have secret identities, and generally do not flaunt their powers in public. Sailor Moon, Pretty Sammy, Cardcaptor Sakura, Saint Tail, Minky Momo and many others fall into this category, and so may Birdy, the intergalactic policewoman who hides in the body of a hapless Japanese (male) student in *Birdy the Mighty*. *Tenchi Muyo's* Space Pirate Ryoko, on the other hand, certainly has magic, is most definitely a girl, and flies constantly. However, she has no secret identity (except when trying to pass for a normal Earthgirl), so she'd be very out of place among anime's traditional magical girls. (Not to mention the fact

Record of Lodoss War Deedlit finds a particularly attractive necklace in the treasure hoard of a dragon. The dragon will shortly appear to investigate the noise. This was one of the first sword-and-sorcery anime, but its magical effects—especially its dragons—are superb.

that she isn't exactly *yasashii*—most of the time, anyway.)

Another magical girl barely fits the definition, since she's an elf. Deedlit is the closest thing to a teenage girl in *Record of Lodoss War*, the epic sword-and-sorcery anime. From the very beginning of the OAV series, she's shown as possessing great power and capable of using it; on the other hand, her feminine side almost becomes a frivolous parody of itself, as she puts the entire party at risk by modeling jewelry at a very inappropriate moment.

School Days

Most often, however, Japanese pop culture offers very unmagical young girls in their natural, present-day Japanese habitat of home and school. Two recent anime series, both based on *shojo manga*, begin from very different circumstances and tell their stories with wildly different techniques, but it should not be surprising that they end up at the same place. After all, Japan is a nation where "the nail that sticks up gets pounded down," although that old saying may be too negative a way to express something that happens in the United States as well. Popular culture, even at its most stylistically radical, still usually points in only one direction: tradition.

Mizuiro Jidai

The story behind Mizuiro Jidai (literally *Water-colored Years*, also sometimes called *Aqua Age* after a hair salon in the story; 1996) is simply the lives of some students moving from junior high to high school.[3] The action revolves around Yuko Kawai, a good-natured, kind, and generally unexceptional girl. She's literally grown up with the boy next door, Hiroshi Naganuma, and they've been friends for a long time. However, as their bodies begin to mature, the feelings begin to deepen. Those feelings don't always get expressed in the right way, but that's part of growing up.

When Yuko's menarche starts in the middle of class, she gets sympathy and support from a source where she least expected it: her rather bossy friend and rival for Hiroshi's attentions, Takako Takahata. (Actually, there are two reasons why Takako's helpfulness shouldn't be surprising. Yuko and Takako shared a secret since fifth grade, caring for a kitten that was living on the school grounds. Also, the heart of the Confucian approach to life is to observe and live up to the names of society's various roles, from the familial to the political. In spite of her smug know-it-all manner disguising a lot of self-doubts, Takako wouldn't be much of a friend if she didn't support Yuko in an area where Hiroshi would be absolutely no help at all.)

Most of the events in the manga and anime aren't very dramatic by most standards. Yuko, a good writer, is asked to write a skit for a talent show and promptly develops writer's block. Yuko throws a Christmas party, which the other girls in class will attend on one condition: Takako can't come. Yuko and Takako are supposed to take charge of the band club at their school, except that Takako is too overbearing and Yuko is too wishy-washy. Yuko's grades start to slide; Hiroshi tries to help, but this causes its own set of problems. . . .

Mizuiro Jidai is, in short, about nothing more

[3] Japanese grade school goes up through America's seventh grade. Junior high corresponds to eighth and ninth grades, while high school only lasts three years. One other difference: the school year starts in April, not September.

Tears

Probably the most striking physical feature of both manga and anime characters is their eyes. Frederik L. Schodt's book *Manga! Manga!* described girls' comics as featuring characters with "eyes the size of window panes." These days, however, the colossal orbs are no longer limited to *shojo* comics and animation. The boy hero of the TV series *Cho Hatsumei Boy Kanipan (Super Inventor Boy Kanipan)*, to pick just one example, has eyes fully as huge as any of the girls in the cast.

But eyes are only part of the equation. Sometimes it seems that the point of having eyes in Japanese pop culture is not to see, but to cry. Movies, plays, manga, and other forms of Japanese entertainment are often classified on a continuum between "dry" and "wet," with tears providing much of the moisture.

Characters shed tears of sorrow, tears of joy, tears of frustration, tears of anger—but this is a good thing. The audience equates the ability to cry with the ability to feel deep emotion, and thus to be human. The villain can be identified (among many other giveaway signs) by being unable or unwilling to shed a single tear. This denotes a lack of compassion, an inability to be *yasashii*.

But of course this can change. Villains, after all, are considered capable of redemption, whether the villain is a magically malevolent marionette (Kuruku in *Unico on the Island of Magic*) or the sociopathic Shion in *Please Save My Earth*. And tears are often the herald of change.

than some *yasashii* kids growing up. The manga and anime are both about When Bad (or Good, or Weird) Things Happen to Good People. You know exactly who to cheer for, and exactly why.

Kareshi Kanojo no Jijo

But what do you get if the girl in question isn't all that *yasashii*? If the guy turns out to be manipulative? If neither kid is really the way they seem in public? You get the 1996 manga *Kareshi Kanojo no Jijo (His and Her Circumstances)*, which looks at the opposite numbers of Yuko and Hiroshi. The choice of an animator for the television version (1998) of the comic was unusual: Hideaki Anno. This was his first animated project after creating *Evangelion*, the most controversial anime of the '90s. *Kare/Kano* is, in terms of technique, just as unsparingly avant

garde as *Evangelion*. Anno brings out all his technical tricks (text flashed on the screen almost too fast to see, long static stretches, collage, even frames from the manga), while adding "super-deformed" caricatures. For all its technical sophistication, though, its message is very similar to *Aqua Age*.

The heroine of this story, Yukino Miyazawa, seems to be the perfect fifteen-year-old. She makes good grades, she excels in sports, she's effortlessly pretty, and the rest of her junior high school class looks up to her as the class leader. Yet, unknown to her classmates, she works like mad to keep up this illusion. Around the house, she trades in her contact lenses for large wire-rim glasses, pulls her hair up under a scarf, and wears an old jogging outfit. She works at academics and athletics for one reason only: vanity. She wants to be admired by others, and so remakes herself into the perfect student.

All goes well until she applies to get into Hokuei Senior High School in Kawasaki, an industrial sub-

His and Her Circumstances
Yukino Miyazawa and Soichiro Arima are the ideal couple. But they're anything but perfect. Both present sanitized images of themselves to the world: Soichiro to hide the skeletons in his closet, Yukino to pretend that everything comes easy to her. They stop playing games when they find each other.

© 2002 MASAMI TSUDA/HAKUSEN-SHA/GAINAX/KARENO-JIJYO-DAN/TV TOKYO/SOFTX

His and Her Circumstances
Yukino and her sisters. This is a pose that Yukino would not want any of her classmates to see. Her life at school is all about surface and pretense, as she spends her days convincing people that she is what she's really not. At home, though, the mask comes off and the pretense is over.

[4] Arima's family manages a hospital. In America, hospitals tend to be large institutions, either civically owned or privately run by corporations or churches or other charitable institution. In Japan, many hospitals and clinics are smaller, family-run businesses. Also, it's not unusual for the families of patients to volunteer to work at the hospital (doing the laundry, etc.) in order to lessen the bill.

urb that's part of the Tokyo–Yokohama urban industrial sprawl. She comes in second on the exams to a boy named Soichiro Arima. He seems to be just as perfect as Yukino: good looking, excellent student, all-around athlete, from a prominent medical family,[4] admired by his peers. Yukino now has an added incentive to continue her public persona: her hatred of Arima for usurping her place as class leader. The problems start in at once: a girl can't be jealous and spiteful and vain and still be *yasashii*.

Actually, she doesn't have much of a chance to be spiteful, since Arima surprises her in the very first episode by saying, "I love you." This confuses Yukino to the point that she lets Arima put her on a host of student government committees. She yells at Arima, hits him, and runs away. He chases her in order to apologize, and his interest in her keeps growing.

When he visits Yukino's house so that they can study together, and he sees the kind of gleeful

chaos caused by Yukino's younger sisters, we learn Arima's past. He lives with an aunt and uncle, because his parents are nowhere to be found. They were the black sheep of the family, living by stealing and blackmail until they disappeared. The aunt and uncle never stop reminding Arima that their family has been prominent since Tokugawa times, and that somehow Arima is the cause of his parents' bad behavior. He puts on a façade of perfection because he feels that he has to. Yukino, however, tells him that, since they love each other, each can accept the other's real personality. They can dispense with their façades, at least with each other.

It's no wonder that romantic love is part of just about every *shojo* story. Adolescence is, after all, just a stepping stone. Even Japanese girls who intend to have some kind of career after schooling always have a particular cultural belief in the back of their minds. They know—because they have been told, overtly and symbolically, for most of their lives—that their greatest destiny lies ahead: becoming not just a wife, but a wife and mother.

IO

Enter the *Mamagon*: The Japanese Mother

They help and they hinder; they stabilize and disrupt; they run the house and its occupants (most of them, anyway). Japanese mothers, in pop culture as in life, have to perfect a very special balancing act.

Yasashisa is all well and good for a teenage girl contemplating love and marriage. But what happens after "happily ever after?" What happens usually is motherhood, an important part of Japanese life that is nonetheless conspicuously underrepresented in anime.

Mothers in manga, though, are another story. They can be plentiful, if you look in the right places. Those places would be comic magazines, with titles such as *Eve* and *Josei Jishin (Women Themselves)* targeted at housewives. Within this genre, as in any other, the subject matter is wide enough to include comedy and tragedy, love and war, psychoanalysis and (definitely) sex. Quests for romance are mixed with stories of how housewives are often taken for granted.

If marriage in Japan is a prison for women, it's a prison where the inmates run the jail. If the proper place for the man is the workplace, that leaves management of the home to his wife, and her decisions are as absolute in her domain as the husband's are in his (and maybe more so). Men in

Japan typically turn their paychecks over to their wives, who give them back an allowance. She manages the household with the rest, which in this day and age can include making stock-market investment choices.

Her main responsibility, though, is to her children. She is their only link to the world in the early years, instilling social norms at an early age. She also tracks their scholastic progress, and in this mothers can become overbearing and hypercritical, demanding as much of the educational authorities as of their children. This is the kind of mother referred to in the Japanese media for a time as *mamagon*, a maternal dragon.[1]

The Dangers of Motherhood

Anime mothers aren't always so strong. A fair share of anime mothers get killed off early in whatever story is taking place, adding a degree of poignancy. The mother of Tenchi Masaki dies when her son is a toddler in the *Tenchi Muyo* universe, thus opening the door for his Juraian family to claim him a decade later. In *Grave of the Fireflies* the death of the children's mother in a World War II air raid, while their father is in the army, precipitates the crisis of the movie by forcing the children to live with distant relatives. In *Key the Metal Idol*, the mother of Tokiko Mima dies shortly after giving birth to her daughter, who is raised by her grandfather to think that she is a robot. Even a child-oriented film isn't safe: the animated movie released in the West in 1984 as *The Enchanted Journey* tells of two domesticated chipmunks, Glicko and Nono, trying to escape to the forest. At one point, Nono explains that she is making the trip because it was her mother's last wish, and the audience sees a flashback to her mother's death.

Evangelion is downright lethal for its maternal figures. First, Shinji Ikari's mother Yui was killed in a laboratory accident (with Shinji looking on) when he was a toddler. Free of marriage, Commander

[1] Kittredge Cherry, *Womansword: What Japanese Words Say About Women* (Tokyo: Kodansha International, 1987), 78–79. In the more traditional extended family, when the parents of either the husband or wife also live under the same roof, these grandparents pick up some of the child-rearing slack if the mother takes a part-time job or goes back to school for an advanced degree. (Joy Hendry, *Understanding Japanese Society* [London: Routledge, 1989], 95.)

Gendo Ikari took up with Naoko Akagi, the scientist in charge of programming Magi, the supercomputer that runs everything in the relocated Tokyo-3 (moved fifty miles inland after melting polar caps left the old Tokyo underwater). This doesn't end happily: Naoko hears Rei Ayanami, a five-year-old child at this point, say she overheard Gendo call Naoko a dried-up old hag. Naoko takes this rather roughly and commits suicide (after killing Rei). Gendo is once again on his own, and years later has an affair with Naoko's daughter, Ritsuko.

Meanwhile, half a world away in Germany, Keiko Soryu marries a German NERV scientist named Zeppelin and has a daughter, Asuka. When Asuka is about five years old, she comes home to find that her mother has hanged herself in grief after discovering her husband had abandoned her for another woman. With Asuka's mother gone and Asuka in a nearly autistic state for two years, Herr Zeppelin marries the woman he ran off with, an American doctor named Langley. However, she is more interested in being a wife than in being a mother, and Asuka is left to fend for herself.

Rounding off this antimaternal group is Misato Katsuragi. After meeting Shinji at the train station and seeing the way he and his father don't get along, she offers to take Shinji into her apartment. Later she also brings Asuka to live with her. She becomes more like a big sister than a mother—although she means well, her cooking leaves a lot to be desired, and in any case she'd rather drink and/or have sex with her boyfriend Kaji. She's already commander of the Eva pilots during business hours; she doesn't always want them around after hours. It's no big spoiler to say that she doesn't get to the last episode alive.

The mothers of *Ranma 1/2* don't fare too well, either. Soun Tendo, head of the Anything-Goes Martial Arts *dojo*, lost his wife before the story even begins. As for Ranma's mother Nodoka Saotome, she's still alive, and both Ranma and his father are

trying to avoid being anywhere near her. When he took his son off to instruct him in martial arts, Genma promised Nodoka to make Ranma a "man among men." Of course, since his fall into the accursed spring Ranma turns into a girl, so "man among men" isn't in the cards right now. If they don't find a way to reverse the effects of the spring, Ranma and Genma both assume that (as Gendo promised Nodoka should they fail) they will both have to commit *seppuku*, a classic samurai form of suicide, to satisfy Nodoka. Consequently, she is rarely if ever seen or even mentioned in either the manga or the anime. Of course, it never comes down to *seppuku*, even though, when she does appear late in the story, she's fully prepared—she wears traditional *kimono* and carries a samurai sword. She almost uses it when she gets the notion that Ran-chan is really her son in drag. She finally relaxes when she catches her son peeking in on some girls. She's even willing to accept his curse—as long as her son still acts macho. This is more than just a gag, though. This would be consistent with the Japanese mother's sometimes-contradictory pulls: she wants her son to succeed, but also wants her son to fit into society.

Key the Metal Idol Tokiko Mima, a girl who thinks she's a robot, is asked by a religious cult to heal a sick child. In a vision, she receives help from her mother, who was, like Key, one in a long line of hereditary miko, or Shinto priestesses. Without knowing what she is doing or why, Key heals the child.

Other Mothers

Some anime mothers are barely there, and serve merely as convenient plot-devices or comic relief. Usagi's mother in *Sailor Moon* is basically clueless about her daughter's secret identity, as Tsutomu's mother in *Birdy the Mighty* is unaware of the fact that her son shares his body with a female alien cop. Magical princess Minky Momo has two mothers: the one in outer space keeps tabs on her from afar, while the child has convinced two Earth adults that she is their child. Both human parents remain clueless as to her magic, and in the end she renounces her magic powers to be their fully human daughter.

Then there's Yoko Mano, the teenage heroine of

Tenchi Muyo in Love Achika *has just watched supercriminal Kain attack her yet-to-be-born son Tenchi. She swiftly and viciously goes on the offensive and destroys Kain—something that the Galaxy Police and whole planets had been unable to do. She is not, however, a monster. She attacked Kain in defense of her son, something most mothers and children can sympathize with.*

the *Devil Hunter Yoko* series of videos (1992)—she's caught in the middle of a mother/daughter dispute. Yoko's grandmother was 107th in a line of demon fighters. Yoko's mother was supposed to be the 108th, but by age sixteen, when she was supposed to come into her own, she was ineligible because (to granny's great shame) she was no longer a virgin. (This may seem like a thinly disguised argument for premarital chastity, but it isn't. Once the sixteen-year-old Yoko officially becomes the next Devil Hunter, granny assures her that now she can go out and screw around as much as she wants. Somehow, though, something always seems to get in the way.)

This brings up one more aspect of extended family life in Japan. In this series, the grandmother tries to dominate the household, while her daughter puts up resistance. In Japan the dispute is more often between a man's wife and his mother. It's a classic power struggle, when the mother who held the power over her son finds the power shifted to his new bride. "Almost half of the Japanese husbands who asked courts to mediate family disputes in 1983 cited conflicts between wife and mother as the cause."[2]

Mother Is a Mother

Other mothers are deliberate obstacles to their children. Kyoko Otonashi seems never to have to deal with a mother-in-law in Rumiko Takahashi's *Maison Ikkoku*. It's just as well, since she has her

[2] Cherry, *Womansword*, 134.

hands full dealing with her own mother. Ichiko Chigusa spends almost all her time in the series trying to get daughter Kyoko to move back in with her, if not trying to fix her daughter up with the rich and handsome tennis coach Mitaka. Mother doesn't think much of Godai's prospects as a college student, and definitely hates the idea of her daughter making a living as manager of a boarding house. In this case, of course, mother isn't right.

Probably the wrongest mother in anime is the Millennial Queen, ruler of the *mecha* world in the 1978 anime *Ginga Tetsudo 999 (Galaxy Express 999)*. The planet Rametal in the Andromeda system is the last stop on the intergalactic railroad serviced by 999, and is also where humans go to cast off their human bodies in exchange for machines. Of course, there's a price to pay. The queen has caused the deaths of millions, and her daughter Maetel makes the trip to Rametal in part because she knows she has to stop her mother.

Speaking of *Galaxy Express 999*, it's the mother of the young hero Tetsuro Hoshino who, in a sense, starts the entire story in motion. When younger, Tetsuro witnessed the robot Count Mecha kill his mother. He later finds out the Count was trophy hunting: he had Tetsuro's mother skinned and has that skin displayed in his castle as an example of the most beautiful of human women. (At some point doesn't every child feel this about his/her mother?) Her renowned beauty is in fact the reason Princess Maetel bears such an uncanny resemblance to Tetsuro's mother.

One very present mother appears in the TV series based on the *Pokémon* game. In his quest for *pokémon*-master perfection, Satoshi (aka Ash) regularly calls home to mom to keep her up to date. He even stops home now and then for rest and recuperation between trials. So far, this is a diminutive parody of the way Japanese businessmen regard their wives—as there to provide maternal comforts rather than a marital partnership. But the

"Pre-Mothers": The Office Lady

The Office Lady, or OL for short, is a still-evolving. part of Japan's corporate culture. The term dates back to the postwar economic boom, which brought significant numbers of women into the white-collar labor force for the first time (with so many men having been killed in the war). These women office workers were first known in popular parlance as "BGs" (short for Business Girls), until they learned that American soldiers used the same phrase to refer to a different kind of "business." The term Office Lady resulted from a contest sponsored by *Josei Jishin* magazine in 1963.[1] As before, the cultural expectation is still for a woman to work a few years, then marry and leave the office. This is common enough that, at the close of the 1980s, a woman's professional "life expectancy" from hiring to marriage was about 6.5 years. Some OLs are kept on staff only to serve tea, greet customers, run errands, and serve as decorations. Some end up marrying co-workers, which is an ideal situation for management: not only does it create a family within the "family" of employees, but the former OL is expected not to berate her husband about working long hours, since she was once in the trenches herself.[2]

The role of the Office Lady is featured—warts and all—in a number of anime and manga. One reasonably accurate portrayal is in the reworking of the *Bubblegum Crisis* OAVs into the series *Bubblegum Crisis: Tokyo 2040*. Lina Yamazaki is shown being lectured to, criticized, propositioned, and basically treated like an inferior; she's even belittled by her robot supervisor. Miss Amamiya, the OL in Shotaro Ishinomori's *Manga Nihon Keizai Nyumon (Comic Book Introduction to Japanese Economics*, translated as *Japan, Inc.)* escapes the more degrading aspects of the job, but is still clearly low on the totem pole, fetching tea and documents.

At the other extreme are the two Office Ladies who serve the president of Mishima Heavy Industries in *All Purpose Cultural Cat Girl Nuku Nuku*. Arisa and Kyoko may work for a lady boss and thus evade sexual harassment, but they're still expected to carry out surveillance, sabotage, and strafing runs as part of their boss's war against her ex-husband.

[1] Kittredge Cherry, *Womansword: What Japanese Words Say About Women* (Tokyo: Kodansha International, 1987), 103.

[2] Cherry, 105–6.

mamagon can, and does, take things even farther. In the second feature film based on *Pokémon* (released in the West as *The Power of One*), a clash between colossal prehistoric *pokémon* threatens the world and its ecosystem. The mother of Sato-

shi/Ash promptly jumps into whatever vehicle will get her to his part of the world, just to make sure that her son is all right.

Art imitated life in the case of *Hadashi no Gen* (*Barefoot Gen*). In the manga and its 1983 anime, Gen Nakaoka is a schoolboy who survives the atomic bombing of Hiroshima. He rushes home to find that his pregnant mother also survived, but that the rest of the family was killed in the fire caused by the bomb. Gen helps his mother deliver her baby in the midst of the hellish chaos caused by the bomb, but the infant doesn't survive for long.

Most of the above happened to artist Keiji Nakazawa (a neighbor helped deliver the baby), in addition to one final twist. According to Nakazawa's autobiographical manga *Ore ga Mita* (*I Saw It*), Keiji's mother survives to go back to work during the Occupation to support her son. (This is shown by her starting to wear Western clothes instead of kimono.) She lives long enough to see her son grow up and get married, but she dies shortly after the wedding. When she is cremated, all that is left is some fine ash. Ordinarily there would also be bone fragments, but their absence is blamed on a low level of radiation sickness that attacked her health throughout her life. Her outraged son decides to fight against the bomb that desecrated his mother's very bones the only way he knows: through manga.

The Miyazaki Mother

Mothers tend to come off best in the movies of Hayao Miyazaki. The mother of the girls in *Tonari no Totoro* (*My Neighbor Totoro*, 1988), for example, is the focus of the entire plot, even though she's on-screen for maybe five minutes. Her husband and children move to a country house in order to be close to the sanatorium where she is recovering from tuberculosis. Her health is still touch-and-go, though, and a telegram comes to say that a sched-

My Neighbor Totoro Mrs. Kusakabe *has no more than two minutes of onscreen time, but her health drives the entire plot. Recovering from tuberculosis in a rural sanatorium, her family moves to an old country house to be near her. When her health takes a turn for the worse, her youngest daughter Mei goes into action.*

uled visit home has to be canceled. This prompts Mei, the younger daughter, to try to take her an ear of corn, believing that it will improve her mother's health. Mei's impromptu trip brings on the final crisis of the film.

Neither Pazu nor Sheeta, the young leads in Miyazaki's *Laputa* (1986), have a living mother, but that means that they can be adopted by a surrogate. In this case, they're embraced by Ma Dola, leader of a gang of flying pirates. She's a bit of a crone, and more a grandmother than a mother, but she sides with the children and against the forces trying to kidnap Sheeta to discover the secrets of the floating city Laputa.

One of the most realistically portrayed mother-daughter relationships in a film by Miyazaki's Studio Ghibli is in *Mimi o Sumaseba (If You Listen Carefully,* also known in English as *Whisper of the Heart,* 1995). The central character, Shizuku Tsukushima, has reached the rebellious age of thirteen, although her rebellions are pretty minor by most standards (such as drinking iced tea out of the pitcher rather than a glass when nobody else is around). And even though Shizuku forgets a num-

ber of things during the film, she dismisses her mother as a "ditz" when mother, going back to school for an advanced degree and running late, forgets where she put her purse.

The wolf-spirit Moro in Princess *Mononoke* (1997) would seem to be an exception to the run of "nice" Miyazaki mothers, yet this beast is more of a mother to San than her biological parent proved to be. As Moro explains to Prince Ashitaka, she met San's parents in the woods. Fearful of being eaten, they threw their baby at Moro's feet and ran. Moro raised San as, in her very motherly words, "my dear ugly furless child" who is "unable to become either fully human or wolf."

Kokiri is an herbalist/witch and the mother of Kiki in *Majo no Takkyubin* (1989). She doesn't play much of an onstage role in either the book by Eiko Kadono or its animated version, known as *Kiki's Delivery Service*. Offstage, however, she's taught Kiki how to fly on a broom (she tried to teach herbalism as well, but Kiki just didn't have the temperament). Still, there's a wonderful moment in the book, just at Kiki's leavetaking to spend a year making her own way in the world by magic:

> Later, after countless times saying the word "Goodbye," Kiki, with the radio hanging from the front of her broom, set Jiji [her black cat] behind her and lifted off. The broom hovered in place a little, Kiki turned back and said her farewell to Kokiri.
> "Mother! Take care of yourself, okay?"
> Since they hadn't been separated even for a little while, both she and Kokiri thought that they'd end up crying.
> "Hey! Hey! No looking around now!" Kokiri's usual voice followed right behind her. With those words, everyone burst out laughing all together.
> Kiki breathed a sigh of relief. Even at such an extraordinary time, it seems that mothers will always be mothers, and Kiki thought that that was just fine.[3]

[3] Eiko Kadono, *Majo no Takkyubin* (*Witch's Delivery Service*) (Tokyo: Fukuinkan Shoten, 1985), 35. My translation.

Still, no matter how nice Kokiri and other mothers may seem, they have to go a long way to dethrone the reigning mother of Japanese pop culture. She's been on the scene since 1946, has outlived her creator, and by virtue of her ordinariness has become the mother of all Japanese mothers, without magic, without *mecha*, without gimmicks.

Sazae-san

Machiko Hasegawa's *Sazae-san* started out as a four-panel comic strip, appearing in a local newspaper in 1946 before going national in 1949. Life wasn't easy during the Occupation—Dr. Tezuka, a medical student at the time, once said that he found that Japan's most pressing medical problem was malnutrition. So it was common for Japanese comic strip characters in those days to bear the names of food.

Sazae-san's entire family fits into this category, since every one is named after one form of seafood or another.[4] The family consists of herself, her husband, their son, her two younger siblings, and her parents, an arrangement one website calls "traditionally multi-generational."

Tradition—or at any rate nostalgia—seems to be one of the major appeals of *Sazae-san*, which ended its comic strip run in 1974 after twenty-five years but has kept its popularity as an animated television series that has run continuously since 1969. This is definitely a kinder, gentler Japan, not concerned with global trade deficits or the Pacific Rim. This is just a story of a family that makes simple mistakes—the kind that everyone laughs about later, over dinner and drinks. It's about getting lost in the new shopping mall; it's about Grandpa mistaking the soup stock for wash water; it's about father getting stuck on the roof when his wife accidentally takes away the ladder. Yes, there were some episodes in the '40s that dealt with those odd Americans during the Occupation, and that later tried to make sense of the college radi-

[4] Frederik L. Schodt, *Manga! Manga!: The World of Japanese Comics* (Tokyo: Kodansha International, 1983), 95. These days hardly any anime or manga still use the food-name formula, though *Bakuretsu Hunters (Sorcerer Hunters)* includes characters with names like Carrots Glacé and Apricot Ice, while the various *Saber Marionettes* series feature androids named Lime, Cherry, and Bloodberry.

cals of the '60s. Yes, current fads came in for some gentle teasing. But for the most part, *Sazae-san* was far more universal than topical. It was—and is—all about daily life.

In its animated incarnation, *Sazae-san* has over 1,600 episodes to its credit, thus surpassing even the *Dragonball* franchise. Oddly enough, *Sazae-san* has so many episodes precisely because it borrows its form from American television cartoons.

Remember that, when television was new, the cartoons shown in the U.S. were usually recycled theatrical short subjects, each about seven minutes long. Three of those could fit easily into a half-hour and still leave room for commercials. This is the same format used by *Sazae-san:* three short unrelated vignettes per week.

The popularity of the comic and the anime meant that the family wasn't to be limited to those media alone. *Sazae-san* became the subject of movies, of live television drama, and its own art museum in the Shibuya district of Tokyo, and it even gave rise to two research institutes. In 1981 the Sazae-san Academy was started, and in 1992 it published an analysis of the long-running manga. The analysis didn't sit well with some observers, though, who started their own academy, the Setagaya Sazae-san Research Association, which published its own findings.

As Charlie Brown would say, "Good grief." And, even though *Sazae-san* is most often compared to Chic Young's *Blondie* comic because of its domestic humor, Sazae-san herself is actually sort of a gender-bender Charlie Brown. She is described as wishy-washy, but that's only because she's engaged in an incredible balancing act. She must be a wife, a mother, and a daughter at the same time. Still, she's lived with that kind of balancing act all her life, as have most Japanese. They also live, for example, the balancing act of believing two or more religions at the same time.

Faith-Based: Christianity, Shinto, and Other Religions in Anime

Japan (and its pop culture) see nothing incongruous about following two or more religions at once. Native Shinto, Buddhism from India, the teachings of the Chinese sage Confucius—all apply at the right time and place.

> You can't live a life without pain.
> —Isamu Dyson, quoting the Buddha in *Macross Plus*

When DIC Studios started dubbing *Sailor Moon* into English, Western viewers probably didn't realize that some scenes were destined for the cutting-room floor. It wasn't because of sex or violence, but because some images Western viewers automatically invest with a great deal of power are taken by Japanese viewers with little more than a mental shrug.

Example: in the R series of *Sailor Moon* episodes, the four Sailor Senshi who assist Sailor Moon are taken aboard the flying saucer of Rubeus.[1] That's the last most Westerners see of them until Sailor Moon vanquishes Rubeus in combat, and she and the others have to escape before the ship blows up. Were the other Sailors in prison? Not exactly. Japanese viewers (and some Western fans) know that the other four spent the time suspended on crystal crosses.

It's ironic that a symbol as potent as crucifixion

[1] The five seasons of *Sailor Moon* are roughly divided thus: *Sailor Moon, Sailor Moon R, Sailor Moon S, Sailor Moon SuperS, Sailor Stars.*

should be edited out precisely because of that potency. After all, the way it's generally used in anime—when it's used at all—is in a manner Westerners can understand. It becomes a form of torture *for someone who doesn't deserve it.*

The Sailor Senshi certainly fit into this category. They were just being used as bait by Rubeus to draw Sailor Moon onto his ship. Another innocent victim is the video girl Amano Ai,[2] the title character of *Denno Shojo Ai (Video Girl Ai)*. In this 1992 anime, based on the manga by Masakazu Katsura, Ai is a "comfort video" girl, who's only supposed to speak consolingly to whoever rents her cassette. However, she not only crosses out of the television and into the real world, but is later electronically crucified by her inventor/programmer, Rolex. Her crime was falling in love with one of the customers, the hapless student Yota Moteuchi.[3] In *Vengeance of the Space Pirate*, an edited and dubbed version of Reiji Matsumoto's *Captain Harlock: Arcadia of My Youth*, pirate queen Emeraldas and Maya, the underground broadcaster who tries to rally Earth against an alien invasion, are hung up on crosses before their execution by firing squad. The fourth installment of *Earthian* features a synthetic human named Messiah whose inventor wishes to erase and reprogram Messiah's memory. He does this by crucifying Messiah on an oddly shaped device set up on the altar of a church. In the film version of *Macross Plus*, virtual singing idol Sharon Apple declares her independence of her programmer, Myung Fan Lone, by suspending her in midair, crucified with a dozen coaxial cables. And in the *Tenchi Muyo* OAV known as "The Mihoshi Special," Galaxy Police officers Mihoshi and Kiyone and Jurai princess Aeka are suspended on crosses while Dr. Washu tries to destroy the universe and space pirate Ryoko tries to compromise Tenchi's virginity. Even crucifixion can be played for laughs.

Knowledge of crucifixion in Japan seems to date

[2] This is another loaded name. Literally, it can mean "the love of Heaven," and the mysterious video store where Yota finds Ai's tape is called Gokuraku (Paradise).

[3] He has a loaded name too, and his classmates love to tease him about it. His family name, Moteuchi, is made up of two *kanji*. *Mote* carries the connotation of "to be popular with the opposite sex." However, the *kanji* pronounced *uchi* can also be pronounced *nai*, and *nai* is the suffix that turns a Japanese verb into a negative. So when his classmates call him *motenai*, they are saying "can't get a girlfriend."

from the sixteenth-century introduction of Christianity itself to the islands. There were several notorious examples of crucifixion in Japan, especially the martyrdom of twenty-six foreign missionaries and their Japanese followers in 1597. Another was carried out by the infamous warlord Oda Nobunaga. A ruthless fighter, Nobunaga abused friend and foe equally, but the blow that sealed his fate involved the mother of Akechi Mitsuhide, a warlord who had allied himself to Nobunaga. During one battle, Mitsuhide had sent his mother to the enemy camp to serve as a hostage to convince the enemy to negotiate. When the enemy arrived at the parley, Nobunaga, ignoring his own terms, had the enemy envoy crucified; the enemy killed Mitsuhide's mother in retaliation.

In June 1582, Mitsuhide was ordered by Nobunaga to lead his forces in an attack on the Mori clan; instead, his men turned on Nobunaga. Trapped in a temple in Kyoto, Nobunaga committed suicide. At the time, he controlled about half of Japan.[4]

What did Japan borrow from Christianity aside from crucifixion? Not a great deal. Attitudes have changed since the Tokugawa ban on Christianity, and in modern times the country has had a small minority of devout and practicing Christians, but in general the Japanese have only been interested in the tangential trappings and trimmings of Christianity. They have simply never needed it to provide a world view or a theology.

The Big Three

We need to remember the context. Japan has existed for centuries with a mix of no less than three governing belief systems, one of which doesn't strictly qualify as a religion even though it serves some of the purposes that religion serves in the West. Yet Japanese were and are able to function under all three simultaneously.

Confucianism, which is actually a social and

[4] Mikiso Hane, *Japan: A Historical Survey* (New York: Charles Scribner's Sons, 1972), 130–34.

ethical code rather than a form of worship, was based on the writings of the great Chinese scholar named K'ung Ch'iu, better known as K'ung Fu-tzu, or Master Kung. In Renaissance times, Western writers romanized his name to the quasi-Latin Confucius).[5]

Master K'ung was a teacher of the elite; in modern terms, it might be more accurate to call him a consultant. He advised nobles in China on state policy and techniques of governance. His advice wasn't always followed, but its common sense survived the centuries and influenced, to one degree or another, most of the societies of Asia.

What Confucius taught was a way of ordering society that emphasized education over heredity. Brains mattered more than birth to Confucius, and his teachings were the foundation for the Chinese imperial system in which government posts were earned by passing rigorous civil service tests. Beyond that, Confucius also saw that the family was the key to society, and that society functioned best

Haunted Junction Buddhism, Shinto, and Christianity all come in for some gentle (and sometimes not so gentle) ribbing in Haunted Junction. Japan has a long history of making fun of its clergy, and sometimes the imagery used to poke fun gets pretty outrageous.

[5] This happened to other great minds of the time as well. Polish astronomer Nikolai Kopernik is now known as Copernicus; Dutch legal scholar Huig de Groot became Hugo Grotius, and so on.

when family members behaved according to a well-understood hierarchy. If you are an older brother, the teacher said, behave like one, and all will be well.

Buddhism came to Japan from India, by way of China. Although Confucius provided a blueprint for an ethical society and a description of what makes a true gentleman in that society, history has shown that power tends to corrupt. Societies based too rigidly on such social hierarchies can often degenerate into despotism as brutal as the old aristocracies. Buddhism turned out to be a perfect counterweight to this tendency, because of its doctrine that the capacity for enlightenment—"Buddha-nature"—is within everyone, regardless of education or social standing. Thus the conscientious Buddhist is supposed to show compassion to all people, regardless of rank. (It actually goes farther than that, calling for compassion for all living things, from animals to insects.)

So, if Confucius gave Japan its ethical ground rules, and Buddhism taught Japan how to leaven those rules with compassion, what does Japan's native religion, Shinto, offer? Nothing less than the identity of Japan itself as a nation, and of the Japanese as a people. Shinto provided the creation mythology for Japan. It provided Amaterasu the Sun Goddess[6] as putative mother of the entire Imperial line and of the Japanese people, and the animistic belief that *kami* (divine beings) are many and everywhere.

The word "belief" is the key here. In Shinto, doctrine takes second place behind the worship itself. Joseph Campbell tells the story of asking a Shinto priest about Shinto's belief system. The answer: "We have no ideology. We have no theology. We dance."[7] He meant the ecstatic trance states entered into by seers, although this isn't limited to Shinto; the so-called "whirling Dervishes" of Sufi Islam are a case in point.

Where does all that leave Christianity? Pretty

[6] She's still present, and not just in Shinto shrines. In an episode of *Card Captor Sakura*, based on a manga by the CLAMP collective, Sakura captures the Mirror Card, which until then had been masquerading as Sakura. When it is identified, it reveals itself in the traditional image of Amaterasu, carrying a mirror.

[7] Quoted in Hane, *Japan,* 23. This line takes on a literal significance when one looks at *Key the Metal Idol:* Tokiko Mima's mother, her mother before her, and all the women of the Mima line were temple dancers.

much marginalized in Japan, a nation that got along for two millennia without it. As far back as Oda Nobunaga, Christianity was seen by Japan's rulers as more destabilizing than beneficial; Christian missionaries were tolerated by Nobunaga more as a political counterweight to the militant Ikko Buddhists than out of an attraction to Christian doctrine. Christians in Japan, both foreign-born missionaries and native converts, were persecuted in the late sixteenth and early seventeenth centuries, but a lot of this persecution was brought on the Christians by themselves.

Francis Xavier arrived in Japan in the mid-1500s to spread the Jesuit perspective on Catholicism, which was autocratic and hierarchical and not unlike the Japanese warlords' top-down view of political power. But then came the Franciscans, who sought to convert the poor and lowly rather than the wealthy and powerful. To make matters worse, the Jesuits were predominantly Portuguese, while the Franciscans were predominantly Spanish, and there was just as much bad blood between the two nations as between the two Catholic orders. With the Jesuits and the Franciscans constantly sniping at each other (a situation made even worse when Protestant missionaries started arriving in Japan in the late 1500s and badmouthed all Catholics), Japan's rulers felt that Christianity might do the nation more harm than good.

Of course, there was also the matter of these rulers' self-preservation. Life in Japan had long revolved around the clan, the region, and the emperor (or the warlord who propped up the emperor): the emphasis was on some powerful group or other. The Christian focus on personal salvation taught its followers to think of themselves as individuals rather than members of a group—unless, of course, the particular Christian sect was the group. The religion was perceived as a threat not just to Japan's native beliefs, but also to the nation's social and political stability. So beginning in

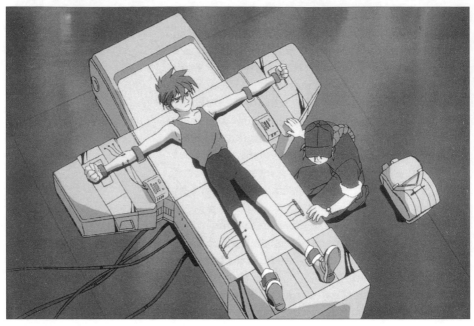

© SOTSU AGENCY SUNRISE ANB

Gundam Wing Heero Yui isn't merely being restrained; the resemblance to crucifixion is deliberate. Japanese artists often incorporate this image in their pop culture creations (see also Sailor Moon), but because the crucifix is not part of Japan's traditional set of religious icons, animators never have a sense of "going too far" by using crucifixion as a storytelling device.

1587 with an (unenforced) demand by Toyotomi Hideyoshi that all foreign missionaries leave the country, a crackdown on Christianity began that culminated in a complete ban on the religion by the Tokugawa shogunate in the first decades of the seventeenth century and the closing of Japan to all contact with the West except for a tiny Dutch trade outpost in Nagasaki.

After the Meiji Restoration of 1868, as Japan rushed to westernize, Christian missionaries returned to Japan after an absence of almost three centuries. They established universities that still stand today; they pioneered education for Japanese girls and charity for the disabled. Today, the bottom line is that, in Japan, Christianity is a vital and important faith to its few adherents (about one percent of the population). For the rest, all they know of it is pretty much what they see in pop culture, whether it comes from Hollywood or Tokyo.

148 | ANIME EXPLOSION !

Following the Doctor

In the late 1950s, when Hollywood was turning out one Biblical epic after another, Dr. Osamu Tezuka developed his own iconography for crucifixes, which pretty much set the standard in Japanese pop culture for all that would follow. The cross served two distinct purposes in Dr. Tezuka's work. On the one hand, it was a death symbol, denoting or even forecasting the death of a character. In addition, it could be used to signal the just conclusion of a story or sequence, which might involve the death of the villain, or avenging the death of a sympathetic character by the arrest of the responsible party. There is a somewhat different usage in a later episode of *Futago no Kishi (Twin Knights)*, the manga sequel to *Ribon no Kishi (Princess Knight)*. In the episode "Okami no Yama" (Wolf Mountain), a mother wolf dies protecting her pups, and is buried beneath a cross. The wolf is not anthropomorphized at all; the reader is intended to view her as a wolf. Topping her grave with a Christian symbol was partly a sign of respect, honoring a mother who died protecting her children, thus conforming to traditional human gender expectations. The wolf, in other words, may not have been human, but she was a mother, according to the culture of the comic's reader, and not just that of the narrative's fantasized European culture.

There is also a religious sense in which the wolf, and the respect accorded to her, could be seen as traditional, even if the symbol used to express the respect is alien to Japanese culture. Buddhism stresses the oneness of all living things, a theme that recurs throughout Dr. Tezuka's works as well as that of other manga artists. There is a connection, after all, between the *Black Jack* episode[8] in which, stranded at sea with two criminals, Black Jack must perform surgery on a dolphin so it can help them find land, and the *kuyo* ceremony described by William R. LaFleur:

[8] "Umi no Stranger" (Stranger from the Sea) in *Black Jack* 1 (Tokyo: Akita Shoten, 1974), 29–51.

Annually in Japan there is an autumnal rite of *kuyo* for eels. Through the medium of national television, each year presents select restaurateurs and their customers, people who love to eat eels, gathered by an altar while Buddhist priests intone the words of sutras to express thanks to the eels for having been so nourishing and for having such a delicious taste. Of course, in this—especially when the whole rite is projected to the nation via the nightly news—the Japanese tell themselves once again that their ties with antiquity are intact and that they as a people are not ingrates or irreligious, however much they consume eels with great relish most of the time.[9]

A group of *Astroboy* stories also employs the cross to signal a just conclusion of the story, while also serving as a death-marker. "Kirisuto no Me" (The Eye of Christ) is the most overtly religious of the group, beginning in a church on a stormy night. A gang of masked criminals invades the church. The priest tells them that Jesus (in this case, the altar crucifix) sees everything. The criminal ringleader, whose mask is blown off by a gust of wind, tells the priest to blindfold the plaster statue of Jesus. As he does so, the priest scratches an ideogram into the statue's eye that identifies the ringleader. The priest is killed, but the mystery is solved when Hige Oyaji, the old teacher who assists Atom in his adventures, makes the connection. The final panel juxtaposes the radiant image of the altar cross with the criminals being marched off to jail.

In the story "Ivan no Baka" (Ivan the Fool), Atom and a group of earthlings are in a spaceship that gets hit by a meteor. The party makes an emergency landing on the moon. While exploring, Atom finds the ruins of an old rocket crashed in a valley. A tape recording reveals that the rocket was launched by the Soviet Union in 1960.[10] The sole survivors of the crash were cosmonaut Minya Mikhailovna and her robot companion Ivan. Since,

[9] William R. LaFleur, *Liquid Life: Abortion and Buddhism in Japan* (Princeton, New Jersey: Princeton University Press, 1993), 145–46.

[10] Recall that, in 1959, the Soviet Union led the United States in space exploration. No matter how implausible Dr. Tezuka's lunar landscape might be, the odds (as seen from 1959 Japan) that Russia would beat America to the moon looked rather good.

in Dr. Tezuka's lunar landscape, plants flourish in a breathable atmosphere and water is available, Minya scratches out a basic but lonely existence. On her deathbed, she tells Ivan to bury her on a hill where she has planted a cross.

When one of the passengers (established at the beginning of the story as a thief) learns that Minya, while she lived on the moon, had unearthed massive diamonds, he threatens to kill the others unless Atom shows him where Minya's grave is. Lunar night begins to fall; Atom takes the others to a rescue ship, while the thief pulls the cross from the ground and uses it as a digging-tool to get to the diamonds, thus compounding desecration with sacrilege. No sooner does he find the diamonds than Ivan appears, mistaking the thief for Minya, as he similarly mistook Atom for Minya earlier. Ivan carries the thief back to the ship to care for him, heedless of his cries for help. The final panel shows the spaceship in the background, the discarded diamonds and the cross in the foreground. Once again the cross is used as the signal of a just conclusion, while it also serves as a symbol of death. Here it represents the doom of the thief as well as the death of Minya.

This same dual usage is seen in "Chitei Sensha" (The Underground Tank). The villain of this piece, General Saborsky, invented the title vehicle as a means to world domination. One of his workers, however, has stolen the tank and used it to rescue Hige Oyaji, stranded in a desert after his plane was destroyed by the general's jet. When the pilot of the tank is killed in a landslide, Hige Oyaji buries him in a grave with a cross as a marker. (It is worth noting here that the dead tank driver is black, for no apparent plot reason. However, it does reinforce the cultural notion that Christianity is essentially a creed for non-Japanese).

Hige Oyaji then digs his own grave and erects a cross for himself; however, when he prays, the words come out "Nanmai Dabu," a scrambled ver-

sion of the "Namu Amida Butsu" prayer to Amida Buddha.[11] Atom hears these prayers and rescues Hige Oyaji.

The story ends with Atom attacking General Saborsky's private jet, knocking off the wing-tips and tail and causing it to crash into the ground nose-first. General Saborsky attempts to escape by driving his damaged tank into a live volcano—a move that means certain death, which he considers preferable to surrender. Again, in the final panel, the wrecked fuselage in the foreground bears a deliberate resemblance to a crucifix grave-marker and also signals the just end of General Saborsky.

A Higher Power

The image of Christianity in Japanese pop culture can be, in a word, fanciful. Some priests in manga and anime are vampire-killers, their roles modeled on the Dracula movies produced by England's Hammer Studios in the 1960s and starring Christopher Lee. In the *Vampire Hunter D* anime (1985), based on a series of novels by Hideyuki Kikuchi, the vampire is named Count Magnus Lee, and Christopher Lee's name is invoked as a vampire gag in *Hyaku Monogatari (One Hundred Stories)*, one of several manga treatments by Dr. Tezuka of the legend of Faust.

The Exorcist also resonated in Japan. The *Ghost Sweeper Mikami* manga and anime (1993) include an exorcist actually named Father Karras, after the character in the movie. Manga "bad boy" Go Nagai produced a bawdy parody of *The Exorcist* in his series *Occult Gang*. As in the movie, a young girl is possessed by a demon and wreaks havoc. The Occult Gang is called in to exorcise the demon. One of the gang, however, inadvertently drinks the holy water that was to be used in the exorcism. This doesn't faze the gang; with the leader reasoning that holy water stays holy even if it isn't in the bottle, the exorcism proceeds by pissing on the possessed girl.

[11] With the pun potential inherent in Japanese, the prayer also sounds like a seemingly unrelated question: "How many pages are there?" It's the kind of question a harried editor might ask a manga artist who is behind deadline, and thus the joke also becomes a self-referential pun on the fact that this is a comic book. Similarly, in the *Don Dracula* episode "Dracula versus Carmilla," the female vampire tells Dracula's daughter Chocula that she works for *Shojo Princess* magazine, which brings an angry complaint by the editor of *Shonen Champion*, where *Don Dracula* was running at the time. An obituary for Tezuka noted that such references were common: "Suddenly we'd read the words '*Genkoryo yasusugite tamaran!*' [The payment for this manuscript is so cheap I can't stand it!]" (Shigehisa Ogawa, "New Classic Music Rag #7," *Shukan Asahi* [February 24, 1989], 111).

© KENSEI DATE / PHOENIX / NEP21

Princess Nine Pitching phenom Ryo Kawasaki prays to the spirit of her dead father. Note that she doesn't have to go to church to do it; the family has its own shrine. This is still common in Japan, and makes it part of ordinary custom for people to invoke the spirits of their ancestors.

One of the most memorable scenes in the apocalyptic Hollywood horror film *The Omen* showed a Catholic priest being skewered by a falling lightning rod. Dr. Tezuka's series *Don Dracula* inverts this scene for comic effect, by having lightning strike a tree branch, which then falls onto Dracula's back in a deliberate imitation of the scene from the movie. (But then, the entire series was a parody of a parody, inspired by the American vampire parody movie *Love at First Bite*, which ran in Japan as *Dracula Miyako e Iku (Dracula Goes to Town)*.

Answering Prayers

Not all Christian priestly appearances are tied to the supernatural. A kindly but ineffectual old priest figures in Dr. Tezuka's *shojo manga* titled *Angel Hill*. A monastery is home for the boy Dan Hayasaka[12] as he develops into a naïve faith-driven boxer in Shinji Imaizumi's *God Is a Southpaw*. Rumiko Takahashi inverted this situation for comic effect in her manga about a young boxer and a Catholic novitiate, *Ippondo no Fukuin (One-Pound Gospel)*.

By far, however, Christianity's main resonance in modern Japan is theatrical: as the backdrop for a church wedding. The old pattern of getting married in a Shinto ceremony and receiving a Buddhist funeral has been amended in recent decades. The

[12] Dan is an interesting name. It's written with a *kanji* that supports a number of readings, including the root of the verb *hazumu* (to rebound, also to be inspired) and the word for "bullet," *tama* in Japanese. What better name for a boxer who, inspired by his faith, rebounds after being hit and attacks like a bullet?

Martian Successor Nadesico
Minato Haruka, operations officer, dressed like Santa, parties with Prospector Gort dressed as one of the reindeer. Christmas in Japan has little to do with Jesus of Nazareth, but is regarded as an auspicious day—and an excuse to party. The crew of the Nadesico certainly follow that tradition.

© XEBEC / PROJECT NADESICO • TV TOKYO

current saying is: "Born Shinto, marry Christian, die Buddhist." A Christian church wedding has become the chic thing to do, to the dismay of priests who at least want to talk about Christianity a little bit. As an indication of how the Japanese perceive the whole issue, the current demand is not just for a church backdrop but for a blond, good-looking priest to perform the ceremony.[13]

Marriage has become tied in Japan to an unusual Christian holiday: Christmas. In Japan, St. Valentine's Day is a very specific celebration: girls give food to the boys they like. This usually consists of chocolate, and there are kits available to make chocolate from scratch. But this is the only time a female is encouraged to take the romantic initiative. It usually falls to the male to pop the question, and Christmas has increasingly become the favored day to do that. So much so that some women get tired of waiting; the 1991 album *Lucky* by pop singer Misato Watanabe includes the song "Kurisumasu Made Matenai"—"Don't Wait Until Christmas."

[13] A delightful manga story by Rumiko Takahashi, "Roman no Akindo" (The Romance Merchant), tells of a struggling marriage chapel. They perform Shinto, Buddhist, or Christian weddings, with the same "priest" officiating at all three—provided he's sober.

Who Ya Gonna Call?: The Spirit World in Anime

Japanese ghosts are a thousand years old, or as young as last week's urban legend. Naïve or nasty, playful or punitive, they're a link to the supernatural even in these hi-tech times.

The supernatural plays a very large part in Japanese pop culture. Ancient legends feature more spirits, from multi-tailed foxes to tortoise-shelled *kappa*, than can be listed here.[1] The prominence of the old ghosts and demons continues to this day, when some of them even turn out to be the good guys.[2]

At times, the battles of good versus evil are in clear-cut, even apocalyptic, terms, without the moral ambiguity that keeps anime and manga fresh to Western eyes. But even in the most basic supernatural battles there are recognizably Japanese patterns. In Buichi Terasawa's manga *Kabuto*, the title character is supposed to be a *karasutengu* or crow spirit. *Karasutengu* have a lengthy history in Japan; Dr. Tezuka used them in several manga set in Japan's old days, notably as comic relief in *Hato yo! Ama Made (Dove! Fly Up to Heaven)*. They also appear in Rumiko Takahashi's *Urusei Yatsura* as a race of crowlike aliens.

Kabuto is a human embodiment of a *karasutengu*, but more important is the fact that he fights

[1] It's no accident that multitailed foxes still appear in video games such as *Sonic the Hedgehog* and *Pokémon*, that the multitailed fox Renamon plays a pivotal role in the third season of the *Digimon* TV series, and that one of the magical characters in Rumiko Takahashi's *Inu Yasha* is Shippo, a shape-shifting fox-spirit who looks like a little boy with a fox's ears and tail.

[2] See an early episode of *Jigoku Sensei Nube (Hell Teacher Nube)*, in which a young student is terrorized on the school playground by a *kappa*, a tortoise-like goblin that lives in rivers. In this case, the *kappa* lives in an underground spring beneath the school and was trying to point out that the school had built its playground over an unexploded World War II bomb.

alongside four other human embodiments of spirit-gods, as they try to defeat Doki, the *kuroyasha* (black demon—who looks suspiciously like Thor in the old Marvel comics). As you might have guessed by now, Kabuto's fellow deities are a woman, a child, a big beefy guy, and a lone wolf—it's the *Gatchaman* science team in yet another disguise.

Snow White

The *yuki-onna* (snow-woman) is one of several vampiric female spirits in Japanese legend. She is a woman in white robes who flies through the sky during blizzards; because her skin is also as white as snow, all anyone can see of her is her eyes (and, in some versions of the legend, her pubic hair). She also appears to men as a woman in furs, holding a bundle and asking them to hold her baby for a moment; those who do so are found frozen to death. Her story makes up one part of Masaki Kobayashi's live-action supernatural masterpiece *Kwaidan*. She puts in a more benign appearance as Yukime in *Jigoku Sensei Nube* (*Hell Teacher Nube*; see below).

A variation on the *yuki-onna* also appears in *Gate Keepers* (2000), a series based on a video game. There are ample clues to this character's identity, beginning with her name: Yukino Hojo (*yuki* meaning "snow"). Then there's her origin: she was found wandering on Daisetsuzan (the Great Snow Mountain) on the northern island of Hokkaido. She never seems to age, she wears traditional kimono rather than modern clothes (the anime is set in the 1960s), she seldom speaks, except in a very soft voice, and then only in verse. One character identifies her speech as *tanka* poetry, a verse form that dates back some 1,300 years. Finally, there's her "gate," the portal to another dimension that she controls. All the members of the AEGIS group (all of them students, of course) psychically control such gates, but Yukino's is the Gate of Ice and Snow, which she uses to create blizzards as weapons against invading aliens.

In the Well

The case of Okiku Ido (Miss Chrysanthemum-in-the-Well) is less sinister, except for what it says about courtly life. In one version, Aoyama is a servant of a noble family who conspires to take over the family fortune by assassinating the head of the household. Okiku, another servant, finds out about Aoyama's plan and prevents the assassination. In revenge, Aoyama frames Okiku and convinces the master to have her thrown down a well. The specific well, at the Hakurajo castle in Himeji near Osaka, is now a tourist attraction by day, but in the dead of night one supposedly can hear Okiku's voice in the well. (Her master heard her night after night, after discovering that Okiku was innocent; remorse and sorrow ultimately drove him to madness.)

This is another old legend brought to life (sort of) in Rumiko Takahashi's *Maison Ikkoku*. During the Obon festival, the residents of the boarding-house take part in a haunted walk (an outdoor haunted house). Kyoko volunteers to be Okiku; the plan is for her to hide in the bottom of a shallow well and speak in a ghostly voice to passers-by. Of course, nothing goes as planned, and the episode ends with six people jammed into a rather small well. (The cover illustration for this manga episode shows Kyoko as Okiku, with a stack of nine dishes

on the edge of the well. This is a reference to the lie that Aoyama told to cause Okiku to be thrown into the well: she was accused of breaking one of a set of ten plates, priceless heirlooms for which she was responsible.)

The Exorcists

With all the spirits roaming pop culture Japan, in recent years exorcism has become a viable (and largely comic) profession for a number of anime characters, including Shinto and Buddhist clerics as well as Christian ones, not to mention purely mercenary freelancers. The lives of most people, including the clergy, can be, let's face it, rather dull—hardly prime material for dramatic treatment. But when the outrageously supernatural moves in, it's a different matter

Reiko Mikami and company

Takashi Shiina's manga *Ghost Sweeper Mikami* has proven popular enough to spawn a TV series and an OAV special (1993) as well as over a hundred print episodes. Mikami is a knockout, which is one of the reasons she can get away with paying so little to her assistant, a lecherous young man named Yokoshima. He has no magical ability whatsoever (unlike Mikami, who uses paper talismans, demon-killing spears, and other devices to dispatch the undead), and is content to hope for a chance to peek in on the boss in the bathtub. Other members of her staff include:

Okinu-chan, *yasashii* but a bit befuddled by modern life. She comes by it honestly, since she was sacrificed to a volcano god three centuries ago and first encounters Mikami as a ghost. Having forgotten how to let go of the world and become one with the cosmos, she agrees to work with Mikami and is restored to life five years into the series. As a ghost and later as a ghost-hunter, she wears the white blouse and red *hakama* of a Shinto shrine maiden or *miko*.

Meiko Rokudo, a middle-school girl from a wealthy family whose body happens to be host to a dozen different *shikigami* spirits. However, when she gets nervous (as seems to happen frequently) she loses all control over them.

Father Karras. Yes, he's named after the central priest in William Blatty's *The Exorcist,* a piece of Western pop culture that had a serious impact in the East. This Father K is a sincere exorcist (unlike Mikami, who charges her clients ten million yen per exorcism).

Shiho Sakakibara

She only puts in a brief appearance in the manga *Oh My Goddess!* (1988) by Kosuke Fujishima, but it's memorable. A cute classmate at Nekomi Tech of Keiichi (the hapless student who dialed Heaven's help-desk and now has the goddess Belldandy as a girlfriend), she's been dabbling in exorcism for a couple of years and is convinced she knows it all. Unfortunately, she doesn't, and actually ends up summoning spirits rather than dispelling them. She also has an indirect effect on the plot by stirring up jealousy in Belldandy. At the end of the episode, Belldandy has confronted her jealousy and learned from it, while Shiho continues on, blissfully unaware of her abilities—or lack thereof.

Meisuke Nueno

In *Jigoku Sensei Nube (Hell Teacher Nube,* 1996), this poor soul is a fifth-grade schoolteacher who constantly wears a black glove over his left hand. It's not a fashion statement—the glove covers up the demon claw that he has in lieu of a hand. Meisuke, also known as Nube, is an exorcist who found himself outmatched in one of his exorcisms, and won out only by taking the demon into himself. So, while he performs exorcisms, among other magical feats, the title character of Sho Masakura and Takeshi Okano's horror/romance school comedy does so from an insider's perspec-

Haunted Junction Most ghosts don't fare too well in anime. Poor little Ninomiya, the spirit of the great nineteenth-century educator and philanthropist Ninomiya Sontoku whose statue once stood in front of most Japanese schools, honoring the diligence and virtue of his youth. Nowadays, however, he is stuck waiting hand-and-foot on Shinto exorcist Mutsuki Asahina.

tive.[3] He teaches at a school with other supernatural practitioners among the faculty and students.

Ayaka Kisaragi and Company

Yugen Kaisha (Phantom Quest Corporation, 1994)[4] could almost be called *"Ghost Sweeper* Lite." There are a lot of similarities between the OAV series *Yugen Kaisha* and *Ghost Sweeper Mikami*: a for-profit exorcism agency run by a hard-drinking, fiery, voluptuous redhead who subcontracts to a variety of others with occult talents, resulting in adventures that mix the humorous and the horrific.

However, the Yugen Kaisha of the title is not as successful an operation as the Ghost Sweepers. The company operates out of Ayaka's home, which is at least convenient, since she prefers, after a night of carousing, to sleep until almost noon. In an apparent bid to save on expenses, her office manager is Mamoru Shimesu, a ten-year-old boy who seems quite accustomed to waking up a boss who sleeps in the nude (but then, his family has a history of being servants to the recently strapped Kisaragi family). Other experts are hired per job, and usually have a day-job already. These include Nanami Rokugo, a pubescent girl who's a "firestarter"; Rokkon, a traditional male (for a change) monk/magician; and Madame Suimei, a stereotyp-

[3] Nube is also the son of an exorcist, but had a falling out with his father when his mother took sick and his father would not (or could not) heal her. He turned as a child to a teacher named Minako for comfort; he took her spirit into himself when he also absorbed the demon who was attacking her. Rounding out the trilogy of women in his life is Yukime, a mountain snow-goddess who was supposed to kidnap Nube and ended up married to him. They're happy enough together, except that she tends to melt if the temperature gets too high.

[4] The title is (no surprise) a pun, using different *kanji* to spell out "Phantom Quest Corporation" instead of "Limited Corporation," which would be pronounced the same way.

ical Western gypsy fortune-teller. Ayaka's main contact is Kozo Karino, at the psychic desk of the Tokyo Police Department, where he would have almost nothing to do if not for the Yugen Kaisha.

Himiko Se

This exorcist is deadly serious. As the heroine (it seems) of the four–part OAV *Vampire Princess Miyu,* her path crosses that of the title vampire, a perpetual fourteen-year-old. Himiko also learns of an order of being that's part demon, part human, called a Shinma, who must be returned to the Underworld by Miyu and her companion Larva. With or without Miyu's help, Himiko has to deal with a vampire, a possessed suit of armor, and an enchantress who turns people into marionettes. In the final installment, she confronts Miyu directly and learns her story. This is one time I will not be a spoiler and give away the ending. This OAV series is one of the most atmospheric in all of anime; a definite must-see.

The Holy Student Council

Adolescence is an anxious time, and in modern Japan some of that anxiety gets projected onto the high school itself, and the thought of what might be lurking there at midnight. A common urban legend is that one school or another was an "execution ground" during World War II, and ghosts reputedly re-enact the killing of prisoners night after night. Students who killed themselves (and they have done so in Japan for a variety of reasons, from imitating someone else's suicide to escaping particularly abusive bullies) have been thought to return to their school. At Saito High, though, the whole thing is played for laughs. What else can you expect, when the school is run by a ghost?

Saito High is the setting of the 1997 "after hours" TV series *Haunted Junction,* and, like another after-hours series, *Those Who Hunt Elves* (1996), the series isn't as risqué as its time-slot suggests. It doesn't

At one time every elementary school in Japan displayed a statue of Ninomiya Sontoku (born Kinjiro, 1787–1856) as a young boy walking along, reading a book while carrying a load of wood on his back. Ninomiya was held in high regard for founding "trust associations" that helped improve the quality of life in rural Japan. He and his disciples established the Hotoku ("repaying virtue") movement to promote morality, industry, and economy. The statues were based on the legend of the young Ninomiya learning to read even while performing manual labor—Japan's equivalent to the stories of young Abe Lincoln, living on the frontier and writing his alphabet in charcoal on the back of a shovel. The government tried to revive the Hotoku movement in the 1920s and 1930s as a state-sponsored alternative to radical farmers' unions. Ninomiya statues thus began appearing in schools in the years before WWII: first small ones, then life-sized figures in bronze or cement. They were meant to inspire the students to follow Ninomiya's example. Some of the statues didn't survive the war or were destroyed during the American Occupation. But many remain to exhort new generations of Japanese youth— though one Ninomiya statue, modified by an anonymous student, was photographed showing the young Ninomiya reading a manga magazine.

[6] The Lolita complex is, of course, named after the title character of Vladimir Nabokov's best-known novel. The Shota complex, on the other hand, is named after the child protagonist in Mitsuteru Yokoyama's manga Tetsujin 28-go (Iron Man No. 28), better known as Gigantor. The pairing of Nabokov's novel with giant Japanese robots has to be one of the more surreal examples of Postmodernism.

take much of anything seriously, including the three students who make up the Holy Student Council. One from each faith (Buddhist, Shinto, and Christian), the three council members are charged with corralling the rowdier of the ghosts. This would be hard to do at the best of times, but these three students bring their own quirks to the table.

Ryudo Kazumi, son of a Buddhist monk, is himself well versed in esoteric Buddhism. One suspects he had to learn exorcism as a survival skill, since he tends to get possessed by whatever spirit's around—usually animals. His particular favorite among the ghosts at Saito High is Toilet Hanako-san. There is a substantial body of stories about Japanese toilet ghosts, ranging from the evil (because, let's face it, few positions leave a person more vulnerable to attack) to the benevolent and protective (handing out toilet paper if one gets caught short). Toilet Hanako-san, though, satisfies a slightly different urge in this series: as an erotic inspiration for those boys who retreat to the toilet to, as it were, let off some sexual steam.

Speaking of sexual matters, Mutsuki Asahina, daughter of a Shinto priest and a *miko* in her own right, frequently gets sidetracked from her own attempts at exorcism. Like so many Japanese schools, Saito High has a statue of educator Sontoku Ninomiya on its grounds.[5] This one, though, comes alive and runs around at night. Mutsuki catches him and turns him into a servant as well as a focus for her own lusts. In case you were wondering if there was an analog to the "Lolita complex" or *rorikon*, in which grown men fixate on prepubescent girls, there is. It's called the Shota complex, and Mutsuki's got a serious case of it.[6]

Haruto Hojo is the central character in this school story: blond, handsome, Christian and fed up with the Holy Student Council. Having to exorcise all these ghosts is keeping him from what he sees as a normal life, although by the end of the series he learns that "normal" has its own prob-

A Magic Number

Yoko Mano being the 108th Devil Hunter was not a random number choice. At the stroke of the New Year, Japanese Buddhist temples sound the bell 108 times for the 108 temptations of this world that must be overcome. We see this happen in an episode of *Hotel*, a manga series by Shotaro Ishinomori, in which an apprentice chef, tempted away from his job by lowlife friends, returns to a life of duty and honor on New Year's Eve, as the 108 chimes sound.

Note also the Chinese version of the myth of Pandora's box, retold in the prologue of Shih Nai-An's thirteenth-century epic *Water Margin* (*Shui-hu Chuan*, or *Suikoden* in Japanese). In this version, an envoy from the emperor frees 108 imprisoned supernatural fiends, letting them loose upon the world. "It is impossible to talk about Japanese irezumi [tattooing] without mentioning Utagawa Kuniyoshi's [prints based on the Chinese legend] *Tsuzoku Suikoden Goketsu Hyakuhachinin* (108 Heroes of the *Suikoden*)," writes the author of an article on *irezumi* for alterasian.com.

"These designs form a large part of all full-body tattoos and are often copied, or else the artist will draw his own illustration of another part of the story." (An anime titled *Suikoden* is more post-apocalyptic than reflective of Utagawa. There's also a video game called *Suikoden*, but based on "ancient Eastern lore" and not the Chinese story.)

A pirate band in the *Outlaw Star* series is called the 108 Suns. On the H side, there's Mitsuko, a sexual vampire and grandmother to Kenji, hero of the *Elven Bride* series. In the second OAV, Mitsuko seduces one of Kenji's National Guard colleagues, and they end up doing it 108 times; no wonder the guardsman is only a withered husk of his former self when it's over. And in *Crying Freeman*, a manga and anime by Kazuo Koike and Ryoichi Ikegami, a *yakuza* gang calls itself the 108 Dragons. But the number isn't always bad news—in the first installment of the *Magical Girl Pretty Sammy* OAV series, Tsunami is chosen to lead the planet of Juraihelm by a group of 108 priests.

Clearly, in Japan 108 is a number to conjure with.

lems, primarily the lack of the very randomness that makes life interesting.

Among the ghosts that live (as it were) at Saito High is a little girl in a mirror, a giant, a science-class skeleton and a Visible Boy—the life-sized torso with removable organs that has apparently creeped-out generations on both sides of the Pacific. Also appearing in the series is a boy who turns out to be a *tanuki* (see the Studio Ghibli chapter for

a report on *Pompoko* and a description of this creature's attributes).

Yoko Mano

Star of the 1992 *Devil Hunter Yoko* OAV series, this sixteen-year-old girl is a reluctant warrior who finds out from her grandmother about her family's legacy as fighters against supernatural evil. Yoko learns she is the 108th in line of succession and that granny could not pass the heritage to Yoko's mother because at age sixteen mom wasn't a virgin. Yoko's combat against evil things *(mamono)* involves the martial arts and a "soulsword." This being the twentieth century, she also quickly picks up a business manager, as well as Azusa, a *kawaii* apprentice. She's also trying to fall in love and have sex (not necessarily in that order), but something always gets in the way.

Yoko's first adventure was only half-serious, and played off the sexual side of her life. From there, things got more serious (although never completely so), with the second OAV containing an ecological message against destroying "sacred" forests; the third sent her back in time to free a *bishonen* prince from a spell; part five brought her up against a demon so big and bad that she had to summon her 107 predecessors back from the dead to help her defeat him; and part six pits her against her evil twin. (You may be wondering about part four. Technically, there isn't one; the installment known as *Part 4-Ever* is actually a collection of music videos.)

Girl Power: The Miko

One special subdivision of these warriors against evil is quintessentially Japanese. Pop culture still invests a great deal of power (mystical or otherwise) in the *miko*. These female shamans of Shinto have been influential in the life of Japan as far back as the third century, when warring tribes were brought together under the rule of the

shaman/queen known as Himiko. According to legend, she was a shaman who focused on magic, leaving day-to-day political rule to her brother.[7] In modern Japan, miko are the young female attendants and officiants at Shinto shrines, and are usually not thought to possess shamanic or magic powers at all.

The role of miko in manga and anime is of course far more colorful than their real-life counterparts. They usually play host to mystical powers, far beyond anything ascribed to a miko in contemporary Shinto, thereby reaffirming Japanese tradition and the power of the traditional belief system. Of course in anime, being a powerful priestess doesn't eliminate romance. This feeds a different Japanese tradition: the belief (held by most males and not a few females in corporate Japan) that a "career woman" is a contradiction in terms, and that the destiny of a woman, even a miko, is still to be a wife and mother. It is interesting, however, to note that for miko in anime, romance is usually a juggling act at best, and at worst can set dire wheels of fate in motion. Still, the psychic powers ascribed to miko are often hereditary and cumulative, so there is a practical incentive for them to seek love and marriage. If they didn't have a daughter to take up the torch, a miko's power could well die with her.

Hino Rei

While viewers of Sailor Moon often see Rei in the middle blouse that is her school uniform, or the variation on it she wears as Sailor Mars, they also see her wearing the white blouse and baggy red hakama of a miko. (We should also note that the color scheme of her Sailor Mars outfit parallels her miko wardrobe.) Her role at the Shinto shrine is tied into Japanese tradition far more closely than anyone else in the cast of Sailor Moon. We occasionally see her as a Shinto diviner, but her exorcism abilities are also incorporated into her Sailor Mars

[7] Mikiso Hane, Japan: A Historical Survey (New York: Charles Scribner's Sons, 1972), 18.

Silent Moebius Nami Yami-gumo is a member of the Attacked Mystification Police, an exorcist squad of the near future. Unlike the other members of the force, she prefers her *miko* robes to a police uniform. It doesn't really matter what she wears; she still gets the job done.

© STUDIO TRON • KADOKAWA SHOTEN / BANDAI VISUAL • SOTSU AGENCY • TV TOKYO

arsenal; it's not unusual for Sailor Mars to slap an *ofuda* onto an enemy, with the incantation "*Akuryo taisan!*" (Evil spirits of the dead, depart!). And yet, in the first episode of the third season of *Sailor Moon*, when Rei talks about what she wants to do with her life, her answer is rather down-to-earth: after being an idol singer and a *seiyu* (cartoon voice actress), she wants to get married.

The Women of the Mima Clan

In *Key the Metal Idol* (1994), we see not only Tokiko Mima (known as Key), but also her mother and grandmother as the inheritors of considerable psychic powers. These hereditary *miko* of a shrine in a small rural valley first have their lives disrupted when a young scientist witnesses the power of Key's grandmother to make a doll move without strings. The scientist (Key's grandfather) then marries the *miko* and subjects her to a battery of tests. Their daughter is subjected to the same scrutiny as she grows older; she escapes the testing only in death, although first giving birth to Key, in whom the destiny of all the Mima *miko* reaches its climax.

Kaho Mizuki

When we first see her, we don't know that she's a *miko* at the Tsukimine Shrine. In fact, even after she wears the white blouse and red *hakama* of a *miko*, Western viewers may not know it. In turning the anime series *Cardcaptor Sakura* (1998; based on a manga by the CLAMP collective) into *Cardcaptors* for the West, Canadian animation studio Nelvana seemed bent on moving the dubbed version as far from Japan as possible. To that end, Sakura's beautiful but mysterious teacher isn't just transformed from Kaho Mizuki into Layla Mackenzie; when seen in her *miko* garb, she refers to the temple grounds as simply "a park." Still, Nelvana had a couple of land mines ahead in adapting the rest of this series. There is the distinct impression that Kaho/Layla and Sakura's brother Toya were once "an item," despite the age difference. (The reason why isn't surprising, when you realize that Kaho is more than a *miko*; she's also one of the moon-related demigods watching over Sakura's recovery of the Clow Cards.) By the second season, Kaho is living with a ten-year-old boy named Eriol. This apparent love affair is also "rescued" by virtue of Eriol being the reincarnation of Clow Reed, creator of the Clow Cards. As it turned out, Nelvana opted for straight translation of the latter part of the series, without trying to explain away the unusual relationships.

Nami Yamigumo

Kia Asamiya created a *miko* for the not-too-distant future in his highly successful manga series *Silent Möbius* and its 1991 anime spinoff. Supernatural evil is plaguing Tokyo, causing the formation of the all-woman (and awkwardly named) Attacked Mystification Police. Nami is one of three generations of the Yamigumo family in this story: her father and grandfather are priests at a Shinto shrine. Nami is recruited into the AMP by her sister Nana, who's friends with Mana Isozaki, one of AMP's higher-ranking officers. However, Nami sel-

dom wears the AMP uniform, preferring a modified version of her *miko* garb (an all-white kimono with red piping). As such, she's one of the more powerful members of the group, and reaffirms the message to the audience that tradition can come in handy, even in a high-tech future.

Cherry and Sakura

This uncle/niece act (he's a Buddhist priest, she's a Shinto *miko*) is the oldest of this group, going back to the 1970s and Rumiko Takahashi's first runaway success *Urusei Yatsura*. They're actually a trio, since Sakura is engaged to Tsubame Ozuno, a practitioner of Western black magic. None of the three, however, can ever get their magic spells to come out quite right.

Kikyo

This takes us to Takahashi's most recent success. Kikyo was a *miko* long ago, charged with guarding the Shikon no Tama jewel. In defending it from the dog-demon who is the title character of *Inu Yasha* (2000), she shoots him with an arrow, freezing him for half a century. Meanwhile, Kikyo dies and is reborn as the schoolgirl Kagome, the heroine of the story. In the meantime, the Shikon no Tama has fragmented and Inu Yasha and Kagome must round up all the shards. Kagome, like Kikyo, is also an archer (archery is also the weapon of another magical girl/*miko*, Sailor Mars).

Miko and professional clergy aren't the only Japanese—whether humans or *anime* characters—with a religious component in their lives. Most houses still have a small family altar, used to remember the ancestors who may be long dead but are still part of the clan. There are separate temples and shrines, but worship in Japan, like other parts of Japanese society, is also a family matter.

The Starmaker Machinery: Anime and Idol

If you ever thought that Britney and Michael had taken pop music too far, think about Lynn Minmay and Sharon Apple, who can stop an intergalactic war—or start one. Anime's pop singing idols are in a league of their own.

Fact and fantasy, truth and illusion, meet to a greater extent than any other in the phenomenon of idolized pop singers, real or otherwise. This is where otherwise separate corners of Japanese pop culture mix and mingle.

The United States is no stranger to the phenomenon known in Japan as the "idol singer," since it was a U.S. export to Japan in the first place. In the 1950s, the Allied Occupation of Japan had officially ended, but the United States was still a large presence because of its use of Japan as a staging area for the Korean War. Japan was exposed to a great deal of American pop culture, including the whole range of activities lumped under the category of "pop singing idol." There were the records, of course, but there were also the fan clubs, the screaming crowds, the touring, the theatrical stage shows, the magazines, the television appearances, the advertising endorsements—all these trappings and more that attached to Frankie Avalon, Pat Boone, Connie Francis, and in fact to just about every popular singer from Frank

Sinatra up to and including the Beatles in the '60s.

While Japan was getting back on its feet economically after the disastrous war, idol singers were seen as a harmless way for the younger generation to blow off steam. The main difference between Japanese and American idols is that displays of fan affection in the United States have usually been those of female fans screaming after male idols, from Frank Sinatra and Elvis Presley to Menudo and 'N Sync, while Japanese idols are usually girls who have both boys and girls as a fan base. The Japanese variant on the idol started when Japanese promoters substituted squeaky-clean Japanese singers for Western idols. The problem is that idol singers, like sushi, go stale very quickly. Most Japanese pop singers have a fairly short shelf-life, and try to do as much as they can before they become obsolete.[1]

Song of the Cute Peacock

The whole system was depicted in microcosm by Dr. Osamu Tezuka (no surprise there) in *Shiro Kujaku no Uta (Song of the White Peacock)*, a manga he created in 1959 for the girls' magazine *Naka-yoshi (Good Friends)* that describes the rise and fall of an idol in terms that haven't changed much over forty years. A girl, Yuri Kogawa, and her mother receive word from the government that the remains of the girl's father, who was missing in action in World War II, have been discovered on an island near New Guinea, along with something else: a white peacock that refuses to be driven from the remains. The girl takes it both as a pet (which she names Piko) and a last living link to her father, even though the mother predicts that the bird will be a problem.

In fact, it starts out being more beneficial than bothersome. The girl is a pianist (presumably passable enough in talent) who finds that the peacock dances to her music. This is the only break she needs: soon she and the bird are cute media dar-

[1] Jeff Yang and Claudine Ko, "Idolsingers" in Yang *et al.*, *Eastern Standard Time: A Guide to Asian Influence on American Culture from Astro Boy to Zen Buddhism* (New York: Houghton Mifflin, 1997), 265.

lings. However, after awhile Piko is locked up in a zoo by Yuri's sleazy manager, Yuri's popularity wanes, and the manager who created her career drops her like a hot rock to handle the next fresh face that comes along. Even though the sleazy manager shoots the peacock and it dies (but not before one last dance for Yuri), the story does not end on this tragic note. Thanks to an army buddy of her father, Yuri goes on to study at a conservatory and becomes a concert pianist, still drawing inspiration from memories of the white peacock.

There's as much fantasy to this story as any other manga, except for one thing. The girl and her bird got work mainly because they were cute. Never underestimate the appeal of cute, especially in Japan. Although Japan has its share of big-haired heavy-metal bands, grunge rockers. and techno performers, the crucial quality for an idol singer in the land of Hello Kitty is still to be cute.

Storm Warning

Yet mention should be made of a sea change that hit anime and its music in 1987. When the first installment of an OAV series titled *Bubblegum Crisis* was released, its opening notes signaled something new. Fans heard Kinuko Omori, a rock singer rather than an idol-wannabe, belt out a dark and driving version of "Konya wa Hurricane" ("Tonight is the Hurricane"), a song solidly in '80s rock idiom. This wasn't just a marketing decision: it was also an integral part of the story. The *Bubblegum Crisis* world is essentially reworked from Ridley Scott's film *Blade Runner*: rogue robots commit mayhem in the streets of a futuristic Tokyo, and the police are powerless to stop them. Enter the Knight Sabers, a vigilante group of four women (one of whom is the daughter of the scientist who invented the robots in the first place) with high-tech body armor beyond anything in the police arsenal. One of the Knight Sabers is a rock singer, Priss Asagiri, thus putting "Konya wa Hurricane" in context.

Parallel Universes

Let's say you're a fan of the *Tenchi Muyo* OAV series. You then discover the *Magical Girl Pretty Sammy* OAVs, featuring many of the same characters, but in different relationships. Jurai Princess Sasami, who once looked up to Tenchi as a big brother, is now unabashedly in love with him, as are Ryoko and Aeka, now students at a high school where one teacher is the former mad scientist Washu. Sasami's mother leaves the running of the family CD store to Mihoshi and Kiyone, two college students. Then you check out *Magical Project S*, a weekly TV series based on the *Pretty Sammy* OAVs. Only, not quite. While Sasami's father was missing in action in the OAV series, he's now happily married to a totally different mother. Mihoshi and Kiyone are now teachers at Sasami's elementary school.

What's going on here? Manga titles can keep a story line going for years without the cast morphing into different identities. Creators can develop characters and plant hints for future story development. In anime, however, production of a weekly series won't begin without development of (at least) thirteen episodes. This locks the staff into certain character relationships. Changing these from the ground up is a way of bringing back popular characters in fresh contexts.

Tenchi Muyo is not the only anime franchise in which the viewer is handed a cast of characters, only to see them switch identities and relationships in a different project. It happened to the cast of the *El Hazard* OAV series when it became *The Wanderers*, a weekly television series. It happened to the cast of the *Vampire Princess Miyu* OAV series when it too went weekly. Naoko Takeuchi's magical girl Aino Minako, the star of *Code Name Sailor V*, kept little besides her name and her cat Artemis when she joined the cast of *Sailor Moon*.

And if you think I'm going to tie this in to Dr. Osamu Tezuka—you're right. A number of minor characters reappear in Tezuka manga and anime from one end of his career to the other, forming what I like to call the Tezuka Repertory Company. If, for instance, Dr. Tezuka needed a sleazy impresario for *Song of the White Peacock*, all he had to do was recycle a sleazy impresario from *Tetsuwan Atomu*. The character in *Atomu* known as Hige Oyaji appeared throughout the doctor's career, even starring in the movie version of *Metropolis*, made more than a decade after Dr. Tezuka's death. Thus did the God of Comics solve the pop culture problem of having to be both fresh and familiar.

Metropolis Hige Oyaji *is one of Dr. Tezuka's recurring characters.*

As surely as Bill Haley's "Rock Around the Clock" became the herald of rock'n'roll when it was used in the 1955 film *The Blackboard Jungle,* "Konya wa Hurricane" pointed the way for music that broke the anime mold of cuteness. More than a decade later, the musical palette has grown exponentially, encompassing sounds that range from big-band jazz (the themes to the *Cowboy Bebop* and *Ghost Sweeper Mikami* TV series) to Slavic-sounding choral music (the films *Macross Plus* and *Ghost in the Shell*). The prize for eclecticism probably goes to the *Escaflowne* TV series, whose music ranges from Indian raga to Gregorian chant to classical music evocative of British composer Frederick Delius. Still, the majority of the singers heard in anime are idol singers, and the predominant note is still cute.

This works out well because anime voices need cute as well. A number of pop singers are also *seiyu* or voice actors. That way, if their latest record isn't on the charts, their voices are still before the public. If they're lucky, they'll land a role in a TV series running twenty-six weeks or more, keeping them busy and forestalling the dreaded day that their careers are declared over. Conversely, a dramatic voice role can sometimes be parlayed into a singing career. *Seiyu* also become radio announcers and can even be heard lending their voices to computer games.[2]

Tops of the Pops

Not all singers cross over to anime voice work (or vice versa), but of those who have, the reigning queen is probably Megumi Hayashibara. Not only is she a talented singer, she's able to handle voices for a variety of diverse characters. She sings the title songs for the OAVs of *All-Purpose Cultural Cat Girl Nuku Nuku* and supplies Nuku Nuku's voice; she's the voice of the title character in *Video Girl Ai;* in *Evangelion* she's the soft-spoken Rei Ayanami and (in flashbacks and dream sequences) Shinji's

[2] Speaking of radio, the decentralized nature of Japanese media means that radio is still a major performance platform. A number of anime series were later adapted as radio dramas, some of which have been issued on CDs known as "drama disks."

dead mother Yui.[3] She plays the three different personalities of Pai in *3x3 Eyes*; she's Lina Inverse, the hot-headed teenage sorceress in the sword-and-sorcery parody *Slayers*; she's the rogue gambler Faye Valentine in *Cowboy Bebop*; she's the voice of the android Lime (whose catch-phrase "I may be stupid but I'm the star!" pretty much sums her up) in the *Saber Marionette* stories; and she provides the voice for the female aspect of Ranma Saotome (known to fans as Ran-chan) in *Ranma 1/2*. She has resisted being cast as a single type and has demonstrated a considerable range of talents.

The same holds true for Aya Hisakawa. In 1999 she released a best-of CD called *Decade,* reflecting her ten years as a popular singer. In an industry in which the careers of some stars have the life span of a moth, this is an achievement in itself. But she's also a sought-after voice actress. Her roles include Skuld, the youngest of the three Fates in *Oh My Goddess!* (the themes for this series of OAVs are sung by the Goddess Family Club, made up of Hisakawa, Kikuko Inoue, and Toma Yumi, the three *seiyu* who voice the goddess sisters); the title character of *Iria*, about a futuristic teenaged bounty-hunter-in-training; devil-hunter Yoko Mano; Cerberus, the winged keeper of the Clow Card deck (renamed Kero-chan) in *Cardcaptor Sakura* (known on American TV as *Cardcaptors)*; Miki, the pianist *cum* mathematician whose obsession with his sister Kozue leads to trouble in *Utena*;[4] Arisa, the Rambo-like "office lady" for Mishima Heavy Industries in *All-Purpose Cultural Cat Girl Nuku Nuku*; and she's especially known for playing the bookish student Mizuno Ami who helps save the universe as Sailor Mercury in *Sailor Moon*.

The Composers

We might mention at this point the other end of the creative process: the composer. Songwriting for an idol is pretty thankless, and is shown fairly accurately in an episode of *Key the Metal Idol*. In this

[3] By the way, that's a hint to a key plot point in *Evangelion*.

[4] It's not uncommon for women to perform the voices of young boy animated characters, both in Japan and the United States. Yet the fact that the berserk Dilandau of *Escaflowne* is voiced by a woman is actually a clue to one of that story's bigger surprises.

particular sequence, idol singer Miho Utsuse's producer and the boss of Ajo Heavy Industries are faced with a pile of cassettes. These are demos from songwriters, only a few of which will be chosen for the next Miho album.

Similarly, after she recorded her first album, Megumi Hayashibara decided to try her hand at writing songs for her second album (as documented in her autobiographical manga). She found it to be a lot harder than it seemed, and even her best efforts were torn apart, with a few promising-sounding phrases rescued for submission to professional songwriters. Japan is not unaware of the singer/songwriter; it's just that idols are chosen for stage presence and vocal delivery, not for creative ability.

In recent years, two composers for anime have especially stood out. Joe Hisaishi has worked on almost all of Hayao Miyazaki's feature films since *Nausicaä of the Valley of the Wind* (1984), in a relationship similar to the one composer Bernard Herrmann had with Alfred Hitchcock. Hisaishi's scores are memorable and fully cinematic. He knows full well how to bring out a mood in a given scene, whether it means the use of sound-alikes of familiar Japanese melodies—"Sampo" (Stroll), the opening theme for *My Neighbor Totoro,* sounds like a reworking of the popular postwar song "Konnichi wa Akachan" ("Good Morning Little Baby")[5] and establishes the happily nostalgic mood from the opening frame—or quasi-European music (for *Kiki's Delivery Service*). He also knows when to pull back and let the movie speak in silence. In fact, a number of Miyazaki fans complained that the English dub of *Kiki's Delivery Service* produced by the Disney studios added musical cues where none were originally intended.

The post-modernist prize for anime music composition surely belongs to Yoko Kanno. Perhaps the most creative composer on the scene, this self-trained prodigy started composing songs

[5] The song is also revived for an episode of *Utena*, in which Nanami, sister of the Student Council President, becomes convinced she has laid an egg and prepares for motherhood.

at age three. Her scores are marked by the widest musical palette in the business. Her music for *Please Save My Earth* (1993) is lush, romantic, and nostalgic, in keeping with the story of love and reincarnation, while her "Madame's Memories" (also known as "Magnetic Rose"), the first of the three segments of Katsuhiro Otomo's *Memories* (1995), is a brilliant pastiche of Puccini operas, driving up the tension as space salvagemen are bedeviled by the ghost of an ancient diva (as well as their own past lives). For *Macross Plus* (1994) she wrote songs for virtual idol Sharon Apple in several different languages and idioms, ranging from the raunchy to the angelic. For the TV series *Cowboy Bebop* (1998) she worked almost entirely in big-band jazz, Delta blues, and other American music idioms. Her real gift is her ability to write pop songs that would sound at home in a far-distant time or place. And she still has a long career ahead of her.[6]

As does Maya Sakamoto. She was all of sixteen years old in 1996 when she sang Kanno's theme for the *Escaflowne* series and provided the voice of the series' heroine, high school track star and Tarot-card reader Hitomi Kanzaki. Since then, Sakamoto has voiced other anime series, and is one-half of the pop duo Whoops!!, along with Chieko Higuchi (both girls were *seiyu* in the 1996 *shojo anime* TV series *Mizuiro Jidai (Aqua Age)*. Mainly, though, Sakamoto has been a specialist in the songs of Yoko Kanno, and has recorded several albums of Kanno's compositions (some of which were set to Sakamoto's lyrics). While some of these are the kind of sugary pop confections favored by idol singers, Kanno's work is more often complex and innovative, stretching the boundaries of pop culture music, and Sakamoto's clear, pure voice is a perfect showcase for it. The Kanno/Sakamoto collaboration may yet give rise to a new kind of idol singer in the twenty-first century.

[6] As does one of Kanno's lyricists, an otherwise unknown author named Françoise Robin. Several webpages have suggested that Robin and Kanno are one and the same person.

Macross/Robotech *The ulti-mate weapon against the Zen-traedi invaders is . . . singing idol Lynn Minmay. In what has to be one of the strangest plot twists ever, this sugary pop singer stops the invading aliens in their tracks. It seems they've never heard anything like her simple love ballads and they'll stop fighting to study her and her music.*

Musical Monsters and Messiahs

But enough of real life Let's look at some idol singers as portrayed in anime. The rigors of the starmaker machinery in the real world look like child's play compared with what some anime idols have had to endure.[7]

Lynn Minmay and Company

In a sense, Minmay's the mother of all anime idol singers, having come to life in *Superdimensional Fortress Macross*. This series (and its Americanized version *Robotech*) proposed one of the most outrageous plots in anime: an idol singer bringing peace to two warring galaxies.

[7] Please note: this list does not include rock singers like Priss in *Bubblegum Crisis* or *Cutey Honey*. Their performances do not include the baggage of the idol singer, and they don't make a career out of being cute.

The 1982 TV series turned out to be just the beginning of the *Macross* franchise. In 1993 a six-part OAV series took the story to a higher level. *Macross II: Lovers Again* doesn't focus on the original characters, but preserves the idea of the idol singer as part of global defense. In this series, ten years after the first *Macross*, Lieutenant Sylvie Jeena is both a pop singer and a fighter pilot (at age seventeen, no less). She not only inspires her own forces against the invading Marduk aliens; she also causes a change of heart in the Marduk's own singer/priestess Ishtar. Normally Ishtar's songs rally the alien troops for battle, but after seeing Earth people's happiness brought on by Sylvie's love songs, Ishtar decides to sing for peace rather than war. We are also reminded early on of the limited life of an idol singer when huge projections of a Minmay concert fail to stop the invading Marduk.

This series was followed in 1994 by another series of OAVs (like *Macross II*, this was later stitched together into a feature-length film) titled *Macross Plus*. This time, the idol singer is Sharon Apple, a computer simulation programmed by Myung Fan Lone, a former singer herself who has developed a love/hate relationship with music and is (usually) content to let Sharon be her voice.[8] Being romantically pursued by two test pilots isn't much solace to Myung; in fact, the internal contradictions of such a relationship (and painful repressed memories rising out of the triangle) have an effect on Sharon Apple that puts the entire world in peril. This was Yoko Kanno's first anime score, and the music made viewers sit up and take notice. The songs in the previous year's *Macross II* sounded like the typical idol songs of the day. Kanno created music that seemed to be written in a far future or a distant galaxy, but kept its listener appeal.

And then there's *Macross 7*, yet another variation on the theme. Here a rock band, Fire Bomber, whose members double as soldiers in the battle against space aliens, replaces the idol singer alto-

[8] In 1996, science-fiction author William Gibson published *Idoru*, about a Japanese software idol singer, Rei Toei, and the teenage fan who travels halfway around the world to find her, Chia Pet McKenzie. This book about the future is also an excellent look at Japanese pop culture in the present.

gether. Lead singer and flying ace Basara Nekki prefers songs to weaponry. He also finds out in the course of this long-running series that he's the illegitimate son of the band's guitarist, who has the unlikely name Ray Loverock. The band also includes Mylene, a female vocalist, and a drummer named Bihida from the Zentraedi race. Quite a soap opera.

Miho Utsuse

A major subplot of *Key the Metal Idol* (1994) involves the attempt by Key to change from a robot into a real girl. Her dying grandfather/inventor told her that the change would require the energy of thirty thousand friends. She decides that the best way to harvest such energy is to become an idol singer. The reigning queen of idol singers at the time, however, is Miho Utsuse. She has it all: monstrous stage shows with elaborate theatrical set pieces, a fan-club run by the boyfriend of Key's homegirl Sakura, sellout stadium shows. Key attends one such show and (borrowing a gesture more often seen performed by Tuxedo Mask in *Sailor Moon*) stabs Miho in the chest with a rose, stopping the concert.

Key had realized what the viewer was just beginning to guess: that Miho Utsuse is no longer a real singer. In an inversion of Key's quest to move from robot to human, the onstage Miho was an android, linked to the mind of the real Miho, now a wrung-out, exhausted prisoner of the war-profiteer industrialist Ajo. She's been driven so hard that, lately, another idol singer–wannabe has had to fill in: Beniko Komori, an aggressive young redhead who favors a harder-edged musical sound and leather dominatrix stage costumes. In the final battle, Key comes into her own and literally blows Beniko off the stage with a single note. When Key finally does meet Miho, it's in the very last scene of the series. *Key the Metal Idol* draws much of its plot from the whole starmaker ma-

chinery behind the idol singer, and it's not a pretty picture.

Mimu Emilton

Idol Project, the vehicle in which Mimu appears, was originally a computer-based role-playing game, and has now spawned three anime videos. Mimu enters a competition at the Starland Festival that puts all her abilities to the test: kids in trouble that need rescuing, stages that collapse, ninja crows that attack the stage, space aliens that hijack the competition. The entire thing, unlike *Key the Metal Idol*, is played pretty much for laughs. In this universe, a would-be idol singer just needs a kind heart, a pretty smile, a large dream, and a good sense of rhythm. And cute. Lotsa cute.

Princess Minerva/Cutey Kamen

Princess Minerva is strictly for laughs, an OAV that's a parody of sword and sorcery stories as well as idol singing. Princess Minerva finds life so boring that she sponsors a talent contest, the winner of which gets to be Minerva's bodyguard. However, she can't resist entering her own competition as Cutey Kamen, a double tribute to Go Nagai heroines (Cutey Honey and Kekko Kamen). However, while the android Cutey Honey could convince people that she was a rock singer, Cutey Kamen has a godawful voice and sings to the accompaniment of a mechanical German band.

Minky Momo

Granted, we only see her as an idol singer in the finale of *Minky Momo: La Ronde in My Dream* (aka *Magical Princess Gigi and the Fountain of Youth,* 1985) and then it's her teenaged magical manifestation that takes the stage. She's a hit, but when Minky Momo comes back onstage as a child, nobody recognizes her.

Hummingbirds

Following Japan's surrender to the United States in 1945, the Japanese constitution was rewritten to define its military as strictly a self-defense force. This neutralized the military's ability to make global mischief, but it also left it with time on its hands. This series asks the question, why not just combine the jobs of fighter pilot and idol singer? They wouldn't have much to do anyway, except fly around the country giving public relations concerts.

Needless to say, the winning musical group isn't exactly the Spice Girls. The Hummingbirds are a quintet of sisters, ranging in age from eight to eighteen, and (of course) cute. They occasionally fight off enemies, but see more action against competing bands trying to steal their contracts. The 1993 OAV proved popular enough to spawn several sequels.

Mima Kirigoe

Perfect Blue (1997) shows us the very dark side of idol singing, based on a novel by Yoshikazu Takeuchi. When we see Mima for the first time, it's her last performance as lead singer of the pop idol trio Cham. She's been thinking of a career move away from upbeat tunes, lacy baby-doll costumes and small but devoted crowds. She wants to break into acting, but going that route means racy photo sessions and a part in a controversial television series called *Double Bind,* an elaborate tale of an idol singer whose mind starts falling apart. Then, a website shows up on the Internet in which the old idol-singer Mima persona repudiates her new acting persona, and when dead bodies start piling up, Mima starts losing the distinction between life and art. Thanks to the skills of first-time director Satoshi Kon, so do the rest of us.[9]

Dick Saucer of Dragon Half

A male idol singer for a change, in one of the

Perfect Blue *Mima Kirigoe seems to have it all as lead singer of the pop trio Cham. Trouble comes, however, when she embarks on a new career as an actress. Disturbing websites based on her life appear, and so do dead bodies. Yoshikazu Takeuchi's novel, brought vividly to the screen by director Satoshi Kon, has the flash and slash of a Brian De Palma thriller. Definitely not for kids.*

[9] This was his directorial debut, but Kon came up through the ranks, working with Katsuhiro Otomo on anime such as *Memories* and *Roujin Z.*

funniest anime ever, *Dragon Half*. The title refers to Mink, whose mother was a dragon, and whose father, a knight, decided to marry the dragon rather than fight it. Their daughter may have wings and a tail and be able to breathe fire, but she also has a crush on a hunky human idol singer with an extremely weak voice; he seems to need his microphone more than most. Unfortunately for Mink, he's also a dragon-hunting knight.

There's no possible way to take this OAV or its manga seriously; the gags are nonstop and outrageous, from Tom-and-Jerry slapstick to bizarre wordplay (Mink's father dismissing the idol singer as "Dick Sausage"); and the characters shift into and out of "super-deformed" caricature mode in the blink of an eye. To top it all, there's the show's equally deformed theme, a song about omelets sung to the tune of the final movement of Beethoven's Symphony No. 7. You have to hear this one to believe it.

14

It's Not Easy Being Green: Nature in Anime

*We've already seen pop-culture Japan as a land of balancing acts:
public/private, business/pleasure, duty/desire. What happens when
the split is nature/technology, a dichotomy of global proportions?*

> Do you know that our word for "nature" is of quite re-
> cent coinage? It is scarcely a hundred years old. We
> have never developed a sinister view of technology,
> Mr. Laney. It is an aspect of the natural, of oneness.
> —from *Idoru* by William Gibson

We hear the laments all too often on
both sides of the Pacific. There are
fewer and fewer green spaces left.
Children will grow up never having known ex-
panses of countryside. Wilderness should be pre-
served. And it will be—maybe next year.

Anime has a lot of idealism to offer, but not
much of it gets translated into practical commit-
ment. At least Hayao Miyazaki, having celebrated
the Japanese countryside of a few decades ago in
My Neighbor Totoro (1988) and many other films, has
started buying up tracts of rural land to preserve
for those who would respect and enjoy a non-ur-
ban way of life. He has his work cut out for him.

There's always been a price to pay for progress.
In the medieval Japan of Miyazaki's *Princess Mono-*

noke (1997), forests had to be cleared and the trees burned for charcoal; iron sand had to be dug out of the earth. Just as these actions scarred the land, the movie presents two teenagers who were personally scarred by this advance in technology. Prince Ashitaka, from an isolated tribe in the east, was infected by a monstrous boar he killed. The boar became a monster because it was shot by a bullet—one of the first fruit of the new technology. In seeking the source of the bullet, he meets San, a feral child who, on behalf of her guardian wolves and other spirits of nature, wages war on the polluting humans. It finally takes the Earth spirit, the source of all life, the Shishigami, to bring about a truce between the two warring sides.

Studio Ghibli has done other films on the theme of civilization having separated itself from nature. *Pompoko* (written and directed by Miyazaki's long-time collaborator and studio partner Isao Takahata; 1994) tries to reconcile animal and human civilizations by focusing on a group of *tanuki*: legendary raccoon-like animals with magical powers. These *tanuki* (who in this movie look a little too much like members of the Care Bears™ toy line) create images of fantastic monsters and even take on human form in an attempt (unsuccessful, as it turns out) to stop civilization from encroaching onto their forest. Miyazaki's first masterpiece, *Kaze no Tani no Nausicaä (Nausicaä of the Valley of the Wind,* 1984), gave us a world blighted first by war, then by pestilence in the form of gigantic insects and toxic jungles. Only the title character is able to discover that nature is slowly healing itself, with the help of the very insects that the humans are trying to destroy.

Another Takahata film, *Omoide Poroporo (Remembering Drop by Drop,* usually translated as *Only Yesterday;* 1991) is a fascinating (if sometimes dizzying) series of memories that connect Taeko, an "office lady" in 1982, with her experience of being ten years old in 1966. She remembers her childhood while taking a sabbatical in the country at a

small farm that grows flowers to produce a specific red dye. While not precisely natural, this farm life is pastoral, and very different from Tokyo—different enough so that Taeko is tempted to leave Tokyo for the farm. Even Ghibli's 1995 music video *On Your Mark* contrasts the hostage angel's urban captivity with the wide open spaces.

When Professor Kusakaba in Miyazaki's *My Neighbor Totoro* moves his daughters to a country house, he wants to be closer to the sanatorium where his wife is recovering from tuberculosis. The house, however, has another feature that connects the area to beneficial natural forces: there is a large camphor tree nearby. This tree, called "king of the forest," is already venerated by the locals in the Shinto manner, with a paper rope (called a *shimenawa*) wrapped around the trunk. Of course, such a mighty tree is an ideal home for a Totoro.

In anime, nature is often depicted as double-edged, although the same could be said for the city as a place of both delights and dangers. An animated feature from the Tatsunoko studio dubbed into English and released in 1984 as *The Enchanted Journey* features Glicko, a pet chipmunk who learns that his real home is the forest. Anxious to find it,

Grave of the Fireflies Nature is often a vital character in anime. It can suggest the primeval wellspring of life, as in My Neighbor Totoro, *or its hidden dangers, as in* Princess Mononoke. *In this scene from* Grave of the Fireflies, *the audience is reminded of happier times for the two doomed children, in a city untouched by American bombs.*

he escapes the city, picks up some pointers and a traveling companion at the zoo, and makes his way home. The natural predators he encounters along the way are downright demonic, but the beauty of the countryside keeps him going.

Although there's never an overt plea for conservation, the various TV series and movies in the *Tenchi Muyo* universe have a very definite pro-tree message. Trees turn out to be the guardians of the royal house of Jurai. On that distant planet, certain trees are sentient beings who provide psychic energy to specific partners, retain memory, and are capable of communication. They're actually capable of even greater feats: when Princess Sasami was accidentally killed, energy from Jurai's most important tree, Tsunami, brought her back to life.[1] In the second Tenchi movie, *Manatsu no Eve (Midsummers' Eve)*, a single twig from a Juraian tree is enough of a weapon to vanquish the demon Yuzuha.[2]

Speaking of the demonic, the second OAV in the *Devil Hunter Yoko* series begins with a construction crew breaking the seal on a forest shrine. This looses some demons for Yoko and Azusa to fight, and before the story is over they realize that some parts of nature need to be left untouched.

There is a subtle "city versus country" dichotomy at work throughout *Key the Metal Idol*, as Key's early life in her secluded rural valley is contrasted with the bustle of modern Tokyo. Sometimes this dichotomy is also expressed in the series' "human versus machine" question: what exactly is Key? It's all brought to a head in the concert in which Key sings her song. The song turns out to be one of the oldest archetypes in music, perhaps the first type of song ever sung: a lullaby. Beyond that, the song consists almost entirely of nature images.[3]

Even *hentai* films have shown some greening in recent years. The first film in the *Angel of Darkness* series of OAVs has a science professor at a prestigious girls' academy break the eldritch seal on a

[1] An audience watching the Japanese-language version would find a stronger connection between Sasami and Tsunami. They're both voiced by the same *seiyu*, Chisa Yokoyama.

[2] For more on the trees of Jurai, go to http://www.geocities.com/Tokyo/Dojo/3958/trees.html.

[3] A sample of the lyrics, by writer/director Hiroaki Sato: "Starling, turtledove, gold beetle, and a giant purple butterfly, all in a dream."

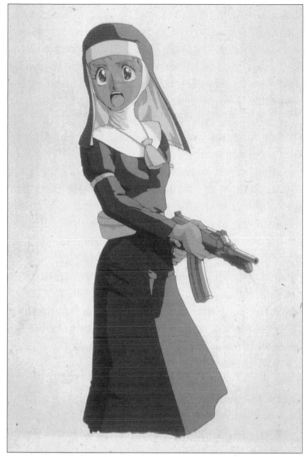

Gall Force: Earth, Chapter One
When aliens invade the sanctuary of the Geo Chris group and threaten the Tree of Life, even nonviolent Sister Sally decides it's time to take up arms. She and her comrades have a single mission: to protect the Tree of Life, gathering its seeds to replenish a blighted Earth.

tree; possessed by an evil spirit trapped behind the seal, he begins to turn into a monster. The only way to combat this force is when the spirits of forest elves enter into and empower a lesbian student at the academy.

In a few anime nature takes its revenge. *Agent Aika, Brainpowered, Blue Submarine No. 6, Yokohama Shopping Journal,* and *Evangelion* are just some of the stories that look to the future and find that the polar caps have melted (for one reason or another), killing billions of people and submerging almost all of Japan. The various stories have slightly different takes on these events: Aika tries to profit by salvaging stuff lost in the flood; Alpha, an an-

© 1989 ARTMIC

Gall Force Sister Sally of Geo Chris gives Sandy Newman one of the seeds of the Tree of Life. Sandy helped save the members of Geo Chris from the aliens, even though they couldn't save the tree. But Sandy—who can remember what growing plants were like—now has the obligation of returning to the surface and planting the tree. Having defended Earth, she must now help reclaim it.

droid, runs a coffee shop on the road to Yokohama (now just a lonely country backroad) to serve those who still make the trip; and *Evangelion's* Misato Katsuragi, whose father was killed in the big meltdown, still sings the praises of air conditioning (in what has become year-round summer in Japan) as "the triumph of man over his environment." All three share the view that life (of sorts, in Alpha's case) still goes on.

Other cautionary tales take place in the past rather than in the future. *Please Save My Earth* has its septet of scientific observers arrive at a moon base thousands of years ago to track the evolution of life on Earth. Unfortunately, they neglect to monitor their immediate surroundings, and a plague cuts their observations short—until they are reincarnated in Japan. Similarly, in *E.Y.E.S. of Mars*, the people of that planet, having screwed up their environment and their hopes for survival for a second time, launch their souls from Mars onto the planet that will be called Earth.

Green Earth, Blue Cat

One of the biggest names in Japanese pop culture, *Doraemon*, isn't too well known in the West. The title character of the manga series by the team of Fujio Fujiko[4] is a blue robot cat with a magical kangaroo-like pouch. He befriends a schoolboy named Nobita and they share hundreds of fantastic adventures. The comic started publication in 1970 and was first animated for television in 1979. An annual feature-length Doraemon film is a staple of spring in Japan, and Doraemon merchandise still floods the country,

Although written and animated for a grade-school audience, *Doraemon* has served up stories that can be called environmental.[5] Eri Izawa describes the 1974 manga episode "Wolf Family":

Nobita and Doraemon seek to help hunters who want to find (and kill) the fabled (and recently ex-

[4] The name, which sounds like the pen name of a single cartoonist, represented the team of Hiroshi Fujimoto and Motoo Abiko.

[5] Information about these *Doraemon* stories is from Eri Izawa's essay "Environmentalism in Manga and Anime," which can be found at http://www.mit.edu/people/rei/manga-environmental.html.

tinct) Japanese wolf, based on a report that the wolves had been seen nearby. Doraemon transforms Nobita into a wolf to help in the search. The wolves find Nobita and accept him as family, and Nobita learns of their difficult life, of how they lived peacefully before the humans came and began exterminating them. Upon returning to human form, Nobita changes his mind; he no longer wants to hunt the wolves, and would rather protect them.

This is superficially similar to any of a number of Western cartoons, especially Disney's, which anthropomorphize animals or inanimate objects: *The Lion King* and *Beauty and the Beast* are prime examples. However, the Japanese—and other Asians with a Buddhism-influenced culture—have a very different, non-Western approach to humanizing the non-human.

Buddhism's keynote is a sense of compassion for all sentient beings. In the rite known as *kuyo*, the Japanese even extend this compassion to inanimate objects. The scholar Hiroshi Wagatsuma has described a "memorial service" held for sewing needles that were broken or blunted and no longer useful: they were placed in a block of tofu, thanked for their service and told that they could now rest in peace.[6]

This may seem the height of silliness to an outsider, but it is simply a display of respect and gratitude for services rendered—a very large part of the Japanese culture. To a great extent, environmentalism itself is nothing more than that: a respectful recognition that humanity is dependent upon nature, rather than divorced from it. Unfortunately, rituals such as *kuyo* often fail to solve the real problem, serving only as a formality, a way of placating one's conscience before going back to business as usual.

Another *Doraemon* episode mentioned by Izawa is rooted in the nostalgia that informs much of even the most radical Japanese pop culture. Nobi-

[6] Cited in William R. LaFleur, *Liquid Life: Abortion and Buddhism in Japan* (Princeton, New Jersey: Princeton University Press, 1993), 143–45.

ta's parents are shown lamenting that they used to be able to sit at night and listen to the songs of dozens of different insects. They are now part of the suburbs, though, and Nobita wonders what he's missed. In the end Nobita and Doraemon realize that most of the insects have moved on or disappeared—except for cockroaches. The punch line is at once funny and sad.

The Doctor

Dr. Osamu Tezuka used his comics and animation to preach against pollution, among other social problems. We see it clearly in *Jungle Emperor* and *Leo the Lion*, stories set in a natural world in which almost any appearance of a human is potential pollution. We see it indirectly in *Kurubeki Sekai,*[7] a 1951 science-fiction story in which a "dark gas" from space threatens the Earth (as the story was written during the Korean War, the gas could also be seen as metaphorical "war clouds"). The message was especially explicit in the "Black Rain and White Feather" episode of the manga *Unico,* as the heroine's health was threatened by pollution from a totally automated factory.

Tezuka's voice of conscience continued to speak even after his death in 1989. In 1996 master animator Osamu Dezaki (who started out as a student animator with Tezuka's Mushi Productions in 1963) directed and co-wrote a feature film based on one of Dr. Tezuka's most popular creations, Black Jack. In this feature, a spore that grows in a small corner of an isolated desert bestows both wonderful and horrifying side effects. These can be controlled by the extract of a certain plant. By the end of the film, however, a scientist announces that the plant can no longer combat the effects of one strain of the virus carried by the spore. He blames pollution, the fouling of the planet's air and water, and tells both his audience and the viewer to do something: "The Doomsday Clock is ticking!"

[7] The title literally means "the world to come" and has been translated "Next World," but Dr. Tezuka was directly inspired by the 1936 British film *Things to Come*, directed by William Cameron Menzies with a screenplay by H. G. Wells.

After sitting through this movie, you realize that the scientist isn't crying wolf. Unfortunately, such anime treatments of environmental themes are about as far as Japan (or the United States) seems to be willing to go. In a world where industrial development equals progress and progress means being taken seriously as a nation by other industrial powers, there are simply too many built-in incentives not to clean up humanity's messes. Platitudes about green space may make one feel good, but at some point someone will have to actually try to preserve the Earth. The planet cannot live on pop culture alone. But at least anime can be part of the road map reminding us of where we want to go.

War Is Stupid:
War and Anti-War Themes in Anime

Countless battles have been fought in Japan's long history, even though
World War II—terminated by the atomic bomb—sets the tone of most
anime. Japan's view of pacifism thus carries considerable weight.

> Violence never solved anything.
> Trust me; I'm a military man; I know these things.
> —from the anime *Final Fantasy* (1994)

In its long history Japan has seen periods of nearly incessant warfare, but also hundreds of years in which the country was at peace, both at home and with its neighbors. This history contributes to Japan's current popular culture view of war: a view that is complex, if not conflicted. Wars are still fought in anime, and warriors are praised for their fighting spirit, yet a pacifist belief in the ultimate futility of war tempers these mixed messages.

Anime depictions of war can be divided into: (a) real wars Japan was involved in, (b) fictional battles involving Japan (past, present, or future), and (c) battles with little or no connection to Earth, except that at least one of the combatant species is humanoid. The more distant the action is from any real military, the easier it is to root for one side or another without feeling like a combatant.

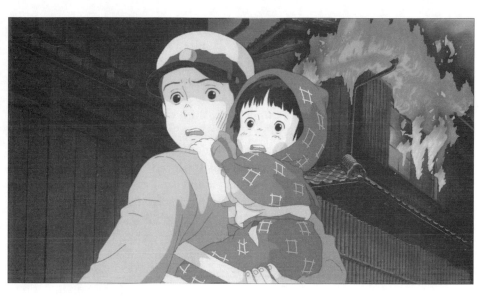

Japan at War

Perhaps the most controversial genre of anime in
some circles, even more controversial than pornog-
raphy, is anything to do with Japan during World
War II. Intended as they are for domestic consump-
tion, Japanese pop culture depictions of the war
come from a perspective that non-Japanese often
find problematic. Specifically, outsiders have diffi-
culty seeing Japan as a victim, the stance that is
presented in most Japanese retrospectives on the
war. Disturbed by the fact that these comics and
movies do not depict Japan's responsibility for the
war or show Japanese soldiers committing atroci-
ties, foreign critics tend to dismiss stories of Japa-
nese deaths on the battlefield and privations on
the home front. When Japanese pop culture de-
scribes the suffering of the Japanese people, the al-
most inevitable critique in some circles is, "What
about the Bataan death march?"[1] What this atti-
tude overlooks is that many Japanese experienced
the war years as civilians. For them, the war was a
time of terror and privation due to events that
seemed largely, if not entirely, beyond their control.

Isao Takahata, the director of the anime version
of Akiyuki Nosaka's novel *Hotaru no Haka* (*Grave of*

Grave of the Fireflies Seita car-
ries his sister Setsuko through
a firestorm, as their neighbor-
hood is bombed by American
napalm in World War II. No
history book can adequately
capture this image, but surely
it has recurred in most of the
wars fought since the begin-
ning of civilization: children,
separated from their parents,
running for their lives.

[1] The author saw this response
in the guestbook of a website
dedicated to the treatment of
Japanese-Americans sent to
internment camps. Some people
just don't know how to behave
as guests.

the Fireflies, 1988), set out to tell a very specific story about two children who starved to death near the end of the war. Keiji Nakazawa, in his semi-autobiographical *Barefoot Gen,* set out to tell a very specific story about living through the atomic bombing of Hiroshima and its aftermath. Nakazawa, in hindsight, attacked Japanese militarism; *Hotaru no Haka,* in contrast, for the most part leaves politics alone as irrelevant to the lives of two orphaned children. In either case, it is difficult to see how issues such as Japanese war guilt or atrocities in Asia or the Pacific could be introduced as anything other than an artificial and ideologically driven digression from the stories these films are trying to tell.

Contemporary stories involving Japan in fictional wars can be just as controversial as looking at the very real war in the recent past. These stories also test the author's creativity, since the postwar Japanese constitution limits the country's military to a self-defense role. The manga *Silent Service* by Kaiji Kawaguchi (animated in 1985 by director Ryosuke Takashi) gets around these limitations with a Tom Clancy–style story set in the near future. In it, the United States and Japan have been jointly working on a secret weapon, in clear violation of the Japanese constitution: a new class of nuclear-powered submarine.. The prototype, a vessel dubbed the *Seabat,* is so secret that another Japanese sub is "sunk" and its crew listed as presumed dead in order to provide the personnel to man it.

The sub's commander, Captain Kaeda, has no use for the political machinations on both sides of the Pacific, and hits on an extreme form of protest: rechristening the sub the *Yamato* (the ancient name of Japan, and also the name of the most powerful battleship in Japan's World War II fleet), he declares it to be a sovereign nation (complete with twelve-mile boundary) and (maybe) nuclear weapons. He simply wants to demonstrate that, even though the Cold War is over, some mentali-

Silent Service Captain Kaeda leaves one assignment behind to take on another: helming the secret nuclear submarine Seabat. When he realizes that the sub is being used as a pawn in superpower politics, he declares his independence. His thoughts and actions are those of a samurai; because he has already been declared "Missing, Presumed Dead, " he has no thought for his own life.

ties haven't changed, notably those of the United States. In spite of public statements that Japan is an equal partner, the United States has persisted in treating Japan as if it were a client state, and in this story the White House has even drawn up contingency plans to re-occupy Japan should the need arise. The subject of *Silent Service*, which upset superpatriot Americans, was not "Jap treachery" but American treachery.

The United States also comes in for some lumps in "Stink Bomb," the second part of *Memories*, a 1995 release based on a trilogy of manga by Katsuhiro Otomo. A nerdy lab assistant, looking for a prototype cold remedy, accidentally swallows a prototype bio-weapon instead. He develops a literally killer case of body odor in a story that is by turns humorous and harrowing. As he nears Tokyo, the government decides that they have to kill him, but this is vetoed by an imposing black officer in a military uniform with "U.S." displayed prominently on the lapels. It seems that funding for this weapon came covertly from America, and the Americans want to keep the plague carrier alive for study. As anyone could predict after seeing any of the *Alien* movies, trying to hold a deadly weapon for observation usually backfires.

Jin-Roh Under battle gear with hints of Nazi uniform design is Kazuki Fuse, an elite Japanese soldier dedicated to stopping the streetfighting and terrorist bombing that is breaking out in an alternate-history Japan. After he witnesses one suicide bombing—by a teenage girl— he starts to question his mission in life.

Japan at War—Sort of

The third segment of *Memories* deals with war in a different way: it looks at a society where war is taken for granted. "Big Cannon City" is nothing more than a day in the life of a family in a town where every waking moment is dedicated to a strange and undefined war. Nobody ever sees the enemy, because they live in "moving cities." Colossal cannon are fired at wherever these cities are supposed to be, except that this is Victorian-era hi-tech of the genre that has come to be called "steampunk," and the cannon can only be fired up to four times each day. Even the language reflects the society's obsession with the war: instead of father and son saying *ittekimasu* (a standard Japanese goodbye, literally meaning "I'm going but I'll be back") when they leave the house in the morning, they say *"shoottekimasu."* Apart from a few union organizers trying to alert cannon workers to toxic conditions, nobody seems to see anything wrong with their dreary and pointless way of life.

Jin-Roh (1998) is a film written by Mamoru Oshii (director of *Ghost in the Shell*), directed by Hiroyuki Okiura (who has worked on *Akira*, *Memories*, and

196 | **ANIME EXPLOSION !**

Jin-Roh Fuse gets too close to his subject, as he meets and is drawn to the older sister of the "Red Riding Hood" suicide bomber. Once the bomber stops being part of the student mob and starts wearing a face, no amount of high-tech armor can protect Fuse.

Ghost in the Shell, among many others), and based on that science fiction staple: the alternate history. In this case, in a reimagining of the post–World War II era, Japan borrows from the worst of Nazi society, including hi-tech soldiers who patrol the streets, looking for Red Riding Hoods. This is the fanciful name given to terrorist bombers (usually young girls) who try to resist Japanese Fascism. *Jin-Roh* starts when one soldier, Kazuki Fuse, sees Nanami, a Red Riding Hood, set off a bomb, killing herself in the process. Drawn against his will to her funeral, trying to understand what drove such a child, he meets Kei, the bomber's older sister. Their inevitable affair pushes Fuse to start questioning the military that he has blindly served.[2]

The Big One

The atomic bomb appears in several different disguises in Japanese pop culture, including the historical bombs of 1945. When *Aki-e no Komichi (The Path to Autumn)*, a *shojo manga* by Hideko Tachikake, was published in book form in 1985 after being serialized in *Ribon* magazine, the last four pages of the book carried an autobiographical piece, "Watashi no Kyofusho" ("My Morbid Fear"). The artist talks about her obsessive speculations about death—speculations that trace back to her connection to World War II. Her mother, she notes, was born in 1932, lived through the war, lost her father who was fighting in the South Pacific, and

[2] Even as this chapter was being written and *Jin-Roh* was being shown on a limited basis in the United States, the terrorist events of September 11, 2001 claimed (by some accounts) 3,000+ lives. It would hardly seem to be the time or place to talk about a movie in which a suicide bomber was the "good guy." Yet, at the risk of offending some sensibilities, I have to point out that one man's terrorist is another man's freedom fighter. This is precisely the moral dilemma faced by the protagonist of *Jin-Roh*.

still panics if a movie on TV sounds an air-raid siren. In the end Tachikake adds her voice to the cry of "No more war!" uttered by none other than pop singer Boy George, whose band Culture Club had an anti-war song on the charts at the time. The ending can seem silly, and the impression is reinforced by the fact that Tachikake draws herself in "super-deformed" mode. Only the realization that she means every word of this story saves it from triviality.

Barefoot Gen is about Hiroshima and its aftermath, so of course the bomb figures prominently. Manga artist Keiji Nakazawa appears as Gen Nakaoka in this semi-autobiographical story, animated in 1983. The visual style is simple, and very cartoonish—until the moment of the explosion. Then the audience sees—in slow motion—the various ways the bomb killed the people of Hiroshima on August 6, 1945. Few of these hellish images were based on the manga, but one powerful image appeared both in print and on the screen: the image of a horse galloping down the street in panic, its mane on fire.

The bomb appears by allusion in the 1998 anime of Hiroshi Takashige's manga *Spriggan*. America's Central Intelligence Agency controls a so-called Machiner's Platoon made up of cyborg soldiers. Two of these soldiers are nicknamed after the bombs America dropped on Hiroshima and Nagasaki: Fat Man and Little Boy.

Gall Force: Chikyusho 1 (*Gall Force: Earth, Chapter One*) is set in a distant post-atomic-war future. The superpowers have blighted the planet, but have hidden a total of thirty bombs "just in case." These bombs are discovered and almost used against an invasion of aliens—but that plan is abandoned at the last minute, partly because nobody wants to unleash the horror again.

In another story, set a thousand years after nuclear annihilation, somebody is indeed ready to unleash it again. Hayao Miyazaki's *Nausicaä of the*

Valley of the Wind), shows an Earth with a disrupted ecosystem, ravaged by giant insects and toxic jungles. It also gives us an elaborate metaphor for the seven-day atomic war that brought this all about: seven gigantic faceless beings called God-Soldiers. They were believed to have perished in their own fire, but the big-as-a-house heart of one God-Soldier has survived, still beating. Queen Kushana of Torumekia is bent on regenerating the last God-Soldier as a weapon against the giant insects. However, she uses it before it has finished regenerating and, after one powerful attack, the nascent God-Soldier falls apart.

Science fiction such as *Nausicaä* is politically safer (for the most part) than history, and futuristic warfare is a science-fiction staple in anime, reflecting the influence of Western movies such as *Star Wars.* One recurring theme in these future-war movies is that the ultimate weapon may in fact be too much for us to handle. *Memories* and *Nausicaä* sounded that theme; this is also the dilemma of *MD Geist* (1986), about an enhanced biomech warrior who functions as an awesome one-man army. His existence, however, begs the question of what to do with him in peacetime.

Reiji Matsumoto created three manga reflections on the war that were animated in 1994 as a feature titled *The Cockpit.* The first story, "Slipstream," poses an interesting question: what if the Germans had developed the atomic bomb, as they were known to be trying to do? Matsumoto's protagonist, a Luftwaffe pilot named Erhardt von Rheindars, is assigned to guard the German bomb. His decision to deliberately fail the mission is understandable, given that von Rheindars has been a single-combat knight now threatened with retirement because of a weapon of mass destruction.

Wanna Buy a Gun?

Since World War II, Japan has been more inclined toward trade wars than the shooting variety. But

the worlds of military and money come together in the arms dealer, who has become a handy villain in modern anime. The head of Ajo Heavy Industries in *Key the Metal Idol* does much more than promote idol singer Miho Utsuse; he uses her stage shows to help develop battle robots that can be controlled by the mind of a single person. He doesn't even do it for the sake of the nation; he just wants to market the technology to the highest bidder.

Looking back to medieval Japan, Lady Eboshi in Hayao Miyazaki's masterpiece *Princess Mononoke* is a different kind of war profiteer. On the one hand, she demonstrates humanism rare for her time in establishing Tataraba ("Irontown" in Neil Gaiman's English adaptation). Lady Eboshi created employment for lepers, prostitutes, and the dregs of Japanese society by putting them to work in her colossal iron smelting works. On the other hand, they do not make pots and pans, forks and knives. Rather, they make guns and bullets, which are eagerly purchased by warlords jockeying for political power. It's bad enough that Eboshi is a war profiteer; she is destroying Japan's ecosystem in the process. Miyazaki intends the viewer to note that the two forms of pollution are related, as in *Nausicaä*.

The ultimate weapon meets the war profiteer to disastrous results in *Iria: Zeiram the Animation* (1994).[3] In a plot with more than a nod toward Ridley Scott's *Alien* and its sequels, an indestructible and unstoppable monster, called Zeiram, is causing interplanetary havoc. However, he's not the villain of the piece. That place is reserved for Vice President Putubai of the Tadon Tibaday Corporation. He tried to harness Zeiram for use as a weapon but (of course) couldn't, leading to the deaths of dozens of people and the need for an elaborate cover-up.

Katsuhiro Otomo's *Roujin Z* (1991) has a more humorous take on economic militarism. The gov-

[3] The title distinguishes this film from the live-action sci-fi film *Zeiram*, which told essentially the same story.

Roujin Z Sometimes it seems that it would take the Buddha himself to stop our headlong rush toward war, and that's sort of what happens in Roujin Z. A mechanized hospital bed runs riot, building onto itself with whatever's handy. Since the occupant of the bed wanted his wife to take him to the beach at Kamakura, the bed picks up a landmark along the way: Kamakura's giant bronze Buddha statue.

ernment ministry in charge of health care for old folks introduces a semi-sentient hospital bed. This automated marvel provides for all the patient's needs, from feeding and cleaning to entertainment and physical therapy. However, the bed also exists to test prototype circuitry that will be used in warfare. Unfortunately for the government minister who thought up this scheme, he didn't count on some college students and old-age pensioners hacking their way into the bed's main brain. . . .[4]

At the far humorous end of this continuum is the current president of Mishima Heavy Industries, Akiko Natsume. When her father was still running the corporation, she fell in love with and married Kyusaku Natsume, one of the company scientists. However, when Natsume realizes that the NK-1124 android he is working on is supposed to be used in warfare, he steals it and the couple's son, Ryunosuke. He modifies the android to be a companion to the boy, but since this is a comedy, the biological component of this biomech android can't be human. This wasn't the place for the existential angst of Paul Verhoeven's *Robocop* or Mamoru Oshii's *Ghost in the Shell*. This android is driven instead by the brain of a stray cat, one that Ryunosuke befriended and that was killed during a strafing run by Akiko's Office Ladies. What results is Nuku Nuku, title character of a series of OAVs released between 1992 and 1994, whom Antonia Levi has called "an ultimate weapon which can be easily distracted by a ball of string."[5]

[4] Antonia Levi talks about *Roujin Z* as if it were a sequel to *Akira*. Both are based on manga by Katsuhiro Otomo, but Levi missed the fact that *Akira*, a deadly serious dystopian fantasy, was the exception to Otomo's work rather than the rule. Bottom line: *Roujin Z* is *funny!* See Antonia Levi, *Samurai from Outer Space: Understanding Japanese Animation* (Chicago: Open Court, 1996), 118.

[5] The name seems to be partly based on its model number (NK-1124), partly a babytalk variant on *neko*, the Japanese for "cat." Actually, *nuku nuku* appears in the dictionary, and has the very catlike connotations of "warmly, snuggly, carefree," etc.

Gundam Wing Just as Relena Peacecraft is the voice of absolute pacifism, Dorothy Catalonia is her opposite number: a girl whose eyes glaze over blissfully at the prospect of war. She's in love with the spectacle of battle, with the chance for warriors to prove themselves. The concept of "casualties " seems never to have occurred to her.

[6] The various suits of body armor used by OZ are named after signs of the Zodiac.

Give Peace a Chance

Finding humor in war itself (or rather in the inability of war to accomplish what can best be done by peaceful means) is the territory of the animated television series and OAVs known as *Irresponsible Captain Tylor* (1992). Based on a series of novels by Taira Yoshioka, this story tells of a youthful spaceship commander in charge of a ship with a misfit crew and even a misfit name: the *Soyokaze (Gentle Breeze)*. It's the only ship of the line whose bridge includes that staple of Japanese bars: a *tanuki* statue. In other words, Tylor is more fraternity party animal than samurai warrior. His response to military threats is swift and unconditional surrender. Yet, somehow, everything always works out for the best.

A very different kind of science-fiction critique of war is the TV series *Shin Kido Senki Gundam W (New Mobile Report Gundam Wing, 1995)*. This forty-nine-part story is only one recent manifestation of the Gundam franchise, which has been animated one way or another for two decades. In this manifestation, there is war tension between the Earth, which has combined all nations into a world government, and the outlying space colonies. These tensions are in fact being aggravated by a faction of the Earth military (a secret society calling itself Organization of Zodiac,[6] or OZ) and the greedy industrialists of the Romefeller Foundation. Military repression by OZ begets military response (in the rebel group White Fang, and in a breakaway faction of OZ that swears allegiance to one of its generals), but there are two main forces countering the war-hungry on both sides. One is a quintet of teenage boys, each piloting a giant humanoid robot known as a Gundam (having been built of indestructible Gundanium alloy). These warrior robots wreak whatever havoc they can on the military, although the pilots' lives and psyches are often threatened in the process. The second countervailing force is the absolute belief in pacifism embraced by Relena Peacecraft. Her father,

The Irresponsible Captain Tylor Warfare, Captain Tylor style. Instead of blasting away at the incoming enemy fleet, his strategy is to sit down and have a few drinks with the alien Empress. Even better if the Raalgon Empress is a giggly teenage girl with a taste for Audrey Hepburn movies. . . .

the Foreign Minister of Earth, is assassinated early in the series, and she sets out in her own way to bring a nonviolent end to the war. As TV series go, this is an oddity, with the action switching between giant robots blasting each other apart and talking heads debating the practicality of pacifism. But this conflicted series about the future may be the best commentary on Japan's conflicted past and present regarding warfare.

Peace as Kids' Stuff

Even the most juvenile modern animation can contain an anti-war message. Such is the case with the 1985 film *Minky Momo: La Ronde in My Dreams* (released in the West as *Magical Princess Gigi and the Fountain of Youth*). The titular magical girl watches her earthly foster parents take off for a tropical vacation, then investigates when their plane vanishes. The jet has been hijacked by Peter Pan(!), who controls a Fountain of Youth, and (true to his belief that one should never grow up) has been reverting grownups back to childhood. Even in this story, we see the forces of the world military trying to take over the fountain. In the end, Peter packs everything up and leaves the planet, restoring the former grownups and saying that the Earth

isn't ready for what the Fountain of Youth has to offer.

More often than not, though, anime views of war are through the victim's eyes—and if the victim is a child, so much the better. We in the audience may see through the eyes of the orphans doomed to die in *Grave of the Fireflies*, or the children in the Peter Pan–created paradise who need to be rescued by Minky Momo. We may see through the eyes of Shion, the orphan with telekinetic powers in *Please Save My Earth*, or of Chitose Kobayashi, whose story of having to flee formerly Japanese-occupied Korea after World War II is the subject of *Rail of the Star* (1993, directed by Toshio Hirata).

By viewing the world of war through the eyes of children (including adolescents), the Japanese pop culture is able to sustain its currently predominant vision of war. By focusing on people who cannot be considered combatants in any sense, and identifying with them, the Japanese audience can accept that World War II was less about a half-century of imperialist expansion than about its innocent victims. Whether the war was started by Japanese or *gaijin* becomes immaterial. The larger truth is maintained: war victimizes children.

The victim perspective is carried over from Japanese children to Japan itself. Elsewhere in this book Japan's tendency to view itself as a David surrounded by global Goliaths has been discussed. When pop culture reminds the modern-day audience of the odds against Japan during the war, any film showing the absurdity of Japan getting into the war states a message that is pacifist without being disloyal. An audience that watches the submarine *Yamato* take on the rest of the world in *Silent Service*, or sees the hulk of the battleship *Yamato* before it becomes the framework for an interstellar spaceship in *Star Blazers*, feels no irony in asking itself: "What were we thinking?"

The Battleship *Yamato*

Reiji Matsumoto is known for his impressive themes, plots, characters . . . and vehicles. Hardly any other creator of anime or manga has brought so many fanciful modes of transportation so vividly to life. Think of the interplanetary cruiser disguised as a steam locomotive in *Galaxy Express 999*, or *Queen Emeraldas* and the spaceship built out of an old pirate schooner.

Most American fans were first made aware of these marvels when Derek Wildstar walked on what was once the bottom of the Pacific Ocean in the first episode of *Star Blazers* (1974). Known in Japan as *Uchu Senkan Yamato (Space Battleship Yamato)*, the series featured a spaceship built onto the hull of an old battleship. To Americans, this might just be a fancy design concept. Japanese viewers know, however, that this isn't just a random battleship it's the *Yamato*.

As international tension rose in the late 1930s, a naval arms race ensued, and the Imperial Japanese Navy was aware the United States would be a formidable enemy, much richer in manpower and material than Japan. Their response was to protect themselves with the ultimate battleship. The *Yamato* and her sister ship, the *Musashi*, were the largest and most powerful battleships ever built. Completed in December 1941, as Japan plunged into war with the U.S., the *Yamato* (the ancient name for Japan) was built in the Mitsubishi Shipyards in Nagasaki. At 863 feet long (almost three football fields), it was bigger than most aircraft carriers of the day, and required a crew of 2,500 men. Its main weapons were nine cannon, mounted on three triple-gun turrets each capable of firing shells eighteen inches in diameter—a design that remains in the space-cruiser version, which shoots laser beams instead of artillery shells. (For comparison's sake, the next largest Japanese battleship, the *Nagato*, was 725 feet long, carried a crew of 1,368, and had eight cannon firing 16-inch shells.)

The sheer size of the *Yamato* was also its great weakness: all that power came at the expense of speed. It couldn't go any faster than 27 knots. Because the *Yamato* could not keep up with fleet carriers, the Imperial Navy was reluctant to use her as a carrier escort.

In April 1945, *Yamato* was sent on what turned out to be a suicide mission, a last-ditch effort to stave off the Allied invasion of Okinawa. Attacked by nearly four hundred planes, it was hit with between eleven and fifteen torpedoes and seven bombs. One of the torpedoes happened to hit the ammunition hold: The resulting explosion split the hull of the *Yamato* in two, and the ship sank with the loss of nearly its entire crew. This event marked the end of the Imperial Japanese Navy, but not (if *Star Blazers* is to be believed) the end of the *Yamato*.

What Goes Around

Children may be victimized by war, but children still grow up into the adults who wage the wars. Only a few anime focus on adult combatants; many of these, which paint a bitter and unglorious picture of war, are based on the work of Reiji Matsumoto. In addition to the *Star Blazers* series and the five feature films based on the space cruiser *Yamato*, and other science fiction battles involving Captain Harlock, Queen Emeraldas, and other major characters, there is the trilogy of World War II stories by Matsumoto collected as *The Cockpit* (1993). All of these point out the dirt and death of war, while romanticizing it at the same time.

On an adult level, the 1986 anime *Windaria* is one of the finest expressions of antiwar sentiment that isn't couched in modern-day or futuristic terms. The film starts out as heirs to the thrones of neighboring kingdoms meet in the woods in secret to declare their love and their refusal to accept their countries' war fever. However, when their parents die and they must lead their countries, *giri* (obligation) raises its ugly head. Rather, *giri* runs headlong into personal desire (*ninjo*). The only way that they can avoid fighting their parents' war, and thus each other, is through death. In a surprising and moving scene, the princess kills her beloved, then herself.

Rather: it's surprising to us in the West. The Japanese would have seen it all before. The ritualistic Kabuki theater has a number of staple plots, like anime, and one of these is for two lovers to face the conflict between *giri* and *ninjo*. Their response to the conflict is often *shinju*, a murder/suicide that acts as an extreme form of protest. In spite of its quasi-medieval Western trappings, *Windaria* shows the two lovers taking a very Japanese way out.

We also see it at the end of *Shiriusu no Densetsu*, the Sanrio-produced 1981 anime feature released in the West as *Sea-Prince and the Fire Child*. This fa-

ble also gives us a love affair between the heirs of two warring kingdoms, in this case the kingdoms of fire and of water. At the climax of the film, Syrius, blinded prince of the water kingdom, follows the voice of his beloved Malta of the fire kingdom, heedless of what the sun's rays will do to him. They kill him, and Malta takes his body back into the sea, knowing that she will drown.

If any Western script—animated or live—tried to present an ending like that, the reaction might be, "What a waste!" You should realize, however, that in the culture that gave rise to anime nothing is wasted, and that even the soul is recycled.

Birth and Death and Rebirth: Reincarnation in Anime

In what is probably the most unusual form of conflict resolution in pop culture, some anime bad guys are not destroyed but reborn—literally or metaphorically. Immortality is viewed as a curse rather than a blessing.

The moral universe of anime has its share of internal contradictions (as does Western civilization and its pop culture). On the one hand, the universe is often presented in anime as cold and disinterested in human notions like love and justice. "The Japanese view," writes Antonia Levi, "is that the universe is amoral and the sooner we all accept it, the better."[1] On the other hand, a mechanism exists to restore the balance and undo evil, even though it may take years or even centuries: the Buddhist concept of reincarnation.

Western viewers, who at least pay lip service to the notion that "justice delayed is justice denied," insist on a judicial system that functions solely in the here-and-now. The notion of a speedy trial is written into the Bill of Rights (even if the backlog in the courts at this time means that a civil action can take four years to come to trial—surely an odd definition of "speedy"). The notion of trying and punishing a surrogate is anathema; the notion that, left to itself, the cosmos will work everything out for the best is even more repugnant. Yet these

[1] Antonia Levi, *Samurai from Outer Space: Understanding Japanese Animation* (Chicago: Open Court, 1996), 99.

ideas are intrinsic to the mind-set of the Japanese pop-culture consumer, and are reflected in anime and manga.[2]

The view of the soul embraced by popular Buddhism in Japan comes into play here.[3] With the notion of rebirth into another body comes the assumption that there is a reason why, and an explanation for the specific nature of that rebirth. To answer the question why, Buddhism developed the doctrine of *karma*.[4] Western culture marginalizes belief in rebirth, but Asian cultures have found the concept not only workable but useful, and for centuries it has been a central fact in their lives, even in our own science- and technology-governed times.

Japan, for example, copes with the moral dilemma of abortion with images of Jizo, the bodhisattva regarded as a protector of children. These small stone statues are erected in cemeteries to apologize to a fetus for being aborted, and as a focus for prayers that the soul of the fetus will be reborn into better circumstances. Thus there is a belief (which the West simply does not share) that nothing irretrievable has been lost by an abortion, and that there may be a greater good in the long run.[5] This approach to abortion reflects a broader belief that informs other aspects of Japanese life as well, including pop culture.

A Daimyo's Best Friend

None of this is recent; remember that Japanese culture goes back well over a thousand years and has lots of experience with tales that traffic in a non-Judeo-Christian definition of the soul. Take *Hakkenden*, an elaborate eighteenth-century epic by Kyokutei Bakin that became the basis for a 1990 OAV anime series. In this tale, the *daimyo* Satomi, besieged by enemy troops, rashly promises his daughter, Princess Fuse, in marriage to whoever brings him the head of the enemy general. The next day, Satomi is stunned when Yatsubusa, his

[2] It should also be noted that Japan is one of the least litigious of the developed countries, while Americans seem to run to court at the drop of a hat.

[3] There are, to simplify it a bit, two schools of Buddhism: Theravada, the "old school," is closely tied to the original teachings of the Buddha. Mahayana Buddhism allows for more input from the local culture. Japanese Buddhism, which arrived by way of China, is very Mahayana.

[4] The Japanese use the word *en*, but the Sanskrit *karma* is still the most common usage in the West.

[5] William LaFleur, *Liquid Life: Abortion and Buddhism in Japan* (Princeton, New Jersey: Princeton University Press, 1992), 148–49.

wolfhound, shows up with the head of the enemy commander. Fuse, reminding her outraged father that a samurai's word is his bond, takes the dog to a mountain cave. She spends her time reading religious texts and praying for a human soul to enter her "husband" Yatsubusa.

Her father, however, is so enraged at this state of affairs that one of his servants (himself in love with Fuse) takes it upon himself to shoot the dog. The bullet, however, passes through the dog, killing Princess Fuse as well. At the moment of her death, eight shining stars rise out of Fuse's body, the embodiments of eight Confucian virtues (wisdom, loyalty, sincerity, devotion to one's parents, and so on). These spirits fly off in different directions, and are reborn as eight boys with identical flower-shaped birthmarks. They grow up widely separated, but are brought together by destiny to fight for the *daimyo* Satomi.[6]

Born Again

Consider, in the light of the *Hakkenden* legend, one of several anime starting in 1991 based on *Locke the Superman*, a manga by Yuki Hijiri.[7] Locke is not a Western-style superhero; he is an esper (someone with heightened powers of extra-sensory perception) called in for special jobs. This particular job involves a futuristic *zaibatsu* (multinational corporate conglomerate) that seeks to rule the universe under the leadership of the Great Zog. The corporation's activities are being attacked, however, by another powerful esper, a space pirate named Leon. Of course the story builds to a confrontation between the espers—in space, no less—and if that were as far as it went, the story would be a cliché. The story is saved, ironically enough, by the introduction of another cliché: Leon's sister, the nearly blind Flora, with whom Locke is in love.

Before the final battle, the viewer/reader is given additional information to muddy the ethical waters. Like his sister, Leon is disabled—he has a

[6] From our perspective, Satomi, who indirectly had his daughter killed, scarcely deserves the loyalty and bravery of the eight dog-soldiers (*hakken*) of the title. But our perspective is not the point. They were, in a manner of speaking, the children of Satomi's devoted daughter Fuse and his faithful dog ,Yatsubusa; the dog-soldiers' devotion to their *daimyo*/grandfather is the whole point of the story.

[7] This OAV is titled *Locke and Leon* in Japan, but in the West it is part of a series of tapes collectively titled *Space Warriors*.

prosthetic arm, since the Great Zog destroyed his arm as a child, as well as his sister's vision. Therefore, both sides of the conflict are painted as both sinned against and sinning, victim and victimizer. How does one resolve such a moral dilemma?[8]

This anime takes the novel approach (novel in the West, at least) of reclaiming Leon's soul, although not his body. During their final battle, Leon finally puts all of the pieces of the puzzle together, realizing the harm he has caused in trying to avenge his own wrong. He immediately concedes the match by hurling himself into the sun. This does not, strictly speaking, kill him, since the epilogue of the story shows us Locke and Flora happily married, with a son who is the reincarnation of Leon (the hair is the giveaway). Leon is thus reborn as his own nephew, and becomes the good person he was meant to be through a new upbringing by the justice-minded Locke and the *yasashii* Flora.

Trying to redeem someone like Leon might have seemed futile to Westerners, but in the Japanese belief system based on reincarnation it was the most practical thing to do. The reason why is summed up in the 1999 anime series *Monster Rancher*.[9] A young boy named Genki gets transported to a fantastic world, where he has to fight a Godzilla-like monster named Mu. But he realizes that defeating the physical body of Mu is not enough: "What if he's reborn again and again and again?" Evil, like matter, can neither be created nor destroyed, but it can be changed.

Another rebirth takes place in the third-season story-arc of *Sailor Moon*. The whole thing starts with a geneticist named Professor Tomoe. An explosion in his laboratory almost kills him and his ten-year-old daughter Hotaru. He is offered recovery, for a price, by an alien messenger of a dark interstellar entity with the unlikely name of Pharaoh 90. Under the alien's orders the professor sets out on a search for three pure hearts, within which dwell three talismans: when united, these talis-

[8] Dr. Tezuka called such a dilemma "the egoism of the State" when it defines national policy and employed it in many of his manga, most interestingly in *A Message to Adolf*. Set at first in the 1930s, the story juxtaposes two boys named Adolf, one a Jew and the other a member of the Hitler Youth. But the story does not stop there; in the Middle East of the 1960s the Jewish Adolf has become an Israeli terrorist, surrendering (as far as Dr. Tezuka was concerned) whatever moral authority he gained in the first part of the story.

[9] Based on the video game *Monster Farm*.

mans form a source of power, the Holy Grail. Even without the talismans, the Professor needs pure hearts as medicine for his daughter, who is sickly and subject to strange fits. Consequently, she spends almost all her time at home and is very lonely.

In fighting to keep people's pure hearts from being stolen, the Sailor Senshi find themselves at cross-purposes with two new Senshi: Sailor Uranus and Sailor Neptune, who know only of the impending end of the world should the Messiah of Silence awaken, and are trying to find the talismans to save the world, whatever the cost. Midway through the story-arc Chibiusa returns from the thirtieth century to complete her training as Sailor Chibi Moon by making an important friend back in the twentieth century. After some false starts (including a young boy who is a precocious master of the Japanese tea ceremony)[10] Chibiusa meets Hotaru. Her compassion for Hotaru's loneliness binds them together. Chibiusa is followed to this century by her guardian, Sailor Pluto, who intercedes between the Sailor Senshi and Sailors Uranus and Neptune.

The three Outer Senshi (Uranus, Neptune, Pluto) are found to possess the talismans that form the Holy Grail. However, Professor Tomoe manages to steal both the Grail for Pharaoh 90 and Chibiusa's pure heart to revive Hotaru, at which point Hotaru reveals herself to be another servant of Pharoah 90, a slinky grownup named Mistress 9. Yet all is not lost; Hotaru also is the rebirth form of Sailor Saturn, the only Sailor Senshi with the power to destroy the world. With the help of Sailor Moon (who prevents Sailors Uranus and Neptune from killing Hotaru, since they're afraid either Mistress 9 or Sailor Saturn could bring about the end of the world), Sailor Saturn destroys Pharaoh 90 at the cost of her own life.

We next see Sailor Moon carrying a baby. We can tell from the eyes and the hair that this is Ho-

[10] Quite a few of the holders of "pure hearts" in this story-arc practice traditional Japanese arts (the teamaster, a *taiko* drummer, a karate instructor), but there are also a couple of idol singers, a concert pianist, a little girl who adopts stray cats, a race-car mechanic, the Sailor Senshi themselves (in fact, Hino Rei, who's also a *miko,* is the first to get zapped), and a genetic scientist named Dr. Sergei Asimov.

taru reborn. She's given to her father, who is likewise reborn (in a sense, amnesia having driven away his memories of working for Pharaoh 90), and once Chibiusa has a chance to see Hotaru's rebirth and Uranus and Neptune make peace with Sailor Moon, the story-arc ends happily.

Another literal rebirth comes at the end of *Midsummer's Eve* (1997), the second theatrical feature based on the *Tenchi Muyo* story line. This story manages to overlay three different holidays from two different planets: Christmas from the West; Obon, the Japanese midsummer festival celebrating the annual visit of the ancestral spirits from the land of the dead; and the midsummer Startica festival on the planet of Jurai. Tenchi Masaki, a high-school student whose house is suddenly overrun by aliens (all of them female) is baffled by the sudden appearance of a girl his own age who calls him "papa." This girl, Mayuka, is in fact a clone, created by a demonic spirit attempting to avenge herself against the Jurai royal family. (Tenchi's grandfather was a prince of Jurai before he abandoned the throne and fled to Earth.) In the end, Mayuka is reduced to a gemlike essence, but is reborn in human form, with the consent of the Masaki household.

Redemption

This same theme is played out symbolically in the second feature film based on Osamu Tezuka's character Unico. *Unico in the Island of Magic* has the little unicorn do battle with Kuruku, a mistreated marionette who has learned magic in order to turn the world into toys that he can abuse in turn. Unico becomes involved only by being adopted (temporarily) as a pet by Cheri, whose big brother Toby has apprenticed himself to Kuruku. Unico fights not only to protect Cheri but to reclaim Toby, but he does not win by defeating Kuruku, any more than Locke defeated Leon. Through a compassionate understanding of the wrongs done to Kuruku,

Grave of the Fireflies These children are dead. The main characters of Isao Takahata's Grave of the Fireflies *starve to death just as World War II ends. The only thing that stops this masterful movie from being unbearably depressing is the possibility that they will be reborn into a better world.*

Unico offers his friendship to the puppet. Kuruku, who lived only by his hatred of living things, is undone by Unico's love; in the end, he becomes a simple marionette again. Cheri finds him and, because we know her to be *yasashii*, we know she will not mistreat him, and that history will not repeat itself.

Another symbolic playing-out of the idea of rebirth to a better life, far less benign than Dr. Tezuka's tale, happens at the end of *Grave of the Fireflies*, the melancholy masterpiece from Studio Ghibli. Isao Takahata directed and wrote the screenplay based on a memoir by Akiyuki Nosaka. We learn at the very beginning of the movie that two Japanese children, Seita and his little sister Setsuko, have starved to death just after Japan's surrender in World War II; we then spend the rest of the movie watching in horror as it happens in flashback. At the end of a movie in which fireflies have represented everything from stars in the sky to lights on a distant train, two fireflies representing the souls of the children rise into the night.[11]

A Westerner in the audience, brought up on happy endings, may fail to see how this is anything but a bleak ending. It's definitely sad, but it's not bleak. There is hope in the Japanese cultural perspective that the cosmos will give these two orphans of the storm a second chance, in a place and

[11] The title refers to one other appearance of the insect in this story. The children capture fireflies in a glass jar, using their light for a lamp. In the morning, the bugs are dead and the children bury their husks in a small hole.

time better for them than Japan at the end of World War II.

Similar symbols appear at the end of *Mermaid's Forest*, a 1991 Gothic horror tale by Rumiko Takahashi. This is part of a series of stories by Takahashi in which eating a mermaid's flesh can bestow eternal life—if it doesn't kill you first. In this story, twin sisters competing for the same man set off a decades-long string of tragic events. When at the end one of the sisters dies, the other throws herself into a burning house—followed by the man they fought over. Later, the camera looks up at the sky, showing one shooting star, followed by two others. The symbolism is obvious: the souls of the unhappy trio have been returned to the cosmos.

Such an ending is also alluded to in the first episode of the first *Tenchi Muyo* television series. Tenchi and galactic pirate Ryoko are trapped on the edge of a cliff with the police closing in. Ryoko declares that they may be doomed, but "we'll be stars in the sky forever." This also refers back to the Tanabata legend and the lovers who were turned into stars that meet in the sky only one day a year.

By far the most elaborate statement of the themes of destiny and reincarnation in purely human terms is Saki Hiwatari's anime/manga *Please Save My Earth*. The story begins on another planet, centuries ago, and deals with a romantic triangle that soon takes on a more complex geometry. At base, though, there is still an essential three-sided competition: two men, Shion and Gyokuran, are both in love with Mokuren, who favors Shion. A plague breaks out and, in order to stack the deck in his favor for the next life, if not this one, Gyokuran arranges for only Shion to be inoculated. Sure enough, Shion is the last one left alive. He spends nine desperate years alone, going deeper into madness, before he too dies of the plague.

They are all reborn into modern-day Japan, and

sure enough, Shion's rebirth was delayed nine years, so that he's still a child when his "colleagues" are teenagers. But Gyokuran's plan was only partly successful; it causes a great deal of trouble and sorrow for all concerned, but in the end it does not prevent Shion and Mokuren from being together. In fact, because Gyokuran tried to isolate Shion from Mokuren, the second time around it is Gyokuran who is isolated, by having his beloved Enju reborn as a man rather than a woman.[12]

The Blessing That's a Curse

In contrast to the view of reincarnation, the few depictions of immortality in Japanese pop culture usually show that eternal life has a very steep price. In two stories by Rumiko Takahashi, *The Mermaid's Forest* and *Mermaid Scar*, we meet characters who have lived for hundreds of years. They have tasted the flesh of a mermaid, and most of those who did have lived unhappily ever after. They share the negative, cynical world-view of the Flying Dutchman, the Wandering Jew, and Count Dracula, to name three Western mythic images of immortality.

Speaking of Dracula, there is an entire subgenre of stories in anime and manga drawing on the Transylvanian terror in one form or another. As different as these portrayals are, they share the notion that vampires are discontented because eternal life turns out to be not all that desirable.

Yet people still desire it, because they don't have it. One scientist allows the quest for eternal life to warp his humanity. The third installment in the 1990 OAV series *Cybercity O-Edo 808* features a crazed old industrialist, Shionji, searching for immortality. He can find it only by becoming a vampire. In searching for the means to prolong his life, he used people like lab animals and abandoned his own humanity, according to Remi, an assistant-turned-victim.

[12] "Hold on!" you may be saying. "You said Gyokuran was in love with Mokuren." He was, but he was also attracted to Enju, who actually was in love with Gyokuran. I warned you about the geometry.

The 1988 OAV series *Vampire Princess Miyu* is a chilling set of variations on the theme that immortality corrupts, that it warps both those who have it and those who seek it. [13]

Case in point: Kei Yuzuki, from the second OAV. This student would seem to have it all: wealthy family, good looks, a future all mapped out for him. The problem is, he knows he's a *bishonen*, and doesn't ever want to lose his good looks by growing older. At first, he seeks out a girl he knows is different, even if he can't say how he knows. In reality she's a Shinma, a half-demon named Ranka. She's been draining the life out of students at the school, leaving life-sized dolls behind. However, something different happens this time. Kei realizes that he loves the girl, she loves him in turn, and Ranka turns Kei into a doll. After Miyu banishes Ranka and the curtain comes down (literally; we see the traditional Kabuki striped curtain), marionettes Kei and Ranka dance amid a fall of cherry blossoms.

If not actual immortality, the illusion of immortality—trading in one's skin and bones for a durable metallic body—has long been a science-fiction staple. It is also the keynote of Reiji Matsumoto's classic manga *Ginga Tetsudo 999* (*Galaxy Express 999*). The 1978 anime version as directed by Rintaro (Shigeyuki Hayashi) is focused on the same message—that immortality corrupts—as we follow Tetsuro across the universe in a cosmic steam locomotive. Tetsuro starts out (again in a future dystopia reminiscent of *Metropolis,* with machine bodies at the top and humans living in the slums below) wishing for a robot body to replace his own, because he would then (he thinks) be able to hunt down the robot who killed his mother. He ultimately rejects immortality, with guidance from the mysterious Maetel, who bears a strong resemblance to his mother.

Of all the stops by the *Express,* the stop on Pluto is certainly one of the most visually stunning im-

[13] Since the OAVs, there has been a manga series and a spinoff TV series. As often happens (with *Tenchi Muyo* and *El Hazard,* for example), the characters and the groundrules are rewritten for each new incarnation.

やつはそこで
鉱石探査と分析の仕事を
していたらしい
ある日だしぬけに大きな鳥と
出会ったのだな
鳥は彼にテレパシーで
話しかけたのだそうだ
もちろん ただの鳥じゃない
なにしろ宇宙の中だ

つまり……その……おかしな
ことだが彼に魅力を感じて……
彼と結婚したいと
いったんだそうだ
鳥がそんなことというのは
どうも奇妙なのだが
とにかくそういった

Phoenix *The legendary phoenix has had a place in mythology in cultures all over the world, not just in the West (where it's found yet another lease on life thanks to Harry Potter). Dr. Tezuka's phoenix, the subject of eleven novel-length manga and a feature film, watches over the life, death, and rebirth of several species, including humans.*

ages in all anime. On Pluto, Tetsuro finds out what happens to the humans who trade in their bodies for machines: the bodies are laid out, row on row, beneath the permanently icy surface of Pluto. The entire planet has been turned into a necropolis, and the keeper of these bodies is herself still conflicted over whether she should have traded in her beautiful face and body for a faceless machine.

Reborn from the Ashes

The ultimate expression in Japanese pop culture on the question of death, rebirth, and immortality was created by Dr. Osamu Tezuka. Between 1967 and 1988, he created eleven volumes of stories (and also wrote and directed an anime feature film) in which the central characters, in one way or another, encounter the *hi no tori*—literally, the firebird or phoenix. Like the legendary animal, this phoenix is shown bursting into flame, dying in the fire, and being reborn out of its own ashes. The stories, however, focus on another magical power of

the phoenix: whoever drinks its blood can never die. Dr. Tezuka's phoenix appears in a variety of times and places, even to some non-human characters. Its mission is to remind them of the true nature of the cosmos (true to the Japanese perspective, at any rate). Like the cosmos, the phoenix transcends petty little things like time, space, and human desires, and serves as the embodiment of Dr. Tezuka's humanist philosophy.

More important than eternal life, in the Japanese view of the cosmos, is the intrinsic value of our very limited life: compassion for the essence of a thing. This is a rough translation of the phrase *mono no aware*, and it carries the idea that something may be special precisely because it is impermanent and fated to disappear.[14] This is the meaning of the cherry-blossom–viewing parties held in Japan every spring (and shown in too many manga and anime to count). The blossoms (which some have likened to human flesh) appear for a brief time, then fall to the ground. They are the ultimate reminder that human life is very impermanent, but that, for the short time it's here, can also be very beautiful.

And here, at last, we can see why Japan would make *Titanic* one of the highest-grossing movies in the country's history. Whatever the film's visual or musical attractions may be, the film also fits neatly into a popular culture that finds romantic beauty in a love that lives briefly and dies suddenly. The Japanese have been watching this movie for hundreds of years, on the stages of Kabuki and the Takarazuka Opera, on television, and every spring when the cherry blossoms fall.

[14] Compare this with the scene in Antoine de Saint-Exupéry's children's classic *Le Petit Prince* (*The Little Prince*), in which the title character meets, and thoroughly dislikes, a mapmaker who won't put roses on his maps. Flowers, after all, are ephemeral and of no importance to mapmakers. A Japanese audience would side with the rose-loving Prince, and it should be no surprise that an anime television series was based on *Le Petit Prince*.

Part Two:
Films and Directors

Windaria

Wars are about soldiers; they're also about farmers, lovers, water, trees, vegetables, birds, and the soul. And the high price of duty. So says this classic story.

Anime was on the verge of going international in a big way when *Windaria* came out. The year was 1986, two years before *Akira*. Nothing in American animation existed then, or perhaps exists now, to compare to *Windaria*. In its breadth of story and scope of ideas, this anime feature is actually closer to Western epics such as David Lean's *Doctor Zhivago* than to anything produced by Walt Disney.

Isu's Story

Windaria is a continent (or possibly an entire world) where the small village of Saki (simply called the Valley in the English dub) borders an inland sea. The humble farmers of Saki are concerned about the growing talk of war between Paro (the Shadowlands) and Itha (Lunaria). The two rulers are angry at each other and eager for battle, while their respective children know that a war would shatter their secret love. The peasant Isu, however, gets caught up as a cat's-paw in the growing hostilities. . . .

For those of the post-*Pokémon* generation, *Windaria* looks decidedly old-school. For its time, though, it was state of the art, and its creators had solid pedigrees even then. Director Kunihiko Yuyama began with television, creating animation for the series *Magical Princess Minky Momo*, *The Three Musketeers*, and *Goshogun*. He's gone on to work on *Leda: Fantastic Adventures of Yoko*, *Wedding Peach*, *And So the Summer Began* (the second movie based on *Kimagure Orange Road*), and *Slayers*. He's even directed a two-part *hentai* comedy titled *Weather Report Girl*. His most-seen work, though, is *Pokémon*; he's worked on television episodes as well as three films.

Windaria is based on a novel by Keisuke Fujikawa. It's not surprising that it lends itself to animation, since Fujikawa has also been involved with anime for years. His TV anime resume includes *Uchu Senkan Yamato*, *Cat's Eye* (a TV series about female cat burglars), and several Go Nagai projects, including one of the earliest giant-robot shows, *Grandizer*. At the other end of the scale, he's also written for the Godzilla-silly kids show *Ultraman*.

Fujikawa's novel, read over the beginning and ending as narration, suggests the memoirs of Isu, now an old man approaching death. In the anime, however, we begin with Isu's funeral, even as we hear his voice declare that he almost annihilated all of Windaria, and that he has spent the last decades of his life atoning for what he's done. The look of the characters is decidedly Caucasian, and the whole thing is set in a quasi-medieval past (although with *mecha* and firearms). However, there are a number of points—from the essential to the trivial—that clearly signal the movie's Japanese roots.

1. *The Tree of Life*
This is another movie that, like *My Neighbor Totoro* and *Gall Force: Earth Chapter I*, holds a gigantic tree as an object of respect, even of worship. According

to the farming peasants of Saki, this tree is said to have the power to bring pleasant memories to those sheltered by it. Although the tree grows on the border between the two lands, it is big enough to survive the war between Paro and Itha; because it grows on the border between the two lands, it could not avoid the war. It survives in better shape than the people of Saki.

The tree also symbolizes the purity of nature, as we learn that the war is in great part about water. We briefly meet one resident of Saki, who was driven mad by drinking tainted water from Paro, and are told that in earlier times Itha shared its access to pure water from the inland sea with Paro, but that the access has been limited as tensions grew. Saki, home of the tree, has neither the tainted waters of Paro nor the human-controlled waters of Itha (which is built on land reclaimed from the inland sea and survives only through an elaborate system of locks and dams). So this is yet another case of an anime carrying a subtle pro-green message, quite compatible with Shinto's emphasis on nature and on purity.

2. Daikon

Two of Saki's peasants are Isu and his wife Marin (Alan and Marie in the dub). They grow vegetables to sell in Itha's marketplace. We see them growing tomatoes and lettuce, which aren't exactly culturally specific. However, we also see Isu harvesting a distinctly Japanese vegetable: the daikon. A member of the radish family, the daikon resembles a large white carrot, and can grow to weigh a whopping fifty pounds!

The appearance of a daikon cues a Japanese audience that the people of Saki are rather like Japanese, because they grow a quintessentially Japanese vegetable. You know who to cheer for, even before the plot gets rolling in earnest.

3. Shinju

We've already noted a very Japanese plot device in *Windaria*. Paro's Prince Ahanas and Itha's Princess Jill (Roland and Veronica in the dub) have been lovers since before the movie begins. They have to sneak away from their respective kingdoms, though, to meet on a stone bridge that borders the two lands. They resolve to resist the war fever growing between the two countries.

Although Paro's technology includes machine guns and flying machines, the couple are hampered in their love by having carrier pigeons as their most sophisticated communications medium. In an early scene, we even see Isu take the message from one bird, read it aloud to his fellow peasants, then re-attach it. It's no surprise that the death of one of these birds helps propel the plot.

Both Ahanas and Jill promise to heed the dying wishes of their parents, before realizing that those wishes require them to wage war on each other. This is, therefore, more than just the conflict of *giri* and *ninjo*, duty and desire. They are responsible for whole kingdoms, and can no more ignore the political consequences of their love than Hamlet could ignore the implications of his ghost/father's wishes. Hamlet, after all, wasn't just avenging the death of his father: he was expected to kill a king.

It's an altogether impossible situation, and Jill knows it. When they meet on the bridge for the last time, Jill (who had earlier—and playfully—stolen Ahanas's pistol without his knowledge) shoots Ahanas with his own gun. He lives long enough to tell Jill "I love you" one last time. We then see her raise the gun to her own head. . . . The camera pulls back to a long shot, so we see only the bridge. We hear a shot, a splash, and know exactly what happened.

4. The Dragon Kingdom

This is more an allusion than a direct reference, but it's something a Japanese audience would pick

up on. Isu receives a commission from a shadowy figure (actually a courtier from Paro) promising wealth and power in exchange for carrying out a few tasks. After he does, Isu abandons his wife for a life of drunken debauchery at the court of Paro. The only thing that shakes him loose is an assassination attempt. He sneaks out of the kingdom and returns to Saki, only to find that the war between Paro and Itha had spilled over even into his pastoral valley.

This is similar to the legend of Urashima Taro, a Japanese folktale that appears in a number of variants.[1] In the classic version, the forty-year-old fisherman Urashima Taro abandons his mother and his village to visit the undersea Dragon Kingdom. Finding this kingdom isn't his idea. In some versions of the story, Urashima has simply taken his boat too far out; his nets pull in a huge turtle with a five-colored shell that turns into the Sea Princess Otohime. A version from Okinawa has Urashima rescue a small turtle that is being stoned, kicked, and otherwise tormented by thoughtless children. A few days after Urashima returns the small turtle to the sea, he's visited by a *huge* turtle that invites him under the sea.

In the glorious Dragon Kingdom Urashima is greeted by Sea Princess Otohime, who has fallen in love with the man from the land. She invites him to a marvelous dinner, after which she invites him to her bed. Urashima dallies with Otohime and her ladies-in-waiting for what he believes is three years. When he returns to his village, however, he finds that fifty years have passed, and everyone he knew, including his mother, is either dead or changed beyond recognition.

Other cultures have similar tales, of course. Swiss poet Charles Ramuz wrote a similar story, in which a soldier tempted by the Devil took a three-day pass, only to find that he had been away from his unit for three years. (This became part of Igor Stravinsky's classic musical drama, *L'Histoire du*

[1] Keigo Seki, trans. Robert J. Adams, *Folktales of Japan* (Chicago: University of Chicago Press, 1963), 111.

Soldat.) In America, "Rip Van Winkle" is one of the best-known stories by Washington Irving. It tells of a man who, having fun with supernatural beings, ends up sleeping for twenty years instead of one night.

Of course, each culture would be most familiar with its own variation on this theme. Isu's dalliance, escape, and homecoming would read like Rip Van Winkle to us, but would remind Japanese of Urashima Taro.[2]

5. *The Phoenix*

The movie opens, as mentioned above, at Isu's funeral. This is the first time we see what is apparently an unremarkable occurrence on Windaria. A large bird, seemingly made of glowing red light, rises from the body and soars out over the inland sea. This happens several times in the anime, and usually involves the birds flying toward some strange flying machine that crosses the horizon from time to time. Perhaps the ship is symbolic of the enlightenment that Isu wrote he spent most of a long lifetime trying to achieve.

Despite its swallow-like tail, the bird spirit suggests nothing so much as the best-known bird in Japanese pop culture: the phoenix of Osamu Tezuka. Although his manga *Hi no Tori* spanned the last twenty of his forty years as a cartoonist, the meaning of Dr. Tezuka's bird is consistent: it "symbolizes human existence that transcends good and evil."[3]

It would be too simplistic to say that the spirit-bird only means that the dead have transcended the concerns of the living with questions of good and evil. This entire story is about the ultimate meaninglessness of this duality. Was Paro wrong in waging war against Itha? Was Itha wrong in withholding fresh water from Paro? Was Isu wrong in wanting to seek fame and fortune, even if it meant forsaking his wife and helping to start a war? The last question would seem to be the easiest to answer, since Isu spends the rest of his life

[2] There's an especially touching use of this story in *Cowboy Bebop*. As the episode "Speak Like A Child" begins, Jet Black is telling Ed the story of Urashima Taro. They're interrupted by the delivery of, of all things, an ancient Betamax videotape. Once they find a machine to play it on (which involves them meeting a VCR *otaku*), they find that it is a tape of Faye Valentine, made when she was only thirteen years old. (The severely injured Faye had been cryonically suspended for over fifty years until her injuries could be healed.) The jaded and cynical adult Faye watches her wide-eyed adolescent self literally cheer her on from decades in the past. In the later episode "Hard Luck Woman," the Urashima Taro connection becomes explicit as Faye meets one of her old classmates—now a withered old woman in a wheelchair.

[3] Hidemi Kakuta, trans. Keiko Katsuya, *Catalogue of the Osamu Tezuka Exhibition* (Tokyo: Asahi Shimbun, 1990), 244.

working to rebuild Windaria after the disastrous war. But would he have tried to rebuild Windaria if he hadn't caused its destruction? Perhaps it was the only way his soul could have achieved enlightenment. The simple answer, of course, is that there are no simple answers, on Earth or in Windaria.

Popular culture, alas, is ephemeral; very much here today, only to be gone tomorrow. A decade ago, before nihilistic *mecha*-oriented works like *Akira* caught the attention of animation buffs beyond Japan, *Windaria* was a striking example of the art as well as a heartfelt plea for peace. It's hard to find now, but it's still a brilliant piece of art. And its message of the uselessness of war has never been more timely.

6. Water

This hardly seems Japan-specific: water is a biological necessity for every plant and animal on Earth. Water, however, has great significance in the Shinto religion. Shinto shrines keep a *tsukubai*, a stone basin of water, so that worshippers can rinse their hands and mouth. The earliest Shinto shrines were usually built near a river, a spring, or a waterfall. These fresh-water sources would be sought out for geographical as well as sacred reasons: the Japanese islands are surrounded by undrinkable sea water, so fresh-water sources are literally matters of life and death, for Japan as well as for Paro and Itha.

2

Wings of Honneamise: Tora-san in Space

The first film from the Gainax studio features a nobody as the hero—
a nobody who makes you look through the sky, past the weather, and
into what is possible . . .

American fans of anime and manga these days tend to be young. They weren't around in dizzying decade for manned space flight that began in 1961 when the Soviet Union put cosmonaut Yuri Gagarin into orbit and ended in 1969 when Apollo 11 landed on the moon. For some, the space race was an extension of the terrestrial Cold War between the U.S. and the U.S.S.R.—those who were rocketed into space were seen as "single-combat warriors" playing out a greater geopolitical game as well as daring to take one of humankind's riskiest voyages.[1]

Wings of Honneamise, the first fruit of Studio Gainax, has a very different premise. What if a nation planned for space travel before the technology was ready? What if the best kind of rocketry they could manage was a half-baked contraption that wasn't much better than a Wright brothers prototype? And what if the space explorers of that country were treated not as national heroes but as a national joke—a bunch of misfits, losers, and slackers unfit for "real" flying?

[1] See *The Right Stuff* by Tom Wolfe (New York: Farrar, Straus, and Giroux, 1979).

The roots of Studio Gainax actually go back about a decade before *The Wings of Honneamise*. In August 1981 science-fiction fans in the Osaka area got together at a convention known as Daicon 3.[2] The convention opened with a five-minute piece of animation produced by some college art students, most of whom had never worked in the medium before (at least, according to the Gainax website; it's also said that the nucleus of Gainax met while working on the *Macross* series).[3] By the following autumn, however, they had produced three works under the name General Products (which was also the name of a sci-fi store they had started). For Daicon 4, they again produced a five-minute animation clip that surprised its audience with its technical brilliance. By the next month, these amateur animators were making ambitious plans to expand their work into a full-scale production called *Royal Space Force*. But large-scale animation required money, which required incorporation; Gainax was founded in December 1984 specifically to make *Royal Space Force*, which was later renamed *The Wings of Honneamise*.

The 1987 film was written and directed by Hiroyuki Yamaga, who has since gone on to become president of Gainax.[4] The score was by one of the biggest names in Japanese rock music, Ryuichi Sakamoto. Also big was the budget: a record-setting eight billion yen, supplied by the Bandai toy company.

This film follows the Royal Space Force career of an Everyman, Shirotsugu "Shiro" Lhadatt. However, for all practical purposes, we can call him Tora-san.

The Traveling Salesman
The Tora-san live-action movies can be found in the *Guinness Book of World Records* as the longest series of motion pictures centered around a single character: "a tubby, middle-aged man dressed like a pre-war market salesman: a loud, chequered suit, a

[2] As with so much else in Japanese, this is a pun, and a particularly delightful one. Daicon can be short for "big convention," but a *daikon* is a white radish.

[3] Helen McCarthy, *The Anime Movie Guide* (Woodstock, New York: The Overlook Press, 1996), p. 58.

[4] The Gainax website declares that this film "destroyed the entire concept of animation as just for kids." It thereby conveniently overlooked such sophisticated classics as *Galaxy Express 999* (directed by Taro Rin, based on a manga by Reiji Matsumoto), *Nausicaä of the Valley of the Wind* (written and directed by Hayao Miyazaki), *Windaria* (see the previous chapter), *Project A-ko*, *Barefoot Gen*, *Night Train to the Stars*, and Dr. Osamu Tezuka's *Hi no Tori 2772*. If *Wings of Honneamise* destroyed anime as a kids-only medium, the target was already pretty weak.

woolen waistband, an undershirt, wooden sandals and a shabby hat."[5] That character is Torajiro Kuruma, known affectionately as Tora-san, a traveling salesman with a dubious track record. He never seems to succeed, from the first film *Otoko wa Tsurai yo (It's Tough Being a Man)* to the last, at anything—at least, as society counts success. He's sentimental, but he's also got the cunning of a thief. He has a quick temper, but he also has a love for life and almost infinite compassion. His only "home base" is with his parents and his married sister's family. Even though his brief encounters may help other people, he never seems to benefit, and just keeps moving on, like a Japanese version of another cinema icon, Charlie Chaplin's Little Tramp.

The plots for all of the Tora-san films are a formula, summed up by John Paul Catton: "Tora-san arrives in some remote Japanese town, fixing to charm the locals out of their cash. Tora-san meets a local maiden and falls in love. Tora-san finds himself on the brink of marriage and gets cold feet. Tora-san abandons his scheme and heads back to his sister's house in Shibamata, Tokyo, and ponders the errors of his ways while getting pickled in *sake*."[6]

Tora-san was first brought to life on the screen in 1969 by Kiyoshi Atsumi, whose death in August 1996 at age sixty-eight finally broke the string of films at forty-eight. With a track record like that, it's safe to say that Tora-san touched something essential and immediate in the Japanese movie-going public. Donald Richie wrote in his obituary for Atsumi:

[5] Ian Buruma, *Behind the Mask: On Sexual Demons, Sacred Mothers, Transvestites, Gangsters, and Other Japanese Cultural Heroes* (New York: Meridian, 1984), 209.

[6] From *Tokyo Classified* (http://www.tokyoclassified.com/bigin-japanarchive249/241/biginjapan-inc.htm).

Coming from the working-class area of Shibamata in downtown Tokyo, Tora-san was a common man who always tried hard and fell flat. It was the fall that was funny, but what kept people coming back was his naive goodness. . . . To Japanese who grew up with Tora-san, the loss was personal. It was also a sign that tradition was dying. Though the real Shibamata

had for years not resembled the cozy film version, the vision of a perfect hometown persisted because it was needed in a country in flux. Now that Tora-san is dead, a part of Japan seems gone as well.[7]

That hidden (but not altogether missing) part is certainly not the drive for excellence, the quest to compete in the global economic arena with the major Western powers. It's a more peaceful drive, linked to the human comedy. It is *senryu* rather than *haiku*, with both types of verse following the same seventeen-syllable count, but with the former commenting on the human condition while the latter looks at the natural world. Tora-san is all about falling, then rising up and persisting nonetheless. He's all about the reassurance that life, despite large or small calamities, will go on.

It's Tough Being an Astronaut

And now we are ready to meet Shiro Lhadatt, his fellow pilots, and his "family." In the opening narration, Shiro tells the audience that he is just an average guy. His grades in school and his scores on military tests put him squarely in the middle of the pack. For once, we have an anime hero with no superpowers, no magical talismans, and not even much determination or *ganbaru* spirit. Shiro's only childhood dream was flying, but that was denied him when he didn't qualify for the Navy, where the jets were. Instead, he ends up in Honneamise's Royal Space Force.

That force is, to put it simply, a joke—a pet project for the royal family, without the technology to actually get a man into space, and secure in the knowledge that it won't happen anytime soon. They still test the technology, though, using human subjects—and those subjects often die. The members of the Royal Space Force do little except attend funerals for their own.

Our first view of Shiro Lhadatt is at one of those funerals. He arrives late and out of uniform, appar-

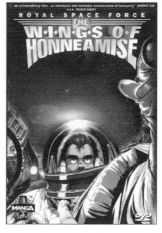

Wings of Honneamise The box art shows Shiro Lhadatt about to be shot into space. The events leading up to this first flight is the meat of the film: a story of political maneuvers and military secrets, of discovered love and blossoming faith, of all-too-human emotions in a barely imaginable world.

[7] Donald Richie, "It's Tough Being a Beloved Man: Kiyoshi Atsumi, 1928–1996," *Time International* 148 (8), August 19, 1996. Available at http://www.time.com/time/international/1996/960819/appreciation.html.

ently still recovering from a night on the town and general dissatisfaction with the life he leads. These opening minutes with the Force establish what life on Honneamise is like. It's an elaborate example of "world-building," one that many have commented on. But to focus on this depiction of a planet and its civilization is to miss the point. The artifacts and technology of a new locale aren't important in themselves; they're just tourism. What matters to an audience are the people who live in this place: who are they, are their problems like ours, what can we learn from watching them? Popular culture, after all, has never been merely an exercise in world-building, whatever the culture. Bilbo Baggins isn't memorable because he's a hobbit, but because of the trials he faces in his travels.

In the Royal Space Force, Shiro doesn't have a life with much to offer: abusive training by day and haunting the pleasure quarter by night. One night, though, he sees something absolutely out of place in the quarter: a woman standing on a corner, preaching to the passers-by about the love of God. Shiro wouldn't have listened to her any more than the others, but she thrusts a leaflet into his hand.

He finds the leaflet the next morning when he wakes up back at the barracks—having stumbled into the bed of the dead soldier. It's a very bad omen to sleep in a dead man's bed, but it's also a symbolic rebirth, prompting Shiro to ride the trolley to the end of the line, where the leaflet said a religious meeting would be held. Shiro finds that he's the only one at the "meeting," at the home of the woman preacher, Riqinni. She lives with Mana, a child who could safely be called repellent. This surly and uncommunicative girl-child, adopted by Riqinni, is the opposite of the kawaii ("cute") children usually seen in anime.

Shiro has dinner with Riqinni and Mana. In talking about the Royal Space Force to someone outside the military, for the first time Shiro sees in someone else's face the excitement such explo-

ration can raise. It excites him as well, and he goes from being just another slacker to volunteering for the first manned launch into space. This makes him not only a media figure to promote the Royal Space Force, but also a target for those opposed to the space program. To complicate matters, the head of the force announces that their space vehicle will be a "warship," which has the effect of accelerating the push to develop space-ready technology.

While Shiro trains, forces are at work around him that threaten to sabotage the launch. The project has become so expensive that only the royal family, in a sweetheart deal with an auto manufacturer, can come up with the money to continue. Money is diverted from other projects, to the point that anti-monarchy radicals are gaining more and more support. Meanwhile, the Army has decided that the launch serves no useful military purpose, so it creates a purpose: the launch site is moved to the very border of a hostile neighboring state. The Army wants the launch to serve as a provocation, tempting the other country to invade.

Things are also shaky on a personal level for Shiro. The house where Riqinni and Mana live used to belong to Riqinni's aunt. So much money is owed that the electric company bulldozes the house, while all Riqinni can think to do is pray. Her absolute faith hasn't taught her much about dealing with the real world.

One rainy day, Shiro goes to visit Riqinni, who now lives with Mana in a small warehouse and does farmwork by day. As she changes out of her wet clothes, Shiro's old habits reassert themselves and he tries to rape Riqinni. She knocks him unconscious. The next day, she apologizes to him, taking the blame for his attack on her. This adherence to her religion shakes Shiro to the point that he starts going back to the pleasure quarter to hand out leaflets with her.

Launch day coincides with an invasion of Hon-

neamise by the neighboring republic. After all that's happened, it's almost anticlimactic that the rocket successfully puts Shiro into orbit. Although the Defense Ministry had written him a speech he was trying to memorize as the first words from space, he abandons that speech for a passage from Riqinni's holy book, and a message that mankind (on that planet, at least) has no reason for war, because there are no borders.

What follows is a montage that is in part a tribute to Stanley Kubrick's 2001: A Space Odyssey. The audience sees a series of impressionistic images, suggesting that Shiro's life is passing before his eyes (we see him as a child reflected in a window). This is followed by yet another montage: the growth of a planet's civilization, from primitive cavemen through to industrialization and flight. The last image we see, before the credits, is of Shiro's capsule orbiting the planet.

What happens to him after that? Marc Marshall's review of the film says that Shiro successfully returns to the planet, and that this is confirmed both by writer/director Yamaga and by the production-sketch montage under the closing credits.[8] Except that the sketches are very rough, and don't clearly show any such thing. If anything, there's a scene in the movie that confirms Shiro's true fate. After the launch, we cut to the pleasure quarter, where Riqinni is again trying to hand out leaflets, being ignored as usual. A single snowflake falls and melts on her outstretched leaflet. She looks up at the other falling snowflakes. Perhaps she alone is looking past them, knowing that Shiro is up there.

Like Tora-san, Shiro's hopes for a family life amounted to nothing. Professionally, he succeeded beyond his childhood dreams—whether or not it cost him his life.

[8] http://animeworld.com/ reviews/honneamise.html.

Utena: Giri/Ninjo and the
Triumph of Conservatism in Pop Culture

Sometimes it takes an upside-down school to point out how to do the right thing. One girl versus the End of the World, and class is about to begin.

At the risk of being a spoiler, I will defend revealing the outcome of the highly stylized, eccentrically symbolic 1997 TV series *Shojo Kakumei Utena (Revolutionary Girl Utena)* created by the team known as Be Papas.[1] My defense is to point to T. S. Eliot's line: "In my beginning is my end." Utena's fate should come as no surprise—perhaps a shock but not a surprise. Her fate was foretold in the very opening of the first episode.

A Fateful Duel

The TV story (there's also a manga story and a feature film, all somewhat different from each other) takes place at the Otori Private Academy.[2] It's a vaguely European boarding school, with classes ranging from middle through high school. There's a secret, though, tucked away in the back: a surreal-looking arena where fencing matches are held to determine the "engagement" of the Rose Bride, the dark-skinned and childlike Anthy Himemiya. The elaborate game is at the behest of whoever is send-

[1] Primarily, animator Kunihiko Ikuhara and artist Chiho Saito.

[2] *Otori* means "phoenix"; in the context of a story about people struggling against themselves and each other "to bring the world revolution," it's a very loaded name.

© BE-PAPAS • CHIHO SAITO/SHOGAKUKAN • SHOKAKU • TV TOKYO

Revolutionary Girl Utena You
have to be careful making your
way around Otori Academy;
things are seldom what they
seem. Here we see Miki, the ob-
sessive/compulsive pianist and
math genius, and the eternally
pleasant Anthy Himemiya. Yet
one is an evil magician who
has brought a curse down on
the school.

ing dispatches signed "End of the World" to mem-
bers of the Student Council; someone whom no
one ever sees (echoes of Franz Kafka).

Utena Tenjo doesn't enter this closed society;
she's already in it, although marginalized. She's in
the middle school, an aggressive athlete but an av-
erage student. Her one standout trait is wearing a
modified boy's school uniform (however, none of
the boys seem to wear the red bicycle pants she fa-
vors). Her choice of apparel goes back to the time
her parents died. A handsome prince (are there sto-
ries with princes who *aren't* handsome?) praised
her fortitude, then gave her a ring inscribed with a
rose. She decided that the way to emulate and hon-
or this prince was to dress and act like a prince.
Years later, once she's in Otori Academy, she no-
tices that roses are the dominant motif.

While watching Anthy tend the roses in the
academy gazebo, Utena takes a fateful step. As the
story opens, Anthy is "engaged" to the school's
kendo champion, high-school student and Stu-
dent Council vice-president Kyoichi Saionji. Saion-

ji, however, is no gentleman, and Utena sees him slapping Anthy around. (We earlier saw the cad take a love letter sent to him by an admiring girl and post it on a bulletin board for him and his friends to mock.) Unable to hold back, Utena challenges him to a duel. She expects it will just be a little one-on-one in the kendo hall, but instead she is told to meet Saionji in the mysterious fencing arena.

This isn't your usual duel. Saionji takes his weapon from Anthy, literally: she goes into a trance, and the handle of a saber pops out of her chest. Saionji draws the saber out of Anthy's body without harming her. (At this point, one wonders why Anthy, who seems to possess supernatural powers, is so submissive. The answer must wait until later.) Utena would seem to be outclassed: Saionji is older and more experienced, while Utena is armed with a piece of wood. However, she not only wins the match, but the "hand" of Anthy.

The Coed Who Knew Too Little
Why was she allowed to battle for possession of Anthy? It was all a mistake. "End of the World" had warned the Student Council that a new duelist was coming to carry on the plan "to bring the world revolution." Everyone presumed that Utena was the new challenger and ended up involving Utena in a game she didn't even know she was playing. This sets the wheels of tragedy in motion.

In this respect, there's a very clear Western model for what takes place in *Utena*: the classic films of Alfred Hitchcock. We have an outsider whose actions open the door to a parallel world, unguessed-at until then. This certainly describes Jimmy Stewart in *Rear Window, Vertigo,* and the remake of *The Man Who Knew Too Much;* Sean Connery in *Marnie;* Tippi Hedrin in *The Birds;* and especially Janet Leigh in *Psycho.* All of these characters take a small (and occasionally illegal, or at least unconventional) step off their accustomed

Revolutionary Girl Utena Student Council member Kyoichi Saionji thinks nothing of slapping Anthy around; she is, after all, the "Rose Bride" and is engaged to him. But this isn't the only example of Saionji's swinish behavior. Utena finally challenges him to a duel, setting the wheels of the plot in motion.

paths, which leads them onto strange and even horrific new paths, often with disturbingly kinky sexual overtones. At the end of the path, someone is dead.[3]

A Japanese audience would have realized that something else was happening at this school: the constant head-on collision between *giri* and *ninjo*, between social obligation and personal desire. Personal desire seems to be winning, but also warping the student body.

The Confucian ideal underlying Japanese society, after all, is built on putting *giri* before *ninjo*. Deny one's social obligations, putting ego first, and the foundations of civility start to crumble; neglect your obligations and you lose face. To the extent that pop culture is inherently conservative and ratifies the culture's most common shared values rather than advocating anything avant-garde, the bottom line of this story will be that the students in the hothouse, "self-indulgent" (as one student describes it) atmosphere of Otori Academy ignore their responsibility and indulge their private passions at their own risk. They may meet the destined end of a phoenix and burn up, but may not be able to rise out of the ashes again.

In Utena's case, the viewer gets a clue early on that she's neglecting her destiny. From the beginning, we hear of her meeting the prince as a child

[3] It may be a coincidence, but the central story-arc involves the breeding of a Black Rose with which to destroy the Rose Bride; it's being bred in the basement of a building that looks suspiciously like the Bates house in *Psycho*.

Revolutionary Girl Utena Ute-na Tenju (shown here with her friend Wakaba) starts out as a mere observer of the odd happenings at Otori Academy. But it is her attention to the goings-on that propels Utena—a teenage girl who wants to be a prince and rescue damsels—to stop watching and get involved.

and wishing to imitate him. However, what we hear is a child's version of what happened; this is clear in the original Japanese dialogue, in which the tale is told with a child's voice rather than that (in the English dub) of Utena the teenager. Yet Saionji recalls the encounter differently. He and Toga Kiryu, the Student Council president, were traveling together (we find out later that they were accompanied by Akio, the real villain of the piece) when they found a young girl hiding in a coffin. Toga eventually tempted her out.

Remember the *Kojiki?* The story of Amaterasu in the cave has just reappeared in a surprising guise. It reminds the viewer that Utena was never destined to be a prince. If anything, she should be a princess, if not a goddess. If she were more aware, she would follow her destiny rather than her personal wishes. Once again, we see someone who is headed for disaster because she doesn't get it.

Student Bodies

Almost everyone at this school gets caught in this duty-versus-desire bind, and revealed in a light that's not at all flattering. Miki, the youngest Student Council member and a talented pianist and mathematician, is so obsessed over having played piano duets with his sister (that's all they did, but Miki's obsession borders on the incestuous) that

he doesn't even recognize her lack of talent. His sister, meanwhile, seems to be one student among many being debauched by Toga Kiryu. For a time he's "engaged" to Anthy, having beaten Utena in a duel to claim her, yet he flirts with other girls while his Rose Bride "fiancée" is in the same room. Kiryu seems to take his loss to Utena in their rematch in episode thirteen the hardest; he's shown in the Student Council chambers, listening over and over to a recording of a message from "End of the World." His sister, Nanami, is out primarily to make a name for herself, even at the expense of others. Juri Arisugawa, the best fencer at Otori, lost her *yasashii* spirit some time earlier when her friend Shiori stole the boy they both liked, making Juri the odd one out in a romantic triangle.[4] And we've already seen Saionji in action.

Because "End of the World" has said that whoever is "engaged" to the Rose Bride must defeat all challengers in order to bring the world revolution, Utena fights all of the above before the series is a third over. The two duels against Kiryu are the most interesting. Utena loses the first duel because Kiryu plays the psychological card, suggesting to Utena that he was the prince who visited her as a child and gave her the ring with the rose crest. (In fact, he was, as Saionji's recollection confirms.) Unable to defeat the person she wanted to emulate for so long in the arena, Utena loses her aggressive, princely personality and gives up trying to do much of anything in the academy, and even begins to wear a girl's school uniform. Of all people, it took some tough love from Utena's pesky friend Wakaba (the one who was always declaring her love for Utena), and the sight of Kiryu's swinish behavior toward Anthy, to awaken Utena for a rematch.

At first it doesn't seem like a good idea. Kiryu reveals another hidden power in the Rose Bride by telling Anthy to transfer the Power of Dios from herself to his sword. She does so by kneeling and kissing the blade in the closest simulation of fella-

[4] For one of the better Juri pages on the web, see http://www.geocities.com/hollow_rose/main.html.

Revolutionary Girl Utena Anthy Himemiya transfers "the power of Dios " to the saber with which Toga Kiryu will fight Utena. She makes the transfer by suggestively kissing the blade. For an animated series that takes place in a boarding school and uses a light and happy palette of colors, there are some very debauched happenings behind closed doors.

tio possible on broadcast television. The glowing sword breaks Utena's blade. Her resistance, however, actually extinguishes Kiryu's blade, and she wins back possession of the Rose Bride.

The most interesting part of the duel is Anthy's reaction to Utena's rally. Anthy recalls to herself that this is like "that time"—and a tear falls down her cheek. Anthy continually gets slapped, shoved around, and humiliated, but there was no such provocation for this tear. It is a reaction to a past memory and a dread of the future. In Utena's beginning is Utena's end, and the Rose Bride knows it.

The Bride Who Knew Too Much
Of the two leading characters in this thirty-nine-episode series, Utena is probably the most straightforward. Her roots are clear: she's a direct descendant of Princess Sapphire, the sword-wielding cross-dressing princess in Dr. Tezuka's *Princess Knight* and of Oscar de Jarjayes, the sword-wielding cross-dressing noblewoman in Ryoko Ikeda's *Rose of Versailles*. Both of them had clear missions: to rescue damsels in distress (even if Princess Sapphire's main mission was to rescue herself and her mother).

On the other hand, Anthy Himemiya clearly fits

© BE-PAPAS • CHIHO SAITO/SHOGAKUKAN • SHOGAKU • TV TOKYO

Utena the Revolutionary Girl
We know Utena is a girl. We also know she wants to be a prince and help young maidens in distress, as she was once be-friended by a prince in an hour of grief. So she goes in for princely things, like dueling. And she may even win the un-likely battle of saber against wooden practice sword. But will victory now only mean de-feat later?

the bill of a damsel in distress. She's slapped by Saionji, mistreated by Toga Kiryu, taunted by Nanami Kiryu, and befriended by only one person: Utena, who blunders into the academy's hidden world of secret duels and "End of the World." Yet we also know that a mystical power of sorts re-sides within Anthy. You would think she could take care of herself.

At one point she could, but that was before she too succumbed to the Otori affliction of placing *ninjo* over *giri*. Like a number of others (Miki and his sister, Nanami and her brother), Anthy gave in to feelings toward her own brother that bordered on the incestuous. We don't see this brother, Akio, until the thirteenth episode, and the information about him and Anthy comes in bits and pieces (of-ten in symbolic pieces that need decoding) right up to the end, when we finally realize what has been going on. Anthy's status as perpetual victim is not that of a good person misused by evil people; Anthy herself committed an unforgivable act, and was living out her punishment when Utena came along.

In the mixed-up world of Otori Academy, sym-bolized by a castle hanging upside-down above the dueling arena, princes are supposed to save princesses, but can't. Akio, one such prince, has been prevented by his sister Anthy from rescuing any more princesses. Although her motives were at worst mixed (she was concerned for his health, but perhaps also demanded his attention), she ended up trapping only his *yasashii* spirit, leaving behind a manipulative, lascivious, and very power-ful monster for a brother. For this she suffers, only to be rescued by Utena.

Akio tries to forestall the rescue, maneuvering people into duels to try to defeat Utena, or at one point hoping to replace Anthy as the Rose Bride. Akio even seduces Utena, trying to convince her through sex that she is a princess and not a prince. Utena, however, stays true to her desire to emulate

the prince she met as a little girl. This means rescuing the princess named Anthy, even if doing so means paying the ultimate price.

And so it is that, in a story more outrageous than most in terms of gender confusion, we see that the old-line definition has been working all along. Plain and simple: a girl cannot be a prince. An old Japanese proverb puts it this way: "*Otoko wa matsu, onna wa fuji*" (Man is the pine tree, woman is the clinging vine [wisteria, actually]).[5] If she tries to be what she's not, there'll be a price to pay.

And yet, by the end of the story, Anthy is indeed redeemed. She is freed from her imprisonment at Otori Academy. How does she use that freedom? By immediately leaving the campus to search for Utena. And this is one of those cases in which the original Japanese dialogue is critical. Throughout the series, Anthy has declared her subservience to Utena by referring to her with the honorific -*sama*. As she leaves in the final scene, Anthy lets us know simply that she's looking for Utena. No more honorific, since Utena is no longer a prince.

But isn't Utena dead? So it would seem, but Otori was, as I mentioned, a topsy-turvy version of the world, and maybe death wasn't an ending (appropriately for a place named after the phoenix). Certainly someone as powerful as Anthy would know the truth of it, so her quest for Utena should be accepted as exactly that: not a quest for an ideal, like Miki's search for his sister or Juri longing for the time before she was betrayed by her "friend" Shiori. Anthy goes off to search for a not-truly-dead Utena Tenjo. In Utena's end is Utena's beginning, and the Rose Bride knows that, too.

4

Giant Robo: Anime as Wagnerian Opera

It takes seven giant episodes to answer Daisaku's question: "Can happiness be achieved without sacrifice?" And it takes a really giant robot to tell this epic tale.

O f all of the adjectives that could be applied to an anime, "Wagnerian" may seem the oddest. It is a word derived from one of the most un-Japanese characters of all time: a sybaritic and self-indulgent artist, capable of making free with other folks' money and other men's wives; a hypocritical, sycophantic, nationalistic anti-Semite who not only held himself above his contemporaries but who had a theater built to the precise specifications of the dozen or so operas that he completed. Had Richard Wagner been born in Japan, where "the nail that sticks up gets pounded down," he might not have made it out of his teen years. As it is, the only patron he could ever rely on was "Mad King" Ludwig II of Bavaria.[1]

But Wagner the man is not quite the lens through which to watch *Giant Robo.* I mean Wagnerian as in Wagnerian opera: a singular mélange of mythology and emotionalism. Wagner's works using Norse mythology (the four *Ring of the Niebelung* operas) and Arthurian legend (*Parsifal*) as a backdrop for intense passion remain unique in

[1] Ironically, Ludwig became the subject of a *yaoi* manga by Yo Higuri, *Ludwig II.* The story of the Bavarian monarch (1845–86) is in the tradition of Ryoko Ikeda's *Rose of Versailles:* a romanticized mix of fact and fiction, dealing with the monarch's rocky marriage, his homosexual affairs, his hereditary madness, his extravagant life, the conspiracies to remove him from power, and his abrupt suicide. There hasn't been an animated version of Higuri's manga yet; however, with the legendary grandeur of Ludwig's palaces for the eye and the music of Wagner blasting on the soundtrack for the ear— what an anime that would make!

the opera literature, and very few works in other media can lay claim to the adjective Wagnerian.

Probably none of this was on the mind of *Giant Robo* creator Mitsuteru Yokoyama. Born in 1934, Yokoyama was among the first to walk through the door opened by Dr. Osamu Tezuka into the newly expanded medium of manga. His first comic, *Sword of Otonashi*, was published in 1955, and from there he produced over two hundred titles, a number of them quite influential. Some of these were in genres already established, such as ninja action stories (*Red Shadow, The Masked Ninja*), esper action stories (*Babel the Second, Its Name Is 101*), and even the first "magical girl" *shojo manga, Mahotsukai Sally (Sally the Witch)*.[2] But there were two specific genres that made Yokoyama's reputation.

First was the Chinese epic romance. Two lengthy, detailed Chinese novels found their way into manga through his pen: *The Water Margin* and the *Sangokushi* (*Romance of Three Kingdoms*). These multi-volume manga have remained popular decades after their first appearance.

The other is the *mecha* genre. World literature has dealt with artificial men, in one way or another, for centuries; witness the legend of the Golem of Prague and Mary Shelley's *Frankenstein*. The word "robot" dates to the 1920s and Czech playwright Karel Capek's R.U.R. (an acronym for Rossum's Universal Robots). One wartime manga story from 1943 featured a giant robot stomping Godzilla-like through New York City.[3] This giant robot, more than Dr. Tezuka's human-scale and human-emotional robot *Tetsuwan Atomu*, may have been on Yokoyama's mind when he sketched out his *Tetsujin 28-go* (*Iron Man No. 28*) in 1958. It was animated (in black and white) for Japanese television in a series of 96 episodes that ran from 1963 to 1965 (the same time that *Tetsuwan Atomu* was first broadcast). In 1966, the series came to America under the name *Gigantor*. It thus became one of the first of a long line of "giant robot" shows. Yokoya-

[2] Yokoyama had originally wanted to call his witch "Sunny" but found that the Sony Corporation had copyrighted the name. In the 1992 OAV series, when she appears as the daughter of Big Fire's Shockwave Alberto, her name is once again Sunny.

[3] Frederik L. Schodt, *Manga! Manga!: The World of Japanese Comics* (Tokyo: Kodansha International, 1983), 56.

ma also created a different giant robot manga, *Giant Robo*, which became the point of departure for the 1992 *Giant Robo* OAV series.

One of the many elements that makes the series unique, however, is that it is *not* based on *Tetsujin 28-go* or the *Giant Robo* manga as such. Rather, it was based on a screenplay by Yokoyama and director Yasuhiro Imagawa, with characters pulled together from much of Yokoyama's collected works, but especially the Chinese epics.

Experts Fighting Fire

In a future Earth, problems of energy and pollution have been solved. Both fossil fuels and nuclear energy have been rendered obsolete by the Shizuma Drive. Dr. Shizuma was one of five scientists who developed the efficient, non-polluting power source a decade earlier, but only after a disastrous explosion leveled the laboratory at Bashtarlle and killed one of the inventors, Franken von Volger. The story's beginning is appropriately dramatic and starts with an elaborate chase scene in a very Art-Deco future Nanking. The object of the chase is Dr. Shizuma, scared out of his wits and trying to hang onto an attaché case. Coming to his rescue are a variety of characters, including a sharpshooting woman named Ginrei and a twelve-year-old boy piloting a forty-foot robot. The woman and boy are both members of the Experts of Justice, a band of superpowered crimefighters. They try to protect Dr. Shizuma from the evil organization Big Fire, but as the story gradually unfolds, good guys are revealed to be bad guys, villains become heroic, and the boy, Daisaku Kusama, wrestles with existential problems of human happiness. *Evangelion* may have totally rewritten the *mecha* genre, but before that change, *Giant Robo* certainly stretched it to the limits. And it is in that stretching, that pushing the envelope in terms of graphics and action and plot and intense emotion, that *Giant Robo* earns the adjective Wagnerian.

Name	Team	Source
Taiso	Experts of Justice	*Water Margin*
Tetsugyu	Experts of Justice	*Water Margin*
Dojin Issei	Experts of Justice	*Water Margin*
Yoshi	Experts of Justice	*Water Margin*
Professor Go	Experts of Justice	*Water Margin*
Ginrei	Experts of Justice	*Wolf Constellation*
Kenji Murasame	Experts of Justice	*Tetsujin 28-go*
Daisaku Kusama	Experts of Justice	*Giant Robo*
Chief "Silent" Chujo	Experts of Justice	*Babel II*
the Gen Brothers	Experts of Justice	*Water Margin*
Hanzui	Big Fire	*Water Margin*
Jujoji	Big Fire	*Romance of the Three Kingdoms*
Zangetsu	Big Fire	*Water Margin*
Shokatsu Komei	Big Fire	*Romance of the Three Kingdoms*
Ko Enshaku	Big Fire	*Water Margin*
Shockwave Albert	Big Fire	*Mars*
Sunny	Big Fire	*Sally the Witch*
Fitzcarraldo	Big Fire	*Babel II*
Cervantes	Big Fire	*Babel II*
Concussion Kawarazaki	Big Fire	*Mars*
Ivan	Big Fire	*Mars*
Genya	Big Fire	*Seven Shadows of Kagemaru*

Who's Who

Giant Robo is populated by numerous figures straight out of Chinese mythology and legend, primarily by way of Yokoyama's manga version of *The Water Margin*, as shown in the chart here.[4]

The ominously named Franken von Volger, by the way, is a complex homage on the part of Yasuhiro Imagawa. The resonance of Dr. Frankenstein in the name is obvious, but the name also evokes Albert Emanuel Vogler, a character in the 1958 Swedish film *The Magician* by Ingmar Bergman. This becomes especially apparent when Big Fire agent Genya is revealed to be the doctor's son, Emanuel Von Volger. There's yet another layer, though: Franken von Volger also conjures up the image of Dr. Frank N. Furter of *The Rocky Horror Picture Show* (this isn't a stretch; Imagawa has admit-

[4] Much of this information is thanks to the very comprehensive *Giant Robo* website "Behind the Night's Illusions" at http://www.animejump.com/giantrobo/index2.html.

ted the connection, since he's a fan of the parody rock musical).[5]

"Dedicated to All Fathers and Their Children"

These are the final words on the screen as the final episode ends, and they're no accident. The emotionalism in this OAV series seems consistently to revolve around family. We start with Daisaku, who we see in a flashback inheriting Giant Robo, his father's invention, after Big Fire agent Cervantes killed his father. Yet Daisaku spends the latter half of the series trying to puzzle out the answer to the obsessive question posed by his dying father: Can happiness be achieved without sacrifice?

A Japanese audience, by the way, would already know the answer. For years, Japanese households have consistently saved a larger percentage of earnings than American households. (This need to "save for a rainy day" has surely gotten Japan through a decade-long recession in better shape than most other world nations would have been.) As a society with a belief system that favors *giri* over *ninjo*, duty over personal desires, Japan has had considerable experience with delayed gratification and sacrificing to achieve happiness. But this is a lesson that the twelve-year-old Daisaku has to learn the hard way, as he watches his friends fall in battle with Big Fire.

Then there is the agent Ginrei, who first has to deal with the apparent return from the dead of (and this is a dire secret kept hidden for years) her father, Franken von Volger. Later, she has to confront her brother Emanuel (Genya) and his alliance with Big Fire. Emanuel's personal goal, in pursuit of which he is willing to double-cross Big Fire, is nothing less than global destruction in the name of clearing his father's reputation.

Even Tetsugyu, another member of the Experts of Justice, sounds the theme as he reminisces while searching the Himalayas for Daisaku. The boy and his robot were lost after their airship, the enigmati-

[5] This information came from "Tetsugyu's Giant Robo Site" at www.angelfire.com/anime2/GR/FF.html.

cally named *Greta Garbo*, crashed in the Himalayas after battling Big Fire in Shanghai. (We'll ignore the fact that Shanghai is on China's east coast, while the Himalayas are a thousand miles to the west.) Tetsugyu recalls the first man he ever killed: his father, who had gone over to Big Fire.

Twilight of the Robots

The action is non-stop, much of it preceded or accompanied by valorous speeches shouted at the top of a character's lungs. The Experts and Big Fire never attack: they ATTACK!! Chief Chujo, in the final battle, decides to punch out the Orb, a giant spherical spaceship. It may sound strange or even stupid on paper, but it works within the context of the magical world of this anime.

Shockwave Alberto has similar magic going for him, but a magic that is at least explainable in an Asian martial-arts context. His ability to project a wave of energy from the palms of his hands is part of the legendary Chinese "Red Sand Palm" technique.[6] Closer to home, Alberto can also send out shock waves with his voice—another esoteric martial-arts technique known in old Japan as *kiai*.

There are not only themes in this anime that are Wagnerian in mood—there are also a few motifs that directly recall Wagner. For example, the plan by Emanuel to avenge his father recalls the relationship of Alberich and Hagen in the last of the *Ring* operas, *Twilight of the Gods*. Back in the first of the four operas, the dwarf Alberich stole enchanted gold from the river Rhine and forged it into a ring of power, with which he intended to control the world. The gods of Valhalla stole the ring from Alberich, however, and it then traveled through various hands until it came to the hero Siegfried. In his travels, Siegfried encounters Hagen, spawn of a human mother and the dwarf Alberich. To avenge his father, Hagen manipulates the other characters into a war that ultimately destroys the Earth.

In this parallel, Franken von Volger is seen at

Giant Robo On the box art we see just a few of the Experts of Justice. Front and center, with the Chinese dress and the gun, is Ginrei, whose involvement in the case takes a sudden turn when the identity of her brother is revealed; to her right, with the fans, is strategist Professor Go; on the left, with the robes and hatchets, is Tetsugyu, who may drink too much, but is an eager and skilled fighter. And in front of them all is Daisaku Kusama, seen here yelling into his wrist-radio to summon his father's invention and "the mightiest robot of our age": *Giant Robo.*

[6] Kenneth Li, "Five Ways to Kill a Person with a Single Unarmed Blow," in Yang et al., *Eastern Standard Time: A Guide to Asian Influence on American Culture from Astro Boy to Zen Buddhism* (New York: Houghton Mifflin, 1997), 191.

first as Alberich, mysteriously returned from the dead, although what everyone thinks is Franken is actually his son Emanuel. Like Hagen, that Emanuel is willing to do anything, even destroy the world, to avenge the shame of having his father blamed for the early disastrous failure of the Shizuma Drive. By the end of the series, however, Emanuel realizes that in fact his father did not want to destroy anything. The Earth is spared and the potentially hazardous Shizuma Drive is repaired (parallel to the ring of power being returned to the bottom of the Rhine at the end of Wagner's opera cycle). Emanuel, however, has paid the terrible price of killing his sister Ginrei.

In the end, Ginrei tries to teleport into the Orb to confront her brother, but her powers are weakening and the teleport isn't successful. When she gets there, she doesn't even exist from the waist down. As such, she invokes Erde, the Earth-spirit of Wagner's *Ring* cycle who is no more than a torso herself.

The last two installments have the elite of Big Fire watching the battle unfold around the former Bashtarlle. But they don't merely watch. Each person stands on his own pillar, suspended in space, watching a gigantic vision of the Earth from the inside, seeing the battle unfold from what can safely be called a Valhalla perspective.

The parallels between *Ring* and *Robo* don't stretch much farther than that (although it might be worth mentioning that Shockwave Alberto, like Wotan, the ruler of the gods in Valhalla, lost an eye in past battles). Further Wagner/anime couplings would have to wait until 1999, when *Harlock Saga* appeared: an animated version of a Reiji Matsumoto attempt to mix elements of the *Ring* cycle into the story of his beloved space pirate Captain Harlock.[7] But that, as they say, is another story . . .

[7] See Patrick Macias, "Harlock Saga" in *Animerica* 9, no. 3 (March 2001): 6.

Flying with Ghibli:
The Animation of Hayao Miyazaki and Company

Bring together a labor union organizer, an Italian airplane, a medieval scroll painting, some French detective novels, a John Denver song, and tanuki—a partial recipe for Japan's best-loved animation studio.

Comparisons are always imperfect. Any time you say something is like something else, it implies that there are areas where the fit is not exact. Case in point: trying to describe animation masters in Western terms. Two Japanese animators have been compared to American artist, studio boss, and showman Walt Disney, but the two are as different from each other as they are from Uncle Walt.

The main difference is temporal. Walt Disney (1901–66) was born at exactly the right moment. He could explore the uses and potential first of movies, then of television, just as these media were coming into being. He essentially laid the groundwork for all his comrades, imitators, and competitors who followed, including the two biggest names in Japanese animation.

The first has popped up in this book many times already: Dr. Osamu Tezuka (1928–89). He revolutionized the medium of comics in Japan, and created icons as enduring and endearing as Disney's best-known characters. He also tried to animate his

two-dimensional creations, first for movie theaters and then for television, by starting a studio called Mushi Productions, which lasted about a dozen years before going out of business and being reborn as Tezuka Productions. The doctor lacked Walt's business acumen: he welcomed colleagues, competitors, and successors to join in and expand the form and content of his chosen medium. Disney, on the other hand, consistently worked to suppress competition.

The second candidate for "the Japanese Disney" is, ironically, a corporate candidate; not so much a person as a group of up to four creative artists who have helped redefine feature animation. They have worked primarily for one self-created studio whose name is permanently associated with one of these artists. But it is both deceptive and unfair to speak of Hayao Miyazaki as the only creative force at Studio Ghibli.

The Quartet Begins

Books have been written on Miyazaki, on both sides of the Pacific.[1] Here we can take only a glance at Miyazaki's output and that of his main collaborators, paying attention to the lesser-known works and noting their reflections of Japanese culture.

Born January 5, 1941, Hayao Miyazaki could not have become who he is, or created what he has created, without the influence of both his parents. From his father, Katsuji Miyazaki, he got his love of flying and, more specifically, of flying machines. Katsuji Miyazaki was an executive at Miyazaki Airplane, a factory owned by Hayao's uncle. This company made rudders for fighter planes during World War II, and in his youth Hayao endlessly sketched airplanes. From his intellectual mother, Hayao derived the strong, independent heroines who would become part of the signature of his work.

Because he came of school age during the tumultuous rebuilding years of Occupation Japan, from 1947 to 1952 Miyazaki went to three different

[1] That includes what has been written online. This chapter benefited greatly from the very comprehensive fan domain on Miyazaki and his work, www.nausicaa.net.

grade schools. More importantly, it was during these years that his mother spent two years in the hospital and was in shaky health for seven more years. This facet of his life is most clearly reflected in *My Neighbor Totoro* in the mother whose health steers the plot, even when she's not physically present.

During his final year of high school, Miyazaki saw the first Japanese feature-length color animated film, Toei Animation's *Hakujaden* (*Legend of the White Serpent*, 1958), and decided to become an animation artist, in spite of only having ever drawn airplanes—never humans.

In 1963, Miyazaki graduated from Gakushuin University with degrees in political science and economics, which would play more of a role in his career than might seem obvious at first. After college he landed a low-level animating job at Toei. Shortly after he was hired, Toei entered a protracted labor dispute, with Miyazaki leading the demonstrating animators. Within a year he was the chief secretary of Toei's labor union. The vice-chairman was an animator named Isao Takahata. Takahata was born six years before Miyazaki, and joined Toei in 1959. Their paths crossed not only within Toei's labor union, but also on a pivotal film.

Prince of the Sun

In the fall of 1965, Takahata got the chance to direct his first animated feature, *Prince of the Sun: Hols's Great Adventure*, which proved to be very influential in Japan but is still unknown to many Western fans. Miyazaki worked on the film under Takahata. The film was made in the mid-'60s, when both Japan and the United States were feeling waves of social shock as the Vietnam War and experimentation with alternate lifestyles shook up both societies. Another revolution was happening at the same time: television began drawing more and more of Toei's resources, and the role of the animator seemed doomed to extinction or medi-

ocrity. Studios like Toei were expected to churn out television programming, quickly and with little attention to detail—the broadcast equivalent of the trinkets shipped to America by the boatload earlier in the decade, which had made the phrase "Made in Japan" synonymous with shoddy workmanship.

Thinking that this might be their last chance to work together on a quality feature, Miyazaki made a pact with Takahata and Yasuo Otsuka (the film's animation director) to take as much time as they needed to properly finish *Prince of the Sun*. "As much time" turned out to be three years, at a time when a feature could be put together in eight months. The time was well-spent: *Prince of the Sun* has a brilliant look about it that defines it as a mature work. However, the bosses at Toei either didn't know quality when they saw it, or felt the need to stick it to union types like Takahata and Miyazaki. *Prince of the Sun* was shown in Japanese theaters for exactly ten days. The box office receipts were predictably small, and Toei used the poor showing to attack director Takahata. His first directorial project at Toei would also be his last.

There was reason for concern by studio executives. The movie had a sophistication of plot and character that went far beyond Toei's previous efforts. The exhortations of Hols to the villagers to unite against the minions of the Frost King were received as thinly disguised rallying cries by the union and college student protestors disrupting the streets of Tokyo in those heady days. More importantly, the character of Hilda comes across as complex, working sometimes for good and sometimes for evil. She's far from a powerless pawn, and can be seen as the first in the long line of multidimensional heroines from the artists who would later form Studio Ghibli.

Still, it was only a matter of time before Miyazaki and Takahata left Toei. That time came in 1971, when, having worked on a few significant features (including a comic inversion of the Arabi-

an Nights tale *Ali Baba and the Forty Thieves* in which the wealthy Ali Baba has become the villain) they jumped to A-Pro Studios. For the rest of the decade, they produced relatively little animation, but managed to spend a lot of time traveling around Europe: they visited Sweden to secure rights for an animated *Pippi Longstocking* (which was ultimately shelved), went to Switzerland to prepare scenery for *Heidi*, and so on. There were a few projects with Japanese settings, one of which was an animated series from 1972–73 based on the popular postwar samurai manga *Akado Suzunosuke,* but the majority of their projects were based on classics of Western children's literature (*Heidi, A Dog of Flanders, Anne of Green Gables*). And at the end of the decade, the European locales would serve a successful manga hero in one of a series of movies. . . .

Lupin III: Castle of Cagliostro (1979)

This feature was directed and co-written by Miyazaki for Toho Studios, based on a very popular manga series by an artist using the pen name Monkey Punch.[2] The series recounted the adventures of a hero who is supposedly the direct descendant of Arsène Lupin, the "gentleman burglar" turned detective featured in dozens of novels by Maurice Leblanc (1864–1941). Leblanc was originally commissioned to write a magazine piece to capitalize on the success of Sherlock Holmes. Leblanc not only created Lupin, a criminal who could challenge Holmes on his own terms, but also mercilessly tweaked the British detective in a series of stories about a bumbling British detective named Holmlock Shears. It's ironic that Miyazaki started with Lupin and a few years later worked on a Sherlockian television series, *Sherlock Hound.*

Lupin III, the grandson of Arsène Lupin, is more like a "super-deformed" James Bond than like his grandfather, and the Monkey Punch comics and other Lupin III movies are usually full of comic sex,

[2] Information on this film is thanks in part to Andrew Osmond, "The Castle of Cagliostro," *Animerica* 8, no. 4 (May 2000): 8.

comic violence, and comic chases. In *The Castle of Cagliostro*, the level of sex and violence is toned down severely. For example, the damsel in distress is the fleeing bride Princess Clarisse, who provides a plausible reason why Lupin isn't his usual horndog self in this movie: it seems he first encountered her when she was nine years old, and he still feels toward her like a "big brother." How convenient.

Lupin, by the way, is not the only character with a historical antecedent. One member of his gang is Ishikawa Goemon XIII, whose namesake was a samurai who was also reputedly versed in the arts of the ninja. This Goemon, a masterless *ronin*, provided for his wife and children by stealing. According to some legends, he preferred to steal from corrupt government officials, serving as a Japanese Robin Hood. In one legend, he tried to burglarize the quarters of the ruling warlord Toyotomi Hideyoshi in 1594, but unfortunately was caught. After he was captured, he was boiled alive in a large pot (thus giving his name to a type of Japanese bath called a *goemon-buro*).

The film is full of other historical antecedents, although few of these are Japanese. The plot derives in part from a 1924 Lupin novel, *The Countess of Cagliostro*, and partly from *The Clock-Tower Mystery* by Japanese author Edogawa Ranpo.[3] The villain of the piece, Count Cagliostro, is modeled after a real-life counterfeiter, Giuseppi Balsamo, who passed himself off as a count at the court of France's Louis XVI.

It also has another multidimensional female character in Fujiko Mine, a crook who competes with Lupin for whatever the prize happens to be. Her on-and-off dalliances with Lupin are off in this case. She's scheming and cynical, yet has the good grace to stand aside and let Lupin win this one.

But she also becomes part of a dyad of female characters (kindly Princess Clarisse being the other half). While most Ghibli films feature a complete

[3] Say it fast; it's a delightful pen name based on Edgar Allan Poe.

and complex heroine, several feature a dichotomy between two heroines—one virginal, the other wise to the ways of the world. The dyad is apparent in this movie, in *Porco Rosso*, and in *Omoide Poroporo* (although in this last movie the dichotomy is the same woman at two very different stages in her life).

Nausicaä of the Valley of the Wind (1984)

In 1983 Tokuma Shoten, publishers of the monthly animation magazine *Animage*, decided that there was enough interest in Hayao Miyazaki's long-running manga series *Nausicaä of the Valley of the Wind* to gamble on animating it. They chose Topcraft Studios, a small independent studio, on the basis of their work for the American production company Rankin-Bass, for whom they had just completed animation for a feature based on Peter S. Beagle's fantasy novella *The Last Unicorn*. Their next feature would change the face of Japanese animation.

Funding for the movie wasn't too hard to find. Some of it came from Tokuma Shoten. Additional money came from the Hakuhodo advertising agency, where Miyazaki's youngest brother worked.

If any film, in any genre, deserves to be called a groundbreaking masterpiece, it is this feature. How else do we account for the fact that, from its release in 1984, it won first place ten years in a row in the *Animage* magazine poll of fans? Even after the nihilistic *Akira* burst onto the scene in 1988, fans of Japanese animation (those who voted, anyway) still considered *Nausicaä* to be state of the art.

It's safe to say that anyone who has seen the film—even if what they saw was *Warriors of the Wind*, the horrendous English dub from schlock-genius Roger Corman's New World Pictures that cut out twenty minutes, including the entire ecological subplot—remembers it vividly. There are too many memorable scenes to mention, but I'll pick one. Toward the end, Nausicaä is dealing with a baby insect (quite a baby; it's as big as a compact

car). Injured and tormented, it is thrashing about, and Nausicaä is trying to physically force it away from a polluted lake filled with water like acid. She's been injured herself, and the insect pushes her wounded heel into the burning water.

And she screams. It's a scream that tears at the listener and raises the bar for cartoon voices. This is acting. (The actress, by the way, was Sumi Shimamoto, who also voiced Princess Clarisse in *The Castle of Cagliostro*, is remembered as the voice of the widowed landlady Kyoko Otonashi in *Maison Ikkoku*, and has recently returned to voice-work as the mother of girl pitching sensation Ryo Hayakawa in *Princess Nine*.)

The Princess Who Loved Insects

One rather outrageous line of dialogue vanished altogether in the dubbed version, yet it helps to clarify the feminine duality in this movie: between Nausicaä and Queen Kushana of Torumekia, who leads an invading army against the Valley of the Wind. The Torumekians want to recover a terrible and ancient weapon from an airplane that had crashed into the Valley, a weapon Kushana thinks is the only force powerful enough to destroy the giant insects laying waste to the planet.

Kushana, it seems, has a grudge against the bugs. She demonstrates to Nausicaä's advisors that one of her arms is artificial, having been claimed by one of the giant insects. Then comes the line: "Only the man who becomes my husband will see things that are even worse," and we realize that both Kushana's legs are armored in the same manner as her artificial arm. Her battle against the giant insects is thus both planetary and personal. Kushana may be doing what she thinks is the right thing, but she is going about it the wrong way, by using the same weapon that destroyed human civilization thousands of years earlier and thus opened the door for the giant insects in the first place. She may possess weapons to turn against

the insects, but what she lacks is compassion, the *yasashii* spirit of Nausicaä, who truly sees the insects for what they are.

Nausicaä's interest in insects turns out to be important for the entire planet. It is rooted not in science, however, but in Japanese folklore. Miyazaki cites as a model for Nausicaä "The Princess Who Loved Insects," a story from the twelfth-century collection *Tsutsumi Chunagon Monogatari*. It told of a girl who refused to act as she was supposed to. She didn't shave her eyebrows, didn't blacken her teeth, and didn't spend day and night indoors cultivating the deathly pallor that would mark her as a member of a noble house. And she liked insects. As anyone who watches *Pokémon* can tell you, Kasumi (aka Misty) in that series (and girls in general) are not supposed to be fans of caterpillars and bugs. The princess in this story, however, has a deeper understanding of nature than her peers. She feels that in order to love the butterflies, one also needs to love the caterpillars that will become butterflies.

Nausicaä takes this attitude one step further. Her unorthodox actions would hardly make her traditional heroine material, but there is a context for everything she does that justifies her behavior. She collects plant specimens from the toxic forest, and has set up a sophisticated laboratory in the castle to study the pollution of the planet. She studies the insects, but in the central events of the movie and in a flashback to her younger years we also see her maternally protect baby insects from the grownups who would destroy them without a second thought, demonstrating the *yasashii* aspect of her character. Even when she takes a sword and fights off a half-dozen invading soldiers, she does so in order to avenge the assassination of her father, the king. A girl can act aggressively, even violently, and still be *yasashii*. We'll see another example of this when we meet Nausicaä's distant cousin San in *Princess Mononoke*.

Killer Joe

Nausicaä is finally noteworthy because it marks the arrival of another member of the group associated with Miyazaki. Composer Joe Hisaishi was born in 1950 and attended a music conservatory with the intention of writing contemporary classical music. In 1983, the year after the first album of his compositions was recorded, his record label recommended him to write "image music" (pieces that would not necessarily be heard on the soundtrack) for *Nausicaä*. Another composer was being considered for the actual film score, but when they heard Hisaishi's music, both Miyazaki and Takahata wanted him to score the film. Since that time, while he's also written concert music and scores to video games, he has scored most of the Ghibli movies, using a full and rich orchestral palette that is immediately recognizable.

Hisaishi claims his name is recognizable to American music fans. It's another Japanese pun; by putting his family name first (Hisaishi Jo) and changing the way the first part of the family name can be read (from "hisa" to "ku"), we get "Kuishi Jo," which reminds Hisaishi of American composer and bandleader Quincy Jones. Hisaishi also favors spelling his given name "Joe" instead of "Jo," perhaps recalling one of Quincy Jones's biggest hits, "Killer Joe."

Laputa: Castle in the Sky (1986)

This film is the first actually produced under the name of Studio Ghibli. (The name, by the way, is Italian: the nickname of a World War II scout plane. The *ghibli* were planes that scouted the Sahara, and were so called because the name meant "hot desert wind." Miyazaki, let the record show, likes flying and Italy but not Fascism, as his later film *Porco Rosso* makes clear.)

The profits from *Nausicaä* enabled Miyazaki and Takahata to create Studio Ghibli in 1985, with additional funds coming from Tokuma Shoten. Studio

Ghibli was a daring move from the start, because it dedicated itself to animated theatrical features. For most animation studios, television series pay the bills, with theatrical films being produced whenever possible. But remember that Ghibli was started by the men who took as much time as they needed to finish *Prince of the Sun*. In addition to their string of feature films, Studio Ghibli, after almost two decades, has animated a handful of commercials, a couple of music videos and a made-for-TV movie, but no TV series.

Laputa took a full year to produce, and the effort shows. The artwork is highly detailed, from the streets of the mining village to the machinery of the floating castle. (Also visible in *Laputa* are the same fox-squirrel hybrids that Nausicaä kept as pets.) Those interested in the details of the Japanese production might want to note that the voice cast includes a young up-and-coming actress in a tiny role: Megumi Hayashibara.

Names in *Laputa* were one of the big problems for those who wanted to market the film in the West. "Laputa" would read in Spanish-speaking neighborhoods as "the prostitute." (Jonathan Swift knew this already when he created Laputa for his darkly satiric 1726 novel *Gulliver's Travels*. As Takahata noted in one interview, Swift gave the cloud-shrouded floating castle this denigrating name not so that it could stay hidden, but because it was an evil place that did not deserve sunlight.)[4] The names of the young heroes are likewise a problem, with Pazu pronounced uncomfortably close to the Yiddish epithet *putz* and Sheeta . . . you get the idea. Sheeta's name, by the way, derives from India; it's an alternate spelling of Sita, wife of Prince Rama, hero of the epic *Ramayana*.

My Neighbor Totoro (1988)

This is arguably the finest children's movie ever made. In a mid-twentieth-century Japan seemingly never blighted by war and never over-industrial-

[4]http://www.nausicaa.net/miya zaki/interviews/t_corbeil.html.

ized, a father and his two daughters, ten-year-old Satsuki and four-year-old Mei, have moved to the country (the country locale is based on Tokorozawa City, which has resisted—with Miyazaki's help—being absorbed into Tokyo). The girls' mother is in a tuberculosis sanatorium, and they have moved to be close to her. In occupying a battered but beautiful old house, the girls find delights both real and imaginary—the latter include Totoro, a giant furball of a nature spirit, and a creature that looks half Cheshire cat and half cross-town bus. These fantasy creatures enter the girls' reality when mother seems to take a turn for the worse.

Miyazaki, who wrote the story, and whose own mother spent two years in a tuberculosis sanatorium, probably realized from experience that the best way to balance the delightful fantasies of the girls was to invoke childhood's deepest and most universal anxiety: that something bad would happen to Mommy.

We have already looked at some of this movie's reflections of Japanese culture: the Shinto-inspired worship of the giant camphor tree, the family bathing. There are many others, from the stone Jizo images by the side of the rural roads to a fleeting reference to a folktale: A crab, so the story goes, once planted a persimmon seed and stood by the garden day and night waiting for it to sprout. Satsuki writes to her mother that Mei is hovering like the legendary crab over the seeds they got from Totoro and planted.

Satsuki's first entrance into the house contains a very Japanese gesture: without kicking off her shoes, she drops to her knees and knee-walks into the room to pick up an acorn. Even at this most exciting moment, she doesn't forget who she is or what behavior is proper. By extension, pop culture seems to be saying, neither should the audience.

The female duality shows up here in an interesting way: the two daughters. Their names suggest this: Satsuki is the old Japanese name for the

fifth month, and "Mei" suggests the English month of May. Miyazaki's original story featured one little girl, not two. He split them along age lines, with Satsuki being the older and more responsible of the two. This is in keeping with the cultural belief that a child becomes old enough to take responsibility for its actions at age seven. In the Shichigosan ("seven-five-three") festival, Japanese children who have reached these ages are taken to a local shrine to pray for their health and future. This may have grown out of agrarian celebrations that infant mortality had been warded off until a critical age was reached, but it now represents an index of maturity. Mei has yet to reach that level, which is why she has to be watched over by older and wiser spirits: Satsuki, her parents, the old lady next door, the stone Jizo on the road, or Totoro.

Hotaru no Haka (1988)
The book by Akiyuki Nosaka is moving enough as it is, with the author telling of his adopted sister dying of starvation just days before the surrender of Japan in World War II and its occupation by the Americans, but no one who cares about children can watch this film, adapted from the novel and directed by Takahata, without shedding a tear. You can always distance yourself by reading the elaborate website devoted to the film, built by Dennis Fukushima, Jr., and found at www2.hawaii.edu/~dfukushi/Hotaru.html. It will tell you more than you ever wanted to know about the M-69 napalm bombs used by America against Japan. You can read his comparison of the plot to a Bunraku play and see it as another giri/ninjo conflict, with the children wanting their old life back but facing tragedy precisely because it's impossible. You can learn that the Japanese kanji used to write hotaru in the title is a pun, meaning "raining fire" rather than "fireflies." It won't change the ending, though, as much as you might want it to.

For this movie, another principal member of

Studio Ghibli, Yoshifumi Kondo, was character designer and animation director. Before this, he had worked on-and-off with Miyazaki and Takahata on their television series of the '70s. He now joined Studio Ghibli and, his television work behind him, served in one capacity or another on the string of major Ghibli films that was to come, through to *Princess Mononoke*.

Kiki's Delivery Service (1989)

This film, directed by Miyazaki, who also adapted the children's book by Eiko Kadono, eases up (but only a little) on Kadono's depiction of the thirteen-year-old Kiki: a little impatient, a little sassy, a little headstrong—in short, a lot like most thirteen-year-old girls. This one just happens to be a witch who, according to custom, must settle in a village without a witch for one year and make a living through her witchcraft. However, Kiki doesn't know all that much magic, apart from how to fly a broom.[5]

Kiki leaves home at a moment's notice in the film (in the book, she prepares for about a week, but still springs the news on her family).[6] Once she gets to the town of Koriko, Kiki has to be herself, even though she also wants to be like the girls in the town. She envies their clothes and socializing, and most of all envies them their friends because it takes her so long to make one. But this longing to be like the other (non-magic) girls sets up, for me, the best throwaway gag in the movie. Kiki finally uses her flying ability to save the life of a friend on a runaway dirigible, and thus becomes a media star. During the closing credits, we see Kiki looking at colorful clothes in a store window, when a mother passes by with her three-year-old child in tow. The child wears a black dress with a red hair ribbon and carries a broom like Kiki's! Kiki has become a role model without meaning to. She is also, in a sense, reminded—as is the audience—of what will happen someday, after she spends the year

[5] This is shown more clearly in the book *Majo no Takkyubin (Witch's Delivery Service*, 1985). Witches, it seems, have gradually been losing their witchcraft over the years. Kiki's mother, Kokiri, knew only flying and medicinal plants, while Kiki was too impatient to bother learning about plants. There's a note of nostalgia early in the book that something valuable is being lost, perhaps forever. And in fact Kadono wrote a second book, *Kiki to Atarashii Maho (Kiki and Her New Magic)*, where the "new" turns out to be old: Kiki went back home to study her mother's herbal medicine.

[6] As Kiki flies through the night sky during the opening credits, she passes a very large passenger plane that looks nothing like a twentieth-century aircraft—but bears a resemblance to the Torumekian transport that crashes into the Valley of the Wind at the beginning of *Nausicaä of the Valley of the Wind*.

alone proving herself. The appearance of the child version of herself is a reminder that motherhood is still going to be part of her life.

This film was the first one released in English under a deal worked out between Ghibli, Tokuma, and Disney (although an earlier dubbed version of *Kiki* was available). The deal was vindicated with good sales and at least one award: critic Ty Burr of *Entertainment Weekly* pronounced *Kiki's Delivery Service* the best video released in 1997, noting the irony that traditional animation still had charm and power in the year that saw two CGI movies—Dreamworks' *Antz* and Disney/Pixar's *A Bug's Life*—battle head to head. He might also have mentioned that, in the year when Hollywood trotted out its own version of *Godzilla* with the almost panicky promotional line "Size Does Matter," Americans could find out that the biggest Japanese entertainment export was really the heart of a thirteen-year-old witch.

Only Yesterday (1991)

The actual title, *Omoide Poroporo*, means "remembering drop by drop." What writer/director Takahata seems to remember best is the pop culture of

Kiki's Delivery Service With a little help from her mother, thirteen-year-old Kiki prepares to set off on her obligatory year away from home to prove herself as a witch. She has to survive by her magic, which doesn't yet amount to much. Kiki knows how to fly on a broomstick, but little else. The logical result: Kiki's Delivery Service.

1966. Movies, commercials, pop songs, even bakeries from the period and a Takarazuka-style all-girl theater company are alluded to in this adaptation of a nostalgic manga by Yuko Tonai and Hotaru Okamoto (published, perhaps not by coincidence, by Ghibli partner Tokuma Shoten). The manga, however, is set exclusively in 1966—as an exercise in nostalgia, it didn't have much of a plot. Takahata created the device of setting half of the movie in 1982, with Taeko Okajima, a Tokyo "office lady," reflecting back on 1966, when she was ten years old. . . .

Taeko takes a vacation on a farm in Yamagata, a prefecture in the north of Japan's main island Honshu. One of Taeko's older sisters has married into a family of *benibana* farmers (the *benibana* flower yields a crimson dye—interesting in itself, since it's a very specialized commodity, but also a symbolic crop, as one of the flashbacks to 1966 recalls Taeko's first instructions in matters of menstruation). While on this sabbatical, Taeko gets a proposal of marriage from a cousin of a cousin of her brother-in-law, but doesn't act on it by the time the train prepares to leave the pastoral farm and return her to Tokyo—except to say that, when she returns for some skiing in the winter, she won't bring her ten-year-old self along. In this case the duality was Taeko in the past versus Taeko in the present, and she needed the trip to Yamagata to exorcise the child in her and get on with her life.

Porco Rosso (1992)

Internally and externally, *Porco Rosso* is all about flight, and it comes as no surprise that it was written and directed by Miyazaki. The story is about a World War I air ace coping with peacetime and being pressed back into service, but it has much more humor than that plotline would suggest.

Marco Pagot is an Italian pilot in the 1920s. (He's named after one of a pair of brothers who produce Italian animation that Miyazaki worked with a

decade earlier on the TV series *Sherlock Hound*.) Marco survived seeing his comrades die in combat, but with a self-image so low it has transformed his appearance: he now looks like a pig. Hence the name of the movie, which is also his stage-name— "The Crimson Pig"—for the aerial stunt shows he performs.

His life, though, becomes very complicated. He has to deal with his old lover, the chanteuse named Gina, and with her seduction by American movie actor Donald Curtis. We find out later that, while Pagot looks like a swine, Curtis acts like one, shooting Pagot out of the sky to give himself a clearer shot at Gina. Pagot survives to have his plane rebuilt by a schoolgirl-mechanic named Fio. Fio and Gina thus become the film's duality of innocence and experience, and Pagot will need both to be redeemed.[7] In the end, Gina doesn't follow Curtis to Hollywood, getting together in the hotel on the Adriatic each summer with the successful businesswoman Fio and legendary Marco Pagot.

The airplanes in this movie look experimental, even a little absurd, but they aren't fantasy planes like the buglike craft flown by Ma Dola's gang in *Laputa*. These planes are based on actual aircraft from the 1920s, a time when aerial technology was still evolving and designs were much more freeform. They grew out of Miyazaki's love of aircraft and specifically from a manga he created: *Hikotei Jidai* (*The Age of Seaplanes*).

Ponpoko (1994)

The full title *Heisei Tanuki Gassen Ponpoko*, literally translated, means "The Heisei-era Tanuki War Ponpoko." We are currently in the Heisei era, and have been since Akihito became emperor after the death of his father in December 1989.[8] The title is often translated "raccoon war," but that ignores the special place of the *tanuki* in Japan. First of all, it's not a legendary animal, but a real animal around which many legends have grown.

[7] In one scene, Fio is half-asleep and sees Pagot's face as human. This scene establishes that Pagot was not the victim of a magic curse but of his self-loathing. And since Fio is (until the end) the only one who sees him as such, the scene establishes the value of her innocent and *yasashii* character.

[8] When an emperor dies, he takes the name of the period in which he reigned. Thus, Hirohito (1926–89) is now referred to as the Showa Emperor.

Scientifically speaking, a *tanuki* is a member of the dog family (hence its Latin name, *Canis viverriuns*). It has a fat body, short legs and tail, bushy fur, and a face resembling the Western raccoon. It's an omnivorous eater that hibernates in the winter. It prefers to live in heavily wooded areas, always near water, but has been known to come into towns at night to raid garbage dumps. Native to Japan, the *tanuki* is also found in Siberia and Mongolia and was introduced into eastern Europe in the mid-twentieth century.

One magical attribute of the *tanuki* is, to say the least, unique: according to legend, it can inflate its scrotum to the size of a room and drum on it. The *tanuki* has long been associated with drinking, and it is common to find potbellied *tanuki* statues, wine-gourd in hand, decorating the entrance or interior of drinking establishments.

Like the *kitsune* or fox, the *tanuki* is supposed to be a shape-shifter. Specifically, it's capable of wrapping itself in lotus leaves to turn into a Buddhist priest. (The choice of flower is no surprise, since the lotus is a potent Buddhist symbol. A white lotus blooming in a muddy swamp symbolizes the wisdom of enlightenment shining forth even in a polluted world.)

In one story, the *tanuki* and the fox had a contest to see which was the better shape-shifter. The fox disguised itself as a roadside stone statue of the bodhisattva Jizo and used its disguise to steal the *tanuki*'s lunch. The *tanuki*, for its part, said that the next day it would appear to the fox disguised as the emperor. Sure enough, the next day, what looked like the emperor and his retinue came down the road. The fox rushed out to congratulate the *tanuki*—and because it really *was* the emperor—was beaten by one of the guards.

The modern *tanuki* war alluded to in the movie title is against humankind, to stop people from overdeveloping the *tanuki*'s natural habitat by cutting down the forests. (This isn't just ecological

sentimentality. The closer that *tanuki* live to people, the more likely they are to succumb to diseases, particularly to mange, which causes their bushy fur to fall out and leads to their freezing to death.) Actually, though, the events of this movie, directed and written by Takahata, mirror an earlier Great Tanuki War.

This war is captured on an *emaki* (illustrated scroll) in the Kyoto National Museum.[9] Known as the *Junirui Emaki*, it begins with the twelve animals of Chinese astrology deciding to have a poetry competition, with the deer (an animal favored by Buddhists) as the judge. When the *tanuki* volunteers to also be a judge, the other animals laugh him out of the hall, whereupon he rounds up other spirit-animals (such as the fox and the crow) for battle. Needless to say, the battle doesn't go so well for the *tanuki*, who in the end decides to stop the war and pursue the Buddhist path of peace and wisdom.

The movie follows the legends closely, including the *emaki* tradition of satirizing human follies by putting animals in kimono. What was satirical in the old days becomes literal in this movie, as the *tanuki* decide, having lost the war with the develop-

Modern-day Tanuki War Ponpoko A group of tanuki discuss their options. Human development has disturbed their forest, and fighting to preserve their woodland home may be a lost cause. This movie, written and directed by Isao Takahata, is an updated version of a Buddhist legend from the twelfth century, about another tanuki war that also turned out to be a lost cause.

[9] The following is based on information from http://www.kyohaku.go.jp/mus_dict/hdo8e.ht m, the Kyoto National Museum site. It was written by Junji Wakasugi and translated by Melissa M. Rinne.

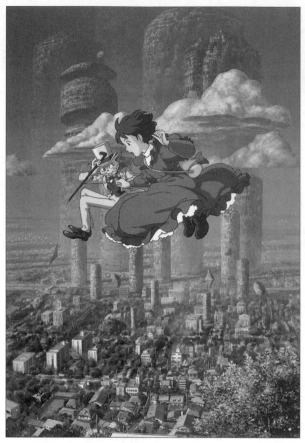

Whisper of the Heart *Flying sequences in Ghibli films are usually accomplished by aircraft or magical items such as a broom or a special stone. Here the flying is all in the mind of Shizuku Tsukushima, casting herself as the heroine (and worried about her leap into the unknown) as she begins writing a magical saga entitled "If you listen carefully. . . ." This, by the way, is the meaning of the movie's original title, "Mimi o Sumaseba." Her companion, The Baron, is based on a statue of a fancily dressed cat in an antique shop owned by the grandfather of Shizuku's boyfriend, Seiji.*

ers, to shape-shift one last time, put on human clothes, and live as humans for the rest of their days.

Mimi o Sumaseba (1995)

This movie version of Aoi Hiiragi's girls comic is the only film directed by Ghibli lead animator Yoshifumi Kondo. The location of the movie is important in the context of Ghibli movies. At one point in the movie, student/heroine Shizuku Tsukushima writes satiric lyrics to the pop song "Take Me Home, Country Roads":

Concrete Road, wherever I go
Plow the valleys, cut the trees

Western Tokyo, Old Mount Tama
That's my home, a Concrete Road.

In this case, it's literal. The action takes place in western Tokyo, on Mount Tama—the same mountain area that the *tanuki* tried to protect from human development in *Ponpoko*. In fact, the final scene of *Ponpoko* dovetails precisely into the first shot of *Mimi o Sumaseba*. The same piece of ground, now changed for all time.

The title *Mimi o Sumaseba* is deliberately chosen: "If you listen carefully . . ." are the opening words of the epic story written by the heroine, Shizuku. It's her last year of junior high, and this bookworm is known to her friends as "Queen of Verse" for her talent at putting new words to old melodies. (In fact, her version of "Take Me Home, Country Roads" is a thread running throughout the movie.) But she's finding it rather boring, especially when she meets Seiji Amasawa. They get off on the wrong foot at first, as happens so often, but after a while he tells her of his ambition: to become not a player of violins but a maker of them. In fact, he's taking several months to travel to the mecca of violin-making, Cremona, Italy, to try his hand as an apprentice. This inspires Shizuku to write while he's gone—not just another parody lyric, but her first extended prose story, a fantasy-romance that weaves in characters and plot-threads already seen in the movie, including items seen in the antique shop owned by Seiji's grandfather. It's a purely internal quest, but she grows stronger when she comes out the other side.

That the quest happens at all brings up one interesting scene. While she's writing her epic story, Shizuku's mind wanders off of schoolwork and her grades suffer. Her parents call her on the carpet for it but, instead of laying down the law and telling her to shape up, they listen to her insistence that she has to do this (although she's vague about what "this" is) to test herself. Shizuku's mother re-

calls going through something similar in her youth; her father warns her that, if things go wrong, she'll have nobody to blame but herself. That's it. Once again, harmony (*wa*) is restored through consensus, and once again a risky behavior (Shizuku gambling with her transition from junior high to high school) is justified in the context of the traditional cultural value system. In contrast, Shizuku's friend Yuko complains that her parents give orders rather than discuss, and we see her refuse to talk to her father because they had a quarrel. Lack of discussion leads to lack of consensus, which in turn leads to lack of *wa*.

There are a number of changes between the manga and the animated film, some trivial and some more important. The most crucial change is in living arrangements. In the comic book the Tsukushima family lives in a house, implying a certain level of affluence. However, the post-bubble recession was in full swing by 1995, and the Tsukushima family finds itself pinched, literally and figuratively. They now occupy a small apartment, with the family's two daughters sharing a room and sleeping in bunk beds, and with their mother taking classes so that she can finish a degree and get a job. Books and papers seem to be stacked all over the apartment. The main difference is the front door. Every time it opens and closes, it does so with a hollow metallic clunk reminiscent of a hatch in a submarine. There are still futons airing out on the balcony and tatami matting on the floor, but this story is a long way from classic Japanese architecture. But then, so is its audience.

Mononoke-hime (1997)

This film, written and directed by Miyazaki with Kondo as a lead animator, went on to be the biggest moneymaker among Japanese films, breaking a record set by E.T. and was itself bested only by *Titanic*. When it was presented in English as *Princess Mononoke* (with a script by Neil Gaiman,

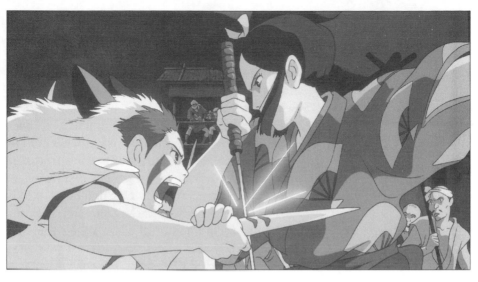

best known as a comic-book creator), the second Disney-produced dub of a Miyazaki film, there were problems. After Prince Ashitaka is infected by the rampaging boar, he finds that the arrows he shoots do more damage than usual. Limbs and heads go flying, which gave Western audiences fits of nervous giggling. This is the kind of violence that had only appeared in American animation on the parody level—in the battles between Tom and Jerry, or the Road Runner and the Coyote. As absurd as the damage seemed, though, it was deliberately included in the film to demonstrate how much more lethal and corrupting firearms (the real cause of the boar's curse) were than bows and arrows. Still, the surface violence contributed to Disney's decision to back away temporarily from the rest of its deal with Ghibli/Tokuma.

The problem with the female dualities in this film is in choosing just one. San, the "Princess of the Evil Spirits" of the title, is an obvious contrast to Lady Eboshi, who runs the ironworks at Tataraba. She can also be compared to and contrasted with her foster mother, Moro the wolf spirit. Yet, as Moro points out, San is neither fully human nor fully wolf when the story begins. Even

Princess Mononoke San, the *feral child, attacks Lady Eboshi, who runs Tataraba (or Irontown), which has been polluting the land, water, and air. San may not seem the compassionate, yasashii heroine common in such movies. However, let the record show that, despite her ferocious attacks, San never kills anyone!*

at the end, there's no easy "happy ending"; she doesn't ride off into the sunset with Prince Ashitaka. She will continue to live in the forest, while he lives in Tataraba, helping to rebuild the city along more humane lines. Meanwhile, they agree to see each other "from time to time."

This makes San unlike Kiki or Shizuku or Sheeta, all of whom go through considerable changes by the end of their respective films. San's true analog may be Nausicaä, who essentially stayed herself while changing the world around her.

Princess Mononoke was the last film with Yoshifumi Kondo as animation director. When the film premiered, Miyazaki announced that he would retire from filmmaking, leaving Ghibli in the capable hands of animators like Kondo. However, Kondo died suddenly in early 1998 of a brain aneurysm, at age 47. Retirement would have to wait.

Tonari no Yamada-kun (1999)

Directed and written by Isao Takahata and based on a manga by Hisaichi Ishii, this movie is truly unique among animated films in general, not just among Ghibli's films. The reason is the source material: *Tonari no Yamada-kun (My Neighbors the Yamadas)* is a four-panel gag strip, not a long-form manga. While it seems easy to animate some *manga*, since they incorporate cinematic devices into their visual vocabulary, the four-panel strip, familiar in the West to any newspaper reader, almost defies conversion into an extended narrative.

The artistic style of the strip would also seem to defy animation: simple line-drawings in an exaggerated caricature style, the antithesis of the realistic Ghibli look. Yet Takahata adopted that style—line drawings, filled in with a watercolor-style wash, and manipulated by computer—to present a movie that is a series of vignettes, some short, some long, some hilarious, and some pleasantly reflective. Like the conversion of Charles Schulz's *Peanuts* comic strip into countless televi-

sion specials, this is the rare success of one medium converted to another.

Again the family is typical: parents, children, plus the wife's mother and the family dog. Some characters speak Kansai Japanese.[10] The children (son in junior high, daughter in third grade) are academically average. Dad is a salaryman, a section chief (hancho)[11] in his corporation. There's also a wedding, where dad is supposed to make a speech during the reception. He spends days laboring over the speech, only to show up at the reception with the wrong manuscript; consequently, he has to make up his speech off the cuff.

If there's a message at all in this film, it's in this vignette. You plan, you work, you try your best, and everything still ends up going wrong. But you pull yourself together and try to get through it with as much dignity as you can muster. Certainly a lesson for any nation, but definitely for recession-weary Japan.

Sen to Chihiro no Kamikakushi (2001)

Miyazaki's latest written-and-directed feature surpassed both Princess Mononoke and Titanic at the box office, putting Miyazaki back in the lead as Japan's top-grossing filmmaker (at least until just after Christmas 2001, when Harry Potter and the Philosopher's Stone swept Japan).

Once again, the title in Japanese—the film in the U.S. is titled Spirited Away—is a pun that points to a duality. "Sen" is another way of pronouncing the first character in the name "Chihiro." In a sense, Chihiro is one person, and Sen is quite another. Chihiro is what Miyazaki considers to be an all-too-common modern ten-year-old: jaded, cynical, lacking any passion for life. The change happens as her parents take her through a tunnel and come out the other side into an alternate reality, a therapeutic hot springs for spirits, monsters, and witches (including the "living soot" from Totoro),

[10] The Kansai dialect, spoken in the Osaka (aka Kansai) area, tends to be a bit rougher and has a more defined lilt than standard Japanese, which is what is heard on national TV and throughout the Tokyo area.

[11] This word is the source of the American phrase "head honcho." American soldiers in Japan during the Korean War picked up the word and brought it home.

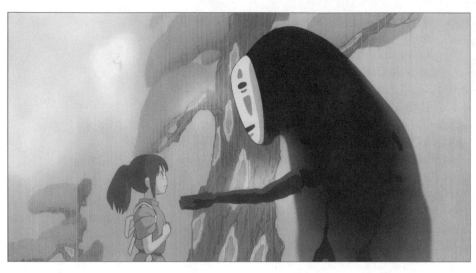

Spirited Away Chihiro, re-
named Sen by the owner of the
"spirit bathhouse" where she's
forced to work, is the youngest,
newest, and clumsiest worker
there (not only that, but every-
one complains she still smells
like a human). Still, through
luck or instinct, she generally
does the right thing. Even if it
means inviting in the spirit
called No Face, whose appetite
turns out to be voracious.

[12] This is a rather grim children's
story about a farmer who adopt-
ed a rabbit, a marauding *tanuki*
who kills the farmer's wife, and
the revenge carried out by the
rabbit (in the spirit of filial devo-
tion, one assumes). A web ver-
sion of this story can be found at
http://jin.jcic.or.jp/kidsweb/folk/
kachi/kachi.html. In one of the
OAVs based on Kosuke Fujishi-
ma's manga about Tokyo police-
women, *You're Under Arrest*, the
policewomen visit a kinder-
garten class about to put on its
own version of "Kachikachi
Yama."

with buildings whose architecture reflects the ear-
ly-1920s Taisho period. Without a thought, Chihi-
ro's parents eat food that was set out as an offering
for the gods and are turned into animals; it's up to
Chihiro (or "Sen," as the local spirits insist on call-
ing her) to reverse the spell.

Although the roots of this story seem linked to
Homer's *Odyssey*, at least in the motif of people be-
ing turned into swine, Miyazaki is quite clear about
the film's origin. It's a direct descendant of folk-
tales such as "Suzume no Oyado" (Sparrows' Inn),
in which a callous act leads to demonic torment,
but there's more to it than that. Miyazaki feels that
"'Kachikachi Yama'[12] and 'Momotaro' have lost
their power of persuasion. . . . Children are losing
their roots, being surrounded by high technology
and cheap industrial goods. We have to tell them
how rich a tradition we have."[13] But it's not just
about children; Miyazaki also joked that "it's tough
being a Japanese god today." They face the same
distractions and hi-tech toys that Japanese chil-
dren face. Ideally, though, to the extent that this
movie redeems Japanese ten-year-olds, it may re-
deem Japanese gods as well.

All of which does not necessarily bar a Western
audience from understanding and enjoying the

film. The basic outlines of the story translate well, even if the cultural specifics don't. And we in the West are certainly just as much in need of redemption from our own toys as are Japanese children— or Japanese gods.

The amazing part about this chapter is that, long though it may be, it isn't finished yet. Studio Ghibli is still producing movies that are as unpredictable as they are wondrous. Nobody could have predicted *Porco Rosso* on the basis of *Nausicaä*, or *Princess Mononoke* on the basis of *Mimi o Sumaseba*.

Speaking of which, 2002 will see the release of the latest Ghibli feature: *The Cat Returns (Neko no Ongaeshi)*. At first, it may seem like a sequel to *Mimi o Sumaseba*: both movies are based on manga by Aoi Hiiragi, and a few of the characters appear in both films. In this film, though, we meet a totally different schoolgirl, who explores the secret nightworld of cats. Yuji Nomi composed the score for both movies, which is directed by Hiroyuki Morita, who has worked on a few Ghibli productions as well as one of the movies based on *Tenchi Muyo*. Miyazaki is credited as executive producer.

No one can truly predict when Miyazaki will retire from filmmaking; he said *Mononoke* would be his last, but he has made two films since then, and more are in the works. I won't try to guess what's coming, but it'll be worth the wait.

[13] From an interview with Miyazaki printed at http://www.nausicaa.net/miyazaki/sen/proposal.html. With all due respect to Mr. Miyazaki, it might be more accurate for him to have said that Momotaro et al. have lost their powers of persuasion as such. The premise of this book is that the figures of folklore and legend have changed from year to year in order to retain their power . . . and Miyazaki's movies have proven his ability to adapt the past to serve the needs of the present.

The *Sailor Moon* Phenomenon:
Love! Valor! Compassion! Middie Blouses!

Ever wonder why a cartoon aimed at teenage Japanese girls would literally circle the globe, embraced by fans from Boston to Brussels to Brazil? Wonder no more.

U ntil 1992, Naoko Takeuchi was one *shojo manga* cartoonist among hundreds, trying to break out of the pack with something unique. She had done several successful series for *Nakayoshi* magazine between 1986 and 1991, when she got a nibble on her line with a schoolgirl superhero comic titled *Code Name Sailor V*. This superhero had a few flaws, certainly nothing uncommon for a fourteen-year-old. However, Takeuchi took her next heroine even further out of the heroic mold, playing up the flaws. Enter the oversleeping, overeating, whiny, klutzy crybaby who has to save the world, keep up with her homework, and chase after a boyfriend: Sailor Moon.

Why did *Sailor Moon* became as big an international hit as it did. Certainly the animated version accounts for some of its popularity, since even the more pedestrian scenes (pedestrian to those who already know anime) have something interesting, while the standout sequences are stunning. But great visuals have been around for a long time. That's not enough of a reason.

The fact that the animated and print versions appeared at the same time was a daring marketing move—daring, but not unprecedented.[1] This, however, is not a sufficient reason.

It's no coincidence that the rise of *Sailor Moon* occurred along with the rise of the Internet. Fans of anime in general, and of the series in particular, had a new and expansive venue in which to compare notes. But this in itself is not the answer.

Sailor Moon has been compared with another television series aimed at roughly the same demographic—*Buffy the Vampire Slayer*—as a prime example of a female empowerment fantasy. But the same argument could be made for other American television series, as far back as the situation comedy *Bewitched*, which was very popular in Japan and helped give rise to the entire "magical girl" genre, of which *Sailor Moon* is a prime example. There's more to it than that.

To give the series its full title, *Bishojo Senshi Sailor Moon* (*Beautiful Young Girl Warrior Sailor Moon*) was essentially the first *shojo anime* broadcast in the West. There were other series broadcast in the '80s that were meant to balance out the more macho anime like *Mach Go Go Go* (known in the West as *Speed Racer*), *Go Lion* (translated as *Voltron*), and the *Macross/Robotech* episodes. The Nickelodeon cable network showed such kinder, gentler fare as *Belle and Sebastian*, *Maya the Bee,* and an anime series based on Saint-Exupéry's classic book *Le Petit Prince*. Still, these were targeted more at a grade-school audience, not aimed at teenage girls.

Sailor Moon for all practical purposes perfected the formula Dr. Tezuka developed in *Princess Knight*. It strikes a balance between romance and action, often relying on humor as the glue to hold the two very different halves together. (For comparison's sake, *Please Save My Earth* has lots of action and lots of romance, but in its animated version is almost entirely humorless. And the humor in *Fushigi Yugi* is more disorienting to a West-

[1] An excellent account of the details of the manga-anime-merchandise campaign that launched *Sailor Moon* can be found in Lee Brimmicombe-Wood and Motoko Tamamuro, "Hello Sailor!," *Manga Max* 19 (August 2000): 30.

Sailor Moon Members of the so-called Outer Senshi, named for the outermost planets of the solar system; they're older than the other Sailors, and have a few darker tones to them. Sailor Pluto (top) is the only one of the group who isn't strictly human; she's a goddess, eternally guarding the Portal of Space and Time. As for Sailors Neptune and Uranus (left and right), it becomes obvious from their dialogue—laced with personal asides and double meanings—that there's something romantic going on. . . .

ern audience, since it isn't driven by the inherent flaws of the characters but by "super-deformed" caricatures.) The humor element also takes much of the edge off of the proceedings, so that this series empowers without threatening to take anything away from anyone. Its international popularity is due, I believe, to this ability to be the best of several possible genres.

The Rising of the Moon

The story takes place in Azabu Juban, a real, present-day Tokyo neighborhood. It's home to the Tsukino family, including their teenage daughter Usagi. Usagi is hardly a role model: perennially late to school, too lazy to study and subsequently always in trouble for bad grades, constantly snacking and arguing with her little brother. In anime's long and rich tradition of "magical girl" heroines, Usagi would definitely seem to be an unlikely candidate—until the day she encounters a black cat with a crescent-shaped mark on its forehead. The cat tells her to defend her friend Naru against an attack by a monster. True to the tradition, she's told to say a few magic words, which transform her into . . . a superpowered klutzy crybaby. All of Usagi's flaws stay with her, but somehow she saves the day. Then she learns that this was no accident, and that the whole story started a thousand years ago on the moon. . . .

This chapter borrows its title from a play by Terrence McNally, and although there's absolutely nothing in common between the story of *Sailor Moon* and AIDS (the subject of McNally's play), the titular virtues of the play sum up Takeuchi's work as well as can be done in three words.

Love

The world of a pubescent girl is a magical country in and of itself: little wonder that this demographic seems to take pride of place in Hayao Miyazaki's films. Whatever else happens, a girl's sexual/ ro-

mantic awakening is waiting in the wings, and this has featured for years in numerous manga and anime, sometimes innocently, sometimes pornographically, and occasionally in a gray zone between the two.[2] In fact, in 1995, during the fourth season of *Sailor Moon's* anime broadcast, a fifteen-minute theatrical special touched on the romantic awakening of one of the Sailor Senshi, the bookish and very unromantic Mizuno Ami.

Usagi's awakening is taking place when the series begins; in fact, she has something of an embarrassment of riches, being drawn first to the owner of a video game parlor, then to the older and somewhat mysterious Chiba Mamoru. Although at first he seldom has a kind word for her, criticizing everything from her grades to her hairdo, they become more than just crime-fighting allies (he joins the long line of masked heroes as Tuxedo Kamen). Just as Usagi is the rebirth of Moon Princess Serenity, Mamoru is the rebirth of Earth Prince Endymion. They were in love a thousand years ago, when Queen Beryl's forces interrupted their happiness, and their meeting in twentieth-century Tokyo is the fulfillment of destiny. As the theme song says, "*Onaji kuni ni umareta no / Miracle Romance*" (Being born in the same country / Is a Miracle Romance).

Valor

Valor and Usagi hardly belong in the same sentence. This girl panics if she forgets her lunch. She would hardly seem to be a match for the procession of absurd, downright surreal monsters she has to fight.

And yet that seems to be the point. Usagi can't help having been the Moon Princess in a previous life, and now that she's stuck with it, she has to find the courage to do what needs to be done (which is, after all, just another way of saying *giri*). This is a more realistic object lesson for the audience anyway—very few of us will inherit superpowers, but

[2] This has given anime in particular, and much of Japanese pop culture in general, a bad reputation in the West. The preference for youthful, virginal females has become known as *rorikon*, short for "Lolita Complex," named after Vladimir Nabokov's infamous novel about an older man pursuing a young girl. Then again, there was a similar theme in the popular American film *American Beauty*, so the tendency is not exclusively Japanese.

© NAOKO TAKEUCHI/ KODANSHA LTD./ TOEI ANIMATION CO. LTD.

Sailor Moon *The sunny and in-nocent face of one of the most globally popular anime of the '90s. Sailor Moon herself is front-and-center, shadowed by her daughter—or, rather, the daughter her descendant will beget in the far future (along with the descendant of Tuxedo Mask, the caped gent in the background). While Sailor Moon's real identity is a school-girl named Usagi (Rabbit), the future daughter is called Chibiusa (cute little rabbit). These two spend much of the series mirroring each other and getting on each other's nerves.*

all of us find ourselves in predicaments that we're not entirely sure we can get out of.

Compassion

Some anime hero shows (notably *Guyver*) have villains with no real personality, and sometimes not even a real name. Hence, they're lined up and cut down in quick order. This doesn't make for much exercise of a *yasashii* spirit. *Sailor Moon* has two classes of villains: the absurd monsters and the thinking, feeling humans. They may not be of this Earth, and they may do incredibly evil things, but they're still human. Along the way, not all of them get destroyed; some are even redeemed. Giving the villains scope to exercise their feelings is very common for anime and manga, just as it's almost unheard of in the West.

Take, for example, a memorable subplot from the first season. In a bad case of crossed wires, a minion of Queen Beryl named Nephrite assumes that Usagi's friend Naru (aka Molly) is, if not Sailor Moon herself, somehow connected to Sailor Moon. Cultivating her friendship (in the dub, under the ridiculously soap-opera name Maxfield Stanton), Nephrite is amazed by her self-sacrificing spirit; she deliberately steps into the path of the Moon Tiara that would have vaporized Nephrite.

Naru's compassionate gesture has its effect on Nephrite; later on Naru makes a joke and he laughs. This would have been beyond him in the past, but love is turning him human. Beryl has to dispatch other minions to kill Nephrite, out of fear he'll go over to the enemy. The death is a clean and pretty one, in the *shojo manga* tradition, with Nephrite dissolving into starlight and drifting into the night sky. However, Naru's anguished scream on the soundtrack had to be a new and unexpected development for viewers who were fed nothing but happy endings year after year. This may not be classic tragedy in the Western literary tradition—it's not *Oedipus Rex* or *Hamlet*—but through this sto-

ry-arc the viewer is taken one (by many accounts) unforgettable step closer to that wider world.

Death does not even have to be part of the picture for fate to take a hand in matters, as demonstrated in the first *Sailor Moon* theatrical feature. Known in the West simply as "the R movie" until a dubbed version was commercially released, it begins with a flashback reminiscent of François Truffaut. What seems to be a seven-year-old pajama-clad Mamoru is shown on a rooftop, giving a flower to another boy, who vanishes into thin air.

We are suddenly in a botanical garden. Usagi and Mamoru are out for a holiday (and looking for a little romantic privacy), and the other Senshi and Chibiusa[3] are trying to spy on them. They're interrupted by the return of Fioret, Mamoru's friend from the flashback, older now and looking very much the *bishonen,* or "beautiful boy." (In fact, this gives rise to some gentle humor suggesting that Mamoru is gay.) We later learn the truth: that Fioret is an alien. He had wandered through space, all alone, dropped in on Earth, and found someone as lonely as he was: the hospitalized Chiba Mamoru, who had just lost both parents in an auto accident. Mamoru had given Fioret a flower as a token of their friendship, but when Fioret returned to space (because he couldn't stay on Earth indefinitely), he promised to bring back a flower for Mamoru.

Unfortunately, Fioret became possessed by, and has brought to Earth, the Xenian flower. This sentient bloom turned Fioret's mind, making him think (among other things) that Usagi was coming between Mamoru and him. When Fioret tries to kill Sailor Moon, however, we are treated to the most amazing plot twist. Remember the flower Mamoru gave Fioret at the very beginning of the movie? Where did *that* come from? From the four-year-old girl who wandered into Mamoru's room, giving him a flower because her mother had just had a baby boy. It was Tsukino Usagi who supplied the flower Mamoru gave to Fioret; therefore, Fioret

[3] The R season introduced a character from the thirtieth century, Chibiusa ("cute little rabbit") who seems to have some sort of resonance with Usagi and Mamoru. The fact is, she's their daughter (rather, the daughter they will conceive when they are reborn in the future). Chibiusa spends most of the R season getting the Sailor Senshi to come to the future to fix what has gone wrong.

Sailor Moon

What's in a name? A lot, when it comes to Naoko Takeuchi's *Bishojo Senshi Sailor Moon*. The name of virtually every character has multiple meanings.

Take the title character, whose name, in the Japanese manner, with the family name first, is Tsukino Usagi. The phrase *tsuki no usagi* literally means "the rabbit in the moon." This alludes to the Sino-Japanese perception of the full moon's craters not as the face of a person (the Man in the Moon) but as the silhouette of a rabbit. Some say that the rabbit holds a vial of the Elixir of Immortality, long sought after by Chinese Taoists. On a more secular note, the rabbit is supposed by others to be pounding rice to make *mochi*, rice cakes with a taffy-like consistency. In any event, rabbit imagery abounds around Usagi, especially in the manga. The same applies to Usagi's four friends. Their names correspond to the powers they call upon and the planets with which these powers are associated:

Mizuno Ami
 mizu = water / Sailor Mercury
Hino Rei
 hi = fire / Sailor Mars
Kino Makoto
 ki = wood / Sailor Jupiter
Aino Minako
 ai = love / Sailor Venus

Why Jupiter and wood? Before they adopted Western astronomy, Japanese stargazers identified Jupiter as Mokusei, the Wood Star. In Japan, giving Sailor Jupiter the Oak Evolution attack makes perfect sense. In the same vein, Mercury is Suisei, the Water Star, and Mars is Kasei, or the Fire Star.

The odd woman out is Sailor Venus, who was transplanted into *Sailor Moon* from *Code Name Sailor V* and has a planet with Western mythological overtones: the association of Venus the planet with the Roman goddess of love was inevitable, as is her rope of linked hearts called the Venus Love-Me Chain.

The name game continues with the villains, almost all of whom are named after minerals, gems, or other earthly elements. Thus, the Sailor Senshi battle Queen Beryl, Rubeus, Emeraldas, Kaolinite, etc. Among the minerals are Zoicite, Jadeite, Kunzite (aka Malachite), and Nephrite. The English dubbed version changes the latter's name to Nephlite, but that's clearly a mistake.

had an obligation to Sailor Moon. The belief in *on* meant that he would have to change his plans about killing Sailor Moon.

The symmetry of the story-arc gets even better. At the beginning, Mamoru tries to kiss Usagi, who's puckered and waiting. However, knowing he's being watched by the others, Mamoru backs off. At the end, Usagi is near death, drained of her life-en-

ergy while trying to get herself and her friends back to Earth. Fioret's final gesture, demonstrating his own compassion by atoning for the business with the Xenian flowers and fulfilling his obligation, is to save Sailor Moon's life. He presents the flower of his own life; Mamoru sucks the life-restoring dew from its petals and feeds it to Usagi, bringing everything full circle with a kiss. It's classic *shojo*.

And About Those Sailor Suits . . .

The Sailor Senshi have uniforms that similar to the ones they wear as junior high and high school students, modeled after British midshipman (or "middy") blouses, with subtle differences in style and color that indicate who goes to which school. When we first see Kino Makoto (soon-to-be Sailor Jupiter), her school uniform is completely different from anything worn in the rest of the school. She's still wearing the uniform from her old school—one she was expelled from for fighting.

During the Meiji period, when Japan reformed its educational system along European lines and public school attendance became required, Gaku-shuin (Peers' School), the private academy for imperial and other noble families' sons (school wasn't coed yet), was the first to institute uniforms. These uniforms (with coats that button all the way up to the collar) were modeled after Prussian military tunics. The rest of the nation's schools followed the lead of the nobility. In 1885, Gakushuin forbade students from coming to school by horse and carriage, which meant that book bags also became a necessity. The country's elementary schools again copied the style. The educational wardrobe has stayed pretty much the same ever since, but with considerable loosening up in recent years, mostly in subtle details: for example, girls wearing fashionably loose white socks. But the uniforms are still there, and are part of an evolving combination of TPO style and personal expression.[4]

[4] ". . . it is common in Japan to think in terms of the acronym TPO: Time, Place, Occasion. If one's dress is appropriate to these three things, the chances of embarrassment are significantly lessened. Times are changing and the rules are not as strong as they were, but it is likely that due to a history that values appropriate dress and due to the custom of looking to those of high rank as good examples of TPO, the rules will remain important in Japan" (http://www.marubeni.co.jp/english/shosha/cover68.html).

7

Escaflowne

The meeting of two worlds that supposedly never meet: Earth and Gaea.
Also, the worlds of teenage boy anime and teenage girl anime. And it
works gloriously!

I t took anime awhile to get into the sword-and-sorcery fantasy mode, but (like the Japanese auto industry) it jumped in with both feet and was producing some stellar product in short order. Some was straight (*Record of Lodoss War*, 1990) and some was played for laughs (*Dragon Half*, 1993; *Slayers*, 1995). *Tenku no Escaflowne* (the full Japanese title, or "Heavenly Escaflowne") from the year 1996 is a magnificent hybrid of magic and science fiction, not unlike the machine Escaflowne itself. It is also another, more important hybrid. This series was a deliberate attempt to blend elements of boys' and girls' anime. Whether or not this was a calculated effort to boost the audience is immaterial—the resulting epic storyline makes it one of the finest television series of the '90s, anime or not.

Run for It!
Hitomi Kanzaki lives in Kamakura, down the coast about thirty miles from Tokyo. She's a high-school student with two main pastimes: running track and telling the future through Tarot cards. She

learned how to read the cards from her grand-mother, who also gave her an heirloom necklace. We find out about one of the unusual properties of this pendant right away: if left to swing back and forth, it always takes exactly one second to swing from one side to the other.

She's been getting running instructions from, and finds herself attracted to, Amano, an older student and also a track runner. He's so good that, as the series opens, he's preparing to leave Japan to continue his training. Hitomi asks him to meet her after school, for a last coaching session and (with luck) a first kiss. But strange things start happening to Hitomi during the coaching session. In the middle of a race, a young man appears directly in front of her on the track, dressed in a quasi-medieval style but with decidedly modern attachments. He appears so suddenly that Hitomi can't avoid a collision—but there is none; she runs through him as if he were a ghost. Hitomi and Amano decide to have her run again. This time, the young man—named Van Fanel—reappears, and along with him, a dragon. Van Fanel slays the dragon, harvests from it a living gemstone, and takes the stone (and, inadvertently, Hitomi) back to his world, Gaea, a mysterious planet that orbits both the Earth and the moon without being seen. There, Van Fanel, revealed to be a prince, uses the gemstone as the power source for his fighting machine: a combination flying dragon/giant armored warrior named Escaflowne. . . .

Birth Pains

Escaflowne was some five years in gestation, and for a time seemed doomed never to get off the ground. However, the time spent and the people involved shaped it into its present unique form.[1]

The series was first proposed by Shoji Kawamori, who had helped create *Macross*. A trip to Nepal had inspired him with ideas for a series involving magic and destiny. He worked with Mi-

[1] Much of the following information is from Egan Loo, "Vision of Escaflowne," *Animerica* 8, no. 8 (September 2000): 6.

Escaflowne Hitomi Kanzaki is not your usual anime heroine. She's a high-school athlete and a reader of Tarot cards, the latter skill taught to her by her grandmother. Both talents come in handy when she's transported to the phantom planet Gaea.

noru Takanashi, a producer at Bandai Visual (by this time, the toy manufacturer had started an anime production company of its own), developing ideas that included the continent of Atlantis and the Bermuda Triangle. At this stage they also decided that, for a change, the lead character would be a girl. Nobuteru Yuki, who had worked on *Record of Lodoss War*, designed the characters. The Sunrise studio was also chosen to work on the series, expected to run for thirty-nine episodes.

Yuki's designs, however, were challenged in the early stages by the man chosen to direct the series, Yasuhiro Imagawa, fresh off the *Giant Robo* OAV series. He wasn't with the project long, leaving it to work on *Mobile Fighter G Gundam*. Before he left, though, he coined the word "escaflowne," supposedly based on the Latin word for "escalation."

Without a director, Sunrise put *Escaflowne* on hold. Meanwhile, Kawamori also left for other projects. It would be two years before Sunrise re-

turned to the idea, and their choice of a new director would be the turning point.

Kazuki Akane made the decision to bring elements of girls' romance manga into the *Escaflowne* project. He wanted to broaden the audience for the series, and justified his choice by pointing to the wild success of *Sailor Moon*, which was being broadcast at that time. The choice is reflected in the final character designs: the knights look much more like *bishonen*, while the heroine stopped being long-haired, curvaceous, glasses-wearing, and eternally confused by her adventure. Instead, Hitomi is slim, short-haired and (to the great relief of many fans) runs like an athlete, rather than with the awkward, arms-flailing manner of the girls in *Sailor Moon* and many other series.

The last important personnel decisions involved voices and music. Yoko Kanno wrote songs for the series, including the theme, and she shared background music duties with Hajime Mizoguchi. Both had worked on the animated version of *Please Save My Earth*, but there would be a difference here. Hitomi would be voiced by Maya Sakamoto, who had just come off of a small role in *Mizuiro Jidai* and was the voice of the "reborn" Major Kusanagi in *Ghost in the Shell*. She also sang the *Escaflowne* theme. Not only was Sakamoto, at age sixteen, the right age to play Hitomi, but in her pure and expressive voice Kanno found the ideal interpreter for her songs. Since then, Sakamoto's star has steadily risen thanks to a series of albums devoted to songs by Yoko Kanno, not to mention their work on themes for other anime series, including *Cardcaptor Sakura*, *CLAMP School Detectives*, and *Record of Lodoss War: Chronicles of the Heroic Knight*. Some of these songs may be mindless pop fluff, but many have a brilliance of craft and interpretation that sets them apart from the run of the mill.

Finally, with the series ready to begin production, budgetary considerations forced *Escaflowne* to be shortened from thirty-nine to twenty-six

weeks. You'll recall that something similar happened to Reiji Matsumoto's groundbreaking 1974 series *Uchu Senkan Yamato*, when it was compressed from fifty-two weeks to twenty-six. In this case, rather than eliminate characters or plot lines from a story that was already elaborately worked out, the staff forced the longer plot to fit in the shorter space. This accounts for the sense that each episode throws a great deal of information at the viewer, but it also gives the series its feeling of epic scope.

How Many Gaeas

Escaflowne would be one of the great anime series of the 1990s even if it stood alone. As it is, however, Japanese audiences had four versions of the story to choose from. While this was a case in which manga and anime were developed simultaneously, it was highly unusual in that two manga were created out of the same project. During the two years that development of the anime was suspended, Kadokawa Shoten (publishers of manga magazine *Comic Dragon* and anime magazine *Newtype* and responsible for such popular anime titles as *Digi Charat, Sakura Wars,* and *Slayers*) wanted to premiere a new manga magazine, *Shonen Ace.* Without waiting for a resolution of the anime situation, Sunrise gave its production designs to artist Katsu-Aki. What resulted was a manga unabashedly aimed at the boys market, heavy on violent fights. This was before the arrival of Akane as the new director, so Hitomi was still long-haired, glasses-wearing, and very curvaceous.

The notion of appealing to both the boys and girls markets did not disappear; Kadokawa simply felt that they could do so with two magazines rather than one. Thus, in 1996, at the same time the television series premiered, another manga series, also titled *Tenku no Escaflowne*, appeared in the magazine *Monthly Asuka Fantasy DX.* Here, the artwork by Yuzuru Yashiro was solidly in the *shojo*

camp, with fewer battles and more character de-
velopment. The title *mecha*, Escaflowne, doesn't
even put in an appearance until the tenth (and fi-
nal) installment, coinciding with the end of the
broadcast series.

The fourth manifestation of *Escaflowne* almost
didn't get made. The TV series happened to appear
in a Japan already crowded with excellent anime:
Evangelion had just ended, *Sailor Moon* was winding
down, and *Cardcaptor Sakura* and *Pokémon* were
drawing in the younger set. Ironically, what gave
Hitomi and company a new lease on life was fan
reaction outside of Japan. Fans in the United
States, France, Italy, and South Korea were caught
up in the unique story and characters.

A South Korean financing company got together
with Bandai and Sunrise to create the feature-
length anime *Escaflowne: A Girl in Gaea* (2000). Aka-
ne worked with screenwriter Ryota Yamaguchi in
creating a movie with the barest resemblance to
its source material. Hitomi is slightly older in this
version, and much moodier. Van Fanel is less boy-
ish and more of a warrior—like so many other
characters, including the cat-girl Merle and the
princess Millerna. Unable in a single feature film to

Escaflowne: A Girl in Gaea
*Hitomi and Van get a
makeover. For the feature film,
the two high-school-aged leads
are drawn as older and more
barbaric than their weekly TV
counterparts.*

explore the theme of destiny that was such a crucial part of the TV series, this *Escaflowne* falls back on the *Shonen Ace* approach and gives us a dark and violent tale of battle after battle.

It could also be argued that there is a fifth version. Late in 2000, without warning, the Fox network began broadcasting *Tenku no Escaflowne* in the United States. This version, produced by Haim Saban (who recycled another Japanese television series into the *Mighty Morphin Power Rangers*), did more than just translate the series; it scrambled it. Footage was dropped, "flashbacks" were added to remind the audience of what had gone before, and the number of commercial breaks was increased, thus leading to further breaks in viewers' concentration. Worst of all, Hitomi's role in this new version was downplayed. Conventional wisdom in Hollywood, after all, decrees that a girl simply cannot be the hero of an action cartoon series. This same conventional wisdom saw the conversion of *Cardcaptor Sakura* into *Cardcaptors*, forcing the appearance of a boy cardcaptor, Shaoran Li, in the first episode rather than the eighth.

With so many things going against it, the inevitable happened: *Escaflowne* was pulled from the Fox broadcast schedule when its run was barely a third over. What could have been America's exposure to a stunning achievement in Japanese pop culture became just another example of the short shrift given to animation in the United States.

Hearts and Minds

But the moral of this story is about more than running and Tarot and *mecha* and cat-girls; it's about destiny. It turns out that Hitomi wasn't the first member of her family to travel to Gaea; her grandmother preceded her years before, and that heirloom pendant of her grandmother's is of Gaean origin. It caused Hitomi to go to Gaea with Van, and it ties Hitomi to the real McGuffin of this piece: the Atlantis machine.

Escaflowne Hitomi meets her counterpart on Gaea in the person of Van Fanel, heir to the throne of Fanelia. With Hitomi's help, Van pilots the elaborate war machine Escaflowne. The combination of mecha battles and budding romance kept the TV series from being limited by its own plot and made it a crossover success.

Escaflowne describes the machine in terms very similar to the Krel machine in the classic American science fiction film *Forbidden Planet*. The ideal of every mad scientist, these machines do not need controls: they can link with the mind of the operator and be guided by pure thought. The Krel, however, forgot their pre-civilized lives. Once their machine was built, it tapped into every impulse, including the baser instincts. (In the movie, the machine creates a monster that is nothing less than Dr. Morbeus's incestuous attachment to his daughter Alta.) Once the machine became operational, the Krel lasted less than a day.

The Atlantis machine accomplishes the same broad changes through thought alone, and Elder Dornkirk, seeking to put his Zaibach kingdom in charge of all of Gaea and preserve the status quo from Hitomi's clairvoyant interference, tries to juggle destiny with the machine by making Hitomi fall in love with Prince Allen Chezar (who happens to look a lot like Amano) rather than Van Fanel. And for a while there, it looks as if he may succeed; Hitomi fudges a critical Tarot reading and starts neglecting her duty. Still, because destiny is bigger than any one Gaean elder, she is able to defy the machine with little more than the kind-hearted beliefs of a Japanese teenage girl.

Manga and anime, like most pop culture, are so-

cial control mechanisms. Not unlike the Krel or Atlantean machinery, they are capable of turning the thoughts and wishes and dreams of the audience into reality, for better or worse. However, the reality cannot be too far outside of the mainstream (or it would betray the other meaning of popular: of the people). Ultimately, no matter how outrageous the situation, the hero or heroine has to promote a socially acceptable conclusion to the story.

Hitomi does exactly that. Her voice is the voice of the audience, saying that there must be a way to settle disputes between peoples other than war, believing that the complex of virtues lumped in Japan under the word *yasashisa* (kindness, gentleness, consideration) can see us through and that love can conquer all. While the collective civilizations of the Atlanteans and the Krel wiped themselves out, one voice of hope was all that was required to put the peoples of Gaea back on the right track. The Krel had no such cultural escape valve and paid the price.

The cynics would doubtless say, "Don't try this at home." How can believing in virtuous behaviors improve the world? Because they *can* improve the pop-culture world, which is all we really need: a reason to hope.

Music columnist Glenn McDonald came to a similar conclusion in a column that focused on the Japanese pop duo Puffy:

> If *they* can be ecstatic in the moment, I should quit demanding that they explain how they reached it, and thus insinuating that they haven't. Maybe all they need me to do is to sing along, helping to celebrate that they happened, and to promise that when I find myself in that position, I too will believe in pure love so intently that it will defy whatever it has to defy to exist. And maybe all we need from them, in return, are gentle, cheerful, exhilarating reminders of what it is we're trying to earn the right to feel, how little it matters whether anybody but us understands

exactly why we want it, and how superfluous it is to betray any part of ourselves in the quest.[2]

The best of anime have always given viewers places they'd like to go and people they'd like to meet, from Lum and Nausicaä to Captain Tita and Tenchi Masaki. They don't exist and therefore can never truly win their battles, but their fictional victories give us reason to hope for our own victories in the here and now. Sometime, somewhere in the universe, the simple emotions of a high-school girl may well be sufficient to put things right.

[2] http://www.furia.com/twas/twas0339.html.

8

Evangelion

The Hedgehog runs away. The director feels suicidal. The audience is per-
plexed. The Doll dies, but not really. The audience is stunned. The Angels
attack. The audience is blown away.

I t's perfectly possible to reduce *Neon Genesis*
Evangelion, the twenty-six-week 1995 series
from Studio Gainax, to a *TV Guide* story-arc,
but doing so only serves to highlight the unique-
ness of this series among other anime—in fact,
among all other television series.

A Date with an Angel
It's the year 2015. With the new millennium came
a catastrophic disaster: the so-called Second Im-
pact, which tilted the planet on its axis, melted the
polar ice caps, and drowned half of the people on
Earth. Humankind (what's left of it) dug itself out
and was trying to rebuild its old glories when an-
other disaster struck: the coming of the Angels.
These Angels bear no resemblance to anything in
the Sistine Chapel (or on American network televi-
sion). These Angels, whose coming is supposedly
foretold in the Dead Sea Scrolls, are gigantic bio-
mechs, living machines as tall as skyscrapers,
whose arsenals include a force field known as the
AT (Absolute Terror) Field.

You should know the drill by now. With the Earth in dire peril, a teenager and his robot (a legacy of the teen's scientist/father) saves the day, right? Well, sort of. There is actually a group of robots known as Evas. These too are colossal biomechs, piloted from within by kids who (for reasons never explained) had to be born after the Second Impact.

The First Child is the enigmatic Rei Ayanami. A quiet, socially awkward girl with pale blue hair and red eyes (no, that's not reversed), Rei—whose name can mean "zero" in Japanese and who pilots the Eva prototype number 00—is a question mark to almost everyone who knows her, not least because all records of her history have been systematically destroyed.

The Second Child, on the other hand, has a name and a history as colorful as her flaming red-orange hair. Born Asuka Soryu Zeppelin, her father was a German scientist for NERV, the group building the Evas. Her mother, Keiko Soryu, had a hard time adjusting to life in the West, especially when her husband Herr Zeppelin ran off with another woman. The distraught Keiko tried to commit *shinju*—the traditional murder suicide—by killing her daughter and herself, but was foiled by Asuka's running away. In the end, Keiko hung herself, committing a symbolic *shinju* by also destroying a doll she had come to perceive as her daughter. Discovering her mother's body sent the five-year-old Asuka into shock for some months, during which time her father married an American physician, named Langley, who adopted Asuka. Hence, Asuka's contorted name in the series: sometimes Asuka Soryu Langley, sometimes Soryu Asuka Langley. She was sent to Tokyo-3 having recently completed college (at age fourteen).[1] Where Rei is a quiet mystery, Asuka is all brass and brashness: Teutonic egotism carried to an extreme.

And then there's the Third Child, with whom our story really begins. Shinji Ikari is the teenage

[1] The original Tokyo was submerged in the Second Impact when the polar caps melted; this incarnation of Tokyo is about fifty miles to the southwest, on the Izu peninsula. At present, it's a national park, featuring Lake Ashinoko, numerous hot springs, and the Owakudani Valley (which becomes the site of a momentous Angel battle in the series). Tokyo-2, by the way, was built by the United Nations about 100 miles to the north of Tokyo-3 in Nagano Prefecture and served primarily as a backup laboratory for NERV.

son of Gendo Ikari, commander of the Eva project, so there is a family connection between father, son, and giant robot as there was in the *Giant Robo* series. Or there would be, if there weren't also abandonment issues between Shinji and his father. Gendo met Shinji's mother Yui when they were in college; she conceived of the Eva project as a graduate student. However, she was killed in a laboratory explosion when Shinji was just a toddler, and Gendo proceeded to hand him off to other relatives. Returning now only because his father needs him to be a pilot, Shinji would rather be anywhere on the planet than flying one of his father's Evas.

This is the exact opposite of *Giant Robo*, wherein Daisaku treats the robot as a colossal keepsake and his membership in the Experts of Justice as a sacred duty. On top of this, Shinji's self-esteem is pretty low; he agrees to pilot an Eva in part so that Rei, hospitalized after her last sortie, doesn't end up killing herself, but mainly so that he can be of some use to somebody. His basic instinct has always been to run away from trouble, to passively agree with everything, to avoid confrontation, and to shut himself in his room with a mysterious cassette tape labeled "Program 25" and "Program 26." Do they refer to the final two episodes of the series, in which creator Hideaki Anno abandons the narrative structure of the series altogether?

What's in a Name?

Called *Shinseiki Evangelion* in Japanese, the series was rendered as *Neon Genesis Evangelion* in English. The word *evangelion* is Greek and means "gospel." The word *shinseiki* literally means "new century," but it can also mean "new era." The scientists at NERV define their new era by the pursuit of a new life-form to "enhance" humankind and thus view their new era as a starting over of life on Earth: a new Genesis. A better translation of the title into English would have been *Neo Genesis Evangelion,* but

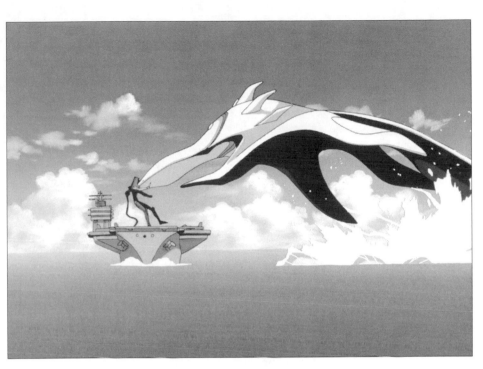

"Neo-Tokyo" had already been used in Katsuhiro Otomo's *Akira*, another controversial post-apocalyptic vision, and it's understandable that Studio Gainax and writer/director Anno wouldn't want viewers thinking that this series was derivative.

But quibbling over one word distracts us from the meaning of the title: "Gospel of the New Genesis." This is a science fiction epic about life starting over, but not because of the Second Impact. The New Genesis of the title speaks of what would (or could) happen if the Angels succeed: humankind would be wiped out, and a new order of being would inherit the Earth. But is NERV part of the defense against invasion, or is it really on the side of the Angels? Or is it both?

It's as if this series borrowed equally from *Giant Robo* for its "teens and robots saving the world" science fiction, *Three Days of the Condor* for the subplot of political intrigue, *Ordinary People* for its theme of the reconstruction of Shinji's psyche in a loveless family and dysfunctional social milieu, and Patrick

Neon Genesis Evangelion To give a sense of scale, an Eva (a forty-foot-tall bio-mechanical device designed to stop the Angels) stands on the deck of an aircraft carrier. The Angels come in a wide range of shapes and sizes, from asymmetrical monstrosities to creatures that resemble humans.

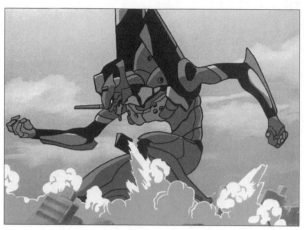

Neon Genesis Evangelion So what is an Eva? Is it a robot (huge, but still a machine that can't think for itself)? If it's an intelligent machine, why does it need a pilot? If it's a machine, why is it subject to berserk rages? If it contains some aspect of a human soul, why doesn't it just say so? It may be that, just as the Human Enhancement Project developed in Evangelion tries to assure the evolution of the human species, the Evas, and the series itself, were evolutionary steps for anime, moving from Astroboy and Giant Robo to an unknown future.

McGoohan's cult TV series *The Prisoner* for an idiosyncratic narrative structure that leaves the audience grasping for clues.

The series starts and ends with writer/director Hideaki Anno. One of the founders of Studio Gainax, he was a principal animator for *Wings of Honneamise* and was also in charge of *Fushigi no Umi no Nadia* (literally *Nadia of the Mysterious Ocean*, usually rendered in English as *Nadia: Secret of Blue Water*). This 1991 TV series, which takes its plot and locations from the writings of Jules Verne, is very well drawn, very fast paced, and very conventional. This easy success after the equally successful *Wings of Honneamise* may have frustrated Anno. In any case, he accounted for the years between *Nadia* and *Evangelion* in a very strange letter, which reads in part:

> It is said that "to live is to change." I started this production with the desire that [the characters] and the world change by the time the story reaches its conclusion. That is my genuine sense of things. I am able to put all of myself into *Shinseiki Evangelion*—a self who for four years was a wreck, unable to do anything. I began this thinking just one thing: "I mustn't run away"—after having done just that, run away, for four years—where all I was doing was simply not dying.

I thought of this production with the feeling that "I want to see if I can put these feelings on film." I know that this is a senseless, arrogant, and difficult course of action—but it is my objective. I don't know what the result will be . . . because the story has not yet ended in my mind. I don't know what will become of Shinji or Misato, or where they will go. This is because I don't know what the staff will be thinking as we go on.[2]

Shinseiki Evangelion pretty much forced Japanese anime producers, directors, and writers to change the rulebook. The series is a marvel: at once conventional and unconventional, incorporating both detailed animation and lengthy still shots, and even frames of text flashed almost too fast to read. Many of its plot points are not clearly resolved—some are not cleared up at all. Beyond a doubt it's the most controversial anime of the '90s. So much so that Anno may have been pressured into issuing several "sequel" specials, which in fact do absolutely nothing to explain the ambiguities of the series. If anything, the movies contribute more ambiguities of their own.

This is as it should be. I happen to agree with Ethan Mordden in his book *Opera in the Twentieth Century*, which is probably the most unlikely title one would expect to find in a discussion of Japanese pop culture. Mordden maintains that composers of twentieth-century opera who have gone back to revise their work invariably lessen it: that the original artistic vision, however problematic, is a better piece of work than any attempt to clean it up after the fact.

So it is with *Shinseiki Evangelion*. It's a collection of exceptions and anomalies, unorthodox techniques and unexplained plot-threads. It appears to be about nothing but itself, or may also be about a great deal more. This is a series that requires the viewer to do some serious digging.

Neon Genesis Evangelion
Shinji Ikari is not a happy boy. He's just been summoned home to Tokyo-3 by his inventor/father after being bounced from one relative to another since his scientist/mother was accidentally killed ten years earlier. Now it's on his reluctant shoulders to take on the Angels. . . .

[2] Actually, an English translation of the letter is included in the first volume of the manga version of *Evangelion*, as translated into English, and also appears several places on the Web. The letter in its entirety can be seen at: http://www.anime-manga -world.de/Evangelion/Tvseries. html.

Impassive Waifs

Evangelion exerted a very heavy influence in terms of character design on the anime that came after it. The enigmatic silent waif Rei Ayanami became immensely popular, especially as a fantasy object for some male fans. The early episodes gave her an inconsistent set of emotions: happy when talking to Commander Ikari, angry to hear Shinji lash out at his father, impassive most other times. This was only part of her mystique, but a lot of other animators seemed to decide that Rei's looks had a lot to do with it.

The combination of red eyes and pale blue hair wasn't a first in anime; Princess Sasami of the *Tenchi Muyo* stories has the same color combination, while other characters have looks that are even more unorthodox. After the successful run of the series, however, impassive waifs (blue-haired or not) seemed to pop up all over the anime landscape. Ruri Hoshino in *Martian Successor Nadesico*, the title character of *Serial Experiment Lain*, Miharu the robot pilot in *Gasaraki*, even Anthy Himemiya in *Utena*, the undersea-dwelling Muteo in *Blue Submarine No. Six*, and the makeover of Sylia Stingray in *Bubblegum Crisis: Tokyo 2040* owe something of their looks to the design of Rei Ayanami.

Evangelion (left) and *Martian Successor Nadesico* The waifs Rei and Ruri.

EVANGELION: © GAINAX / PROJECT EVA • TV TOKYO; MARTIAN SUCCESSOR NADESICO: © XEBEC / PROJECT NADESICO • TV TOKYO

Shin(to)seiki Evangelion?

The mythology of *Evangelion* is one of its most controversial elements, shot through as the series is with Judeo-Christian imagery. The attacking Angels were supposedly foretold in the Dead Sea Scrolls. The opening credits ran each week over a graphic depiction of a *sephiroth*. This is an aspect of the Kabbalah, teachings from the most esoteric and mystical branch of Judaism. The sephiroth is an attempt to graphically depict the ten "letters"

Neon Genesis Evangelion One of the invading Angels takes the direct approach—drilling down to Tokyo-3's underground geofront. This takes a good long while, and gives NERV a chance to attack the Angel. However, its defenses are as formidable as its attack weapons, and include a shield known as the AT Shield (for Absolute Terror). The odds just get worse and worse, but the Evas are up to the challenge.

that symbolize the workings of the universe. The Kabbalah also gave rise to the myth of Lilith, which is invoked in the series. Lilith (an Angel in *Evangelion*) was created—according to the Kabbalah—in order to give Adam a wife and children before Eve was created. There are references to the Lance of Longinus, which in this story is a very large spear, capable of being wielded by an Eva against an Angel. The original, however, referred to the spear the Roman soldier thrust into the side of the crucified Jesus.

In the end, though, it could be argued that the mythic foundation of the series remains totally Japanese. In the beginning, according to Anno's scheme of things, was the First Impact, millions of years ago. This involved the splitting of a divine entity into the White Moon and the Black Moon, respectively the source of the Angels and the source of human life on Earth. The White Moon was buried in Antarctica until the Second Impact liberated it. The Black Moon was buried under the Izu Peninsula, ultimately the location of Tokyo-3.

This certainly recalls the creation of the universe from the Japanese perspective, in which an undifferentiated cosmic soup separated into the light and the heavy, the former becoming the heavens and the latter becoming the sea, with the sky between the two. This also gives the viewer a

*Evangelion Don't let appear-
ances fool you; this is actually
one Angel. Named Israfel, it
can split in two and defend
against two attacking Evas.
The Evas must thus make a co-
ordinated attack, but pilots
Shinji and Asuka can't get it
together. Misato comes up with
the bright idea that they need
to live together, eat together,
and train together for a week.
Maybe the dance leotards were
a bit much, but the episode, ti-
tled "Both of You! Dance Like
You Want to Win!," is one of
the funniest in the series.*

cosmology in which all human life on Earth sprang
from Japan, which means that the Judeo-Christian
references may just be window-dressing. What the
series really offers, at least in part, may be a hi-
tech version of the *Kojiki* (see part 1, chapter 4).

In *Evangelion* much is made (though little is ex-
plained) about the Lance of Longinus. Perhaps it
has less to do with the weapon of a Roman centu-
rion than with the jeweled Spear of Heaven, given
by the gods to Izanagi and Izanami, the male and
female Shinto deities responsible for creating the
Earth. They stirred the primordial soup upon the
seas with the tip of the spear and pulled it from
the water. The bits of matter that dripped from the
spear formed the first of what would become the
oyashima no kuni (the Country of the Eight Great Is-
lands), later known as Japan. The other islands
were born of the sexual union of these divine sib-
lings.

On this basis, we can see Shinji, Rei, and Asuka
as three of the offspring of Izanagi and Izanami:
respectively, Susanoo, Amaterasu, and Uzume.
Shinji, with his clumsy social manners and oc-
casional adolescent erections, certainly behaves,
like Susanoo, in a socially unacceptable manner
(albeit involuntarily), while Asuka/Uzume has few
qualms about flaunting her body. And at the end of
the movie version of the story (as opposed to the
television series), Rei is certainly transfigured into
an Amaterasu-like goddess. Let the record also
show that Rei, who is after all a clone, dies and is
reborn several times during the series.

I don't insist on this interpretation; neither, I
daresay, would Anno or Gainax or many of the fans
of the series. In the end, the series isn't about the
evolution of mankind so much as the growth and
change of some adolescents (including Misato and
her lover Kaji, who despite their age are arrested
adolescents).

But why all the Judeo-Christian trappings—es-
pecially when they're used so inexactly? I submit

that trappings of Western religion are used here precisely *because* they can be used inexactly. When popular culture refers to a religion in a positive light, it usually refers to the belief system embraced by the majority culture. Even though it's never explicitly stated, we in the West assume that the heavenly messengers in *Touched by an Angel* function in a Judeo-Christian context, even though other religions in the world employ the concept of angels. On the other hand, negative portrayals of religion seldom involve the belief system of the majority. Western mass media portrayals of Islam were criticized for inexactness at best, bias at worst, long before September 11, 2001, and things have only gotten worse since then.

Japan has a history of embracing the trappings and trimmings of Christianity, if not the religion itself, ever since the first missionaries arrived in the sixteenth century. Back then, it became fashionable for Japanese nobles to walk the street counting rosary beads or wearing a large, gaudy crucifix. If you asked any of these men about the tenets of the faith, you'd get a blank stare. That tendency continues today with the Japanese vogue for Christian wedding ceremonies in a country where one percent of the population calls itself Christian.

It isn't about lack of information; ample material about Christian beliefs is available in Japan. But the makers of *Evangelion* didn't want information. They wanted a belief system that they could turn into a plausible threat of global annihilation. Shinto and Buddhism don't prophesy anything so dramatic. Judeo-Christianity, however, lends itself to apocalyptic visions. It thus serves the Japanese the way Islam or voodoo serves the pop culture of the West: as a fantasyland onto which we can project our fears and suspicious, claiming that this arcane and alien faith is capable of almost anything.

Neon Genesis Evangelion Rei "synchronizes " with her Eva. The Evas require a certain amount of non-instrument bonding with the pilot. Here, the bonding involves creative visual effects, which seem to be a throwback to '60s psychedelia and tells us very little about the Evas.

Anime (Psycho)Analysis

The Dead Sea Scrolls prophecy has it that the Evas

Evangelion This Angel has not sprung a leak; its major weapon, apart from speed and agility on its spider-like legs, is a highly corrosive acid. Even though this Angel, called Matarael, is one of the weakest of the attackers, it takes the combined efforts of all three Pilots to subdue it—a rare moment of bonding for these troubled teenagers.

[3] Many have supposed that theirs was a gay relationship; I think this is yet another pseudo-gay relationship. Even though we're never really clear as to what (if anything) happened between them in the bathhouse, the fact is that this isn't a case of two pubescent boys falling in love, as in *Song of Wind and Trees*. Kaoru is, after all, the Last Angel in human disguise, which means that the entire question of sexuality is qualified, if not moot. Except as a tactic. In my (admittedly minority) opinion, Kaoru approached the loveless and forlorn Shinji knowing that he was the only viable Eva pilot left. Love was Shinji's weak spot; Kaoru counted on Shinji abandoning, or at least neglecting, his duty when he declared his love for Shinji, so that Kaoru could succeed where the other Angels had failed and make contact with the being called Adam. It's *giri/ninjo* again. Why else would the Last Angel disguise himself as a human?

must confront seventeen angels, and when that happens and only twenty-four episodes of the standard number of twenty-six have elapsed, what comes next? What comes next is the reconstitution of Shinji's psyche. He's been a reluctant Eva pilot, and directed the Eva after vowing to himself that he would not have to kill anyone. Of course, this is a hard enough promise to keep in the best of times, and several characters suffer collateral damage. The damage to Shinji, however, comes when the Last Angel appears in the guise of another Eva pilot, a boy seemingly about his own age named Kaoru.

This is a dilemma similar to Hamlet's. If he follows orders and kills Kaoru, Kaoru dies and Shinji's responsible. If he refuses orders, everyone left on Earth dies. So he kills Kaoru and saves the world, but isn't all that happy about it. Kaoru, after all, is the only person since his mother died who ever said to Shinji, in so many words, "I love you."[3] Shinji's psyche needs some major reconstruction.

Anno provides it with a brilliant avant-garde remix of what has gone before, information that hasn't been supplied up to that point, and even an alternate reality—a "sitcom" version of the story (complete with laugh track) in which Shinji lives in a TV-typical house with two TV-typical parents,

has been friends with Asuka since childhood, and literally runs into Rei on the way to school. She's trying not to be late her first day, and seeing Rei of all characters behaving like Tsukino Usagi—even running down the street with a piece of toast hanging out of her mouth—is a much-needed shot of humor as well as part of the final two episodes' principal lesson to Shinji: he does not have to settle for himself as he is, and that, just as a sitcom Shinji is possible, other Shinjis are possible.

And this raises the question: why? If pop culture is a reflection of important issues in the broader society, what on earth was Japan going through in the '90s that would require such a message?

Quite a lot. The beginning of the last decade of the twentieth century saw the Japanese economic bubble burst: real estate, which had been ridiculously overvalued, plummeted in price, and everything else went with it; the acquisitions of the affluent '80s had to be sold off at a loss; and Japan lost its perceived spot as undisputed leader of the Pacific Rim. In the year 1995, when *Evangelion* premiered, Japan suffered perhaps its worst year since the surrender, capped by the Aum Shinrikyo cult gassing of the Tokyo subway in March and the Kobe earthquake in September.

Anno spoke of *Evangelion* taking place at a time of absolutely no hope. He may have been referring to the year 2015, he may have been describing a period of depression in his own life as he faced topping himself and his past successes, or he may have been describing Japan itself in the *anno horribilis* of 1995, when it seemed to be hit with torments of Biblical proportions.

None of the above? All of the above? Some of the above? Just another ambiguity? Watch the series and see what you can see. Some anime offers food for thought. *Evangelion* is a ten-course banquet.

Please Save My Earth

*Quite literally, a story of now and then: seven scientists from a distant
planet thousands of years ago. They work together, they love, they
conspire, they die. The end? Hardly.*

The world of *shojo manga* is the natural
habitat for love stories of all possibilities
and combinations—domestic and inter-
national, past and present, gay and straight, even
mortal and divine. *Boku no Chikyu o Mamotte (Please
Save My Earth)* by Saki Hiwatari is one of the more
interesting permutations of the genre, involving
love in the fourth dimension. Its production in
1993 as a series of six half-hour OAVs also illus-
trates the pitfalls involved in animating certain
kinds of stories.

Once Upon Two Times
A long time ago, in a galaxy far, far away there was
born a young girl named Mokuren. From her birth
she carried a mark on her forehead—four dots in
the shape of a diamond—that set her apart as a
Kiches, a chosen devotee of the goddess Sarjalin,
with heightened psychic powers. No big surprise,
really, given that her parents were also Kiches. In
fact, their combined powers became vested in
Mokuren. This circumstance was one of the rea-

sons the Sarjalin church preached celibacy for its high-end practitioners: Kiches lose their psychic abilities if they lose their virginity, and such powers were not to be an inheritance from one's parents, but a gift from the Goddess. Of course, that's exactly the kind of restriction that brings about the clash of *giri* and *ninjo*. (And apparently, no two Kiches had ever tried to marry each other before.)

Mokuren exhibits her special gifts at an early age, notably the ability to commune with nature—to "hear" plants and animals. If there are dark spots in her life, they come from the two universal opposites of love and death.

Mokuren's mother dies when she is a child, and Mokuren is kidnapped to live in a school for Kiches run by the Sarjalin sisterhood. A few years later, death comes again, but this time to the father of a friend of hers, a boy named Sebool. Sebool came from a family of circus performers; his father was killed when a trapeze gave way. Mokuren is doubly frustrated. First, she has run up against the limits of her powers—even the chosen of Sarjalin cannot undo death. Second, it is Sebool that makes the Sarjalin vow of chastity start to seem like a bad idea to her. Not that Sebool is making improper advances; it's just that he never lets Mokuren's Kiches status in the sisterhood of Sarjalin color his feelings toward her. She finds it refreshing to be treated as a woman and not kept on a pedestal.

At least, Sebool didn't dwell on her status as a Kiches until his father dies. Then, he begs and pleads with Mokuren to bring his father miraculously back to life, which no Kiches could have done. She shouldn't feel guilty about failing, but she does, in no small part because she is attracted to Sebool.

She finally takes her concerns to the head of the order, and is told that her destiny is to be part of a scientific team at station KK-101, an observational outpost on the barren moon of the third planet of an obscure sun. . . .

Please Save My Earth The box art shows the Ancient Cast—Mokuren and Shion, two scientists from a distant galaxy, observe life on Earth from a base on the Moon. Note the diamond-shaped mark on Mokuren's forehead—the sign of her psychic ability to commune with plants and animals. In the video we see that, before they were killed off by a plague, Mokuren and Shion were very much in love. The anime, however, tells us absolutely nothing of the strange and violent road to that love. For that, the viewer must refer to the manga by Saki Hiwatari.

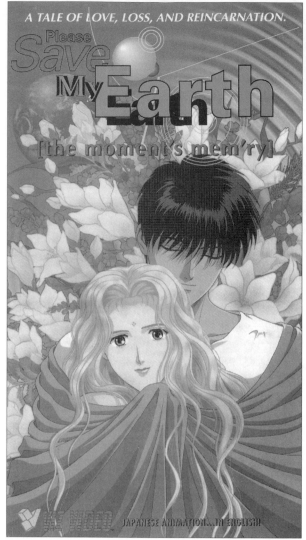

A TALE OF LOVE, LOSS, AND REINCARNATION.

Please Save My Earth

[the moment's mem'ry]

JAPANESE ANIMATION...IN ENGLISH!

Jump ahead to the present day. Alice Sakaguchi's family has just moved to Tokyo from Hokkaido, relocated by Mr. Sakaguchi's employer. She's a typical teenager, but some very atypical things begin happening. For one thing, her babysitting of Rin Kobayashi, the bratty boy next door, has been complicated by the seven-year-old's proposal of marriage. For another, she has an uncanny rapport with animals, and even with plants. Lately, howev-

er, her dreams have been telling her that she was once a scientist named Mokuren and a devotee of the goddess Sarjalin. . . .

In the West our mythology travels in a single unbroken line: we're born, we live, we die. We have one shot at getting it right and have to rely on divine mercy if we don't—and we usually don't. Furthermore, the doctrine of Original Sin dissuades some of us from trying to get it right on our own in the first place.

Well, what if there was a second chance? And a third?

A basic tenet of Buddhism is that we're constantly being reborn onto this Earth, but that's not what we should want. The ideal is to detach, to let your desires for earthly things drop off one by one until the round of rebirth comes to an end. The trouble is, contradictory earthly desires pile up from so many directions that it's sometimes impossible to reconcile them all. Something has to give, and usually the ideal of detachment is the first to go. It seems that all seven scientists at the base, including Mokuren, get attached to something or someone.

When Mokuren gets to KK-101, among the crew are Gyokuran and his friend and rival since childhood, Shion. Shion, as will be discussed below, is aloof and antisocial, but the anime doesn't show the full extent of his sociopathology: at one point in the manga, knowing about the Sarjalin vow of chastity, Shion forces himself on Mokuren. Gyokuran walks in on them and has Shion put under house arrest, but Mokuren intercedes, claiming that in fact they were "married" and that she came to him of her own choice. It was a lie, but there may have been something to it: Mokuren, even though no longer a virgin, impossibly still has the mark of a Kiches after the rape

The scientists end up stranded on the moonbase when an interplanetary war wipes out their entire home solar system. When a plague breaks

out on the base, Gyokuran conspires with the medical officer, Shukaido, to see to it that Shion gets the only sample of the antidote. This way, he reasons, he and Mokuren can die together and thus be reborn into the same place and time without Shion getting in the way.

He is half-right: not only does Shion show up nine years too young, but his nine years of solitude on the moon drove him mad. And the only thing worse than a crazy man is a crazy seven-year-old boy with heightened telekinetic powers. Like Mokuren, Shion has psychic talents. Unlike Mokuren the Kiches, who was able to commune with nature, Shion is a Sarches—a type also known in manga as an "esper," meaning someone with ESP and, in Shion's case, telekinetic abilities.

Like Mokuren, Shion discovered his powers at an early age. Born on the moon that orbited Mokuren's world, Shion was orphaned as a child by a war that devastated the society on that planet. At one point, Shion found himself under fire. His telekinesis kicked in, turning the soldiers' bullets back on themselves. This saved his life but sent him into a guilty antisocial rage, since in his own mind he was now no better than the soldiers. The sisterhood of Sarjalin tried to heal Shion's psyche by finding him a foster home with a man named Lazlo and his companion, a six-foot tall cat named Kyaa.[1] They made contact with Shion's heart and he seemed to be coming around in an environment of love and trust when Lazlo and Kyaa were killed in a car crash. This sudden deprivation left Shion sullen and aloof for years. He denied that Sarjalin even existed; he considered Mokuren's presence on the moon base a challenge to his own bitterly cynical view of life. When he raped Mokuren, he was trying to rape the Goddess.

The Rest of the Story

When this story was animated, it was as a series of six OAVs of about thirty minutes each. The result is

[1] Here's a pun that gets lost in translation. Lazlo explains that the cat (actually a being from another planet) is called Kyaa "because that's what everyone says when they see him." And "KYAA" is Japanese for "EEEK."

visually attractive, but decidedly unsatisfying in another way. Like the reader, the viewer has to decode much of this non-linear story on the fly and in scrambled chronological order. Unlike the reader, however, the viewer (in America, at least) doesn't have the twenty-one volume manga story to fill in the gaps. And some of the gaps are egregious: the six episodes tell nothing of Mokuren's childhood. We're told almost nothing about the events at KK-101 except as they directly affect the rebirth of the characters, and there's not a word about the rape. We do get lengthy, seemingly irrelevant looks at a Mr. Tamura, who befriends the reincarnation of Shukaido.

Interestingly, the best resolution of the problematic adaptation was the separate release of a half-hour of music videos.[2] Incorporating old and new animation (mostly new), these videos teach us about Mokuren's childhood, as well as the nature of the infernal machine Shion/Rin wants to build in Tokyo Tower. Even though this information is alluded to more than directly explained, it goes a long way toward answering the questions of those who have no access to the original manga.

But the answers to some of the questions are themselves, to put it mildly, problematic. Two of Alice's classmates, Jinpachi and Issei, turn out to be the reincarnations of Gyokuran and Enju, who had their own brief love affair on the moon base. This story gives us as the villain—not the sociopathic Shion or the abusive Rin—but the hypocritical and manipulative Gyokuran. His punishment is twofold in the next life: he has to watch as Mokuren and Shion reconnect, even as Alice and Rin, and he can never be with his real beloved, since Enju is now in a man's body.

In fact, this latter circumstance isn't a quirk of fate; Enju wanted to avoid Gyokuran in the next life, even though she loved him. It didn't take her too many days on the moon base to realize that Gyokuran would never return her feelings toward

[2] The music used in these videos is a particular kind of song: image music. These songs, although not used in the original production, are released to "flesh out" characters or amplify plot points, and often contain a composer's best work.

him. He was simply too fixated on Mokuren to acknowledge Enju. Issei doesn't realize the depth of Enju's frustration until another member of the team points it out to him. Enju wanted to be reborn as a male for a reason: to let go of her love for Gyokuran (to which Gyokuran will never respond anyway) and find a new love.

Gyokuran and Jinpachi have something in common: a love of propriety, of always saying and doing the right thing, of never being thought "out of line." There is, however, a price to pay. If Gyokuran/Jinpachi wants true love to come his way again, he'll just have to sit this life out. In the meantime, Gyokuran's obsession with Mokuren and his attempt to create a happy ending led to unhappiness for himself and three other people.

It's a convoluted yet explicit statement of the view that trying to force fate into a particular pattern will have unforeseen consequences, none of them good. It doesn't work on a planetary scale for Dornkirk in *Escaflowne*, and it doesn't work for Gyokuran on the smaller scale of the romantic triangle. The message is clear: don't force it. Whatever's going to happen should be allowed to happen. This may seem fatalistic from our point of view, but it is actually an affirmation that, in love and war and everything in between, things will work out the way they're supposed to.

So what if it takes more than one lifetime?

The Big *Pokémon* Scare

When they were a video game, or a card game, you really could put these "pocket monsters" in your pocket. But, as you know, they're much bigger than that now.

December 16, 1997 was an animator's worst nightmare: the day a cartoon turned toxic. Worse, it wasn't some ultraviolent shocker like *Fist of the North Star*, nor was it a writhing mass of raping tentacles like *Urotsukidoji*. *Pokémon* was one of those cute, cuddly, inoffensive anime aimed at grade-schoolers and based on a popular fad. Worst of all, the episode made international headlines, giving non-Japanese (especially conservative American media critics), already wary of too much sex and violence in television, yet another reason to be suspicious of an entire genre.

The First *Pokémon* Master
In a sense, the digital Pokémon game had its origins hundreds of years ago.[1] Boys in rural Japan would play with whatever was handy, and that included insects. They would gather up large beetles and set them to fight each other. The game was inexpensive, since these beetles lived in the wild and were free for the taking—even the poorest child on the most isolated farm could find bugs for battle.

[1] Some of the following information is from Howard Chua-Eoan and Tim Larimer, "PokeMania," *Time* 154, no. 21 (November 22, 1999): 80.

Satoshi Tajiri wasn't poor, nor did he live in the countryside when he was growing up in the 1960s, but his suburb of Tokyo was far enough from the central city that there were still pockets of nature—ponds, forests, fields—and insects that lived in them. When Tajiri graduated from high school, he declared that, rather than go to college, he would invent the greatest video game of all time. The new industry was still shaping itself when he developed a prototype of the game that would become a worldwide phenomenon.

This was about the time of the virtual pet. These computer games were pet rocks with a twist; the owner had to feed them, clean them, clean up after them, and play with them—all of which only involved pushing a few buttons. These animals were simulations, LCD computer displays that lived in plastic cases about the size of an egg. In fact, one brand of virtual pet, Tamagotchi, was named after the Japanese word *tamago*, or egg.

It made for a rather odd kind of video solitaire, a combination of Tetris and babysitting. At odd intervals your virtual pet would beep, and you'd push the required buttons to satisfy it. Failure to do so meant that the pet would sicken and die. This certainly added a level of poignancy to the game, but it was still a game. And, if it was to stay at all popular, it would have to grow and evolve.

When Nintendo introduced a cable in 1991 that could link two Game Boy units into one, that was the key for Tajiri. He developed his Pocket Monsters (Pokémon for short) and used a prototype of the game to land a job with Nintendo. It took until 1996 to put the finishing touches on it, but the work paid off. The technology of being a ten-year-old Japanese boy may have changed, but the basics were still there. The Pokémon game single-handedly revived the popularity of the Game Boy, which was dying out because of interest in CD-ROM-driven video games. Pokémon swept Japan, and would later score a similar success in the United States.

The players start out with two Pokémon-loaded Game Boys and a connecting cable. This gives them a hand-held version of a large two-player arcade console game. The object is simple: make the pokémon fight each other. With experience, pokémon that survived enough battles evolved into different pokémon. Even though there were 150 possible pokémon when the game was released, some gamers played through them all fairly quickly—and discovered Tajiri's secret payoff: the existence of an unannounced 151st pokémon for those who stayed the course. This was just the sort of gimmick calculated to attract game fans and generate word-of-mouth publicity.

Out of this video-gaming concept was born the television series *Pokémon*. Animated by Shogakukan and aimed at grade-school students, the story centers on a group of children, one of whom (called Satoshi in Japan and Ash in America) has an almost fanatical desire to develop a stable of fighting pocket monsters. There are obstacles along the way, of course, including the comic Rocket Gang. All the monsters are different, and most become even more so, evolving into heightened creatures at some point based on their fighting experience.

Very few of Satoshi's pokémon evolve, because doing so would miss the point. This Pokémon master is only about ten years old, and the pokémon he coaches into battle are themselves very childlike—smaller and seemingly weaker than their opponents. This serves two purposes. It reassures the audience (made up of children as young as Satoshi, if not younger) that size doesn't really matter, and that even the youngest can make a positive contribution. This is also, however, a message for their parents. Japan has long been aware of its status in the world: a chain of volcanic islands, dwarfed by most of its neighbors, both near (China, Russia) and far (the United States). This awareness existed during the Meiji Restoration,

© 1995–2002 NINTENDO / CREATURES INC. / GAME FREAK, INC.

Pocket Monsters Here we see Ash (Satoshi in the original— same name as Satoshi Tajiri, the inventor of the Pokémon video game) and Pikachu, the best-known and best-loved of the pokémon. Small but powerful, capable of delivering powerful electric shocks, Pikachu is surrounded by a bunch of Pichu. This is the youngest form of the species; with time and experience, it will evolve into a Pikachu. (There is a more mature stage—a raichu—into which Ash's Pikachu will probably never evolve; why break up a beautiful friendship?)

The Big Pokémon Scare | 319

when Japan decided that it had to rush to catch up with European civilization; during a half-century (1895–1945) of rampant militarism and war; and during the industrial and trade growth of the 1970s and 1980s. Japan still sees itself as a David among global Goliaths, and any story that shows the victory of a smaller adversary over a greater one (whether that large enemy is Godzilla, a thug in a high school gang, or one of the gigantic Angels of *Evangelion*) enjoys a special resonance.

Few of the pokémon can be said to have any kind of personality, but first among equals is definitely Pikachu. A chubby little yellow electric rodent, Pikachu is clearly the star of this show, and of the merchandising.

The show did wonderfully in the ratings because it managed to cross over to both boys and girls. Part of this was due to the addition of a girl character as a friend of the hero (Kasumi in Japan, Misty in the United States), and partly because the episodes also incorporated the kind of sentimentality common to *shojo manga*. It isn't all about battles; progress toward the tournament is made by being good to your friends and neighbors as well as to your pokémon. It was a deft mix of *ganbaru* and *yasashisa*. Nothing, it seemed, could go wrong.

The Incident

So when things went wrong, they went in a big way. The episode broadcast December 16, 1997 included, among other scenes, someone throwing a bomb at Pikachu. Pikachu responds with his ability to shoot out lightning bolts. Both had happened often enough on television with no ill effects. However, this time the combination of the two was at just the wrong rate of strobing. It induced an epileptic seizure in about seven hundred Japanese children. Most recovered quickly, but a few had to be hospitalized overnight.

They were better off than the anime series—Shogakukan shut down production for four

months to find out exactly what had happened. In the meantime, negotiations were underway to bring Pokémon (the Game Boy cartridge) to the United States. The seizure episode could have been a major stumbling block.

The Name Game

Another was the game's "Japan-ness," as one Shogakukan executive put it. In the end, the anime series' move to the United States involved changing names—a lot of names. Most of the pokémon had specifically Japanese handles. The *pika* in Pikachu, for instance, is the "sound" of a lightning flash. The toad-like pokémon with a plant on his back is called Bulbasaur in the West, but its real name is Fushigidane, a Japanese phrase meaning "weird, isn't it." The dragon Charmander is really Hitokage (Japanese for "shadow"); another human companion, named Brock in the West, is named Takeshi in the East; the Rocket Gang (aka Team Rocket) went from being Musashi[2] and Kojiro to Jessie and James; their feline pokémon Nyase became Meowth; and so on.

Not all the names were changed: Pikachu is still Pikachu, and the cobra Arbok is still Arbok. Other in-jokes and cultural references are simply left unexplained, such as the episode in which our heroes arrive in Dark City, where two pokémon gyms are battling in the streets. They are the Yas Gym and the Kaz Gym. The Japanese viewer would recognize the joke: Yaskaz is a nickname for percussionist Yasukazu Sato.

Another such specific reference is tied to the cycle of twelve animals in the Chinese calendar, which many Westerners are familiar with. What most of them may not realize is that a cycle of the five elements is traditionally overlaid on the twelve-year animal cycle. Of the sixty possible resulting combinations, the matching of fire with the Year of the Horse is still regarded as having special significance. Japanese women born in the Year of

[2] True to the gender-bending in anime, the female member of the gang is apparently named after Miyamoto Musashi (1584–1645), author of a volume still in print as *The Book of Five Rings* and arguably the greatest samurai in history. The other member of the Rocket Gang is named Kojiro, after a rival of Miyamoto's: Sasaki Kojiro.

Pocket Monsters The "pocket monsters " aren't monsters in the classic sense: supernatural beings who either ignore humanity or try to kill it off. They're actually a bit like the series' juvenile audience: usually young, often inexperienced, needing a helping hand. Of course, sometimes, one hand isn't enough, and dealing with pokémon—instead of being a dream job—can be a lot like herding cats. Note the tortoise-like creatures in the upper-right-hand corner of the box wearing happi coats. They're pretending to be tobi (traditional firefighters from the Tokugawa period); a Japanese audience would get the visual joke at once.

[3] This *happi* has nothing to do with happiness. It's derived from the Japanese *han*, meaning half, since it's half as long as a full-length kimono.

the Fire Horse were (and in some cases still are) believed to be talented but too hot-tempered to get along in society. This resonance is in the Japanese audience when the anime series shows a white unicorn with a flaming mane and tail: a "fire-horse" pokémon.

Some elements were so Japanese that they could neither be removed nor explained. So the cartoon simply proceeds as if, in a fantastic realm full of fantastic creatures, there should be nothing odd about a group of turtles wearing identical jackets. However, they're more than just turtles; they're a traditional Japanese fire brigade, and Japanese children watching this get the joke.

The firefighters of Edo (present-day Tokyo), known as *tobi*, were first organized at the beginning of the Tokugawa period (early 1600s), when Edo was being set up as the new capital of Japan. Housing got shoved closer and closer together as government officials, their families, and their servants crowded into the growing city. This meant that the danger of fire took on a new meaning. In the country, houses could be widely scattered, and one house burning down did not automatically threaten its neighbor. In Edo, however, people were running out of room and running out of options for dealing with fire.

The solution was to create groups of specially appointed firefighters to watch for fires, fight them, and tear down adjacent buildings to keep the fire from spreading. Obviously it was a risky business, and the government of Edo turned to *gaen*, gangs of unemployed men—occasionally criminal gangs, but definitely ruffians—who couldn't be hired for anything else.

In time, these gangs of firefighters proliferated, adopting uniforms consisting of the short jackets called *happi* emblazoned with the *mon* (crest) of the particular group, so that one gang could be distinguished from another.[3]

All of this is implicit in a couple of episodes of

the *Pokémon* TV series. Satoshi and friends come across a group of turtle-like aquatic pokémon (called Zenigame in the original, Squirtle in the dub). You can tell these are toughs because they wear sunglasses. Satoshi's Squirtle asserts himself as the alpha male by putting on an even more outrageous pair of sunglasses. He organizes the others into a fire brigade, and we next see them wearing identical *happi* coats, posing in front of a red-striped background meant to evoke the Japanese "rising sun" battle flag of the 1940s.

The Pokémon Movies: Lights! Camera! Angst!

Director Kunihiko Yuyama has directed the (so far) three theatrically released *Pokémon* movies. Anyone watching them after having seen only the television series is in for a surprise. Yuyama uses Shogakukan's happy palette of primary colors to tell some very dark stories.

First was the movie known in the West as *Mewtwo Strikes Back*. Mewtwo is a one-of-a-kind pokémon, cloned from the remains of a mysterious breed called a Mew (in the video game, this was Tajiri's secret 151st pokémon) and enhanced with ultimate weapon capabilities.[4] You can probably guess what happens next, especially if you've seen anime such as *MD Geist* or *Nausicaä* or *Akira* or any similar story in which humankind's ability to develop the ultimate weapon gets ahead of its ability to control it. Mewtwo is born with a colossal chip on its psychically powered shoulders; knowing it was cloned to serve a human pokémon master, it rebels and starts creating his own poké-clones. His aim is to destroy both humans and the pokémon who (from his point of view) allow themselves to be enslaved. The reality, of course, is not so simple, but it isn't until Pikachu refuses to fight its opposite number and Satoshi/Ash is turned to stone (and than revived by the tears of the pokémon) that Mewtwo catches on. In the end, he realizes that "the circumstances of one's birth are irrele-

[4] Its enhancement is accomplished by body armor that looks suspiciously like similar armor from other anime, notably *Bubblegum Crisis* and *Guyver*.

vant" and what's important is what one does with one's life. Nobody in this movie uses the word karma, but this Buddhist principle underlies the resolution of the plot.

One noticeable difference between *Mewtwo Strikes Back* and *The Power of One*, the second feature, is the increased use of computer graphics. The increase is most obvious in the flying machine (in a mix of old and new technologies that has come to be called "steampunk") used by the villain of the piece, a character that would be familiar to some of the grown-ups in the audience: an obsessed collector. Having collected one of almost every pokémon, this evil genius has reached the top of the pyramid. He's now after the legendary guardians of fire, ice, and lightning, but not for their own sake. He wants to use the three to capture the largest and most powerful pokémon of all: the ruler of the sea. Each time he captures one of the three guardians, the planet's climate goes more and more out of kilter. In true storytelling tradition, things get a lot worse before they get better.

However, there is one bit of business that would mean something more to a Japanese audience. Satoshi and friends arrive at the island chain where the plot reaches its climax. One island is having its annual festival, including colorful native garb. However, the role of Festival Maiden is to be played by a girl who, when first we see her, is wearing casual urban clothes, including sunglasses. She dismisses the centuries-old tradition as something for tourists to gawk at. Nevertheless, when the Earth itself is threatened by the ruler of the sea, her ritual performance is instrumental in calming things down.

Japan has any number of festivals at various times of the year, depending on the locale. And in this age of cellular phones and Game Boys, surely Japanese parents have heard their children com-

plain—more than once—that *obon* dances for dead relatives and fertility rites rooted in the agrarian past are meaningless in the modern age. The implicit message in this film: "those rituals had a purpose in the past, they have a purpose in the present, and we may cease to be if the rituals are abandoned." Certainly Japan would not cease to exist if it suddenly gave up all traditional ritual, but it would be a lot less Japanese.

The third movie, *Spell of the Unown*, gives the audience a classically dreaded scenario: a child with one parent gone and the remaining parent threatened. Specifically, a young girl's father is spirited away by an unknown race of pokémon. The girl is given a surrogate father: a large furry pokémon with the psychic ability to cloud people's minds. It also provides a new mother for the girl, who happens to be Satoshi's mom under hypnotic suggestion. In the end, of course, the girl recovers not only her father but her mother as well (although this is only suggested under the final credits).

"We all live in a Pokémon world"

In popular culture, imitation isn't just a form of flattery; it's an inevitability. When something scores a huge popular success, others try to cash in on the formula (or what others think is the formula). In the case of *Pokémon*, several anime series were "inspired" by the success of the TV series, as well as the fact that the series was essentially a long-running commercial for a Nintendo video game. Most of these other series started out in manga rather than as games. These include *Digimon* (little kids with friendly evolving monsters), *Cardcaptor Sakura* (little girl with a friendly monster and collectible cards), and *Yu-gi-Oh* (young boy with collectible cards and magical opponents).

One of the few similar anime series also spun off from a video game is *Monster Farm* (1999; brought to the West as *Monster Rancher*). Here we have a young boy, a girl companion, and magical

beings that live in an alternate universe. This game's gimmick, however, involved CDs. Any old CD will do—pop it into the game console and it "generates" the monster you're supposed to battle. In this case the anime traveled more easily than the game.

It's been several years since the Game Boy version of Pokémon appeared. Since then, Game Boy itself has evolved several times, growing in memory strength and gaining a full-color display. The collectible card mania seems to have slowed down and some of the web pages have gone to seed, but the television series is still in global syndication, telling its stories of courage, compassion, and camaraderie.

Leave it to a few Western fans, though, to try to pour gasoline on a fire. Some actually tried to find an air-check of that infamous episode of *Pokémon* to get copies of the toxic material. Some justified it by making it sound like a thrill ride (ignoring that such rides spend millions of dollars to create the illusion of peril, not actual peril); others likened it to the Japanese stunt of eating *fugu* without eating that fish's lethal toxins. These foolhardy thrill-seekers should treat the footage for what it was: an accident waiting to happen. Shogakukan recognized it, snipped the damaging footage and went about its business. And so should the rest of us.

11

Plastic Little: Not What You Think

She's young, tough, a demon on a motorcycle and shoots to kill. She catches whales for pets. It's an action story, and a love story, with some of the best-looking nudes in anime.

You may think that you have the 1994 OAV *Plastic Little* figured out just by hearing a few details. The main characters are two girls, sixteen and seventeen years old. Once they meet, they spend the rest of the story together: cavorting in a bathhouse in the nude, sleeping in the same bed, going up to the hills to watch the sunrise (almost always a prelude to romance in Japanese pop culture), followed by breakfast at a seaside cafe. One even tells the other "*suki desu*," which can be translated "I love you." So it's at least partly a lesbian romance, right? More than a few Western watchers seem to think so.

The problem with this view is that, in Japanese, *suki desu* can mean "I love you," but that doesn't mean it *must* mean it. In fact, since this form of speech is a more casual way of expressing one's love (as opposed to *ai shite imasu*), it would be more properly translated "I like you." And in fact, Elysse says "*Tita no mono ga suki desho*" ("Tita, I guess I like you"). When you get right down to it, *Plastic Little* is not about lesbians; in fact, it's not about sex at all.

There is, however, nudity and quite a bit of it. This OAV was created by Satoshi Urushibara, who has built his manga career on lovingly detailed female nudes (as compared to the generic nudes in some anime, which are about as anatomically detailed as a Barbie™ doll). He previously produced a work titled *Chirality,* and has worked before with director Kinji Yoshimoto, notably on a rather boring, by-the-numbers sword and sorcery anime called *Legend of Lemnear.* By contrast, *Plastic Little* can hardly be said to be boring.

Ship Shape

After a prologue in an underground laboratory, in which a scientist (you can tell by the white lab coat) places his daughter into an escape pod to the surface just before he is killed by the evil general (you can tell by his outrageously huge shoulder-pads; this parody of Darth Vader's costume in *Star Wars* has become another part of anime shorthand), we cut to a resort hotel. We hear a whiny voice with a request all too familiar to Japanese parents in the summer: "*Umi ni detai yo!*" Its meaning is simply "I wanna go to the beach!" but it has a slightly different literal translation: "I want to go to sea." In this case, the latter is more appropriate.

In a hotel room littered with pizza boxes and a Monopoly game, we see the speaker of the last sentence: a teenage tangle of bedclothes and brown hair. She yawns, and that gives the audience its next clue. All we can see in her mouth are two little fangs. This doesn't mean that she's a vampire or a demon or one of the many cat-girls in anime. In the shorthand of anime, fangs can also denote an alien. So not only are we not in Kansas, Toto, we aren't even on planet Earth—no matter how much it looks like Earth.

She calls for her companions—Mei, Nichol, Mikhail, Balboa, Roger—but they seem to have abandoned her. As she dresses, a voice-mail starts to explain things for us. The girl's name is Tita,

Plastic Little *It's no secret that sex sells—on both sides of the Pacific. It's also no secret that Satoshi Urushihara is a painstaking manga artist whose designs have been lovingly rendered onto film, and never more so than in Plastic Little. Here, in a pose created for the fans and not in the video, is a swimsuit picture of Captain Tita (center), Elysse, and Mei the medical officer. "Fan service" is the term for what is basically a little jiggle, a little skin, a little T and A. It doesn't have to involve nudity; an up-the-skirt glimpse of a character's panties is enough. It's one of the reasons anime leaves a bad taste in some people's mouths, but get rid of it altogether and anime would be very different.*

and, while the others are the crew of a ship, she's the captain! However, the voice-mail message from Nichol, the teenage navigator, tells Tita that, having overslept, she may as well bring lunch to the ship. One more detail: on the elevator, we find that her pockets are stuffed with candy, which she shares with some children. This establishes her *yasashii* credentials and also reminds the viewer that this planet, named Yietta, definitely isn't the United States, where children are warned from the cradle not to take candy from strangers. Japan, however, is different: just as hitchhiking is not perceived as dangerous—in anime or in real life—the general notion of doing deliberate harm to children is so aberrant as to seem almost impossible.[1]

While Tita is still packing the groceries into her scooter, the scientist's daughter runs into her—literally. She's being chased by huge, heavily armed police, so Tita decides to even the odds by pulling

[1] "The Japanese must be the kindest people in the world to thumbing foreigners, and the main difficulty is to avoid taking unfair advantage of them" (Ian McQueen, *Japan: A Travel Survival Kit* [South Yarra, Victoria, Australia: Lonely Planet Publications, 1981], 35).

Plastic Little *Romance is hard to come by sometimes: Tita and Elysse go to a hillside to watch the sun rise over the gas-seas of Yietta. Scenes of contemplation of nature—especially sunrises and sunsets—are usually preludes to romance, and, after watching the sunrise, Tita and Elysse have breakfast an a seaside inn. No sooner does Elysse say "I like you . . ." than attack crafts move in, spoiling the mood completely.*

the girl onto her cycle, barely making an escape.

They're considerably the worse for wear when they get back to Tita's ship, the *ChaCha Maru*.[2] A hot bath is in order, so we get to see the two disrobed girls in a fantasia of an *onsen* that would put most Japanese hot springs (or American water-slide parks) to shame. As they frolic in the slides and waterfalls, Nichol and Roger try to sneak a peek at them; this little bit of voyeurism is, believe it or not, as close to sex as *Plastic Little* gets.

More important to the audience is that the scene establishes their ages. In the Confucian-based society of Japan, age sometimes makes all the difference in a relationship. Anyone who's seen the American broadcasts of the Japanese TV series *Iron Chef* knows that it's one of those genre-blasting hybrid entertainments common in Japan: in this case, a mix of *haute cuisine* and TV wrestling. The challengers are all presented to the audience with filmed biographies establishing their credentials. For some reason, the subtitled American broadcasts never include one detail in the spoken Japanese introduction: the age of the challenger.

It's important in Japanese society to establish relative age in a relationship in order to establish relative position. Yes, it matters that Tita, at seventeen, is a year older than her companion (whose name is Elysse). This makes Tita a "big sister type."

[2] Another indication that Yietta is like Japan: virtually every Japanese boat has a name ending in *maru*. In 2001 we heard of the *Ehime Maru,* a fishing boat run by a vocational high school, which sank when it was rammed by a U.S. Navy submarine. In *Star Trek II: The Wrath of Khan,* James Kirk became notorious at Starfleet Academy for solving the insoluble problem of the *Kobayashi Maru.* Even a rowboat, in an early manga episode of *Maison Ikkoku,* is named *Isoya Maru.* (Speaking of *Maison Ikkoku,* one boarding-house resident is a hostess at a bar that is also called ChaCha Maru. I have no idea of the connection, if any, between that bar and Captain Tita's ship.)

"The big-sister type," writes Cherry, "leads and looks after her underlings on the job, at school or anywhere else. . . . She will be kind to those younger or weaker than herself. . . . [O]lder sisters are authority figures in Japan, where age always confers privileges and responsibilities."[3] And, although these two girls may act like equals and call each other by name throughout the anime (instead of Elysse referring to Tita as *oneesan*, or elder sister), the plot reflects their difference, from Tita's taking the initiative to rescue Elysse to the fact that Tita, in effect, owns the water-park—in fact, she owns the whole ship.

How does a teenage girl end up as a ship's captain, and how does any ship rate this kind of pleasure facility? We find out that Captain Tita is the daughter of the original captain of the *ChaCha Maru*, who was lost at sea six years earlier. Like her father, she's a Pet Shop Hunter, capturing wild sea-dwelling animals for sale as pets. Of course, when your ship has to sail the seas of the planet Yietta (seas which are made of clouds instead of water!) chasing whales, sharks, eels and other large marine life, it has to be pretty large. The bath was built in a seldom-used holding tank, which could easily have held a whale. Meanwhile, as the girls finally get to know each other, the three adults on board (Mei, Mikhail, and Balboa—Roger, who is black, seems to be an older adolescent, or perhaps a younger adult) read in the local newspaper that Elysse was supposed to have been killed with her father in a laboratory explosion. They realize that they may be caught in a political situation too hot to handle. . . .

For the remainder of the OAV, Tita plays Luke Skywalker to Elysse's Princess Leia. In the final scene, having dispatched the villain, neutralized the doomsday device (a perversion of the beneficial machine that was the life work of Elysse's father) and destroyed the entire Yiettan navy (don't ask, it's too technical), Tita asks Elysse to stay on

[3] Kittredge Cherry, *Womansword: What Japanese Words Say About Women* (Tokyo: Kodansha International, 1987), 16–17.

Plastic Little *Once Captain Tita is established as cute, fun-loving, and compassionate, the script gives her permission to get more than a little violent. Not only does she blast the brains of the evil Guizel into hamburger, but Tita and her small, civilian pet-hunting ship the ChaCha Maru manages to destroy the entire Yiettan Navy.*

board. Elysse declines, saying that she wants to continue her father's work. Tita understands; after all, she's continuing her father's work as a Pet Shop Hunter. She understands something else about Elysse, and admits to why she stopped to help her in the first place: she recognized in Elysse "the look of a girl who'd lost her father and [not] gotten over it."

This contextualizes the Tita/Elysse friendship not in terms of sex, but in terms of group membership. Even if they belong to a group of two, it's still a group, and such affiliations are a vital part of living life Japanese. The relationship is neither titillating nor threatening; it's not even sexual. (Sleeping in the same bed? That's all it was: sleeping. They established a link even though they'd just met that day, and even if they couldn't verbalize it as such: that they had both lost their fathers. They slept together not for sex but for skinship.) They're just doing what their Japanese audience does. Even if they do it on a planet where whales swim through gaseous seas, to be caught for pets by teenage girls. . . .

The Old and New Testaments of Masamune Shirow

Artificial organs, cloning, robotics—the science fiction of yesterday is filler in today's newspaper. What will it be tomorrow? Consult a pair of anime by Masamune Shirow.

The *Anime Movie Guide*, by British pop-culture analyst Helen McCarthy, starts in 1983. There were anime produced before then, but that was the year that direct-to-consumer videos (OAVs) were introduced. That was also the year a student at Osaka University of Art self-published the first volume of a manga series titled *Black Magic*.

The name of that student was *not* Masamune Shirow. Like Monkey Punch or Fujio Fujiko, that is a pen name under which he creates his manga. It also gives him a persona to hide behind; unlike many artists who revel in the publicity that comes with success, Shirow prefers to stay out of the spotlight. In an inversion of the way the game is sometimes played, he has never allowed himself to appear in public in that identity. He knew, after all, that Shirow would be the center of attention, while the "real" artist would be below the radar of fandom.

One other aspect of his life is a bit out of the ordinary: Masamune Shirow came to manga rela-

tively late. He focused on sports in his youth and didn't discover comics until he was in college. His choice of Osaka University of Art wasn't because he wanted to further his cartooning skills but because he wanted to study oil painting. However, his manga *Black Magic* caught the eye of the president of the Osaka-based Seishinsha publishing company, who invited Shirow to turn professional. His first work as a pro was *Appleseed*, which was animated in 1988. He's perhaps best known, however, as the creator of *Ghost in the Shell*, animated as a groundbreaking feature film in 1995. Viewing the two anime back-to-back is instructive regarding both works as well as the manga artist who created them.

The Old Testament: Appleseed

In the beginning was the apple. For Masamune Shirow, the new beginning of life on post-apocalyptic Earth was *Appleseed*. The use of the Old Testament symbol of the apple was conscious and deliberate on the artist's part, as he created a future metropolis where all do not live happily ever after.

In 1988, when it was adapted to an OAV and directed by Kazuyoshi Katayama,[1] a lot of philosophical subtleties in the manga were tossed by the wayside in order to boil the multivolume story down to seventy minutes. What's left, unfortunately, is like quintessential '80s Hollywood: a lot of explosions and guns and chase scenes. Even the music is '80s Hollywood synthesizer chase music. There's still a story, to be sure—more of a story than most of the Sylvester Stallone or Eddie Murphy films of the same period—but the action is too Hollywood to be believed. One all too clear example: a SWAT team barges into a room where terrorists are holding hostages. There are four terrorists; four shots are fired at them; they all hit the mark; and they're all head shots to the brain. That's entertainment.

[1] The film's *mecha* unit was supervised by Hideaki Anno, one year after *Wings of Honneamise;* Gainax was one of several studios that worked on the anime.

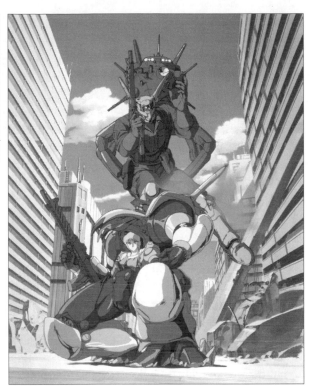

Appleseed The post-Apocalyptic world of the future is far from a utopia; terrorists disrupt the world under reconstruction. Hence, the need for police. *Appleseed* follows two such police: Deunan Knute (bottom) and her partner Briareos (top) as they pursue a group of terrorists. The deeper they dig, and the closer they get to the truth, the more they realize that they've been lied to for years. . . .

Our first look at the terrorists is through a dream. A man searches for his wife through their high-rise luxury apartment, and finds her in the studio, sitting next to an open window. The room looks like it has been ransacked. The birdcage is open, and the bird has just been set free. Then—as her husband watches—she lets herself fall through the open window. Before she gets halfway to the ground, the dreamer awakes in a cold sweat, but in those few seconds we feel something of his terror, and we later understand what drives this terrorist (also a policeman) named Calon. It wasn't a dream; it was a memory.

The story focuses on the efforts of two policemen to stop the terror: a young woman named Deunan Knute and her partner Briareos, who's mostly robot and whose design makes him look like a giant metallic rabbit. As an aide to Athena Areios, the inspector general of Olympus, de-

Appleseed Deunan Knute, an officer trained to keep the peace in the new city of Olympus, does her job a little too well. Surviving in the wasteland that still covers much of post-apocalyptic Earth gave her some instincts the police may value, but the government may regret.

scribes them, "as police they're excellent; as people, they're eccentric." They're also two among many rescued from the non-Olympian wasteland by Hitomi, a government "caseworker" conducting an unspecified "experiment" in bringing people from the wilderness to live and work in Olympus.

Olympus is to be the flagship city built out of the rubble of World War III, its every detail coordinated by a supercomputer called Gaia.[2] Some of the wartime rubble, including tanks and the rotting corpses within them, is still visible. The inspector general is concerned about keeping order in Olympus, and worries—rightly, as it turns out—about "immigration of unstable elements" from the wilderness disrupting the peace.

Post-apocalyptic scenarios have become standard in manga and anime. Think of Neo-Tokyo rising from the ashes of war in *Akira*, or of Tokyo rebuilt after a disastrous earthquake in *Bubblegum Crisis: Tokyo 2040*, or of Tokyo just picking up and moving to the Izu Peninsula after the melting of the polar caps in *Evangelion*. In these cases and so many more, while officialdom and industry put the capital back together, they also have hidden agendas that do not bode well for the common people.

These doomsday stories all contrast with less cynical stories in the same post-apocalyptic genre, for example, *Nausicaä of the Valley of the Wind*, in which global war destroyed all of civilization and required thousands of years for humankind to rise back to even a simple agrarian life. *Appleseed*'s scenario owes more to early twentieth-century science fiction, especially films such as William Cameron Menzies's *Things to Come* and Fritz Lang's *Metropolis*, both of which inspired early manga by Dr. Osamu Tezuka.

Terrorists attack a pyramid-like structure called Tartarus. The choice of name reveals a neo-Greek theme. Tartarus in Greek mythology was a sublevel of Hades. In some accounts, after the Titans

[2] Again, this is nothing new. Recall Jupiter, the central computer in the *shonen ai* OAV *Ai no Kusabi*, or *Evangelion*'s Magi.

were defeated by the gods, Zeus imprisoned them in Tartarus. The name Tartarus was later employed for the place of damnation where the wicked were punished after death. There are classical statues all over this modern city, inspector general Athena's secretary is called Nike, and even the name Briareos has Greek roots as a fifty-headed giant.

There's something else happening, however; a literary allusion, deliberate on Masamune Shirow's part. When Hitomi shouts that she was "born" in Tartarus, she's speaking figuratively. She's a bioroid, a living machine, and Tartarus was where the bioroids were created. This humanoid race, "born" in a laboratory and raised in a utopia where no one needed to struggle for anything, looks back to another dystopian classic, Aldous Huxley's 1932 novel *Brave New World*.

Brave New World, like George Orwell's 1984, commented on the present by putting a mask on it and calling it the future. Both books critiqued the micro-managed life of the Soviet Union under Josef Stalin. Huxley, however, took matters farther, by painting a society that bio-engineered its offspring (thus freeing its inhabitants to indulge in casual sex) and believed religiously in buying things and in soma, a drug that wasn't much more than a low-level opiate (this was before Huxley himself began experimenting with LSD). Ultimately, the heroes of the book break away from the society, having been inspired by someone (known in Huxley's book as the Savage) from the outside.

In *Appleseed*, as in *Brave New World*, society has decided to commit to a structured peace after a disastrous war. In Olympus, however, the battle isn't over yet. Terrorists try to disrupt the well-ordered society from within and without. The police try to cope with the terrorism, serving the state without knowing the entire picture. In the end, a partnership is formed between Deunan, Briareos, and Calon, not just because they were fellow po-

Appleseed. *Yes, there really is a human under and within all that armor. The rabbit-like ears may make Deunan's partner, Briareos, seem whimsical, but don't let that fool you. He's a deadly serious cop hunting down the terrorists plaguing Olympus.*

Ghost in the Shell Major Kusanagi witnesses what can only be called the transfiguration of 2501: software that has become human enough to dabble in metaphysics. Up to this point, in both the manga by Masamune Shirow and its film version directed by Mamoru Oshii, the Major has been plagued by doubt as to how "human" she really is. Here, we see proof of the humanity that still lives beneath her bionic enhancements—in the form of the Major's tears.

lice but because they understand the larger drama unfolding around them.

Appleseed only has time to hint at the implications of bioengineered people. The bioroids act human, and presumably think of themselves as human. Hitomi thinks of herself as such, as does Briareos, in spite of his new machine body. Any speculation about how any of the characters really felt about their situation would have to wait a few years. . . .

The New Testament: Ghost in the Shell

Ghost in the Shell, released in 1995, is an amazing visual achievement in a medium based on amazing visuals. Animated by Mamoru Oshii and based on a heavily footnoted manga, this feature film will inevitably confuse its first-time viewers, dealing as it does with the Byzantine round of backstabbings and powerplays that characterize Japanese politics in the future, both domestically and internationally. The politics of New Port City are the solution but also part of the problem. Instead of terrorists, we're dealing with diplomats and politicians as the bad guys.

There was a hint of this in *Appleseed*, but the ap-

ple had blossomed and borne fruit by the '90s. With the bursting of the economic bubble, Japanese politicians of the ruling Liberal Democratic Party had trouble finding anyone left to run the ship of state—especially after reports began surfacing of financial sweetheart deals between assorted politicians and business interests. Nobody seemed to be clean of the stain, and the tendency of those already in power to continue to rely on the old boy network to get things done only assured that nothing would get done. Skepticism turned to cynicism, and popular mistrust of the government may have hastened the activities of those who claimed to offer an alternative way, including the Aum Shinrikyo doomsday cult and other "new religions."

The action in *Ghost in the Shell* centers on Section Nine of the Ministry of Foreign Affairs. This is a wide-ranging group, dealing with covert operatives from America, deposed dictators from the Third World, and—in the opening sequence—attempts by another country to convince a computer programmer to defect.[3]

Growing out of this governmental gamesmanship—and not by anyone's design—is a piece of software that has taken several names. Its creators refer to it as Project 2501, and intelligence agents call it the Puppeteer. Whatever its intended name, it has, like other software in other sci-fi works, acquired enough information to become sentient. It's being chased by Major Motoko Kusanagi of Section Nine. It's also chasing her at the same time, in part to seek political asylum to protect itself from its creators. The question for Major Kusanagi is: what does she do with it once she's got it?

The Major, it seems, is going through something of an identity crisis. She's ninety-five percent artificial, with a cybernetic body that superficially makes her indistinguishable from ordinary mortals. There is a wonderful sequence in the movie, with Major Kusanagi riding a boat down one of the

Ghost in the Shell The pursuit of the Puppetmaster has been two-edged for Major Kusanagi. In trying to connect with it, the Major's body gets torn to bits. Before she dies, however, she is able to make contact. This sentient software proposes that the Major merge with it, so that their "children" may be born into the Internet. It almost works out that way; the Major's "ghost" is placed in another body—that of a synthetic little girl.

[3] In the manga the other side tempted the Secretary of Commerce; the anime script by Kazunori Ito introduces Project 2501 from the very beginning.

Ghost in the Shell Major Ku-
sanagi and her partner, Batou,
rest and relax on a boat in the
harbor. The Major insists on
scuba diving, even though her
mechanical enhancements
have added over a hundred
pounds to her body. In fact, she
takes her life in her hands by
going diving. Little wonder,
then, that she's been pondering
metaphysics: What makes us
human? What makes us
unique? What happens when
we die?

canals of New Port City. She passes a glass-fronted
coffee shop, and seated on the other side of the
glass is herself. It's really someone else who hap-
pens to have the same make and model of cyber-
netic body, but this wordless encounter, backed
up by Kenji Kawai's haunting score, brings the
whole question of identity and humanity into
sharp focus.

She is, in spite of heightened strength and abili-
ties, an ordinary mortal, asking the same old ques-
tions mortals have asked since the dawn of time:
Who am I? Is there a reason why I'm here? What
happens after I die?

Ancient Japan offered answers to all of the
above in the animistic belief—transferred to Shin-
to—that spirits abound in the world, and aren't
limited to living things. A mountain may have a
spirit, or a piece of wood carved into an arch, or
even a locomotive.[4]

Japan has also spent centuries coming to terms
with machines that seem human. *Karakuri
ningyo*—clockwork wooden dolls that resembled
people—were first built in the Tokugawa period.
Such dolls would "bow" their heads while carrying
cups of tea on a tray. Lifting a cup from the tray
would stop the doll until the cup was replaced. A
legend in the twelfth-century *Konjaku Monogatari*
tells of a farmer who used a similar doll in the
ninth century to water his crops. When the spirit

[4] Frederik L. Schodt, *Inside the Ro-
bot Kingdom: Japan, Mechatronics,
and the Coming Robotopia* (New
York: Kodansha International,
1988), 196. Note that in one of
the stories of the *Don Dracula*
manga by Dr. Osamu Tezuka, a
locomotive was possessed by a
spirit that had to be exorcised.

and the clockwork doll intersect, there can be problems, as will be seen in the chapter on *Key the Metal Idol*.

The real problem here, though, is that the machine is no longer obviously just a machine. Is the Puppeteer sentient, or merely a program designed to seem sentient? And how much of herself can Major Kusanagi trade in for mechanical enhancements and still be human?

The Major finds out by going through a cyborg version of sex, birth, death, and rebirth—merging with the Puppeteer and being transplanted into a new cybernetic body after her old one is almost destroyed. Brought back to life as a young girl, she tells a colleague that she is now neither Major Kusanagi nor the Puppeteer, and that she is off to seek other offspring of this union, born into the World Wide Web itself.

But the Major's dilemma isn't a purely mechanical question. The manga contains elaborate discussions of karma, and one sequence reaffirms that, regardless of enhancements, Major Motoko Kusanagi is still human at the core. In this sequence, the Puppeteer announces that it will "cast off all restrictions and shells, and shift to a higher-level system." It then appears to be transfigured up to Heaven, in the wake of an angel, of which we catch but a brief glimpse. At this moment, Shirow draws a very tight close-up of Major Kusanagi's face, and we see (for the only time in the entire series) the pop-culture proof of her humanity: the tears in her eyes.

Key the Metal Idol

It may not be the loudest, most violent, or most sensuous anime, but Key the Metal Idol *is that very rare animal: a meta-anime, animation about (among other things) animation.*

The 1994 OAV series *Key the Metal Idol* was created to commemorate the tenth anniversary of the Pony Canyon animation studio, a fact that takes on a greater significance once the film is understood in all its layers. It's a fifteen-part science-fiction picaresque quite unlike anything else in anime—a tour-de-force for director and writer Hiroaki Sato (the episodes are of varying lengths but have a total running time of almost nine and a half hours).

The main word in that description, however, is "picaresque." A literary form with a long and important history, the picaresque is characterized by a satirical tone, improbable coincidences, characters popping into and out of the plot for no apparent reason, dizzying changes of (preferably exotic) scenery, and an altogether fantastic journey for the protagonist, either a naïve youth or a lovably sly rogue. In Western high culture, the best example of the picaresque form is probably Voltaire's satiric novel *Candide*. Yet, as can be imagined, many of these elements can be found (to one de-

gree or another) in many anime. *Key* just happens to have more of them than most, and is in its own way one of the best examples of the picaresque form created in the twentieth century.

Unlocking Key
The story opens in present-day rural Japan. A young girl named Tokiko Mima, usually called Key, may actually be a robot, as she claims. Her grandfather is, after all, a noted if eccentric inventor. Or she may be a pubescent human being with a psychosis that makes her think that she's a robot. In any case, the people of the village, including Key's schoolmates, accept that she is what she says she is. One day she is sent home from school because her grandfather has died. The grandfather leaves an audio tape telling Key that, even though she's a robot, she can become human—if she receives the love and friendship of thirty thousand people. Without a second thought, she sets off for Tokyo, where she hopes to emulate the career of the top idol singer of the day, Miho Utsuse. (As far as we know, Key has no experience as an entertainer, but that doesn't seem to matter.)

On her first night in Tokyo, just as she is about to run afoul of a porno movie producer, Key happens to bump into an old friend from the village, a girl roughly her own age named Sakura. This girl is everything that Key is not: loud where Key is quiet, active where Key is sedentary, confrontational where Key is passive. You'd think there's no reason why Sakura should hover over Key so solicitously, even taking it upon herself to try to launch Key's career as a singer. As we find out much later, there's a perfectly good reason: Sakura and Tokiko may have the same father. As for Key's mother, that's where the story really begins . . .

Where the story will end is back home, at least figuratively. Once again, conservative values assert themselves in providing a context for an otherwise outrageous plot.

Key the Metal Idol In a vision, Key sees herself surrounded by the people of her home village. She can't decode it yet, but it's a powerful message—that she can't use her abilities as a miko unless she connects with an audience. At first she thinks of her village—the only audience she knows. Later, she will seek a bigger audience as a pop singing idol.

It Takes A Village

Key was born in the kind of pastoral Japanese countryside that seemingly hardly exists going into the twenty-first century, a village of about a hundred people in a secluded valley. She has psychic abilities, a legacy she shares with her mother and grandmother and generations of Mima family women before her.[1]

These women were *miko*, priestesses at the village's Shinto shrine. Tokiko's mother Toyoko and grandmother Tomiko were subjected to Grandfather Mima's experiments trying to harness their psychic energy; after she was born, Tokiko was hidden in plain sight by the suggestion that she was a robot. The point of all this was to shield her and her powers from the boss of Ajo Heavy Industries, who first approached Professor Mima about building mechanical self-propelled bombs during World War II.

The family of *miko*, the inventor, and the industrialist came together first when Key's grandfather came to the village and saw Tomiko dancing. This was not the wild ecstatic dance of a *miko* entering a trance state, but was purely for entertainment. As she went through traditional stylized moves onstage, a wooden marionette without strings copied her every move, thanks to her psychic abilities. The professor proposed marriage almost im-

[1] "Most anime *miko* are young girls, and in most cases their powers are more related to heredity than training. Moreover, that heredity is almost always along the female line. This idea is most clearly found in the manga *Mai: the Psychic Girl*" (Antonia Levi, *Samurai from Outer Space: Understanding Japanese Animation* [Chicago: Open Court, 1996], 127). See also the *Devil Hunter Yoko* series.

All in the Family

The professor who saw Tomiko Mima dance in *Key the Metal Idol* proposed marriage to her and changed his last name to his wife's. Gendo Rokubungi proposed to Yui Ikari in *Evangelion*, and changed his name to Gendo Ikari. The custom of a man marrying into his wife's family and taking her surname as his own does not exist in the United States, but is allowed for in Japanese culture.

The Japanese call this practice and the person involved *mukoyoshi*, a word made up of the Chinese characters for "son-in-law" and "adopted child." As in the West, the norm in contemporary Japan has come to be the nuclear family, in which the wife takes the husband's family name and they set themselves apart from their parents as a new family. But Japan has an ancient and powerful tradition of marriage-as-clan-membership, and a man may become a *mukoyoshi* if there is no male heir in the wife's family to carry on the family name. By adopting his wife's family name, he becomes the successor to his father-in-law as the legal head of the household. Men who become *mukoyoshi* are typically second or third sons who do not jeopardize the continuity of their own family name in the process (since the first son is regarded as the inheritor and continuer of the lineage). This practice of adult adoption is still the most prevalent form of adoption in Japan.

mediately, but did so in order to study and try to harness Tomiko's powers.

These powers were found to have two well-springs. One was the continued line of *miko* in the Mima clan, continuing from one female temple performer to the next. The other was the villagers themselves, whose love and devotion empowered the performers. This is the most blatant parallel between Key's calling as a *miko* and her decision to be an idol singer.

But another connection is even more important. The particular shrine served by generations of Mima women is specifically dedicated to the goddess Uzume. Remember the *Kojiki* and the story of the cave? Uzume was the dancer whose antics caused the audience to react in such a way that Amaterasu was tempted to look out of the cave, thus restoring the sun and saving the world.

Just to make it all blatantly clear, the president of the Miho Utsuse Fan Club refers to Uzume as "the goddess of show business."

"Welcome my friends, to the show that never ends. . . ."

Uzume can certainly be called a goddess of the popular culture, and in doing so we come full circle. In spite of a cult leader's dire warnings that Key must become a shamaness for his cult instead of a pop singer, Key's career path is basically the same whether she becomes a *miko* or a singer. Each exists because of the need of the audience. They need to see a certain kind of theater take place, theater which may be novel but which is also built on a traditional foundation. Of course the idol singer tradition may not be as old as Shinto, but the emotional investment by the audience is just as great. They both came to see more than just theater; whether at the shrine or at the concert hall, the audience wants a kind of miracle.

And this is just as true of those who draw manga and produce anime, as well as those who enjoy them. Whether the artist and the audience see robots who act like people (*Astroboy*), or people who act like robots (*Key*), or children who pilot robots (*Giant Robo*), or pigs who pilot airplanes (*Porco Rosso*), or even something as real and as prosaic as a schoolgirl drawing a picture of a horse (*Chibi Maruko-chan*) or putting new words to an old song (*Mimi o Sumaseba*)—all of these and more are miraculous, in their own way. Maybe they exist in our place and time, maybe they used to exist, maybe they never did exist and never will. Like all art, though, these images have their own degree of power, as long as there is an audience.

And now we can see *Key the Metal Idol* as more than just an elaborate sci-fi tale of idol singers and warrior robots. It can also be seen as a meta-anime: an animated film about animated films. This isn't as direct as Takeshi Mori's infamous *Otaku no*

Key the Metal Idol *Key spends most of the fifteen episodes of this singular series in a trance: with wide, glazed eyes and an emotionless way of speaking and acting. It is truly a jolt to viewers whenever that facade cracks and we catch a glimpse of the power within her. Here, Key has acted as a shaman for a religious cult and healed a deathly-ill child. Her satisfied smile speaks volumes.*

Video, a pair of mockumentaries from the '80s about the life and trials of an anime fan; instead, it sets up an elaborate metaphor of the power of art—even popular culture—to be capable of simple entertainment, or magic bordering on the miraculous—or both.

Ajo tried to harness the power of the Mima priestesses during World War II to create a self-propelled bomb. This came to nothing, but it inspired his later attempts at using the psychic power of the *miko* to create warrior-robots. This is another way the power of an audience works in the popular culture. The images do not always convey examples of gentle hearts and noble deeds; sometimes they can be twisted to promote sinister ends, or to pander to bad taste and worse instincts.

The good news is that the worst side of the popular culture seldom seems to last for long. Sometimes racism, sexism, religious bigotry, and other inhumane messages pop up in the culture. Fortunately, bad messages seldom result in good art. They may have a brief vogue, but they eventually go their way when the majority of the culture would rather hear a different message.

A message that even an outsider can understand, if that outsider knows what to look for, and how it may be seen.

Afterword: The Future of Anime

A book like this usually ends with a list of resources—titles of anime that qualify as "required viewing," for example. This book has no such list, for two important reasons.

For one thing, popular culture is very ephemeral. Some manga and anime titles are literally here one day and gone the next, and new material rushes in to fill the vacuum. Think of American television: in any given year, two to three dozen new series premiere, of which only a handful survive to a second season. Even if some of those short-lived "failures" were works of actual merit, with superior acting and compelling stories, they're probably gone for good—even with cable channels picking up some older series.

So it is with anime: today's masterpiece may be tomorrow's museum piece, or may be totally forgotten, with a rapidity that would put American television to shame. In manga, the wellspring of many anime, some successful series run on for years, leaving that much less space in the magazines for a new story to catch on with the public. One solution has been to start new magazines. These come and go, and occasionally a story will be enough of a hit that it will be animated. Still, the majority of manga appear and disappear without

ever making it into animation, and even among those that do, a number of them do not make the transition to anime well, and never quite catch on.

Fortunately for the followers of popular culture—and unfortunately for writers who try to document it—these changes are continuous, ongoing. Old talents leave the scene, new talents come on; tastes change; innovations become commonplace, and may then become boring. Still, the best of the best in anime always seems fresh, both to the veteran viewers familiar with it and to the upcoming generation seeing it for the first time. Some scenes (the dozens of bodies under the ice in *Galaxy Express 999*, Sharon Apple's concert flying through the streets of Macross in *Macross Plus*, the entire *On Your Mark* music video) never seem to lose their power—for me, at least.

Another factor is my own subjectivity. If you've paid attention, you've noticed this entire book is a collection of my personal favorites. It's based on my exposure plus my experience, not limited to anime. This book necessarily draws on my entire past—from manga I read a week ago to college courses I took a decade ago—and of course anyone reading this book will have an entirely different set of exposure and experience.

Your taste comes into play as well. Even if all the anime ever made somehow became available to everyone, some titles simply won't interest some fans. There are those who consider themselves too old for titles like *Pokémon* or *Monster Rancher*, some consider *Digi Charat* and other *kawaii* series too cutesy to bear, some dismiss *Dragonball Z* and *Fist of the North Star* as just one fight scene after another, and some won't watch anime if they give off even a whiff of *hentai*.

Three Little Words
So it's the height of presumption for me to declare, as if I were handing down commandments from a mountain, that some anime must be seen and oth-

ers must be avoided. I do, however, have a few rec-
ommendations.

The first is: **watch**. As much as possible. Too
many judgments have been passed on whole sub-
genres of anime, not to mention on anime itself,
without really perceiving its breadth, complexity,
and sophistication. No one could draw an accurate
conclusion on *Sailor Moon*, for instance, having
only seen *Akira*—or vice versa—and neither would
really prepare you for something as free-form as
Shamanic Princess or as epic as *Princess Mononoke*.
Besides, some of the funniest anime are funny pre-
cisely because they parody other anime. (I'm
thinking of *Sailor Victory*, which manages to spoof
Sailor Moon, *Evangelion*, *Key the Metal Idol*, and a
half-dozen other anime titles.) By all means focus
on a genre if it's your favorite, but don't neglect the
others.

My second recommendation: **read**. While anime
has existed for about forty years, human beings
have been around a lot longer than that. Anime is
an art form that is especially good at reflecting the
human condition, as well as cultural specifics
unique to Japan. But you'll be limited in your un-
derstanding of anime if you don't read outside of
anime. Many anime and manga were directly in-
spired by great writing. Even a casual look through
a collection of videos points back to a hundred lit-
erary sources: Japanese and American history,
writers from Jules Verne to Mark Twain, ecology
and theology and the quest for perfection in an
imperfect world. If you ignore literature, you'll only
be seeing a fraction of what's on the screen.

Of course, words don't only appear in books. So
the third recommendation: **surf**. The Internet has
contributed beyond measure to the growth in pop-
ularity in the West of anime. Fans build cyber-
shrines for their own favorites and for the
entertainment and education of others, and the
artists and animation studios themselves have
also taken to the Internet as a way to advertise

new work or commemorate the old. There's a lot of misinformation, speculation, rumor and wishful thinking on the Web, but also a lot of information that's hard—if not impossible—to come by any other way. In addition, I believe that the Web will be the location of the next step in anime. But more about that in a moment.

Do It Yourself

This gives me a chance to discuss an essential part of Japanese pop culture, which has actually pervaded this book without being mentioned before: dojinshi. It's the equivalent of the old "underground" comics of the 1960s in the United States. Some were produced by amateur artists spinning off variations of already-established characters, or creating whole new characters, scenes, and adventures. Others were the work of semi-professionals who chafed at the restrictions of the established syndicates and the Comics Code.

There are two important similarities between dojinshi and underground comics. The first is that popular comic characters are put into bizarre, often sexual, situations. However, that's no surprise for dojinshi, since we already know that Japanese pop culture has a higher tolerance for sexual activity than its Western counterparts. Second, and more important than sex, is the fact that an artist is using someone else's characters; on both sides of the Pacific, this is illegal.

The difference between the two cultures seems to be the statement that the artist is making. In the West, where comic content has to meet the Comics Code or be declared "underground," the non-Code artist may use a Disney character to make a statement about American society and freedom of the press, or about the vapid blandness of the Disney universe. (I recall an issue of Dan O'Neill's *Air Pirate Funnies* in which two of Disney's Three Little Pigs seduced the Big Bad Wolf into a gay encounter.) Owners of such characters tend to sue.

The big difference, however, is that O'Neill and his fellow artists could hardly be called fans of Disney. There was always an element of sarcasm and mockery in the use of the "establishment" characters. This would be another reason for a lawsuit.

In far less litigious Japan, however, *dojinshi* are tolerated because the amateur artists have taken the profit motive out of the picture. These comics are sold at a very low price, just enough to cover the cost of production, and the production run itself is low—a thousand issues or less.

More importantly, the Japanese *dojinshi* artists are truly fans. Even if the content is outrageous, the attitude underlying the comic is respectful and enthusiastic. For this reason, there is no sense that the *dojinshi* are trying to rip anyone off. Some of them are even considered "companion" volumes to the original story (the word *dojin* means "companion"). Another difference is that the artists sometimes work under pen names, and often write as a collective.

Some *dojinshi* art is awful and the "plots" may consist of a single gag, but it is understood that they are not trying to pass themselves off as the real deal. The big comic publishers in Japan seldom go after the *dojinshi*, which sometimes build up their own fan base. In fact, the major publishers keep an eye on the *dojinshi* as a way of assessing up-and-coming talent.

It's the dream of just about every budding manga artist to land a series in a major magazine such as *Weekly Shonen Jump*, and the dream even comes true for a small percentage of *dojinshi* artists. The most dramatic success story has to be the four young women who started out producing *dojinshi* under the collective name CLAMP. (For the record, they are Satsuki Igarashi, Nanase Okawa, Mikku Nekoi, and Apapa Mokona—even though some of these names are also pen names.) They were able to develop their amateur work into a mainstream media empire of sorts, having produced such popu-

lar manga titles as *RG Veda, Rayearth, X, Cardcaptor Sakura, Clover,* and *Miyuki-chan in Wonderland,* most of which have been animated.

Such success is easier to find in manga than in anime. After all, drawing is usually a simple, one-person affair; in the beginning, every artist starts out alone with just a pen and paper. If the artist finds success, a staff can be hired to do the fill-in work. Animation, however, is always a corporate effort, employing a host of artists, writers, voice actors, composers, musicians, and representatives selling the product to television networks or video-tape distributors. It's a pity that there isn't such a thing as *dojinshi* anime.

Ah, but wait a minute . . .

Bringing It All Back Home

Generally speaking, there are two kinds of animation available on the Internet. The first merely delivers animation created the old-fashioned way: twenty-four frames per second of ink and paint (usually with a little help from computers—cel animation these days being a truly endangered species). There are web sites (legitimate or not) that use "streaming" technology to send such animation to one's PC.

The good news is that the range offered is growing, and the sites are even resurrecting old classics. Not only does cartoonnetwork.com present streaming cel animation such as Tom and Jerry, but its sister site Toonami has posted episodes of Reiji Matsumoto anime, from the recent Wagnerian opera–influenced *Harlock Saga* all the way back to the classic *Uchu Senkan Yamato* series (under the Western name *Star Blazers*). They've even begun posting dubbed episodes from *Record of Lodoss War: Chronicle of the Heroic Knight.*

The bad news is that online classic anime may not be coming to a terminal near you any time soon, unless you live in an area already wired for high-speed data lines and are willing to shell out

the extra money (maybe $20 to $40 per month) for a cable or DSL connection. The digital divide is very much alive, defined by region and money.

Unfortunately, streaming technology has a few bugs in it. The information still travels in packets rather than an unbroken signal; for the most part, there will be jerky pictures and audio dropouts even under the best circumstances. If only perfection will do, you'd better get off the information superhighway for now and stick to tapes or DVDs.

The second type of Internet animation is more primitive, but in many ways more exciting. Just as *Pokémon* evolved out of LCD virtual pets, the evolution of web animation began with the animated .gif. A file with the suffix .gif is one of several kinds of graphic files. However, someone programmed two .gif pictures to alternate with each other, and if the drawings were similar to begin with, the drawing appeared to move. The basics of animation spread all over the web in this version of the old flip book.

Gradually more and more pictures got strung together in the file. Usually the movement of the pictures was too slow to suggest more than a childish attempt at animation, but, as computers have grown exponentially more powerful, the animated .gif has become smoother and more complex. The results have accordingly become more and more impressive. I'm thinking of a .gif of the *Evangelion* character Asuka. At first we see the back of her head; then she turns, smiling, with a toss of her hair. The movement is quick and fluid; it's animation. If a file holds too many .gif images, the animation can be sluggish. This problem was solved to a degree with the development of Flash, which is probably the most sophisticated animation software on the scene, though the results still fall somewhat short of what traditional cel animation can achieve.

For the moment, web-based anime is limited to those who can make the best use of Flash and its

resources, and this includes some major names. Monkey Punch, creator of *Lupin III*, now has an animated series on his personal website. Titled *Isshuku-Ippan* (a phrase meaning "just staying for one night and one meal"), it's basically a gag-strip-style story about a luckless *ronin*. Nothing about his life seems to go the way it should. As of this writing, six of these roughly animated gags are available online, including a deliciously sly send-up of the Japanese folktale known as "The Bamboo Cutter's Daughter." There's no dialogue, and only rudimentary sound effects. Monkey Punch refers to it as a "digital comic," but it moves, and that makes it anime. You can find it at www.monkeypunch.com/mp_files/1s1p_html/1s1p.htm.

At the other end of the scale is (guess who?) Dr. Osamu Tezuka. The man died in 1989, but he still points the way for the rest of Japanese pop culture to follow. In this case, his company Tezuka Productions has built a virtual theme park, Tezuka Osamu @ World (with the "a" in the symbol changed to a silhouette of the head of Astroboy). Part of this virtual celebration of Tezuka is a Flash-based anime starring Dr. Black Jack.

If you go to www.bb-anime.tv/bj/free.htm, you'll face a few realities. First, like the Monkey Punch page, it's all in Japanese, with no English version to fall back on. Second, it's a pay site. The promotional video is free, however, and shows the current state of the art in web animation. There isn't merely sound; there's music and dialogue by professional *seiyu*. The camera zooms in and out, pans and dissolves, with image quality that may not be as complex as the OAVs, but is better than just about anything else on the web.

Of course all that can change literally in an instant. Only a few years ago, a Pentium I chip was state of the art, and a one-gigabyte hard drive was the stuff of science fiction. As of this writing, computing capabilities are rapidly growing, and software is being developed for this more muscular

computing. I suspect it's still going to be a long time before a single fan at a home computer can idly whip out an animated scene as fully realized as a clip from *Toy Story* or the *Final Fantasy* game series. I also know that somebody out there is busily designing software to give a user just such power. The day of *dojinshi* anime is not too far off.

I for one can hardly wait.

Bibliography

Books

Asahi Shimbunsha, ed. *Catalogue of the Osamu Tezuka Exhibition*. Tokyo: Asahi Shimbunsha, 1990.

Biskind, Peter. *Seeing is Believing: How Hollywood Taught Us to Stop Worrying and Love the Fifties*. New York: Pantheon, 1983.

Bornoff, Nicholas. *Pink Samurai: Love, Marriage & Sex in Contemporary Japan*. New York: Pocket Books, 1991.

Buruma, Ian. *Behind the Mask: On Sexual Demons, Sacred Mothers, Transvestites, Gangsters, and Other Japanese Cultural Heroes*. New York: Meridian, 1984.

Cherry, Kittredge. *Womansword: What Japanese Words Say About Women*. Tokyo: Kodansha International, 1987.

Gitlin, Todd. *Inside Prime Time*. New York: Pantheon, 1983.

Hane, Mikiso. *Japan: A Historical Survey*. New York: Charles Scribner's Sons, 1972.

Hendry, Joy. *Understanding Japanese Society*. London: Routledge, 1989.

International Division of Nissan Motor Co., Ltd., ed. *Business Japanese: A Guide to Improved Communication*. 2d ed. Tokyo: Gloview, 1987.

Kadono, Eiko. *Majo no Takkyubin*. Tokyo: Fukuinkan, 1985.

Kaplan, David E., and Andrew Marshall. *The Cult at the End of the World*. New York: Crown, 1996.

Kawai, Hayao. *The Japanese Psyche: Major Motifs in the Fairy Tales of Japan*. Translated by Hayao Kawai and Sachiko Reece. Dallas: Spring Publications, 1988.

Kuroyanagi, Tetsuko. *Totto-chan: The Little Girl at the Window*. Translated by Dorothy Britton. Tokyo: Kodansha International, 1982.

LaFleur, William R. *Liquid Life: Abortion and Buddhism in Japan*. Princeton, New Jersey: Princeton University, 1993.

Levi, Antonia. *Samurai from Outer Space: Understanding Japanese Animation*. Chicago: Open Court, 1996.

McCarthy, Helen. *The Anime Movie Guide*. Woodstock, New York: Overlook Press, 1996.

McQueen, Ian. *Japan: A Travel Survival Kit*. South Yarra, Victoria, Australia: Lonely Planet, 1981.

Napier, Susan J. *Anime: From Akira to Princess Mononoke*. New York: Palgrave, 2000.

Reid, T. R. *Confucius Lives Next Door: What Living in the East Teaches Us About Living in the West*. New York: Vintage Books, 1999.

Schodt, Frederik L. *Inside the Robot Kingdom: Japan, Mechatronics, and the Coming Robotopia*. New York: Kodansha International, 1988.

————. *Manga! Manga! The World of Japanese Comics*. Tokyo: Kodansha International, 1983.

Seki, Keigo. *Folktales of Japan*. Translated by Robert J. Adams. Chicago: University of Chicago Press, 1963.

Seward, Jack. *The Japanese: The Often Misunderstood, Sometimes Surprising, and Always Fascinating Culture and Lifestyles of Japan*. New York: McGraw Hill, 1971

Shilts, Randy. *Conduct Unbecoming: Gays and Lesbians in the U. S. Military*. New York: St. Martin's Press, 1993.

Sugimoto, Etsu Inagaki. *A Daughter of the Samurai*. Garden City, New York: Doubleday, Doran and Company, 1934.

Tyler, Royall. *Japanese Tales*. New York: Pantheon, 1987.

Yang, Jeff; Dina Gan; Terry Hong, et al. *Eastern Standard Time: A Guide to Asian Influence on American Culture from Astro Boy to Zen Buddhism*. Boston: Mariner, 1997.

Articles

Brimmicombe-Wood, Lee, and Motoko Tamamuro. "Hello Sailor!" *Manga Max* 19 (August 2000).

Chua-Eoan, Howard, and Tim Larimer. "PokéMania." *Time* 154, no. 21 (November 22, 1999).

Davis, Julie, and Bill Flanagan. "Chiho Saito and Kunihiko Ikuhara." *Animerica* 8, no. 12 (January 2001).

Dawe, Aaron K. "Those Who Hunt Elves. " *Animerica* 8, no. 8 (September 2000).

Karahashi Takayuki. "Riding the Rails with the Legendary Leiji." *Animerica* 4, no. 7 (August 1996)

Loo, Egan. "Vision of *Escaflowne*." *Animerica* 8, no. 8 (September 2000).

Macias, Patrick. "*Harlock Saga*." *Animerica* 9, no. 3 (March 2001).

Nakatani, Andy, translator. "Animerica Interview: Mamoru Oshii." *Animerica* 9, no. 5 (May 2001).

——. "Ceres: Celestial Legend. " *Animerica* 9, no. 4 (April 2001).

Oshiguchi, Takashi. "On the Popularity of *Rurouni Kenshin*." *Animerica* 8, no. 9 (October 2000).

Osmond, Andrew. "*The Castle of Cagliostro*." *Animerica* 8, no. 4 (May 2000).

Richie, Donald. "It's Tough Being a Beloved Man: Kiyoshi Atsumi, 1928–96." *Time International* 148, no. 8 (August 19, 1996).

Shogawa, Shigehisa. "New Classic Music Rag No. 7." *Shukan Asahi* (February 24, 1989).

Smith, Toren. "Princess of the Manga." *Amazing Heroes*, no. 165 (May 15, 1989).

Tebbetts, Geoffrey. "Interview with Hiroki Hayashi." *Animerica* 7, no. 8 (September 1999).

Websites[1]

AAW: Index of Anime Reviews
http://animeworld.com/reviews/
Anime Web Turnpike
http://www.anipike.com/
Arisugawa Juri (Hollow Rose)
http://www.geocities.com/hollow_rose/main.html
Behind the Night's Illusions
http://www.animejump.com/giantrobo/index2.html
Black Jack
http://www.bb-anime.tv/bj/free.htm
Black Moon Japanese Culture Web site
http://www.theblackmoon.com/Contents/content.html
Dr. FangLang's Pavement (His and Her Circumstances)
http://www.geocities.com/Tokyo/4081/file416.html#20
Environmentalism in Manga and Anime
http://www.mit.edu/people/rei/manga-environmental.html
Furyu
http://www.furyu.com/archives/issue9/jubei.html
Hotaru no Haka (Grave of the Fireflies)
http://www2.hawaii.edu/~dfukushi/Hotaru.html
Last Unicorn
http://utd500.utdallas.edu/~hairston/luanimage.html
Kachikachi-yama
http://jin.jcic.or.jp/kidsweb/folk/kachi/kachi.html
Metropolis
http://www.sonypictures.com/cthv/metropolis/

[1]Primarily these are sites used in researching material in this book, but included are a few that might be of special interest to anime fans. Moving up levels in some of these sites often yields more links and information. Be aware that sites and their addresses (urls) change frequently. Searching by the site name on a standard Internet search engine is often the quickest way to find a lost url. The Anime Web Turnpike is one of the main starting points for any anime-related surfing.

Marubeni Shosha (Uniforms in Japan)
 http://www.marubeni.co.jp/english/shosha/cover68.
 html
Megumi-Toon: Girl with the Orange!
 http://www.nnanime.com/megumi-toon/mgbk022.
 html
Metropolis—Big in Japan: Tora-san
 http://www.metropolis.co.jp/biginjapanarchive249/
 241/biginjapaninc.htm
MonkeyPunch.com
 http://www.monkeypunch.com/
Museum Dictionary No. 8 (Kyoto National Museum)
 http://www.kyohaku.go.jp/mus_dict/hd08e.htm
Nausicaä
 http://www.nausicaa.net
Stone Bridge Press
 http://www.stonebridge.com
TechnoGirls Blue-Green Years Page
 http://www.quixium.com/technogirls/blugreen.htm
Tetsugyu's Giant Robo Site
 http://www.angelfire.com/anime2/GR/FF.html

Index of Names and Titles

Titles of anime and live-action movies are in **_boldface italics_**.

1984, 337
2001: A Space Odyssey, 236
3x3 Eyes. See **_Sazan Eyes_**

Aa! Megami-sama. See **_Oh My Goddess!_**
Adams, Douglas, 117
Adventures of Huckleberry Finn, The, 27
Agent Aika, 187
Ai no Kusabi, 95-97
Air Pirate Funnies, 352
Akado Suzunosuke, 108, 257
Akane, Kazuki, 291
Akihito, Emperor, 269
Akira, 6, 14, 18, 223, 229, 259, 300, 323, 336, 351
Akiyama, Joji, 109
Alakazam the Great!, 14
All Purpose Cultural Cat Girl Nuku Nuku, 173, 201
Amadeus, 93
Amakusa, Shiro, 94
Amaterasu, 49, 64, 146, 241, 306, 345
Andy Griffith Show, The, 27
Angel Hill, 153
Angel of Darkness, 70, 71,

97–98, 186–87
Animage (magazine), 259
Anime Movie Guide, The, 333
Anne of Green Gables, 257
Anno, Hideaki, 126, 300, 301, 302, 306, 309
Antz, 267
Appleseed, 96, 334–38
Aqua Age, 125–26, 127, 176, 291
Asamiya, Kia, 167
Astroboy, 5–7, 36, 150–52, 247, 346
Atsumi, Kiyoshi, 232
Aum Shinrikyo (cult), 309, 339
Ayashi no Ceres. See **_Ceres: Celestial Legend_**

Babel II, 247
Bakin Kyokutei, 209–10
Bandai, 231, 290
Barefoot Gen, 58, 137, 194, 198
Batman, 13
Be Papas. See Saito, Chiho
Beagle, Peter, 259
Beetlejuice, 13
Belle and Sebastian, 281

Bergman, Ingmar, 249
Bettelheim, Bruno, 41–42
Beverly Hillbillies, The, 27
Bewitched, 281
Birds, The, 239
Birdy the Mighty, 123, 133
Bishojo Senshi Sailor Moon. See **_Sailor Moon_**
Biskind, Peter, viii–ix
Black Jack, 35, 36, 149, 190, 356
Blackboard Jungle, The, 173
Blue Submarine No. 6, 14, 187, 304
Boku no Chikyu o Mamotte. See **_Please Save My Earth_**
Bonanza, 15
Brainpowered, 187
Brave New World, 337
Bubblegum Crisis, 136, 171
Bubblegum Crisis: Tokyo 2040, 22, 87, 119, 136, 304, 336
Buckley, Sandra, 90
Buffy the Vampire Slayer, 281
Bug's Life, A, 267
Bunraku, 22
Burr, Ty, 267

Buruma, Ian, 36, 90, 117–18

Cameron, James, 37
Capek, Karel, 247
Cardcaptor Sakura. See Cardcaptors
Cardcaptors, 14, 123, 167, 174, 291, 293, 325, 354
Care Bears, 12
Cat's Eye, 224
Ceres: Celestial Legend, 40–43
Chaplin, Charlie, 232
Char's Counterattack, 24
Chibi Maruko-chan, 54, 346
Chirality, 328
Cho Hatsumei Boy Kanipan, 126
CLAMP, 353
CLAMP School Detectives, 291
Clover, 354
Cockpit, The, 199, 206
Code Name Sailor V, 280, 286
Confucius, 115, 125, 144–46
Corman, Roger, 259
Cowboy Bebop, 173, 174, 176
Cream Lemon, 73–77
Crimson Pig, The, 259, 262, 268–69, 346
Crying Freeman, 163
Culture Club, 198
Cutey Honey, xiv
Cyber City Oedo 808, 47, 84, 216

Dallas, 15
Dallos, 10
Dan, Oniroku, 67
Delius, Frederick, 173
Denno Shojo Ai. See Video Girl Ai
Devil Hunter Yoko, 133–34, 164, 186
Devilman, 24

Digi Charat, 350
Digimon, 14, 58, 325
Disney, Walt, 4, 85, 189, 223, 253–54
Disney Studios, 267, 275, 352–53
DNA Hunter, 65
Doctor Zhivago, 223
Dog of Flanders, A, 257
Don Dracula, 153
Doomed Megalopolis, 64
Doraemon, 188–90
Dracula, xii, 70, 152, 216
Dragon Half, 181–82, 288
Dragonball Z, 11, 141, 350
Dumbo, 6
Dynasty, 15

Earthian, 64, 79, 143
Edogawa Rampo, 258
El Hazard: The Wanderers, 116, 172
Elf o Karu Monotachi. See Those Who Hunt Elves
Eliot, T. S., 237
Elven Bride, The, 68–69, 70, 163
Enchanted Journey, The, 131, 185–86
Enzeru no Oka. See Angel Hill
Escaflowne (TV series), 14, 119, 173, 176, 288–97, 316
Escaflowne: A Girl in Gaea, 293
E.T., 275
Etude, 73
Evangelion, 7, 17, 20–21, 31, 95, 118, 126, 127, 131–32, 173, 187–88, 248, 298–309, 320, 336, 345, 351, 355
Eve (magazine), 130
E.Y.E.S. of Mars, 188

F3. See Frantic, Frustrated, and Female

Fake, 87
Fat Albert and the Cosby Kids, 12
Final Fantasy (anime), 192
Final Fantasy (game), 357
Fist of the North Star, 317, 350
Fleischer, Max and Dave, 3–4
Forbidden Planet, 295
Frankenstein, 247
Frantic, Frustrated, and Female, 70
Fresh Prince of Bel Air, 27
Friday the Thirteenth, 70
Fujikawa, Keisuke, 224
Fujio Fujiko, 188, 333
Fujishima, Kosuke, 71, 159
Fushigi Yugi, 282
Futago no Kishi. See The Twin Knights

Gainax, 230, 298, 300, 302, 306
Galaxy Express 999, 135, 205, 217–18
Gall Force, 24, 187, 188, 198, 224
Gasaraki, 304
Gatchaman, 9, 84
Gate Keepers, 156
Gekiganger Three, 9
Genesis Survivor Gaiarth, 121–22
Getter Robo, 9
Ghost in the Shell, 6, 24, 173, 291, 334, 338–41
Ghost Sweeper Mikami, 47, 78, 152, 158–59, 173
Giant Robo, 246–52, 290, 300, 301, 346
Gigantor, 7, 247
Ginga Tetsudo 999. See Galaxy Express 999
Gitlin, Todd, ix–x
Go Lions. See Voltron
God Is a Southpaw, 53, 113, 153

Godzilla (1997), 267
Goshogun, 224
Grandizer, 224
Grave of the Fireflies, 13, 18,
 53, 131, 185, 193–94, 204,
 214, 265–66
Grey, 96
Gulliver's Travels (film), 4
Gulliver's Travels (novel),
 263
Gundam Wing, 14, 95,
 119–20, 148, 202–3
Guyver, 284

Hadashi no Gen. See Bare-
 foot Gen

Hagakure, 90, 107–8, 110,
 258
Hagio, Moto, 84
Haguregumo, 109–10
Hajimete no Homonsha, 59
Hakkenden, 13, 209–10
Hakujaden (Legend of the
 White Serpent), 255
Hamlet, 285
Harlock Saga, 252, 354
Harry Potter and the
 Philosopher's Stone, 277
Hasegawa, Machiko, 140
Hato yo! Ama Made, 155
Haunted Junction, 113, 115,
 145, 160, 161–64
Hayashi, Hiroki, 22
Hayashibara, Megumi, 23,
 173–74, 175, 263
Heisei Tanuki Gassen Pon-
 poko. See Ponpoko
Hell Teacher Nube, 156,
 159–60
Hello Kitty, 171
Hendry, Joy, 101
Here Is Greenwood, 81, 116
Herrmann, Bernard, 175
Hi no Tori. See Phoenix
Higuri, Yo, 95
Hiiragi, Aoi, 272
Hijiri, Yuko, 210

His and Her Circumstances,
 126–29
Hisaishi, Joe, 175, 262
Hisakawa, Aya, 174
Hitchcock, Alfred, 175, 239
Hitchhiker's Guide to the
 Galaxy, A, 117
Hiwatari, Saki, 51, 215
Hokusai, 60
Hotaru no Haka. See Grave
 of the Fireflies
Hotel, 163
Hummingbirds, 181
Huxley, Aldous, 337

I Can Hear the Ocean, 116
Idol Project, 180
Ikeda, Ryoko, 25, 87, 93,
 243
Ikegami, Ryoichi, 163
Ikkyu Sojun, 66
Imagawa, Yasuhiro, 248,
 249, 290
Imaizumi, Shinji, 53
Inoue, Kikuko, 174
Inu-Yasha, 168
Ippondo no Fukuin (One-
 Pound Gospel), 153
Iria: Zeiram the Animation,
 174, 200
Iron Chef, 330
Irresponsible Captain Tylor,
 121, 202, 203
Ishii, Hisaichi, 276
Ishinomori, Shotaro, 23,
 163
Isshuku-Ippan, 356
Its Name Is 101, 247

Jigoku Sensei Nube. See Hell
 Teacher Nube
Jin-Roh, 196–97
Johnny Socko, 7
Jones, Quincy, 262
Josei Jishin (magazine), 130,
 136
Jubei-chan the Ninja Girl,
 106, 107

Jung, Carl G., 38
Jungle Emperor, 8, 190

Kabuto, 155–56
Kadono, Eiko, 123, 139,
 157, 266
Kafka, Franz, 238
kami-shibai, xi, 22
Kanno, Yoko, 175–76, 178,
 291
Kare/Kano. See His and Her
 Circumstances
Kareshi Kanojo no Jijo. See
 His and Her Circum-
 stances
Katayama, Kazuyoshi, 334
Katsu-Aki, 292
Kawabata, Yasunari, 79
Kawaguchi, Kaiji, 194
Kawai, Hayao, 38
Kawai, Kenji, 340
Kawamori, Shoji, 289, 290
Kaze to Ki no Uta (Song of
 Wind and Trees), 90–91
Key the Metal Idol, 131, 133,
 166–67, 174, 179–80, 186,
 200, 342–47, 351
Kiki's Delivery Service, 36,
 119, 123, 139, 175,
 266–67
Kimagure Orange Road, 224
Kimba the White Lion, 7
Kinnikuman, xiii
Kite, 56–57
Kobayashi, Masaki, 156
Koike, Kazuo, 36, 163
Kojiki, 39, 48–49, 61, 241,
 306, 345
Kojima, Goseki, 36
Kon, Satoshi, 181
Kondo, Yoshifumi, 266,
 272, 274, 276
Konjaku Monogatari, 61,
 340
Kubrick, Stanley, 236
Kujaku-O. See Peacock King
Kurubeki Sekai. See World
 to Come

La Blue Girl, 61, 64, 70, 72, 73

Lady Blue, 61

LaFleur, William R., 149–50

Laputa: Castle in the Sky, 123, 138, 262–63, 269

Last Unicorn, The, 259

Lean, David, 223

Leda: Fantastic Adventures of Yoko, 224

Legend of Lemnear, 328

Levi, Antonia, 89–90

Lion King, The, 57

Little Prince, The, 281

Locke the Superman, 210, 211

Lone Wolf and Cub, 36

Lost Universe,

Love Hina, 30

Ludwig II, 95

Lupin III: Castle of Cagliostro, 257–59, 260

Mach Go Go Go. See *Speed Racer*

Macross. See *Robotech*

Macross 7, 178–79

Macross II, 84, 178

Macross Plus, 84, 142, 143, 173, 176, 178

Maeda, Toshio, 72

Magic Users Club, 50, 80, 81, 115, 157

Magical Girl Pretty Sammy, 56, 118, 123, 163, 172

Magical Princess Minky Momo, 43–45, 123, 133, 180, 203–4, 224

Magical Project S, 172

Magician, The, 249

Maho Tsukai Tai. See *Magic Users Club*

Mahotsukai Sally. See *Sally the Witch*

Maison Ikkoku, 19–20, 29–31, 49–50, 116, 134–35, 157–58, 260

Majo no Takkyubin (Witch's

Delivery Service), 123, 139, 157. See also *Kiki's Delivery Service*

Man Who Knew Too Much, The, 239

Marmalade Boy, 33, 88

Marnie, 239

Married . . . With Children, 67

Martian Successor Nadesico, 120–21, 154, 304

Matsumoto, Reiji, 8, 23, 199, 205, 206, 217, 252, 292

Maya the Bee, 281

McCarthy, Helen, 72, 333

McDonald, Glenn, 296–97

McHale's Navy, 15

McNally, Terrence, 282

MD Geist, 199, 323

Memories, 176, 195–96, 199

Men in Black, 13

Mermaids' Forest, 215, 216

Mermaids' Scar, 216

Metropolis (1927), 336

Metropolis (2001), 13, 172

Mimi o Sumaseba. See *Whisper of the Heart*

Mishima, Yukio, 79

Mitsume ga Toru, 71

Miyazaki, Hayao, 35, 36, 37, 39, 52, 53, 119, 123, 137–38, 157, 175, 183, 184, 198, 200, 253–79, 282

Miyuki-chan in Wonderland, 354

Mizoguchi, Hajime, 291

Mizuiro Jidai. See *Aqua Age*

Mobile Fighter G Gundam, 290

Mobile Suit Gundam 0080, 120

Momotaro the Peach Boy, 43–45

Monkey Punch, 257, 333, 356

Monster Farm. See *Monster*

Rancher

Monster Rancher, 14, 211, 325–26, 350

Mordden, Ethan, 303

Mori, Masaki, 58

Mori, Takeshi, 346

Mospeada,

MW, 83, 87, 88

My Neighbor Totoro, 52, 53, 137, 175, 183, 185, 224, 255, 263–65, 277

My Neighbors the Yamadas, 276–77

Nadia: Secret of Blue Water, 302

Nagai, Go, xiv, 9, 24, 152, 180, 224

Nakayoshi (magazine), 280

Nakazawa, Keiji, 58, 194, 198

Nausicaä of the Valley of the Wind, 39, 123, 175, 184, 198–99, 259–62, 323, 336

Neon Genesis Evangelion. See *Evangelion*

Niji no Prelude, 82–83

Ninja Bugeicho, 109

Ninja Resurrection, 106

Ninja Scroll, 106

Nintendo, 318, 325

Noh, 22

Nosaka, Akiyuki, 265

Occult Gang, 152

Oda Nobunaga, 109

Oedipus Rex, 285

Oh My Goddess!, 71, 159, 174

Okamoto, Hotaru, 268

Omoide Poroporo. See *Only Yesterday*

Omori, Kinuko, 171

On Your Mark, 185

O'Neill, Dan, 352–53

Only Yesterday, 184–85, 259, 267–68

Ordinary People, 301

Ore ga Mita, 137
Orwell, George, 337
Oshii, Mamoru, 100–101, 196, 338
Otaku no Video, 346
Otomo, Katsuhiro, 14, 176, 195–96, 200, 300
Outlaw Star, 163

Paros no Ken. See Sword of Paros
Parsifal, 246
Peacock King, 45–46, 47
Peanuts, 277
Perfect Blue, 181
Phantom of the Opera, 70
Phantom Quest Corporation, 160–61
Phoenix, 218–19, 228
Pippi Longstocking, 257
Plastic Little, 82, 83, 327–32
Please Save My Earth, 51–52, 71, 83, 126, 176, 188, 204, 215–16, 281, 291, 310–16
Pokémon, 12, 14, 58, 93, 135–37, 224, 293, 317–26, 350, 355
Pokemon: Mewtwo Strikes Back, 323–24
Pokemon: Spell of the Un-own, 325
Pokemon: The Power of One, 324–25
Pollock, Jackson, 16
Ponpoko, 184, 269–72, 273
Popeye, 3, 6, 12
Porco Rosso. See The Crimson Pig
Porter, Cole, 33
Prince of the Sun: Hols' Great Adventure, 255, 263
Princess Knight, 8, 18, 84–87, 93, 98, 119, 149, 243, 281
Princess Minerva, 180
Princess Mononoke, 35, 37–38, 119, 139, 183–84,

185, 200, 266, 274–76, 277, 351
Princess Nine, 24, 26, 113, 114, 153, 260
Prisoner, The, 301
Psycho, 239
Puffy (pop music group), 296–97

Queen Emereldas, 205

Rail of the Star, 204
Ranma 1/2, 36, 45, 50–51, 54, 67, 82, 93, 119, 132–33, 174
Rayearth, 354
Real McCoys, The, 27
Rear Window, 239
Record of Lodoss War (OAV series), 42, 67, 70, 124, 288, 290
Record of Lodoss War: Chronicle of the Heroic Knight, 24, 291, 354
Red Shadow, 247
Reid, T. R., 28, 31
Return of the Jedi, 122
Revolutionary Girl Utena. See Utena
RG Veda, 351
Ribon no Kishi. See Princess Knight
Richie, Donald, 232
Ring of the Niebelung, 246, 251–52
Rintaro, 14
Road Runner, vii
Robotech, xi, 8, 9, 11, 177–78, 231, 281, 289
Rocky and Bullwinkle, vii
Rocky Horror Picture Show, The, 249
Romance of Three Kingdoms, 247
Rose of Versailles, 87, 93, 243
Roujin Z, 55, 200–201
R.U.R., 247

Ruroni Kenshin, 18, 19, 36, 110, 111, 117, 119

Saban, Haim, 294
Saber Marionettes, 174
Sailor Moon, xiii, 11, 23, 24, 56, 69–70, 71, 80, 116, 118, 123, 133, 142–43, 148, 165–66, 172, 174, 179, 211–13, 280–87, 291, 293, 351
Sailor Victory, 351
Saint Tail, 123
Saito, Chiho, 31–32
Saiyuki. See Alakazam the Great!
Sakamoto, Maya, 176, 291
Sakamoto, Ryuichi, 231
Sakura, Momoko, 53
Sally the Witch, 123, 247
Sangokushi. See Romance of Three Kingdoms
Sato, Gen, 24
Sato, Hiroaki, 342
Sato, Yasukazu, 321
Sazae-san, 140–41
Sazan Eyes, 71, 87, 174
Schodt, Frederik L., 126
Schulz, Charles, 276
SD Gundam, 24
Sea Prince and the Fire Child, 80–81, 206–7
Sen to Chihiro no Kamikakushi. See Spirit-ed Away
Serial Experiment Lain, 304
Shamanic Princess, 351
Shelley, Mary, 247
Shiina, Takashi, 78, 158
Shilts, Randy, 79
Shimamoto, Sumi, 260
shinju (murder-suicide), 225–27
Shinseiki Evangelion. See Evangelion
Shin Takarajima (New Trea-sure Island), 8
Shirato, Sanpei, 109

Shiro Kujaku no Uta. See *Song of the White Peacock*

Shirow, Masamune, 333, 337

Shojo Kakumei Utena. See *Utena*

Silent Moebius, 166, 167–68

Silent Service, 194–95, 204

Simpsons, The, 27

Sirius no Densetsu. See *Sea Prince and the Fire Child*

Slayers, 174, 224, 288

Snow White and the Seven Dwarfs, 4

Song of the White Peacock, 170–71

Sose Kishi Gaiarth. See *Genesis Survivor Gaiarth*

South Park, vii

Southern Cross,

Speed Racer, 8, 22, 281

Spirited Away, 277–79

Spriggan, 198

Star Blazers, 8, 204, 205, 224, 292, 354

Star Wars, 8, 122, 199, 328

Starship Girl Yamamoto Yoko, 121

Stern, Howard, 67

Studio Ghibli, 116, 262

Sugimoto, Etsu, 49

Suikoden, 163

Super Angels, 113

Superdimensional Fortress Macross. See *Robotech*

Superman, 3, 12

Swift, Jonathan, 263

Sword for Truth, 97

Sword of Otonashi, 247

Sword of Paros, 98–100

Tachikake, Hideko, 197–98

Tajiri, Satoshi, 318, 319

Takada, Yuzo, 87

Takahashi, Rumiko, 19, 29, 49, 50, 63, 81, 93, 134, 153, 155, 157–58, 168, 215, 216

Takahata, Isao, 53, 184, 193, 214, 255, 263, 265, 268, 271, 276

Takanashi, Minoru, 290

Takarazuka, 85–86, 92, 93, 219, 268

Takashi, Ryosuke, 194

Takashige, Hiroshi, 198

Takemiya, Keiko, 90

Takeuchi, Naoko, 11, 172, 280, 286

Takeuchi, Tsuneyoshi, *Tale of Genji, The,* 13, 61

Teen Wolf, 13

Ten Little Gall Force, 24

Tenchi Muyo (TV and OAV series), 14, 22, 71, 118, 123, 131, 143, 172, 186, 215, 304

Tenchi Muyo: Midsummer's Eve, 213

Tenchi Muyo In Love (movie), 56, 122, 134

Tenku no Escaflowne. See *Escaflowne*

Tetsujin 28-go. See *Gigantor*

Tetsuwan Atomu. See *Astroboy*

Tezuka, Osamu, Dr., xiii, 5–7, 10, 11, 18, 23, 35, 36, 71, 82, 84–87, 88, 93, 98, 108, 140, 149–52, 153, 155, 170, 172, 190, 213, 214, 218–19, 228, 243, 247, 253–54, 281, 336, 356

They Were Eleven, 84

Things to Come, 336

Those Who Hunt Elves, 54–55, 162

Three Days of the Condor, 301

Three Musketeers, The, 224

Thundercats, 22

Titanic, 37–38, 219, 275, 277

tobi (fire brigades), 319, 322–23

Tokuma Shoten, 259, 263, 267, 268, 275

Tonai, Yuko, 268

Tonari no Totoro. See *My Neighbor Totoro*

Tonari no Yamada-kun. See *My Neighbors the Yamadas*

Tootsie, 83

Tora-san, 231–33

Toriyama, Akira, 11

Touched By An Angel, 307

Toy Story, 357

Toyotomi Hideyoshi, 65, 148

Transformers, 9

Truffaut, Francois, 285

Tsutsumi Chunagon Monogatari, 261

Twin Knights, The, 149

Uchu Senkan Yamato. See *Star Blazers*

Uji Shui Monogatari, 64

Ultraman, 224

Umezu, Yasunori, 56

Umi ga Kikoeru. See *I Can Hear the Ocean*

Unico (manga), 190

Unico on the Island of Magic, 126, 213–14

Urashima Taro legend, 227–28

Urotsukidoji (Legend of the Overfiend), 61, 70, 72–73, 74, 317

Urusei Yatsura, 47, 63, 81, 155, 168

Urushihara, Satoshi, 328, 329

Uses of Enchantment, The, 41–42

Utena, 18, 31–32, 81, 119, 174, 237–45, 304

Vampire Hunter D, 152

Vampire Princess Miyu, 161,

172, 216–17
Vengeance of the Space Pirate, 143
Venus Five, 69–70
Vertigo, 239
Victor Victoria, 83, 92
Video Girl Ai, 143, 173
Voltron, 9, 281

Wagner, Richard, 246
Waltons, The, 27
Warriors of the Wind, 259
Watase, Yu, 40
Watashi no Kyofusho, 197
Water Margin, The, 247, 249
Watsuki, Nobuhiro, 36, 110, 111, 117
Weather Report Girl, 224
Wedding Peach, 224
Whisper of the Heart, 138–39, 272–74, 346
Whoops!!, 176
Windaria, 206, 223–29
Wings of Honneamise, 36, 230–36, 302
Winnie-the-Pooh, 12
Wonder Three, 7
Words Worth, 66
World to Come, 190

X, 354

Yagyu Jubei, 104–6, 258
Yamaga, Hiroyuki, 231, 236
Yashiro, Yuzuru, 293
Yogi Bear, 22
Yokohama Shopping Journal, 187–88
Yokoyama, Mitsuteru, 7, 247
Yoshida, Mitsuhiko, 59
Yoshimoto, Kinji, 328
Yoshitsune, 91–92, 93, 94
Yoshizumi, Wataru, 33, 88
Yugen Kaisha. See *Phantom Quest Corporation*
Yugi-Oh, 14, 325
Yuki, Nobuteru, 290

Yumi, Toma, 174
Yuyama, Kunihiko, 224, 323

Zillion, 9

Viewing Notes

Title

Comments

Title

Comments

Title

Comments

Title

Comments

Viewing Notes

Title

Comments

Title

Comments

Title

Comments

Title

Comments

Viewing Notes

Title

Comments

Title

Comments

Title

Comments

Title

Comments

Viewing Notes

Title

Comments

Title

Comments

Title

Comments

Title

Comments

Viewing Notes

Title

Comments

Title

Comments

Title

Comments

Title

Comments

Viewing Notes

Title

Comments

Title

Comments

Title

Comments

Title

Comments

OTHER TITLES OF INTEREST FROM STONE BRIDGE PRESS

Obtain any of these books online or from your local bookseller.
sbp@stonebridge.com • www.stonebridge.com • 1-800-947-7271

*Quality Books
About Japan*

THE ANIME ENCYCLOPEDIA
A Guide to Japanese Animation Since 1917

JONATHAN CLEMENTS AND HELEN MCCARTHY

This richly detailed guide is required reading for every fan, collector, and moviegoer. Covering more than 80 years of anime history and over 2,000 titles with critical finesse and authority, it is the most comprehensive guide in any language to the entertainment universe that is rapidly winning new audiences and influencing creative cultures far beyond its native shores. With titles in English and Japanese, lists of key creatives (directors, writers, animators, composers, studios), and parental advisories. Fully indexed and cross-referenced.

576 pp, paper, 100+ illustrations, ISBN 1-880656-64-7, $24.95

HAYAO MIYAZAKI
Master of Japanese Animation

HELEN MCCARTHY

By the coauthor of *The Anime Encyclopedia*. Introducing the genius behind Japan's modern animation classics, the creator of Totoro, Kiki, and Princess Mononoke. With detailed discussions of Miyazaki's most important films, design and technical data, story synopses, character sketches, a guide to how animation is made, and a complete filmography.

240 pp, 8 pp color, 60+ b/w illustrations, ISBN 1-880656-41-8, $18.95

THE ANIME COMPANION
What's Japanese in Japanese Animation?

GILLES POITRAS

The otaku's best friend, a comprehensive reference to all the Japanese cultural details in anime you don't want to miss! Fully indexed with regular Web updates by the author.

176 pp, 50+ b/w illustrations
ISBN 1-880656-32-9, $16.95

ANIME ESSENTIALS
Every Thing a Fan Needs to Know

GILLES POITRAS

Answering just about every question a fan (or curious parent) has, *Anime Essentials* is an easy-to-read and fun-to-look-at overview of this pop culture phenomenon. Major players, must-see films, otaku etiquette, how to run an anime club, how to "talk" anime to outsiders, and lots more of interest to both veterans and newcomers.

128 pp, illustrated throughout
ISBN 1-880656-53-1, $14.95

DREAMLAND JAPAN
Writings on Modern Manga

FREDERIK L. SCHODT

A collection of insightful essays on the current state of the manga universe, the best artists, the major themes and magazines, plus what it means for the future of international visual culture. By the author of the acclaimed *Manga! Manga! The World of Japanese Comics*.

360 pp, 8 pp color, 100+ b/w/ illustrations, ISBN 1-880656-23-X, $18.95

Also get Ryan Omega's **Anime Trivia Quizbook,** *vol. 1 ("From Easy to Otaku Obscure," ISBN 1-880656-44-2) and vol. 2, with Scott Rux ("Torments from the Top 20," ISBN 1-880656-55-8). Each volume $14.95, with hundreds of questions, mind-numbing stumpers, and expert groaners.*